AMERICAN IMAGES

The SBC Collection
of Twentieth-Century American Art

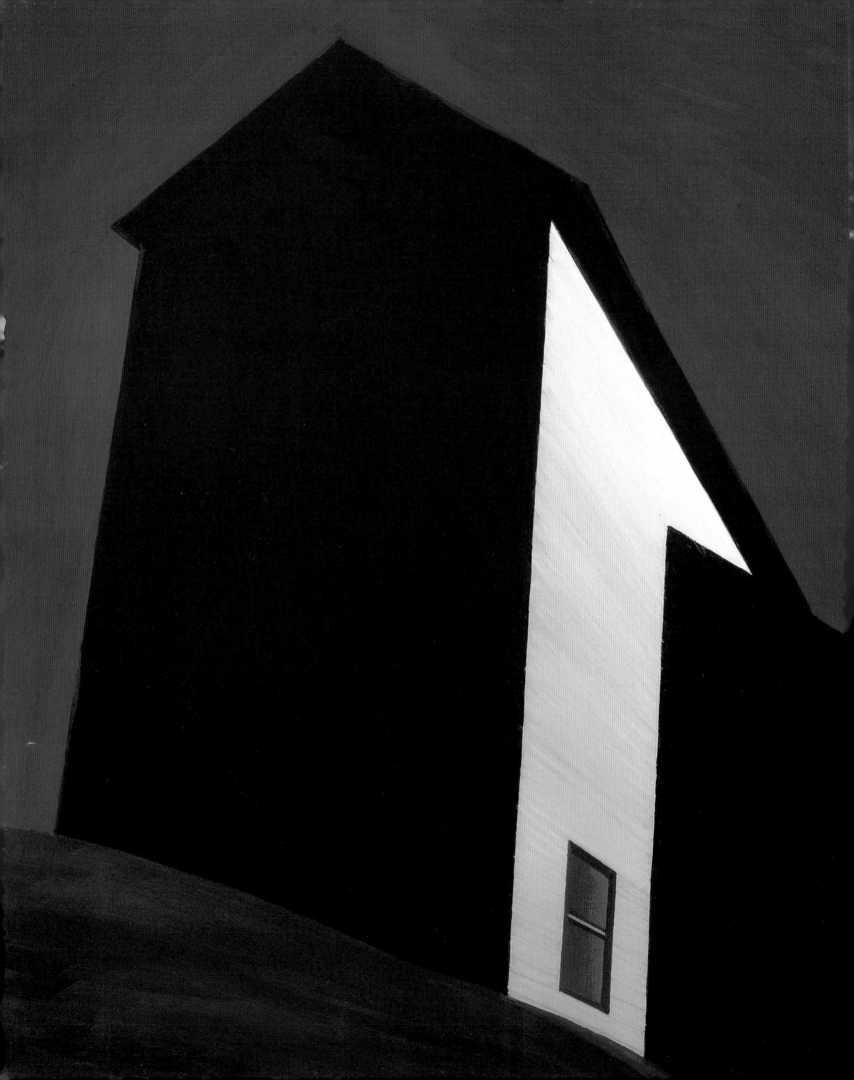

AMERICAN IMAGES

The SBC Collection
of Twentieth-Century American Art

Foreword
Edward Whitacre

Preface
Laura Carey Martin

Introduction
Walter Hopps

Essays
Betsy Fahlman

Matthew Baigell

Susan C. Larsen

William C. Agee

Dore Ashton

Peter Plagens

Irving Sandler

John R. Clarke

Leslie King-Hammond

Jacinto Quirarte

John Beardsley

Afterword
Peter Marzio

SBC Communications Inc.

Harry N. Abrams, Inc., Publishers

The SBC Collection, begun in 1985, consists of nearly one thousand works of American art. The collection is enjoyed by the employees of SBC, but more importantly, the works are a valuable educational resource and are available for loans to educational and art institutions. This book documents the core of the collection and emphasizes the importance of corporate stewardship in American cultural life.

ACKNOWLEDGMENTS

I am most grateful to Ed Whitacre for the encouragement and support he has given me throughout the years. I would also like to thank Zane Barnes for his vision during the early years of assembling the collection. Karen Jennings should be recognized for her insight regarding the importance of arts and education. Also, I would like to thank the employees of SBC, especially David Carlson, Leslie Luther, Cynthia Mahowald, and Lynn McLain for their ongoing involvement in this project. For their invaluable advice, I would like to thank Don Bacigalupi, Jim Burke, Douglas Hyland, and Peter Marzio. I am especially indebted to Walter Hopps who has been so much a part of the development of this collection. For their scholarly contributions, I would like to recognize William Agee, Dore Ashton, Matthew Baigell, John Beardsley, John Clarke, Betsy Fahlman, Walter Hopps, Leslie King-Hammond, Susan Larsen, Peter Marzio, Peter Plagens, Jacinto Quirarte, and Irving Sandler.

Many thanks to Melissa Kepke, Jennifer Hindert, Amy Munger, and Tracey Vera for their thoroughness, intelligence, and good humor throughout this project. For his talent and cantankerous diligence, I would like to thank Don Quaintance, and also Elizabeth Frizzell for her extensive production assistance. I would like to thank Polly Koch for her editorial expertise and Michael Bodycomb, who undertook the formidable task of photographing most of the works illustrated in this book. For their enthusiasm and involvement, I would like to thank Alberta Mayo and Caroline Huber. Also, I would like to recognize Bob Dickemper for his contribution to the catalogue.

Finally, a special thanks to Gator.

Laura Carey Martin
Curator of The SBC Collection

Art Consultation and Publication Direction: Carey Ellis Company
General Editor and Curator: Laura Carey Martin
 Editor: Melissa Marie Kepke
 Research Assistant: Amy C. Munger
 Copy Editor: Polly Koch
 Assistant Copy Editor: Jennifer Hindert

Designer: Don Quaintance, Public Address Design, Houston
 Production Assistant: Elizabeth Frizzell
 Principal Photography: Michael Bodycomb

For Harry N. Abrams, Inc.
 Editor: Robert Morton

Front cover: John Storrs, *Genesis,* 1932 (pl. 41)
Back cover: Robert Longo, *Strong in Love,* 1986 (pl. 166)
Frontispiece: Charles Sheeler, *Powerhouse with Trees* (detail), 1943 (pl. 57)

Library of Congress Cataloging-in Publication Data

SBC Communications.
 American images : the SBC collection of twentieth-century American art/introduction, Walter Hopps; essays, Betsy Fahlman . . . [et al.].
 p. cm.
 Includes bibliographical references and index.
 ISBN 0–8109–1969–9 (cloth) / ISBN 0–8109–2657–1 (pbk.)
 1. Art, American —Catalogs. 2. Art, Modern—20th century—United States—Catalogs. 3. SBC Communications—Art collections—Catalogs. 4. Art—Private collections—New York (N. Y.) —Catalogs. 5. Art—New York (N.Y.)—Catalogs. I. Fahlman, Betsy. II. Title.
N6512.S314 1996
760' .0973'0747471—dc20 95–48920

Contents

Foreword

Edward Whitacre

As we approach the twenty-first century, SBC, one of the world's leading telecommunications companies, is devoted to finding the most efficient and effective ways for enabling our customers to communicate with one another. Although we have primarily relied on technological advancements in our search for more immediate and intimate means of communicating, we are also aware that art, as a form of visual communication, also accomplishes those things.

Our collection of twentieth-century American art, for example, is a daily reminder of SBC's rich one-hundred-year history. The collection, which began in 1985, also reflects the changing environment in which the company has operated since that time. As the telecommunications industry has expanded into global markets, the definition of the "typical" SBC customer and employee has broadened to include people of diverse national and ethnic backgrounds. Likewise, the art collection has grown to reflect SBC's cultural diversity and includes works by artists who share an American nationality but celebrate their individual cultural heritage through their art.

Our vision of the future is exciting and revolutionary, and many artists represented in the SBC Collection share a similar vision. Art is no longer defined as just paintings—the collection includes works done in a variety of innovative techniques, including dye-transfer photography, video installations, and mixed media constructions composed of innumerable diverse materials. At SBC, we are breaking away from tradition to establish a unique, influential presence in telecommunications. Similarly, we support such progressive thinking in the artists represented in the collection.

Since the beginning, we have been committed to sharing this wonderful resource with SBC employees and their families, as well as the community at large, in the form of educational programs, loans to museums, and projects such as *American Images*. This book builds on our commitment to the arts, and I hope that readers will gain a better understanding of the ways in which companies like SBC foster the arts as well as a newfound appreciation for the role art plays as a vibrant form of modern day communications.

Edward Whitacre
Chairman of the Board and Chief Executive Officer

Preface

Laura Carey Martin

Art is among the most eloquent forms of human communication, providing access to a culture's vision of the world and preserving that vision for generations yet to come. Look carefully at the art of any time and place, and you can sense the forces that shaped and colored its creation. Like our most powerful computers, a work of art contains a wealth of enriching information—the equivalent of a million perfectly chosen words, communicated through the optic nerve in a split second, never to be forgotten. SBC Communications has always understood this power. While it embraces the world of new technologies and ever more sophisticated ways to transmit information, unwavering support of the special role of art has remained central to its mission.

SBC Communications started to collect modern and contemporary American paintings, prints, and sculpture in 1985. From the beginning, the collection was a serious endeavor, guided by educated opinion with an eye toward creating a strong corporate asset. The collection, like the company, was expected to change and grow as opportunities presented themselves. When I was called in to advise the corporation, my mandate was simple: Acquire important American works of the twentieth century by acknowledged masters and lesser known or younger artists who may become so, then use those works to enrich and educate the corporate family, the communities served by SBC Communications, and museum visitors around the world.

The artists represented in the collection are as diverse as the corporation itself. Over the past ten years, major works by artists such as Gerald Murphy, Charles Sheeler, Roy Lichtenstein, Joan Mitchell, Georgia O'Keeffe, Mark Rothko, and Frank Stella have become part of the corporate environment of SBC Communications, along with works by successful cutting-edge artists like Willie Cole, Carrie Mae Weems, Luis Jimenez, Daniel J. Martinez, Carroll Dunham, Vernon Fisher, and Suzanne McClelland. The collection also includes artists in yet another category—those whose work of earlier decades, presciently singled out by SBC Communications, is now receiving the attention it deserves. Indeed, our recognition of undervalued early twentieth-century American art has been key to our ability to acknowledge and encourage the work of promising younger artists today.

We have never sought to acquire one of everything or to provide a comprehensive survey of twentieth-century American art, yet our holdings of nearly one thousand works of art do tell a story. It is the story of modern America as mirrored in works of art that, like the constantly evolving culture they represent, push the edge of the envelope as they reach for the future.

We believe these works have much to teach, and starting with SBC's employees,

thousands of people have been given the opportunity to look—and learn. Parts of the collection are frequently sent on the road, traveling in group exhibitions to smaller cities without major museums (SBC also loans selected works to major institutions). As a corporation, we take full advantage of the freedom to send art where we feel it will accomplish the most good. Our extensive exhibition program increases public access to important works of art not only geographically but also intellectually; with all our exhibitions go carefully prepared materials designed to maximize audience understanding and enjoyment. Our "Contemporary Masters Kansas Tour: Selections from the Collection of Southwestern Bell Corporation" (1989), which brought a selection of important works to small arts centers in Kansas, came with a thick bibliography and instructions for potential docents. An exhibition of works by artists like Andy Warhol, Robert Longo, and Elizabeth Murray, which last September helped inaugurate the Arts & Science Center for Southeast Arkansas, targeted younger viewers with a specially designed guidebook that included suggestions for classroom activities, accessible artist biographies, and a no-jargon guide to looking at abstract art.

This catalogue is an extension of our desire to encourage clear, direct talk about twentieth-century American art. Because "art talk" can often be opaque, arbitrary, and difficult to understand, many people have become frustrated and stopped listening—and looking. This catalogue features a very different kind of art history. Leading scholars from all over the country have been asked to use our collection as a springboard to write about modern and contemporary art in a readable, usable manner. How does the place or time during which an artist worked influence his or her art? What can art tell us about our own society? How does art communicate its cultural message from generation to generation? In a series of chronological essays, the great art historical minds of our time consider these questions while introducing the SBC Collection to a larger audience. We know that art history students and art professionals all over the world will find these essays important additions to existing scholarship. But with the catalogue's striking illustrations of important works and its accessible text, we also believe we have created a book that is beautiful, appealing, and useful to everyone.

We are proud of our catalogue, of our exhibitions, of our collection, and of the company that made it all happen. In putting together this official record of the SBC Communications' collection, we can see clearly how far we have come and how successful we have been. While I am extremely pleased to have been a part of it, I want to stress that nothing would have been possible without SBC's leadership. Their vision and commitment are responsible for SBC Communications' unwavering support of the special kind of communication provided by works of art.

Laura Carey Martin
Curator of The SBC Collection

Introduction

Walter Hopps

Perhaps the greatest social invention of the eighteenth century was the dream to found the American Republic. Never had a colonial outpost so vast in land, population, and potential resources presumed to secede from its mother country. Despite the American Revolution's grounding in rationality and pragmatism, modern historians have identified a humanist and aesthetic passion within the imperatives that drove and shaped this political upheaval.

The primary document in America's secession from Great Britain, the Declaration of Independence as drafted by Thomas Jefferson, includes one extraordinary phrase that informed the new Republic's culture from the end of the eighteenth century henceforth. It states that all citizens are entitled to "life, liberty, and *the pursuit of happiness.*" This last, unique concept laid the foundation for what historians now identify as an aesthetic dimension intrinsic to the life of the new nation.

Although art existed for the native peoples of the vast American continent before the arrival of European colonists, such accomplishments were rarely recognized and appreciated until well into the nineteenth century, when the indigenous cultures had been all but destroyed. Most American art, therefore, was imported along with the cultures of its immigrants.

While America harbored and produced significant visual artists before the end of the eighteenth century and throughout the nineteenth century, their advanced training often took place in European academies such as those in Düsseldorf, Rome, and Paris. The fine arts also flourished in niches associated with early American academic communities at colleges such as Harvard and Yale in New England and William and Mary in Virginia. The Pennsylvania Academy of the Fine Arts in Philadelphia functioned both as a major fine arts school and as the nation's first public art museum. Artistic activity grew as commissions, museums, and academies thrived. Although American art remained strongly influenced by the European models, the composition of the American Republic, broadly pluralistic with democratic political institutions and a capitalist economy, succeeded in producing a diverse range of expression.

The seeds of innovation were present from America's founding, but they germinated slowly and subtly. During the nineteenth century, most American art addressed nature: The lyricism of rural life and the harsh splendors of the frontier. The aesthetic stance of these works, however, showed distinct differences. John James Audubon and Albert Bierstadt, for example, both depicted scenes from direct experience. But while Audubon's empirically precise paintings of North American birds and animals exhibit an exquisite composition and execution, they were largely documenting a

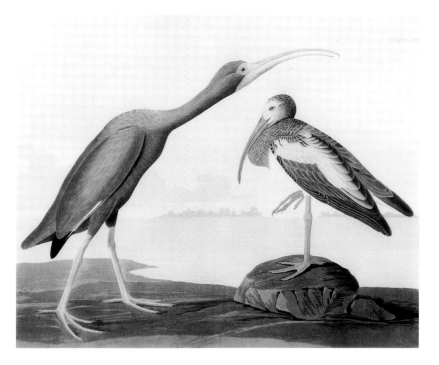

Figure 1
JOHN JAMES AUDUBON
Scarlet Ibis, 1837
Hand-colored engraving and aquatint
on paper
24½ x 32½ in.

naturalist's perspective (fig. 1). On the other hand, Bierstadt and many of his contemporaries worked to present a romanticized and highly dramatic vision of the American frontier.

As America entered the twentieth century, the work of its visual artists progressively achieved a strength and originality that could stand in comparison with its European counterparts. The emergence of modern art coincided with profound innovations in material, technical, and scientific culture, ranging from electric light to the frontiers of quantum mechanics. The expansion of available electrical energy nationwide and the interconnections created by the telegraph and telephone were soon followed by the revolutionary transmission possibilities of radio-wave engineering. Looking back roughly one hundred years, one can see that these new technologies and their futuristic mythologies had a pronounced effect on the nascent life of the American visual and literary imagination.

The signal artistic developments of our century are clearly chronicled by works in the SBC Collection. This still-young collection cannot claim encyclopedic coverage of modern American art. However, core holdings in Realism, Modernist abstraction, Abstract Expressionism, Pop Art, Minimalism, and contemporary Postmodern directions comprise a broad and significant resource. This synoptic introduction and the book that follows review the historical organization of the collection. Surveying the art presented, one can gain a perspective on how American art achieved maturity and came to claim innovative stature on the international stage.

The first section of this volume, "The American Scene," addresses American art from the late nineteenth century through the Depression. Still dominated by strong currents of representation, much of this art is rooted in nineteenth-century Realist modes. A vigorous approach to Realist art dealing largely with urban subject matter, which was developed by Robert Henri and taken up by his younger followers including John Sloan, Everett Shinn, and William Glackens, became known as the Ashcan School (so named for its candid depiction of everyday city life).

From the 1920s to the advent of World War II, another vigorous strain of Realism loosely identified as art of the American Scene flourished. Thomas Hart Benton, the outspoken leader of this movement, chronicled predominately rural and Midwestern scenes often based on subjects from American folklore. John Steuart Curry and Grant Wood, among others, also worked in this genre.

The sustaining master of American Realism, however, was Edward Hopper, who produced prints, paintings, and drawings from 1906 until his death in 1967. One recurrent theme of Hopper's paintings is the uneasy balance achieved when human activity and man-made structures are set against the forces of nature. Hopper's masterful chronicles of the urban landscape parallel the works of photographer Lewis Hine and painter Reginald Marsh, who evocatively depicted the tumultuous big-city lives of construction workers and shopgirls. As the twentieth century unfolded, however, the predominance of Realism often stood in ideological opposition to emerging Modernist directions in American art.

While the roots of modernity extend back to the 1860s in Europe, flowering near the turn of the century in Paris, Modernist art in America emerged late, taking hold slowly in the first decade of the twentieth century. Few commercial art galleries existed at that time in the United States, and there was no museum of modern art until the founding of the Société Anonyme in 1920. Perhaps ironically, the first Modernist art enterprise in America was established by Alfred Stieglitz, a master of the essentially representational medium of photography. Stieglitz, who also published groundbreaking catalogues and journals, opened his gallery, 291, in 1905 in New York. Named for its address on Fifth Avenue, this germinal space staged the first public exhibitions in the western hemisphere of Pablo Picasso and Henri Matisse. Through Stieglitz's efforts the medium of photography became an essential part of the modern enterprise, and he identified and promoted many of the new Modernist American painters who are discussed in the second section of the book, "Modernism Before 1945."

In 1913, a landmark, large-scale event thrust modern art into the consciousness of the American public. "The International Exhibition of Modern Art," usually referred to as the Armory Show, was originally organized by a committee of independent artists including those from Henri's circle, later directed by Arthur B. Davies. The exhibition, which was launched in New York and later toured to Boston and Chicago, was intended to promote new (primarily Realist) American art by displaying it within an international context. Paradoxically, because it included a vast number of Modernist works from Europe, the exhibition became the most explosive and highly publicized showing of modern art ever in America. The mostly negative public outcry did not deter an estimated one-half million people from attending. The ensuing public debate provoked an American interest in new forms of art that has not yet abated. In addition, the Armory Show stimulated a crucial handful of American collectors (such as Walter Arensberg, Katherine Dreier, and Duncan Phillips) to begin modern art collections that had an international perspective.

By 1920, a significant number of American artists drawn to the modern idiom had sojourned in Europe, primarily Paris. Such artists as Stuart Davis, Marsden Hartley, John Marin, and Stieglitz spent important parts of their careers in Europe, while Man Ray and the grandly lyric Cubist Gerald Murphy settled abroad as expatriates. Artists belonging to this new breed were not simply soaking up techniques in European

Figure 2
JOHN D. GRAHAM
An American Girl, 1931
Oil on canvas
36 x 28¼ in.

academies but were involved in an intricate cultural cross-pollination with their European counterparts.

Pioneers of American art associated with Modernism include Davis, Arthur Dove, Georgia O'Keeffe, Man Ray, Marin, and William Zorach. Davis, Marin, Max Weber, and Zorach were early interpreters of a Cubist structure derived from their French contemporaries. While Weber's and Zorach's work comprise a close American link to the Cubism pioneered by Georges Braque and Picasso, Marin's paintings and water-colors interpreting country and city views demonstrate a gestural approach unique to the Cubism of the time. A fluid Cubist style was also employed by Arthur B. Carles, whose complex still-life compositions anticipated aspects of Abstract Expressionism. A Cubist-inspired approach to abstraction from nature similarly lies behind important portraits and still lifes by John Graham (fig. 2) and meticulously rendered picto-rial vistas by Charles Sheeler.

Of all these, Davis stands unchallenged as the primary artist to develop a Cubist structure with a uniquely American viewpoint that included a visual response to the musical idiom of jazz. His imagery and graphic techniques also tended to prefigure the Pop Art that would spring up in the 1960s (fig. 3).

Man Ray was perhaps the most versatile American Modernist. His artwork encompasses every aspect of painting, watercolor, drawing, printmaking, and photography as well as innovative sculptural techniques. Though Man Ray is better known for his Dada, Surrealist, and Cubist works, for many historians his finest achievement is in the realm of photography.

The Depression of the 1930s spans much of this period. Arising in response to the economic hardships of these times, federal funding of the Works Progress Administration (WPA) indirectly sustained the new art by providing modest but con-tinuing support to a large number of artists. From the WPA sprang large-scale pub-lic works such as representational murals, geometric abstractions by Ilya Bolotowsky, and documentary photographic projects. Its support was also crucial to younger artists such as Jackson Pollock and David Smith, who would assume major importance in the revolutionary artistic endeavors of the following decade.

Figure 3
STUART DAVIS
Detail Study #1 for Cliche, 1955
Gouache on paper
12¾ x 15 in.
© 1996 Estate of Stuart Davis/Licensed by VAGA, New York, NY

"Mid-Century Innovation," the third section of this book, covers the period from the 1940s through the 1950s. Centered in New York, the primary innovative mode of art at this time was Abstract Expressionism. Critics used the term to describe a broad range of highly subjective, antidecorative, and gestural artmaking that evinced a powerful, if controversial, pres-ence from about 1940 forward. The major American artists of this New York School, including Arshile Gorky, Willem de Kooning, Franz Kline, Pollock, Mark Rothko, and Clyfford Still, were born near the turn of the century. They underscored the in-clusiveness of the Abstract Expressionist mode, which encompassed both the linear ges-tural activity of de Kooning or Pollock and the calm, expansive color surfaces of Rothko.

A younger generation born after 1920, whose abstract art mostly dates from the 1950s forward, includes John Chamberlain, Richard Diebenkorn, Sam Francis, Helen Frankenthaler, and Joan Mitchell. Ellsworth Kelly's and Al Held's contemporaneous work diverged from the Abstract Expressionist mode toward a minimally modulated color-field abstraction.

During the modern period, the pervasive international influence exerted by Abstract Expressionism was rivaled only by the impact of French Cubism from earlier

in the twentieth century. Given the extremely high monetary value placed on Abstract Expressionist art, the practical approach of acquiring smaller works on paper has allowed the SBC Collection to provide a broad representation of these seminal artists.

By the mid 1950s, major new directions were developing alongside the continuing vitality of Abstract Expressionism. "From Pop to Minimalism," the fourth section, traces a period in American art that includes disparate components such as Pop Art and imagist art, Minimalism, Conceptual Art, and several modes of Realism. Beginning in the 1950s, works by Robert Rauschenberg and Jasper Johns started to incorporate a complex fusion of abstract and representational images, often rendered with collage or assemblage techniques. At the same time, separate from Abstract Expressionism, a Minimalist method of totally abstract art was developed by such artists as John McLaughlin and Kelly. These two modes would move in the following decade in radically different directions.

The explosion of Pop Art that occurred in 1962 was propelled by the pioneering accomplishments of Rauschenberg and Johns. Rauschenberg, whose early abstract work is based within the tenets of Abstract Expressionism, soon was using both flat materials (cloth and photo reproductions) and three-dimensional objects to retrieve real-world allusions for his art objects. Johns created enigmatic renderings of common, recognizable forms such as targets, flags, alphabets, and numbers either as elements within his paintings and drawings or as images occupying the entire surface of the work.

Confronting an art world suffused with many forms of serious abstraction, Pop artists took the radical step of depicting concrete images based on advertising and popular culture. These works often were rendered with commercial art techniques. By freely borrowing from vernacular or "low" sources, Pop Art provoked a severe critical reaction that incorrectly attempted to characterize the work as merely a spoof of "high" art and culture. The leaders of Pop Art were Roy Lichtenstein, Claes Oldenburg, James Rosenquist, and Andy Warhol. A large younger generation includes Edward Ruscha and Joe Goode. In its early stages, Pop Art was probably the most controversial indigenous mode of art ever to arise in America.

Though not directly allied with Pop Art, the imagist artists H. C. Westermann Jr. and John Baldessari utilized eccentric and evocative literal pictorial elements in their work. Each of these artists would inspire a group of younger artists working outside of New York—in Chicago and California, respectively.

Concurrently with Pop Art, new modes of abstract art in the 1960s included color-field painting and Minimalism. The contemporary master Frank Stella first developed several series of monochromatic paintings (black, aluminum silver, and copper) with severely symmetrical, banded surfaces, then went on to use bright colors and highly complex compositions (fig. 4). Sol LeWitt based his drawings and large, wall-sized compositions on the repetition of linear motifs. Ultimately, Minimalist artists reduced the idea of art to the depiction of nothing beyond the immediate materials or configurations of the art itself.

From its late eighteenth-century beginnings to the present day, American art has been markedly pluralistic. The country's citizens and immigrants have conspicuously amplified the multicultural spectrum of twentieth-century art. The final section of this volume, "Contemporary Diversity," makes clear that art of the 1980s and 1990s encompasses a variety greater than has existed at any other time in our culture. Every mode of artmaking developed since the nineteenth

Figure 4
FRANK STELLA
The Great Heidelburgh Tun, 1988
Silkscreen, lithograph, and linoleum block print on paper
74¼ x 54¼ in.

Figure 5
ROBERT LONGO
Arena Brains, 1986
Lithograph on paper
44 x 28⅞ in.

century is still being practiced, whether it is rooted in the art of the Realist master Hopper or the abstract genius de Kooning or Warhol's widely influential Pop legacy.

Another result of the pluralism of contemporary art has been the overdue recognition of art produced by members of various ethnic groups. Among African Americans, the art of Romare Bearden and Jacob Lawrence (contemporaries of de Kooning) and the innovative color-field paintings of Sam Gilliam (from Stella's generation) have received widespread acknowledgment. While the work of many different artists is noted apart from the ethnic origins of its creators, artists of similar ethnic backgrounds have often gained greater exposure and recognition by organizing and exhibiting collectively to help emphasize the communal cultural aspects they share. This approach has been effectively employed by both African-American and Hispanic artists. A pluralism persists within these categories. The range of Hispanic art, for example, extends from the structurally abstract sculpture of Jesus Moroles to the haunted, poetic paintings of Carlos Almaraz.

Because of its wealth of commercial galleries, museums, and publishing enterprises, New York remains the center of contemporary art. Nonetheless, artists working in other regions of the country are producing work of equal importance. A brief selection from the SBC Collection illustrates the validity of geographically diverse regional styles. In California, the elegant abstractions of Billy Al Bengston and the intimate Realist art of Vija Celmins are significant contributions. William Christenberry and Beverly Buchanan provide vivid reflections of the culture of the South. Working in their individually distinct Expressionist modes, James Surls and Michael Tracy are among major contemporary artists in Texas.

New York is the primary base for a number of vital Postmodern artists. Robert Longo (fig. 5), David Salle, and Richard Prince have each defined new directions rich with complex imagery. Gretchen Bender, with her multimedia versatility, and Peter Nagy, with his contemporary hieroglyphics, are prominent among myriad younger artists who carry forward a vanguard spirit in our nation's art.

Each of the eleven essays appearing in this publication focuses on a particular historical development in twentieth-century American art. The authors' cogent analyses of selected artists and works document achievements throughout this century and emphasize the remarkable proliferation and variety of art in contemporary American society.

While the SBC Collection eloquently chronicles historical accomplishments, its keen interest in young contemporary artists and emerging trends reflects an awareness of the critical role art plays in understanding our own world. The artistic discourse and aesthetic experience provided by the SBC Collection are a rich embodiment of the humanist ideals Jefferson envisioned as a vital element of American society.

"Delicacy of detail is the essence of art."

—*William Merritt Chase*

"Never mind bothering about the detail."

—*Robert Henri*

The American Scene

Realism: Tradition and Innovation

Betsy Fahlman

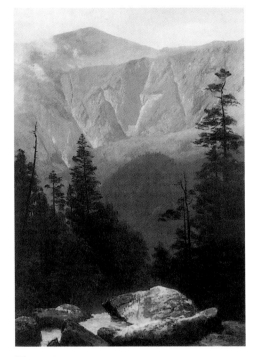

Figure 6
ALBERT BIERSTADT
Mountainous Landscape (no date)
Oil on paper mounted on canvas
21¼ x 15¼ in.

previous page:
GEORGE BELLOWS
Harbor at Monhegan (detail), 1913–15 Plate 1

Throughout its history, an important characteristic of American art has been realism, and not until the first generation of our avant-garde emerged in the mid 1900s was this trait significantly challenged. This essay explores the various manifestations of American Realism, as exemplified by the artists included in the SBC Collection, over a chronological span of nearly one hundred years. Although they are often divided by century, artists of the second half of the nineteenth century and the first half of the twentieth have many interconnections in theme, training, and style, despite a considerable variation in how representation was handled. The works under discussion exemplify the progressive pluralism and aesthetic diversity in American art, thus suggesting the larger scope of its history.

Beginning in the late 1820s, our first nativist school of painting arose, and no subject was more popular than the landscape; enthusiasm for it remained strong until the end of the century. After thoroughly recording the regions near the Hudson River, American artists traveled west in search of the sublime grandeur of an Edenic wilderness as yet undeveloped by white settlers impelled by a sense of Manifest Destiny. Albert Bierstadt (1830–1902), born in Germany, showed his work at the National Academy of Design in New York in 1858 and left the next year on the first of six trips west (his last was in 1881). His explorations inspired a series of large canvases like *Mountainous Landscape* (fig. 6) that emphasized the dramatic scale and grandeur of his distant subjects. Both patrons and members of the art-viewing public were fascinated by the careful delineation of the diverse regions of their country, near and far. A topographical realism is characteristic of the impressive canvases that resulted from these explorations.

Landscape links the earlier generation of American Realists who preferred rural themes with the later school of American Impressionists, many of whom had direct connections with their French counterparts. Expatriate Mary Cassatt participated in several of the French Impressionists' Paris exhibitions and remained close to Edgar Degas and Camille Pissarro. Still later, Theodore Robinson's residence in Giverny enabled him to establish a friendship with the town's most famous resident, Claude Monet, whose stepdaughter married another American artist, Theodore Earl Butler. Impressionism extended its influence as wealthy American collectors became increasingly astute patrons of French work. But it was not until 1898 that a group of American Impressionists, known as The Ten, made its debut in New York, though its members had long worked in this "new" style.[1] They continued to exhibit together until 1919.

One of The Ten, Massachusetts-born Childe Hassam (1859–1935), traveled extensively in Europe but preserved a strong sense of his American roots. In 1915, at

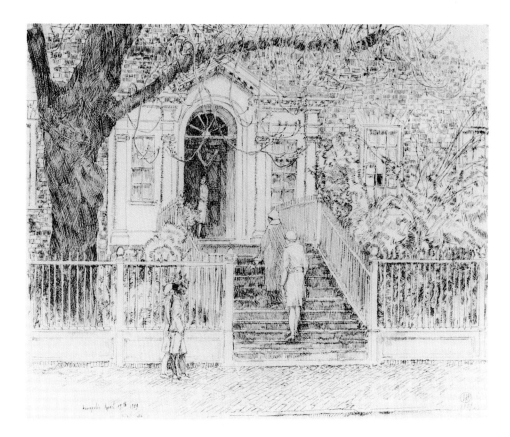

Figure 7
CHILDE HASSAM
The Chase House, Annapolis, 1929
Etching on paper
7 3/4 x 9 in.

the age of fifty-six, the artist turned to printmaking, producing a series of etchings inspired by scenes near his Long Island studio in East Hampton. Many of his images reflect his travels throughout America. In *The Chase House, Annapolis* (fig. 7), Hassam portrayed a Colonial residence in Maryland, where two fashionably dressed women ascend the steps of the mid Georgian mansion as another waits by the front door to greet her visitors. Informed by a nostalgic charm, images like these reveal the Impressionist fascination with the lively visual play of light and shade. The sketchy quality permitted by the etching medium enabled the artist to effectively record a fleeting moment. Hassam's interest in the modern context of historical structures reflects the Colonial Revival movement, which had remained strong during the fifty years since the 1876 centennial.[2]

Another member of The Ten was Willard Leroy Metcalf (1858–1925). Born near Boston, he became an important New England Impressionist, producing more than one thousand canvases depicting this region. He began making summer visits to Giverny during the late 1880s, and by the turn of the century he had developed his characteristic style, gradually shifting from figural subjects to landscape. Beginning in 1909, he frequented the town of Cornish, New Hampshire, where he was part of an art colony centered around the home of the late sculptor Augustus Saint-Gaudens, who had died in 1907. The landscape of the neighboring small towns along the Connecticut River served as Metcalf's subject matter, and it was probably there that *Cherry Blossom* (1912, pl. 3), an early spring scene, was executed.[3]

Other American Impressionists, however, preferred the international perspective offered by this school of painting. Joseph Pennell (1857–1926), a member of an old Philadelphia Quaker family, was one of these expatriates, though he is best known as a printmaker in the painter-etcher tradition established by James Abbott McNeill Whistler, with whom he had once worked. While living in London between 1884 and 1917, Pennell executed a watercolor of Inigo Jones's famous Baroque structure, *The*

Banqueting Hall, Whitehall (fig. 8), possibly as a study for a print he intended to make. A highly successful illustrator and writer, Pennell published a number of articles on London, a city he knew intimately. He was fascinated by the way contemporary life played against the historical backdrop presented by the British metropolis. Pennell, who made regular visits to America during his sojourn abroad, returned to his native country toward the end of World War I, settling in Brooklyn Heights in 1918.

It was in Pennell's native Philadelphia that the group that became known as The Eight had its genesis. There Everett Shinn, George Luks, John Sloan, and William Glackens—all staff artists for several city newspapers—initially met Robert Henri (1865–1929), who became the catalyst for the first major American artistic revolution of the twentieth century: The Ashcan School. Their differences from the more urbane and sophisticated Impressionists were not as great as might be supposed, for many Ashcan School artists were French trained, and styles and themes overlapped. However, The Eight's exploration of urban experience differed in emphasis from that of their predecessors.

The group gained notice at the turn of the century in New York, where their charismatic leader moved in 1900 and where several of Henri's artist friends from Philadelphia had already established themselves. The group—joined by Ernest Lawson, Arthur B. Davies, and Maurice Brazil Prendergast—made their debut in 1908 at the Macbeth Gallery in New York. United less by style than by their opposition to an increasingly conservative art establishment exemplified by the Academy, the group challenged those artists who seemed no longer willing to entertain progressive ideas.

It was the subject matter favored by the central members of The Eight—a pointedly unidealized vision of the American city and its inhabitants—that art traditionalists found most troubling. At odds with the inflexible ideals stemming from Renaissance humanism espoused by leaders of the Academy, artists in The Eight were fundamentally concerned with the ordinary life they saw around them. As a result of their work as illustrators, they knew how to study their environment as sharply trained observers. Stylistically, their work derives from the dark, painterly Naturalism of Baroque masters Diego Rodríguez de Silva Velázquez and Frans Hals and of the nineteenth-century French artist Edouard Manet. The American artists mixed this style with a strong element of urban Romanticism.

Figure 8
Joseph Pennell (1857–1926)
The Banqueting Hall, Whitehall
(no date)
Watercolor with Chinese white on paper
9 x 13½ in.

The Eight made their most significant contributions during the first decade of the twentieth century. Although their influence was challenged by the aesthetically more adventurous Modernists, whose efforts culminated in the landmark Armory Show of 1913, in the years that followed that exhibition, the major members of The Eight continued to make well-received paintings, drawings, and prints in their characteristic Ashcan School styles. Work by five members of The Eight—Glackens, Shinn, Sloan, Lawson, and Henri—is represented in the SBC Collection, spanning a wide range of mediums, chronology, and subject matter.

William J. Glackens (1870–1938) began his career as a newspaper artist in Philadelphia, and after traveling in Europe, he settled in New York in 1896. He supported himself as an illustrator until the mid teens, after which he was able to concentrate on painting. His pastel *Washington Square* (no date, pl. 6) records a scene in the outdoor "urban room" at the center of Greenwich Village, near where he lived. Evident in this work are his strengths as an artist-reporter: Glackens was a quick draftsman, and his lively technique shows how keenly he observed the interactions of the figures he pictured.

Everett Shinn (1876–1953) had also been a newspaper staff artist in Philadelphia. Moving to New York in 1897, he continued his commercial work. Between 1900 and 1903, he made his only trip to Europe, spending about a year in Paris and London, an experience that inspired him for the rest of his career. From the start, he favored the medium of pastel, an aesthetic compromise between the freedom of drawing and the color-saturated but more time-consuming and labor-intensive technique of oil. His first one-person exhibition was held in 1899 at the Pennsylvania Academy of the Fine Arts, where he showed forty-eight pastels. By 1912, Shinn had become active more as an interior decorator and stage designer, but throughout the late 1930s and 1940s, he returned to his earlier interest in depicting street life. Typical of his late work is his pastel *Paris Square (Winter)* (1940, pl. 19), which portrays an urban streetscape. Drawn from a journalistic memory, the scene demonstrates a style that is quick, sketchy, and perceptive.

John Sloan (1871–1951), who like the others pursued a career as an illustrator, retained a graphic sense of social observation in his work. The only member of The Eight to produce a substantial body of prints, he began his first series of etchings in 1905. His series title and theme were New York City Life, a subject that continued to absorb him throughout his career. Sloan was especially fascinated by the vibrant interactions of the residents of Greenwich Village, interests evident in his etching *Romany Marye's in Christopher St.* (fig. 9).[4] Pictured is a popular local restaurant, frequented by artists, writers, and intellectuals, where Marie Marchand served as an "old-time provider of philosophy and food."[5] A follower of anarchist Emma Goldman, she opened the first of her bohemian restaurants in 1912. The dynamic Romanian immigrant, described as a "feminine counselor, philosopher, and friend,"[6] took a lively personal interest in her patrons, for whom she also read tea leaves and palms. Seated at a table in the foreground, Sloan and his wife, Dolly, are shown in conversation with the hospitable owner.

The spectacle of life as enacted on rooftops held an equal fascination for Sloan: "I have always liked to watch the people in the summer, especially the way they live on the roofs."[7] He observed:

> In the spring as the rays grow warmer, the tenement roofs in New York begin to come to life. More washes are hung out—gay colored underthings flap in the breezes, and on Saturdays and Sundays girls and men in bathing togs stretch themselves on newspapers, blankets or sheets in the sun, turning over at intervals like hotcakes. I think that many of them are acquiring a coat of tan in preparation for coming trips to Coney Island. The roof life of the Metropolis is so interesting to me that I am almost reluctant to leave in June for my summer in Santa Fe.[8]

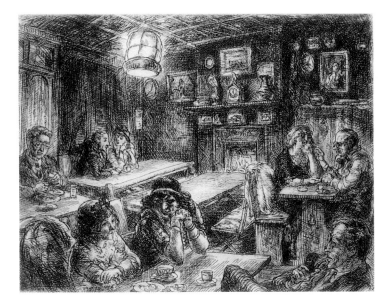

Figure 9
JOHN SLOAN
Romany Marye's in Christopher St., 1922
Etching on paper
8½ x 8¾ in. (image)

Figure 10
JOHN SLOAN
Sunbathers on the Roof, 1941
Etching on paper
7 x 7¾ in. (image)

He recorded these ordinary activities, which he described as "human comedies which were regularly staged for my enjoyment by the humble roof-top players,"[9] in a number of prints and drawings. His etching *Sunbathers on the Roof* (fig. 10) is informed by a gentle flirtatiousness, showing a lounging couple visited by a friendly cat. The young man has been reading a newspaper, while his female companion, who has carelessly kicked off one of her high-heeled shoes, prefers a romance novel.

For Sloan, the people ever present on the New York scene were essential elements of his dramatic urbanscapes. In contrast, Ernest Lawson (1873–1939) gravitated to less inhabited landscapes, characteristically focusing on scenes where the urban and the rural came together. His links to American Impressionism were direct: He had studied during the 1890s with two members of The Ten, John Twachtman and Julian Alden Weir, and subsequent study in Paris brought him in contact with the French painter Alfred Sisley. Then, in 1898, Lawson settled in Washington Heights in a house on 155th Street. At the turn of the century, this part of northern Manhattan marked the point where the city began to give way to a more rural landscape. Although Lawson moved to Greenwich Village in 1906, he regularly returned to paint in this uptown area, as well as in neighboring Morningside Heights. His canvases blend the lyric and the melancholy, as seen in *The Pond and Gapstow Bridge, New York City* (1914, pl. 5), a winter scene similar to several other works by Lawson set in Central Park. Typically, his brush strokes in the painting are visible, and his delicate use of color creates a poetic tonalism.[10]

Regardless of their preferred subjects, the members of The Eight shared close professional associations and personal friendships. The conviviality of artist relations among The Eight is seen in a lithograph by George Bellows (1882–1925), *Artists Evening* (fig. 11). Bellows had been a student of Henri's from 1904 to 1906, and although he did not exhibit with The Eight in 1908, his work reflects their aesthetic and thematic concerns. The SBC print records a gathering of artists at Petipas, a boardinghouse and French restaurant that was a popular gathering place for poets, painters, writers, and actors in New York. Located on West 29th Street, Petipas also inspired paintings by Sloan and Luks. Pictured standing in the Bellows print is John Butler Yeats (the father of the poet William Butler Yeats and the painter Jack Butler Yeats). Bellows and his wife, Emma, are seated next to the elderly bearded artist and writer. To his right, Henri gestures animatedly as he talks with Yeats, who was an entertaining

and charming conversationalist. Henri's second wife, Marjorie, is shown drawing at the table on the left side (she is the middle of the three figures).

The heat of the city, however, often proved stifling for The Eight. As they escaped the oppressive summers of New York in search of cooler environs as well as mental stimulation from fresh experience, these artists found subjects throughout the United States. In spite of The Eight's distinctly urban influence on American Realism, rural landscape remained close to the heart of American artists. Since the nineteenth century, Maine in particular had attracted painters, whose frequent visits paralleled the development of that state as a summer resort. The island of Mt. Desert (whose most famous town is Bar Harbor) appealed to many landscapists, including Thomas Doughty, Thomas Cole, Frederic Edwin Church, and Fitz Hugh Lane. Twentieth-century artists responded in much the same way to the state's charms. Modernist artist John Marin first visited Maine in 1914, producing a series of images inspired by Deer Isle that includes his 1928 watercolor in the SBC Collection (pl. 26; see page 83). Monhegan, a small, rugged island in Boothbay Harbor about fifteen miles off the Maine coast, also attracted a number of artists. Of these, the most famous was Rockwell Kent, who came to the island with Henri in 1905. Others who visited included Charles Demuth, Leon Kroll, Edward Hopper, and Edward Henry Potthast.

Henri first visited Monhegan for six weeks in July 1903, accompanied by his old friend and Pennsylvania Impressionist Edward Willis Redfield. As Henri observed, "From the great cliffs you look down on a mighty surf battering away at the rocks—pine forests, big barren rocky hills. . . . It is a wonderful place to paint—so much in so small a place one could hardly believe it."[11] He liked Monhegan so much that he even considered establishing a summer studio on the island, but this project was never realized. He returned again, however, during the summer of 1911 and made his last trip to the island in late summer and early fall of 1918, accompanied by his wife, Marjorie, his sister-in-law, Violet Organ, and two former students, Lucie Bayard and Ruth Jacobi. They remained until October. Because German submarines had been reported off the coast, there were few other visitors to the island. It was on this trip that Henri executed the two pastels in the SBC Collection: *In the Deep Woods* (1918, pl. 7) and *Sunlight*

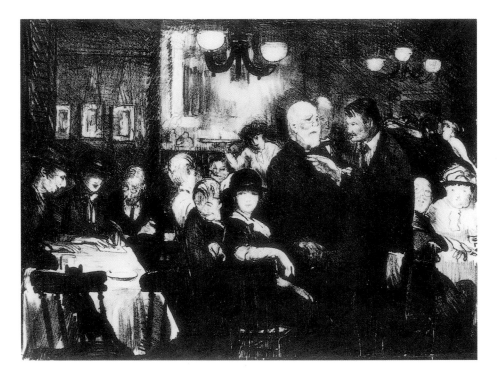

Figure 11
GEORGE BELLOWS
Artists Evening, 1916
Lithograph on paper
9½ x 12⅞ in.

in the Woods (1918, pl. 8).[12] Since 1902, Henri had concentrated on figural subjects, but on Monhegan it was landscape, not people, that intrigued him. Because his studio was dark, he worked mostly outdoors. The pastels depict Cathedral Woods, a densely forested area whose trees arched over the pathways. The enclosure they provided contrasted with the open spaces near the ocean, and Henri took pleasure in the rough beauty of both: "... and then you can disappear from the sea into the pine forests ... they are wild."[13]

In July 1911, Bellows went to Monhegan with Henri and Randall Davey, a student of the older artist. The place made a deep impression on Bellows, and he described it succinctly: "The island is only a mile wide and two miles long, but it looks as large as the Rocky Mountains."[14] The month he spent there was productive, and his paintings reflect the dual influence of Henri and Winslow Homer. Subsequent summer trips inspired a series of powerful oils. Bellows spent the summer and fall of 1913 on the island, and *Harbor at Monhegan* (1913–15, pl. 1), begun during his second visit, reveals his continuing attraction to the same everyday activities of ordinary people that had interested him in the city. He completed the work in March 1915.

Bellows spent the summer and early autumn of 1918 and 1919 in Middletown, Rhode Island, on a farm near the sea about three miles from the fashionable resort of Newport. During his first visit, he was too absorbed by the war to paint much, but 1919 proved to be different. He enjoyed painting in the open air, and in *Three Children* (1919, pl. 2) he pictured his daughters Anne, age eight, and Jean, age four, with a local farmer's son named Joseph (members of his family frequently appear in Bellows's canvases).[15]

As in the earlier century, landscapes were also sought to the west. An important artists' colony was established in New Mexico, centered around Taos and Santa Fe. Modernists and Realists who visited the Southwest were often fascinated by the structures, Native-American inhabitants, and vistas they saw. Henri first visited Santa Fe in the summer of 1916 and returned during the summers of 1917 and 1922. At his encouragement, Sloan made his first trip to New Mexico in 1919, accompanied by Davey. He was so impressed that in 1920 he purchased an old adobe house, and for the next thirty years, he returned nearly every summer.[16] He installed modern plumbing in the house, which was surrounded by an orchard and gardens, and constructed a studio nearby. Like Henri and Bellows, Sloan enjoyed painting outdoors, and his *Landscape, Santa Fe* (c. 1925, pl. 9) is a product of one of his excursions. As the artist explained:

> I like to paint the landscape in the Southwest because of the fine geometrical formations and the handsome color. Study of the desert forms, so severe and clear in that atmosphere, helped me work out principles of plastic design, the low relief concept. I like the colors out there. The ground is not covered with green mold as it is elsewhere. The piñon trees dot the surface of hills and mesas with exciting textures.... Because the air is so clear you feel the reality of the things in the distance.[17]

As the twentieth century took shape, however, themes of industry, work, and labor promulgated by The Eight and other urban Realists remained influential. Aaron Harry Gorson (1872–1933), for example, favored the dynamic industrial landscape of Pittsburgh, which inspired his *Industrial Site at the River* (fig. 12). The smokestacks, factory buildings, and bridges over the city's several rivers fascinated him. A Lithuanian immigrant, Gorson had studied at the Pennsylvania Academy of the Fine Arts in Philadelphia with Henri, Sloan, Shinn, and Glackens. Following study in Paris

between 1899 and 1903, Gorson settled in Pittsburgh, where his patrons included the Mellons and the Carnegies, two of the city's leading industrialist families. In 1921, he moved to New York. Although recognized in his lifetime, he is little known today.

The legacy of the philosophy and subjects of The Eight was perpetuated by Henri's many students. He was a magnetic instructor, and his students comprised a broad range of American artists whose styles varied widely after they left his classroom: Hopper, Guy Pène du Bois, Patrick Henry Bruce, Andrew Dasburg, Bellows, Stuart Davis, Yasuo Kuniyoshi, Kent, Walter Pach, Morgan Russell, and Eugene Speicher. Many followed Henri's dictum to paint the life that they knew from personal experience.

Guy Pène du Bois (1884–1958), who studied with Henri between 1902 and 1905, was one such artist who adhered to Henri's philosophy. The human figure was his most characteristic subject, and he was fascinated by the social interactions between men and women and by the roles imposed by class and profession. Early work as a court reporter had introduced him to the possibilities of the legal system as subject matter. His *Addressing the Jury* (1947, pl. 20) is a late work in the tradition of sardonic social commentary established by nineteenth-century French artists Honoré Daumier and Jean-Louis Forain. Typical of this period is Pène du Bois's feathery technique, mysterious coloration, and the depiction of his characters as types, rather than specific individuals.

After the 1920s, as the Depression era deepened, themes of social protest became a significant aspect of American Realism. Known for his sharply critical imagery, William Gropper (1897–1977), who had studied with Henri and Bellows, depicted many scenes in order to alert his viewers to the need to change oppressive social and economic conditions. Gropper was active in political causes, and his views grew out of a deeply felt humanitarian sympathy for the economically downtrodden and exploited. Where some might find his images of black agricultural laborers merely stereotypical products of the Southern scene, Gropper sought in his work to challenge the impoverished conditions that kept black Southerners tied, through either tenant farming

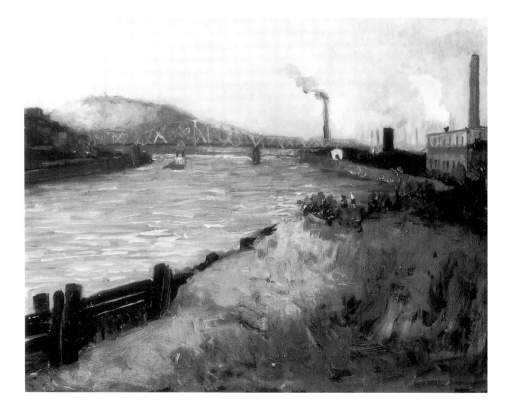

Figure 12
AARON HARRY GORSON
Industrial Site at the River, c. 1916
Oil on canvas mounted on board
16 x 20 in.

or migratory labor, to the increasingly exhausted soil monopolized by white land-owners. *Field Workers (Tobacco Pickers)* (1942, pl. 15) is a typical example. Gropper's theme was a common one among the government-sponsored photographers of the Farm Security Administration and the Regionalist painters working under various New Deal arts programs such as the Works Progress Administration. In search of greater opportunity, many African Americans chose to abandon agriculture for jobs in the Northern industrial cities, a process of social dislocation vividly chronicled by African-American painter Jacob Lawrence (pl. 116; see pages 195–96).

In the years following World War II, significant changes were occurring throughout American society and American art. Realism remained an option for artists, but with the rise of Abstract Expressionism, representational styles were no longer at the center of advanced aesthetic dialogue. The sometimes uneasy existence that had been shared by the two modes throughout the first half of the twentieth century was not sustained over the next several decades, as a vigorous exploration of largely Formalist issues instead ensued among our leading artists and critics.

NOTES

1. The members of The Ten were Frank Weston Benson, Joseph R. De Camp, Thomas Wilmer Dewing, Childe Hassam, Willard Leroy Metcalf, Robert Reid, Edward E. Simmons, Edmund Charles Tarbell, John Henry Twachtman, and Julian Alden Weir. With the death of Twachtman in 1902, William Merritt Chase became part of the group.

2. Hassam executed more than 375 etchings, as well as about forty-five lithographs (1917–18). These were printed by George C. Miller. Hassam's most prolific years were 1920–24, during which time he made eighty plates of scenes from East Hampton, New England, and New York. Between 1924 and 1927, he traveled south and west, producing more than fifty plates. See Royal Cortissoz and the Leonard Clayton Gallery, *Catalogue of the Etchings and Dry-Points of Childe Hassam, N.A.* (1925, 1933, reprint [revised], San Francisco: Alan Wofsey Fine Arts, 1989): 260. *Independence Hall*, 164–65; 309. *The Chase House, Annapolis*, 187, 191. *The Chase House, Annapolis* is reproduced in James C. McGuire, *American Etchers: Childe Hassam, N.A.* (New York: T. Spencer Hutson & Co., 1929), vol. 3, catalogue no. 309.

3. The painting probably depicts either Plainfield, New Hampshire, or Windsor, Vermont.

4. See Morse, *John Sloan's Prints*, 308, catalogue no. 278.

5. Brooks, *John Sloan*, 235. Sloan's spelling of Romany Marie, of whom he also painted a portrait (1920, Whitney Museum of American Art), is idiosyncratic.

6. Brooks, *John Sloan*, 60.

7. John Sloan, quoted in David W. Scott and E. John Bullard, *John Sloan, 1871–1951* (Washington, D.C.: National Gallery of Art, 1971), 89.

8. John Sloan, in a pamphlet written for the College Society of Print Collectors, quoted in Morse, *John Sloan's Prints*, 340.

9. Scott and Bullard, *John Sloan*, 123.

10. The SBC canvas was painted in 1914, the year that Lawson and Bryson Burroughs had a successful joint showing in July in Paris, shortly before the outbreak of World War I.

11. Robert Henri, letter to his parents, July 12, 1903, quoted in Homer, *Robert Henri*, 112.

12. Stylistically and thematically, these echo earlier oils such as *Cathedral Woods, Monhegan Island* (1911, Toledo Museum of Art).

13. Homer, *Robert Henri*, 112.

14. George Bellows, quoted in Bruce Robertson, *Reckoning with Winslow Homer*, 107. Bellows spent several summers in various Maine locales: 1911, Monhegan; 1913, Monhegan and Matinicus; 1914, Monhegan; 1915, Ogunquit; and 1916, Camden, Matinicus, Criehaven.

15. One writer suggests this may have been set in Sakonnet, not far from Middletown. See Morgan, *George Bellows*, 225.

16. His first residence was located on the Calle Garcia. In 1940, he built a house, which he named Sinagua, six miles out of town.

17. John Sloan, *Gist of Art*, 147. The painting is recorded in Elzea, *John Sloan's Oil Paintings*, vol. 2, 276, catalogue no. 270.

The Vigor of Americanism

Matthew Baigell

What might this phrase—The Vigor of Americanism—mean in the history of American art? In its best sense, it means the examination of the physical and spiritual landscapes of the United States, an examination that began in the late eighteenth century and reached a climax in the 1930s with the advent of the movement known as American Scene painting. It is an examination that informed and continues to inform our knowledge of American art and culture from the first days of the Republic and even from Colonial times before the Revolutionary War. This examination derives its strength from a desire to know and to understand the texture and fabric of the country, as well as the desire to communicate those qualities in understandable visual language to the American people.

Although artists have had, through the decades, an immense amount of personal space in which to exercise their imaginations, a feeling has persisted that only by recording the look of the country and the activities of its people can artists identify most broadly with the nation's dreams and goals. For many artists, the very nature of their art has compelled them away from an alliance to the concept of art for art's sake (as important as that certainly is) and toward a coordination of their art with their varying readings of American places and of the many American minds.

Repeatedly, writers and artists have called upon their peers to examine the prospect before them. For example, in Ralph Waldo Emerson's address "The American Scholar," delivered in 1837, he asked "not for the great, the remote, the romantic; what is doing in Italy or Arabia; what is Greek art or Provencal minstrelsy." Rather, as he continued, "I embrace the common, I explore and sit at the feet of the familiar, the low." By this he meant "the philosophy of the street, the meaning of household life" as "topics of the times."[1] He called for a poet to celebrate these things as well as other aspects of American life—its politics, its religion, its people, its economy.[2]

Walt Whitman was certainly such a poet, who himself urged yet more poets to present and reflect the nation in their work. For him, "the United States themselves are essentially the greatest poem,"[3] but the country can never entirely fulfill its promise until it "founds and luxuriantly grows its own forms of art."[4] What might be the content of such an art? For Whitman, the content lay less in abstract ideas than in the manifold activities of "the common people."[5]

These thoughts, in one way or another, motivated generations of artists and art critics, particularly in the first half of the twentieth century. The most notorious of these critics, because of his aversion to European art, to Modernist art, and to artists he did not feel were sufficiently "American," was Thomas Craven who, echoing Whitman, argued for an American art by and for Americans. "The only outlet, the sole means of

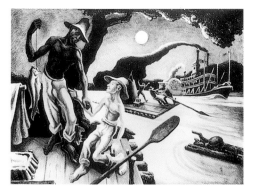

Figure 13
THOMAS HART BENTON
Huck Finn, 1936
Lithograph on paper
17½ x 22½ in. (image)
© 1996 T.H. Benton and R.P. Benton Testamentary Trusts/
Licensed by VAGA, New York, NY

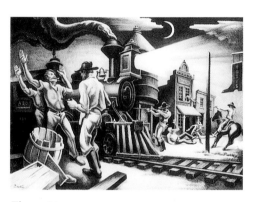

Figure 14
THOMAS HART BENTON
Jesse James, 1936
Lithograph on paper
17½ x 22½ in. (image)
© 1996 T.H. Benton and R.P. Benton Testamentary Trusts/
Licensed by VAGA, New York, NY

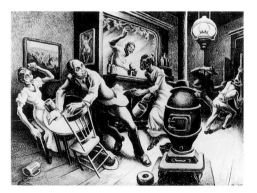

Figure 15
THOMAS HART BENTON
Frankie and Johnnie, 1936
Lithograph on paper
17¾ x 22¾ in. (image)
© 1996 T.H. Benton and R.P. Benton Testamentary Trusts/
Licensed by VAGA, New York, NY

escape, for the American painter," he said, "lies in the discovery of the local essence, after which we hope for a viable native school."[6]

The idea of discovering the local essence really began early in the nineteenth century. It went by the name of *association psychology*, according to which one's early geographical, psychological, political, and personal associations helped form one's outlook and character. Since these associations were by definition American ones, one would grow up with an American character—whatever that might be. The language of association psychology at that time permeated people's thinking, as is evident in these words from a speech given in 1816 by New York governor DeWitt Clinton: "And can there be a country in the world better calculated than ours to exercise and to exalt the imagination—to call into activity the creative powers of the mind, and to afford just views of the beautiful, the wonderful, and the sublime?"[7] The answer, of course, was no, that the United States was unparalleled as a source of exalted creativity.

The environmentalist ideas of the late nineteenth-century French sociologist Hippolyte Adolphe Taine only added to the pervasiveness of associationist thought when he wrote that to know an artist and the art of a country well, one must study all aspects of that country's culture, down even to its weather patterns. Taine influenced at least two generations of American artists, including Robert Henri, Edward Hopper, and Thomas Hart Benton, the last fully acknowledging Taine's influence on his desire to develop a distinctively American art and style. In fact, the very concept of American Scene painting in the 1930s is unthinkable without acknowledging the profound influences of both association psychology and Taine's thought. Coupled with the nation's sometimes xenophobic, isolationist impulses after World War I and with the hostility in the American art world to European Modernism, this conviction of an American essence assumed a dominant role in the history of American art through the early decades of the twentieth century. It helps explain the unquenchable desire of so many artists to document the appearances and activities of their fellow citizens, as well as the look of the countryside. As Benton said, "I believe I have wanted more than anything else, to make pictures, the imagery of which would carry unmistakably American meanings for Americans and for as many of them as possible."[8]

Thomas Hart Benton (1889–1975), the major artist of the American Scene movement, is well represented in the SBC Collection by three lithographs based on three main panels in his mural cycle *A Social History of the State of Missouri*, which he completed in 1936 for the capitol building in Jefferson City. Each lithograph represents three different aspects of life in Missouri, and each derives from a different source: *Huck Finn* (fig. 13) from Mark Twain's novel *Huckleberry Finn*; *Jesse James* (fig. 14) from Missouri history; and *Frankie and Johnnie* (fig. 15) from the popular folk song of that name. Together they show how artists like Benton explored aspects of the nation's history through its novels, its mythology, and its high and low culture, as well as through actual scenes—all aspects that, as Whitman would have agreed, helped create the American people.

It is important to note, however, that conveying the American essence in art did not necessarily mean an undiluted celebration of the common people. *Huck Finn* depicts the journey down the Mississippi River taken by Jim, the escaped slave, and by Huck, who is fleeing the clutches of civilization represented by his aunt. There is no doubt that the American notion of freedom, particularly the freedom to reinvent yourself as the person you want to be, was central to Benton's interest in this episode from the novel. His *Jesse James*, however, is a more ambiguous figure. Immensely popular with the local population after he began in the late 1870s to rob banks and hold up trains whose owners charged outrageous interest rates, James appealed to Benton's sense of political egal-

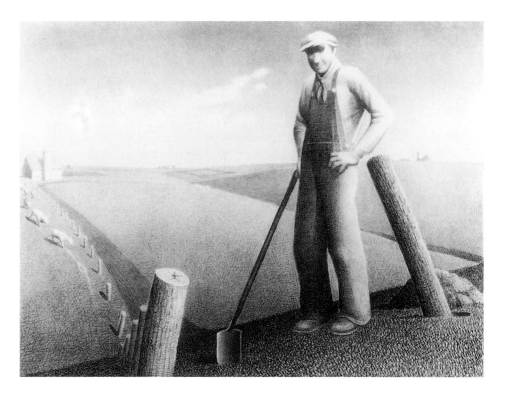

Figure 16
GRANT WOOD
In the Spring, 1939
Lithograph on paper
9½ x 12½ in.
© 1996 Estate of Grant Wood/Licensed by VAGA, New York, NY

itarianism and his sympathy for the downtrodden (even as James represented the potentially chaotic outlaw violence that lies at the extremes of individual freedom).

In contrast, one can find no redeeming egalitarian traits in the story of Frankie and Johnnie where Frankie, as in the song's lyrics, "shot her man 'cause he done her wrong." Rather, this work describes the senseless violence of the modern city. Where *Huck Finn* suggests a mutual alliance between two different people, *Frankie and Johnnie* conveys a sense of modern alienation and mutual antipathy. Together, all three works reflect the notion popular at the time of a native "healthy" American character at risk of being overwhelmed by modern life.

Grant Wood (1892–1942), the second member of the American Scene triumvirate (John Steuart Curry [1897–1946] is the third) could also be critical when so inclined—witness the pinched, tight-lipped couple in his *American Gothic* of 1931 (Art Institute of Chicago), probably the most famous American painting of this century. A son of the Iowa soil, Wood nevertheless believed that while his "faith in Middle Western material is not based alone upon its being fresh and unused, and does not proceed from any 'booster spirit' for any particular locality," it is—and here he echoes the theories of association psychology and of Taine—"founded upon the conviction that a truer art expression must grow from the soil itself." Along with this conviction came Wood's determination to make art accessible to ordinary Americans. He believed that "art isn't worth a damn if you can't make these people around here appreciate it. An art that loses contact with the people is lostWe must get back to simple relations between the artist and the public."[9] He goes quite a ways back, however: His lithograph *In the Spring* (fig. 16) describes a scene that only the oldest farmers would have remembered. The contemporaneous drought of the 1930s, which resulted in massive dust storms and farm foreclosures, is not pictured, nor can we find a modern tractor or plow anywhere. Instead, we see a precisely ordered farm that seems to have been worked entirely by the heroized farmer who, with his shovel, dominates the scene. Wood clearly respected those who worked the land, and he loved the land itself. "The naked earth in rounded, massive contours, asserts itself through everything laid upon it," he exclaimed, and in those who farmed the land, such as his parents, he found "a quality bleak, far away,

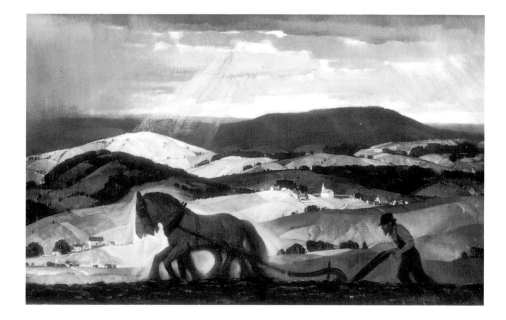

timeless—the severe but generous vision of the midwest pioneer."[10]

Arthur Meltzer (b. 1893), in his *Pennsylvania Plowing* (fig. 17), created a slightly grittier version of the same theme. Here, an Amish farmer works as hard as his horses to plow the land. Bound by the same old-fashioned ways emblematized in the woodprint, this farmer, too, refuses modern contrivances. And Meltzer, in order to suggest the preference for, and persistence of, older ways, included a church, a graveyard, and a tiny village in the distance. The rhythms and lifestyles of the past continue, providing a ballast for contemporary life. *Pennsylvania Plowing* also hearkens back to the idea of the United States as a producer-oriented rather than a consumer-oriented society. For Meltzer, as for Benton and Wood, the yeoman farmer and the active worker provided the backbone for the country and could still be called upon to sustain it into the future.

Urban artists also heroized the worker, in this case those who helped build the country's skyscrapers, bridges, and roadways. Many, but not all, of these artists were immigrants or children of immigrants. Their American experiences were urban ones, and they celebrated the dynamism of the city rather than the certainties of the countryside. Lewis Hine (1874–1940), in his photographs of the construction of the Empire State Building like the untitled work in the SBC Collection (1931, pl. 17), often caught workers in acrobatic positions, as if they were trying to keep up with the city's frenetic pace. Others, such as Minna Citron (1892–1992) in her etching *Construction II* (fig. 18) and Ernest Fiene (1894–1966) in *Razing Buildings, West 49th Street* (fig. 19) seem to have prowled the streets in search of subject matter. One critic in 1938 even singled out Fiene as the metropolitan equivalent of the Midwestern Wood. As a child of the city's streets, Fiene said that he was "most interested in the environments of man and the things man has made." Not bound like Wood by the past, but rather caught up in the process of developing new traditions, he believed that "out of this new civilization, out of this machine age, a new school of painters will be developed."[11] These artists would presumably take the true measure of the country, the America that lived in the present tense.

Yet, like Benton, many of these urban artists who took the measure of American life found both a light and a dark side, especially those who recorded more mundane and literally more pedestrian city activities—the people on the street. For instance, Reginald Marsh (1898–1954) was, as one of his contemporaries said, "in love with New York."[12]

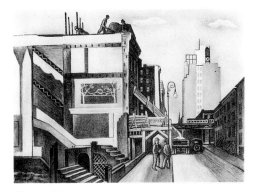

Figure 19
ERNEST FIENE
Razing Buildings, West 49th Street, 1932
Lithograph on paper
11 x 14⅜ in.

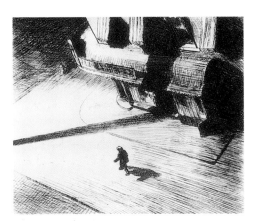

Figure 20
EDWARD HOPPER
Night Shadows, 1921
Etching on paper
7½ x 8⅞ in. (image)

He saw it as a stranger saw it—people in constant motion, open, expansive, sophisticated in an urban way. The women in paintings like *Girls in the Street* (1946, pl. 18) are not so much provocative as comfortable with their sexuality. Yet even as Marsh painted ordinary people, the nobodies of the city, as if they projected a sense of exhilaration, there is something else about them that connotes exactly the opposite. Everything seems transient. Nobody relates. Everybody is alone in the crowd, isolated, passing one another in the shallow spaces allowed them. If one were to stop, he or she would be bumped aside. There is no time to stop, to reflect, or to think, no time, that is, to develop traditions in the modern metropolis. For these people, physical appearance, not spiritual substance, is everything.

It was Edward Hopper (1882–1967), more than any other artist of his generation, who explored this dark side of the American character, the spiritual exhaustion of the city dweller, that sense of alienation that keeps people locked up inside themselves. His *Night Shadows* (fig. 20) brilliantly catches the sense of ennui that began to appear in the works of several artists during the 1920s. The person walking in the middle of the street does not know that we are observing him, and we are too far away to make contact. We do not inhabit the same psychological or physical space as he does. Furthermore, Hopper manipulated the darks and lights of this print in a way that relegated the man to a series of dark smudges in a composition of strong verticals and diagonals. The man is reduced to a component in an organizational pattern. In comparison to Fiene's optimism, we might say that Hopper instead captured the feelings of those who were defeated by the machine age, the ones who were ground to a pulp by the big city, who literally could not break loose from its organizational patterns.

However, this was part of the American essence that should not be denied; indeed, critics loved Hopper's work. By the late 1920s, Hopper was considered the one artist "who is getting more of the quality of American life into his canvases" than anybody else. And echoing the tenets of association psychology and Taine's theories, critics found "the environment which he paints is the environment in which he and the rest of us have grown up; we may see its bareness and crudity, but we are still bound to it by strong ties,"[13] adding that his "subjects form the background of the majority of adult Americans. Ugly, sordid, commonplace, they are part of our consciousness and we are bound to them with strong ties of early impressions."[14]

This sense of human impoverishment reflected the same widely held belief that Benton had responded to, that the mechanization of society and the centralization of business interests into ever larger units were inhibiting personal growth and the ability of individuals to make their own way in the world. Political figures including President Woodrow Wilson as well as social observers such as Lewis Mumford and Walter Lippmann recognized the growing problem, but they were at a loss to prescribe a cure. Artists such as Hopper and Benton acknowledged the loss in their own distinct ways, and their acknowledgment has undoubtedly contributed to their lasting importance as interpreters of the interwar period. In the works of these two artists, as well as in that of others, the vigor of Americanism (and both were dedicated Americanists) lay in their desire to confront directly the problems they observed in contemporary society.

But they by no means wallowed in pessimistic thoughts. Both artists found comfort and pleasure in the landscape. Hopper's *Gloucester Harbor* (1926, pl. 12), one of many studies of the town and its waterfront, records the brilliant clarity of light that generations of artists have observed along the northeastern seaboard. Works of this sort speak in a different way to the vigor of Americanism in their eschewing of European styles and conventions of landscape painting for the immediate experience of the scene itself.

That the celebratory side of Americanism should find expression in landscapes is not surprising. Since the earliest years of the nation, artists have sought to paint the particularities of the American landscape in an effort to possess symbolically the enormous land mass of the country. Art provided the means to give witness to religious and spiritual presences experienced in nature, to record sublime and beautiful vistas, and not least, to document whatever was out there. Thomas Cole, a founder of the Hudson River School, was reminded when he left for Europe in 1829 to "keep that wilder image bright," [15] or to keep the pristine look of American scenery in his mind's eye. Cole's friend the artist Asher Brown Durand, in a series of letters written to an imaginary artist in 1855, cautioned the painter to study the American landscape carefully and perhaps avoid going abroad altogether. And in our own day, artists are still studying the landscape as American landscape, most notably the so-called Heartland Painters, including Harold Gregor and Keith Jacobshagen.

During the early decades of this century, a great florescence of landscape painting occurred all over the country. In each geographical area, artists sought to convey characteristic features of the land so that, as John Marin once said of his Maine landscapes, the scenes painted would be "redolent" of that particular area. Julian Onderdonk (1882–1922) evoked in his Texas landscapes, like the SBC Collection's *Texas Bluebonnets* (1910, pl. 4), scenes that are certainly redolent of their locale. Their significance lies in the fact that we read them not as Impressionist color exercises, which would dilute their sense of place, nor as examples of precise locations, which would make them too site specific. Rather, we read them as evocative of the area in general, which allows many, many people to respond to them as imaginative re-creations of Texas itself. As Onderdonk said, "I think the greatest artist is he who can in the simplest manner touch the whole heart of nature and mankind."[16]

Like Onderdonk in Texas, Victor Higgins (1884–1949) painted the landscapes he knew best, those of northern New Mexico. In *Taos Foothills* (c. 1925, pl. 13), which he probably painted between 1924 and 1927, he caught the precise qualities of light and air of the region. Higgins settled in Taos in 1920 and some eleven years later stated what can be considered his credo: "An artist cannot be a stranger to a country if he would paint beneath the surface. He must feel the confidence of familiarity if he is to add vitality and originality to the interpretations of his country."[17] That is, like Marin and Onderdonk, Higgins wanted his works to be redolent of the atmosphere of his region, and only by so doing could they be considered original interpretations of that part of America.

Clarence K. Chatterton (1880–1973) and Rockwell Kent (1882–1971), both pupils of Robert Henri (as was Hopper), also felt deep commitments to particular landscapes, and both wanted to communicate their feelings to others as well. Chatterton lived much of his adult life in the Hudson River Valley, while Kent spent the last half of his life on his farm in the Adirondack Mountains. Both painted the surrounding countryside regularly, especially Kent, whose *Asgaard Cornfield, California* (1950, pl. 16) is a portrait of his working farm. And Chatterton's *Rock Pasture* (1931, pl. 11) is the sort of scene anybody might easily stumble upon within a few miles of his home.

Again, as with Wood, these painters' approach to art emphasized its ordinary nature and so strengthened its popular appeal. Chatterton's attitude toward art can be traced back to any number of earlier artists, starting with the late eighteenth-century figure Charles Willson Peale. That is, Chatterton believed there was nothing special about an artist—art was just a matter of good training and hard work. Furthermore, as he said in 1932, "An artist should express himself with as little fuss as possible and in a frank, uncompromising manner."[18] Kent also insisted on the importance of clarity

Figure 21
MILTON AVERY
Sketcher by Seaside Cliff, 1939
Watercolor on paper
21⅝ x 29½ in.

and communication. He said that "the arts are of experience and its embodiment of the mind and heart, being to me essentially a manner of sharing with others what we have learned and loved in life We do our utmost to be clearly and fully understood."[19] Kent, like Onderdonk and Higgins, treated art as a language with which to communicate feelings and experiences, a vehicle to establish and maintain community. Consequently, the artist should seek images in the local environment and local culture.

For other artists, the landscape provided a way to communicate spiritual presences as well as celebrate place. Georgia O'Keeffe's paintings of Texas and New Mexico (fig. 26, pl. 33; see page 62) exemplify this point of view. So does Curry's *The Sun Rises Over Kansas* (no date, pl. 10), which wonderfully evokes the artist's sheer joy at watching the sun rise over the land. Moreover, the sun's warming rays seem to offer a blessing upon a landscape that is productive, serene, and in harmony with itself. Paintings of this sort, portraying the peaceful settlement and subsequent development of the land, speak to the American dream of a country where destiny may be completed before one's very eyes.

The Charles Burchfield (1893–1967) watercolor *November Sun Emerging* (1959–59, pl. 14) is a more personal work reflecting, in the creative process, the continuation of strong religious and spiritual undercurrents that had buoyed up much nineteenth-century American art. In the painting, as the underbrush and the trees stretch upward, the rays of the sun beam downward, linking the physical with the spiritual and Burchfield's earthly presence with the radiance of the heavens above. His paintings are as much celebrations of his joy at being in nature as of the spiritual qualities that nature generates. Once, in a wooded area, he said, "I am home again—this is mine. Here only can I be with God; the spirit coming through these trees is both me and my creator, merged."[20]

Around 1940 and continuing into the post-World War II years, this spiritual certainty at the heart of Americanism shifted. Perhaps the loss of values following the horrors of World War II forced a numbing reassessment. Whatever the causes, the vigor of Americanism and of the American Scene movement gave way before a different kind of vigor, that of abstract art and of an internationalization of American art.

Milton Avery (1893–1965) clearly alluded to this development in his painting *Sketcher by Seaside Cliff* (fig. 21). The landscape is still there, but it is not localized. Rather, the viewer responds primarily to the colors and forms. Avery was less concerned with the environment or with past psychological associations than with the aesthetic problems of relating blue to magenta and centralized to peripheral forms. His responsibilities were more to the realm of art than to the physical presence of place or historical memory.

That the spirit of American Scene painting, with its emphasis on a depiction of ordinary people through art that is readily accessible, should have finally bent to the winds of Modernism blowing through the first half of the twentieth century is perhaps inevitable. But the concept of a native character remained a strong current in American art. It simply found other means of expression, the abstraction of the New York School being in many ways as quintessentially "American" as the landscape and common people and heroized Americanism expressed in the art of Benton, Wood, Hopper, and O'Keeffe. As long as artists continue to examine the physical and spiritual landscapes of the United States in whatever form, their work will speak both to the vigor of Americanism and to the vigor of art in America.

NOTES

1. From "The American Scholar," in Joel Porte, ed., *Ralph Waldo Emerson: Essays and Lectures* (New York: The Library of America, 1983), 68–69.

2. *Emerson*, 465.

3. From "Preface to Leaves of Grass," in Justin Kaplan, ed., *Walt Whitman: Poetry and Prose* (New York: The Library of America, 1982), 5.

4. From "Democratic Vistas," in *Whitman*, 931.

5. From "Preface to Leaves of Grass," in *Whitman*, 6.

6. Thomas Craven, "American Painters: the Snob Spirit," *Scribner's Magazine* 91 (February 1932), 83–84.

7. DeWitt Clinton, quoted in Thomas S. Cummings, *Annals of the National Academy of Design* (Philadelphia: George W. Childs, 1865), 12. See also Robert Streeter, "Association Psychology and Literary Nationalism" in *North American Review, American Literature* 17 (1945), 243–254.

8. Thomas Hart Benton, quoted in John I. H. Baur, ed., *New Art in America* (Greenwich, CT: New York Graphic Society, 1951), 131.

9. Grant Wood, quoted in F. A. Whiting, Jr. "Stone, Steal, and Fire: Stone City Comes to Life," *The American Magazine of Art* 25 (December 1932), 336–337; and in Darrell Garwood, *Artist in Iowa: A Life of Grant Wood* (New York: Norton, 1944), 151.

10. Grant Wood, quoted in Wanda Corn, *Grant Wood: the Regionalist Vision* (New Haven: Yale University Press, 1983), 2–3.

11. All of the information on Fiene comes from Linda Hyman, *Ernest Fiene: Art of the City, 1925–1955*. (New York: ACA Galleries, 1981), n.p.

12. Edward Lanning, "Reginald Marsh," *Demcourier* 13 (June 1943), 3.

13. Lloyd Goodrich, "The Paintings of Edward Hopper," *The Arts* 11 (March 1927), 136.

14. Quoted in *The Art Digest* 3 (1 February 1929), 3.

15. The phrase first appeared in William Cullen Bryant's sonnet, "To Cole," published in *The Talisman* (an annual) in 1829, and has since appeared in virtually every serious publication on the artist.

16. Julian Onderdonk, quoted in Cecilia Steinfeldt, *The Onderdonks: A Family of Texas Painters* (San Antonio: Trinity University Press, 1976, 112; and cited in J. Gray Sweeney, "The Onderdonks, Robert and Julian," *Southwest Art* 18 (April 1989), 128.

17. Dean A. Porter, *Victor Higgins: An American Master* (Salt Lake City: Peregrine Smith Books, 1991), 16.

18. Clarence Chatterton, quoted in Bennard B. Perlman, "The Look and Art of C. K. Chatterton," *C.K. Chatterton, 1880–1973* (New York: ACA Galleries, 1980), n.p.

19. Rockwell Kent, quoted in Richard O. West, *"An Enkindled Eye," The Paintings of Rockwell Kent* (Santa Barbara: Santa Barbara Museum of Art, 1985), 14.

20. Charles Burchfield, diary entry, December 19, 1935, the Whitney Museum of American Art, New York.

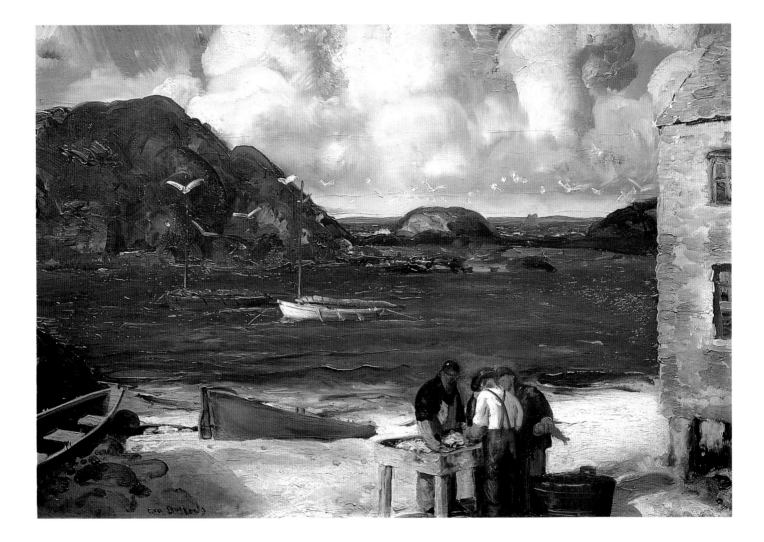

1. GEORGE BELLOWS
Harbor at Monhegan, 1913–15
Oil on canvas
25 3/4 x 38 in.

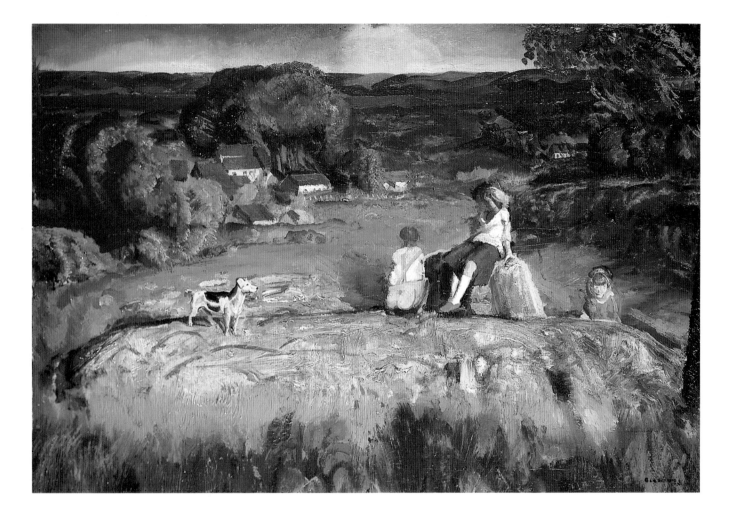

2. GEORGE BELLOWS
Three Children, 1919
Oil on canvas
30 3/8 x 44 1/8 in.

3. WILLARD LEROY METCALF
Cherry Blossom, 1912
Oil on canvas
26 x 29 in.

4. JULIAN ONDERDONK
Texas Bluebonnets, 1910
Oil on canvas
14 x 20⅛ in.

5. ERNEST LAWSON
The Pond and Gapstow Bridge, New
York City, 1914
Oil on canvas
21⅞ x 25 in.

6. WILLIAM J. GLACKENS
Washington Square (no date)
Pastel on paper
10⅝ x 18⅝ in. (image)

7. ROBERT HENRI
In the Deep Woods, 1918
Pastel on paper
12³/₈ x 19⁷/₈ in.

8. ROBERT HENRI
Sunlight in the Woods, 1918
Pastel on paper
15 1/4 x 19 in.

9. JOHN SLOAN
Landscape, Santa Fe, c. 1925
Oil on board
16 x 20¼ in.

10. JOHN STEUART CURRY
The Sun Rises Over Kansas (no date)
Oil on canvas
30 x 38 in.

11. Clarence K. Chatterton
Rock Pasture, 1931
Oil on canvas
30 x 44 in.

12. EDWARD HOPPER
Gloucester Harbor, 1926
Watercolor on paper
14½ x 20 in.

13. VICTOR HIGGINS
Taos Foothills (c. 1925)
Oil on canvas board
14 x 17⅞ in.

14. CHARLES BURCHFIELD
November Sun Emerging, 1956–59
Watercolor on paper
37³/₄ x 31⁷/₈ in. (image)

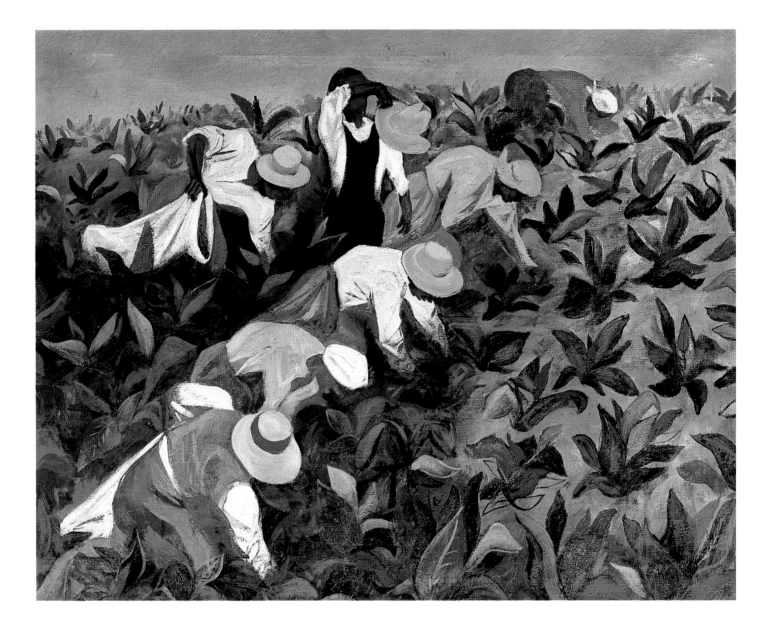

15. WILLIAM GROPPER
Field Workers (Tobacco Pickers), 1942
Oil on canvas
27 x 34 in.

16. ROCKWELL KENT
Asgaard Cornfield, California, 1950
Oil on canvas
28 x 44 in.

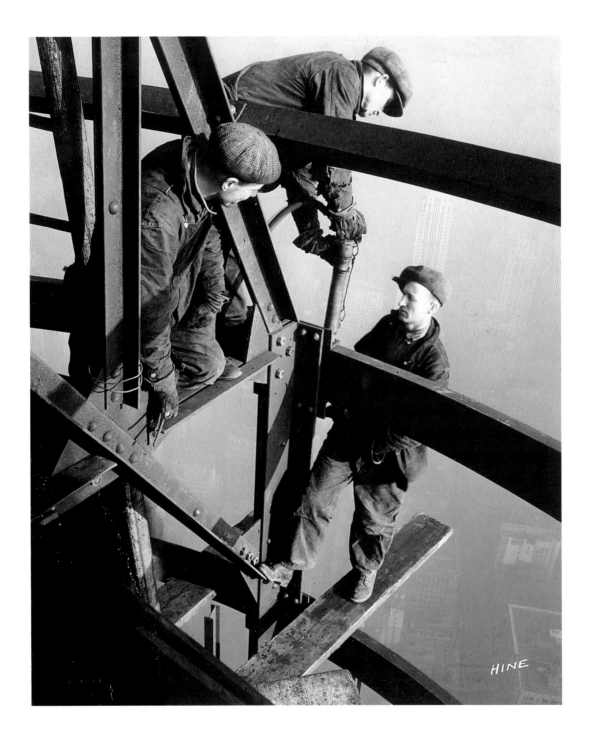

17. LEWIS HINE
Untitled [Construction of the
Empire State Building], 1931
Vintage gelatin silver print
19¼ x 15¼ in. (image)

18. REGINALD MARSH
Girls in the Street, 1946
Tempera on paper
22½ x 31 in.

19. EVERETT SHINN
Paris Square (Winter), 1940
Pastel on paper
14 x 20 in.

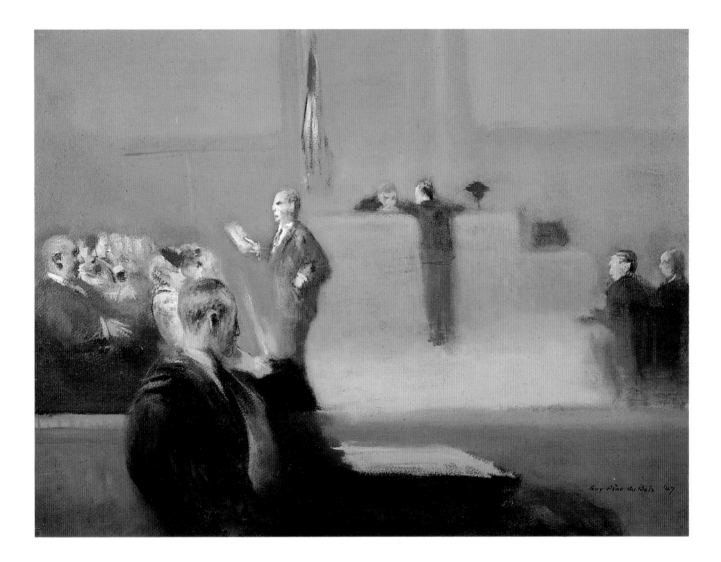

20. GUY PÈNE DU BOIS
Addressing the Jury, 1947
Oil on masonite
19⅝ x 25½ in.

"Thus all real art has always been and will always be essentially abstract, regardless of changes in subject matter, material, and technique.... If any care to call this viewpoint 'art for art's sake,' let them make the most of it. I call it art for society's sake. A society which cannot afford such an art is poor indeed."

—*Stuart Davis*

Modernism Before 1945

The Lure of the Modern

Susan C. Larsen

In the first two decades of the twentieth century, a large portion of the American art world was both seduced and transformed by the sheer innovative force of European Modernism. During this time, the dynamic turn-of-the-century artistic movements of Fauvism, German Expressionism, Cubism, Futurism, Constructivism, and Dada appeared successively before the public. While some artists reacted against European Modernism by celebrating the nativist styles characteristic of American Scene painting discussed in the previous essay, many more American artists and critics flocked to the European scene eager to understand and assimilate the new styles and concepts. In return, the formal language of European Modernism, especially that of abstraction, was quickly grafted onto American subjects.

Important cultural differences were often ignored or submerged in the rush to join in the spectacular transformation offered by the dazzling changes in European painting and sculpture. Our hearty, often uncritical embrace stretched to include a wide spectrum of divergent philosophical, social, and artistic concepts, which we seized upon for their novel visual effects and refashioned to typically American purposes. Startlingly soon, a new history was born—one of American Modernism. It would trace an elliptical path from an early and zealous advocacy of European styles and concepts to a very successful hybridization with indigenous Realist tendencies (aided by photography), followed by a more mature understanding of European abstraction that encompassed both its philosophical implications and its formal limitations.

The Armory Show of 1913 introduced a broad American public to the new art of Europe and, in even greater numbers, to American artists past and present. It was earlier, however, within the circle of artists, collectors, and critics nurtured by Alfred Stieglitz (1864–1946) between the years 1905 and 1913, that the first important link between American and European art of the early twentieth century was made. Stieglitz traveled repeatedly to Europe, visiting Berlin, Dresden, Munich, London, and other cities in search of innovative photography. Meanwhile, his understanding of modern painting and sculpture grew. In his own early work, such as in his celebrated image *The Steerage* (1907, pl. 21), we see a brilliant synthesis of moving, albeit structured, narrative and dynamic visual composition. But Modernist concerns were not yet fully present, for although Stieglitz took great care with his extraordinary composition, he used it primarily to delineate the human faces of exhausted yet hopeful immigrants to America disembarking from their physically and emotionally demanding voyage.

Immigrants were a perfect image. Even as American artists traveled to Paris, Berlin, Munich, and elsewhere to witness the innovations of European Modernism, impoverished, talented, and eager Europeans were coming by the millions to America. New

previous page:
GERALD MURPHY
Bibliothèque (detail), 1927 Plate 27

citizens and new ideas arrived in New York in unprecedented numbers during the period between 1900 and 1914. Stieglitz's photograph *The Steerage* characterizes this opening decade of the century in America while demonstrating the aesthetic and humanistic power of the nascent medium of photography.

In the years before the Armory Show of 1913 and the outbreak of World War I in 1914, many of the American artists who would later be part of Stieglitz's circle also spent important periods of time in Europe. Max Weber went to Paris in 1905 and stayed until 1908, the year he spent in the atelier school of Henri Matisse. John Marin went to Paris in 1905. Abraham Walkowitz spent a year in Paris from 1906 to 1907.[1] Other artists traveling to Europe included Edward Hopper, who made his first Parisian sojourn in 1906 and stayed until 1909. Charles Demuth spent the season of 1907–08 in Paris. Walter Pach, a primary organizer of the Armory Show, first went to Paris in 1906; he would return several times prior to the opening of that great exhibition that serves as such an important turning point in American art history.

It was in 1907 that Stieglitz's exhibitions at 291 (located at 291 Fifth Avenue), or the Little Galleries of the Photo-Secession, as they were formally named, changed markedly. Prior to this season, he had championed the cause of modern photography exclusively through exhibitions at the gallery and in his important journal *Camera Work*, first published in 1903. After 1907, Stieglitz's commitment to modern photography continued unabated, but he now emphasized its affinities with modern art. The 1907–08 season at 291 saw exhibitions of the work of Auguste Rodin and Matisse. The following year featured the work of the Americans Marsden Hartley and Marin, and by 1909, the program had expanded to combine both European and American Modernists. Stieglitz's conversion to radical Modernism, and especially to abstraction, began with his appreciation of Paul Cézanne, whose work he featured in a solo exhibition of 1910. That season also featured works by a number of other European artists including, perhaps most significantly, Pablo Picasso.[2]

To the American public, the Armory Show came as a shock and, for some, a revelation. For Stieglitz and his circle of artists, however, it provided more of a review of their own individual exposure to Modernism in Europe over the previous five years. Exhibitions at 291 had prepared a small but avid New York art audience for this onslaught of modern art and its disturbing notoriety during the run of the Armory Show. Thus, it may be said that the Armory Show was a corollary event to developments already well under way in New York. Americans were already assimilating the syntax of Cubism, the color of Fauvism, and the dynamic visual analysis of Futurism by the time the big survey of modern developments captured the attention of New Yorkers and the nation.

New York (1912, pl. 22) by Max Weber (1881–1961) supplies ample evidence of the dramatic and complete assimilation of Cubism already achieved by some American artists in advance of the Armory Show of 1913. Weber's characterization of New York was unsentimental and prophetic as he juxtaposed a phalanx of massive skyscrapers against a field of fractured red rooftops. Old New York with its beloved and familiar landmarks on a human scale here gives way to austere steel-framed paragons of geometric order. The dynamic new architecture of New York is also of paramount importance in *Cityscape* (fig. 22) by Abraham Walkowitz (1878–1965). Without nostalgia and with an exuberance born of the new century, Walkowitz described a city alive with the pulse of technological innovation. Raucous and widespread waves of physical and emotional energy in this work were directed toward a brilliant future. Cubism provided an expressive vehicle for both of these Americans, but in their case, a characteristic American confidence in the technological future turned the language of

Figure 22
ABRAHAM WALKOWITZ
Cityscape, 1912
Charcoal on paper
18¾ x 14¼ in. (image)

Cubism into a hieroglyph of modern life. The intimacy of Georges Braque's and Picasso's cabaret environment was nowhere in evidence. Instead, these and other American artists pushed Cubism to sustain sweeping views of urban New York. An electric atmosphere fed by social and technological change provided the conduit for Walkowitz's and Weber's futuristic images of the city.

If urban hieroglyphs signaled the birth of a new age, the familiar images of farm, field, and ocean tied the work of American Modernists to a longer, older landscape tradition stretching back to the origins of American painting in the seventeenth century. John Marin (1870–1953) is celebrated for his paintings of turn-of-the-century Manhattan transformed by the forces of Modernism. Over the many decades of his artistic life, though, Marin was just as passionately devoted to a careful study of nature's elemental forces in many areas of America but especially in coastal Maine. *Off Deer Isle, Maine* (1928, pl. 26) was painted several years after the introduction of modern art in America, and Marin, who sought and found the sustaining pulse of nature in this landscape, rendered that energy in Modernist terms. Turbulent waves and flat horizons create an interplay of form and rhythm understood by Marin as a basic condition of nature's eternal flux. Human activity in the city was merely another form of an energy generated most beautifully in the far reaches of nature.

William Zorach (1887–1966) rendered *Maine Houses* (fig. 23) by applying a rigorously Cubist geometry to simple wooden structures already blessed by a fundamental plainness characteristic of rural American architecture. Many American Modernists examined their native culture for antecedents of Modernist geometric form and soon found a congruence in the smooth, calm contours of American folk sculpture, geometric quilts, plain country furniture, and vernacular rural architecture. Zorach and Marin were among the many Americans who came to rural Maine in search of an American formal language that could be seen as running parallel to the reductive tendencies of European Modernism. They found in Maine important precursors to modern design, but they also renewed themselves in the vital open spaces of rural America, which proved ever more important as the cities grew larger and more congested.

Andrew Dasburg (1887–1979) filled his painting *Finney Farm, Croton-on-Hudson* (c. 1917, pl. 24) with glowing primary colors that describe the blocklike buildings of a small Hudson Valley town. The influence of Cézanne's geometric structuring of nature is evident, and it is also clear that Dasburg had studied the work that Braque and Picasso produced during the early stages of Cubism from 1908 to 1910. Yet Dasburg departed from all of his European precedents, remaining true to the unruly forces of nature, when he allowed a central tree to dominate the painting as it curves and spreads across the landscape. American Modernists were able to absorb and use the structural language of Cubism, but few would place abstract order above their adherence to the realities of nature. Thus, the work of American Modernists often possesses a personal and idiosyncratic character, while it also demonstrates great variety. The basic American commitment to individual observation of life and nature gave these artists a license to adapt, to transform, and to translate European Modernist form into a new idiom with its own goals and freedoms.

A surprising but also quite logical counterpoint to Cubism was the abstract system of curves proposed by Polish émigré sculptor Elie Nadelman (1882–1946) during the years he lived in Paris. Independently of Braque and Picasso, he evolved a system of repeated curves to describe nature's forms. *Female Nude* (fig. 24) is from the period when Nadelman fully realized this curvilinear system—even as the cubic rectilinear grid was first being explored by Picasso. Reminiscences of classical sculpture pervade this abstract female form whose graceful movement is achieved by a disciplined

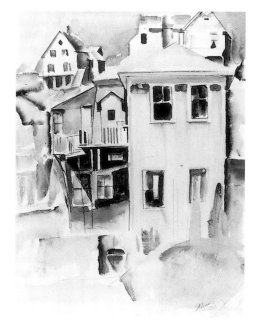

Figure 23
WILLIAM ZORACH
Maine Houses, 1918
Watercolor on paper
15¼ x 11⅞ in.

Figure 24
ELIE NADELMAN
Female Nude, 1906
Ink on paper
15⅜ x 7¼ in.

Figure 25
ALFRED STIEGLITZ
Portrait of Georgia O'Keeffe, c. 1932
Vintage gelatin silver print
9¼ x 6⅝ in. (image)

structure of contour lines. Nadelman came to America in 1914 to seek even greater celebrity and was encouraged by his exhibition at 291 in 1916 after his participation in the Armory Show of 1913. He grew to love and understand the unique formal and expressive qualities of American folk art, eventually amassing a vast and historically important collection. In time, as he turned to wood and to direct carving methods, his own work began to reflect his admiration of these elegantly simplified native forms.

By the 1920s, the first onrush of enthusiasm for European Modernism had waned, and many American artists sought a greater balance between description and abstraction. *New York Elevated* (c. 1924–26, pl. 30) by Czech-born Modernist Jan Matulka (1890–1972) derives its monumentality from the Manhattan skyline and its flattened yet blocklike forms from Synthetic Cubism. Central to this work is the presence of the triangular-shaped elevated station. Matulka recreated the scene by inflating the size of the station while drastically reducing the scale of surrounding buildings, especially those at the left side of the composition. In his work, Matulka responded strongly to the look and modern rhythms of Manhattan life, as did his contemporary Stuart Davis. Both of these artists used abrupt shifts of scale, flattened patterns, and deft transitions from two- to three-dimensional space to render modern life in the idiom of modern art.

Photography may not seem to be a particularly malleable medium when such abstract shifts of space and scale are called for, but by assuming unexpected angles in their depictions of modern subjects, photographs from this time achieved great expressive impact, often communicating a profound psychological disassociation. Berenice Abbott (1898–1991) in her *Skyscraper* of 1935 (pl. 40) adopted a dramatic oblique angle capable of monumentalizing the foreground building while diminishing a nearby warehouse and its electric sign into a bizarrely diminutive self-caricature. Abbott, in her work, took into consideration the space-time experience of the contemporary viewer who walks along city streets, occasionally gazing upward at massive vertical buildings, and she was also aware of how the dizzying antihuman scale of modern architecture can render one awed and disoriented in the midst of the city.

Even as American art became inextricably tied to Modernist developments in Europe, a small group of painters close to Stieglitz sustained a steady devotion to themes derived from biological forms and the emotional resonance these can create in the human psyche. The work of Georgia O'Keeffe (1887–1986) was surprisingly free of European influence when she first stepped into Stieglitz's life in 1917 and thereby onto center stage of the American art world. Her early watercolors and drawings on paper were breathtakingly original and served as primary sources for the work of her contemporaries as well as her own later paintings.

By 1932, when Stieglitz produced his *Portrait of Georgia O'Keeffe* (fig. 25), her character was firmly established, and it owed little to stereotypical feminine beauty. In this photograph, O'Keeffe's sober, almost ascetic hairstyle sustains the dark simplicity of her garment, the acute shadows and angles of her face, and her strong shadow cast upon the wall. Stieglitz's modernity lay in his willingness to show the strength of his companion's character while mining O'Keeffe's wellspring of personal power to define and enhance her physical beauty.

By now his desire to support a uniquely American Modernism had become the central mission of Stieglitz's personal and professional life. In the aftermath of the Armory Show and especially at the end of World War I, European art had overwhelmed the American art market, greatly reducing the possibilities for native-born Modernists. During the 1920s and 1930s, Stieglitz worked to sustain the careers of a small circle of intimates. Among those at the center of his affections were Arthur Dove, Hartley, and O'Keeffe.

Marsden Hartley (1877–1943) was indeed a pioneer of American Modernism. His art was influenced by a variety of styles, notably Fauvism, Cubism, and Dada—works of Cézanne and Picasso were among his greatest inspiration. While Hartley was undoubtedly affected by European Modernism, his paintings became increasingly more traditional as he shifted his focus to landscape and still life, evident in his painting *Rain Coming–Sea Window–Cape Ann* (c. 1933–36, pl. 36). His pastel drawing *Calla Lilies* (c. 1920, pl. 23), executed from his memories of the New Mexico landscape, is another example of Hartley's still-life studies. Drawn with rich color and bold strokes, this pastel makes evident Hartley's eye for detail.

O'Keeffe's *Black Maple Trunk–Yellow Leaves* (1928, pl. 33) was exhibited in 1931 at Stieglitz's new gallery, An American Place.[3] One of her more forceful canvases of this period, its characteristic monumentality and drama were achieved by cropping the image, rendering it in stark contrasts of color, and modeling it with an otherworldly, satiny smoothness. O'Keeffe had started to look toward American subjects in the 1920s and 1930s, particularly toward rural, natural, and powerful forms that conveyed the protean energy of the land. These were years of despair in the United States, and many other American artists also turned to rural themes to suggest a natural refuge from the bewildering social breakdown of the Great Depression. However, O'Keeffe and other painters of the Stieglitz circle sought a specifically spiritual renewal in the timeless forms of nature's cycles of birth and death, much as the Transcendentalist poets of the nineteenth century had looked to eternal cycles of life and time beyond our grasp or understanding. Her interest in natural forms persisted throughout her career, exemplified by *Not from My Garden* of 1967 (fig. 26).

In the careers he fostered, Stieglitz's judgment proved prophetic, although from a commercial standpoint, Marin and O'Keeffe contributed vastly more to the gallery's budget than did Dove and Hartley. Later audiences grew to value all four artists very highly, thus redeeming the artistic fortunes of Arthur G. Dove (1880–1946), who suffered greatly throughout his difficult and impoverished life. In Dove's work, one does not sense suffering, however, but joy. His is a view of nature full of wonder, an exploration of the familiar and the mysterious in equal measure.

Dove's mood of ecstatic reverie before nature is present in *Reflections* (1935, pl. 47), a macrocosmic ode to the sun's power to set all things in motion toward a state of transcendent unity. Typical American art patrons of this period appreciated narrative subject matter, exactitude, and a sense of formal completion in the art they purchased. Dove's freely emotional, raw, abbreviated work as a result found little favor except among a few thoughtful and sophisticated art lovers such as the sensitive collector Duncan Phillips.[4] Dove's art vaulted to a position of great importance and respect only after World War II when the New York School of Willem de Kooning, Arshile Gorky, Robert Motherwell, Jackson Pollock, and Mark Rothko first emerged. The work of these abstractionists, as well as of figurative artists such as Milton Avery, revealed how far ahead of its time Dove's art had been with its expressive fusion of human feeling and abstract form.

White Channel (1942, pl. 48) by Dove is as spare and authoritative as any European abstraction, but it still speaks of Dove's love for the sea and of the reciprocal relationship between humankind and nature. Among the artists of the Stieglitz circle, a strong affinity existed between Dove and O'Keeffe, who admired each other's work and acknowledged mutual influences over several decades of artistic evolution. They are perhaps the most truly original of our early Modernists, and their art continues to move contemporary audiences in our own time.

Yet another influential female artist, Helen Torr (1886–1967), transformed Dove's

Figure 26
GEORGIA O'KEEFFE
Not from My Garden, 1967
Oil on canvas
15 1/8 x 12 in.

emotional solitude with the gift of a loving, lifelong partnership. Torr's art has only recently received the regard and serious study it has long deserved. Torr used the forms of nature emblematically, almost as a type of pictographic language. In *Composition* (1935, pl. 45), a marvelous transparent bird perches on a short length of rope, which suddenly sprouts delicate leaves. The digestive system of this little bird is plainly revealed, a circumstance which only adds to its mysterious presence. Two leaves that hover on a blue-gray field resemble the wings of a flying bird, further elaborating the artist's humorous, paradoxical transmutations of bird, leaf, and rope. Torr's sensibility was one of devoted attention to the details of nature accompanied by a unique sense of syntax, humor, and paradox. Dove more often took a macrocosmic view, even when looking into details. Together they enjoyed the rugged outdoor life they led, even when it held significant hardship, for it enabled them to keep working and to explore nature's mysteries full time in the company of each other.

For all its focus on natural forms, American Modernism did not neglect the mechanical spirit of the new century. It is well known that one of the most notorious works of art featured in the 1913 Armory Show was Marcel Duchamp's *Nude Descending a Staircase No. 2* of 1912 (Philadelphia Museum of Art, Louise and Walter Arensberg Collection). A brilliant, robust synthesis of the erotic and the mechanical, it confused a naïve public but stirred and energized an entire segment of the American art community. Together with the mechanical-erotic paintings of Francis Picabia, also shown in the 1913 landmark exhibition, Duchamp's famous nude signaled an artistic transformation for the machine age.

Fellow Armory Show exhibitor Morton Livingston Schamberg (1881–1918) was painting Post-Impressionist landscapes in 1913, but he soon anticipated the implications of European Dada in a series of elegant, cool, enigmatic works he began in 1916. Dada, a movement that arose after World War I, was embraced primarily by poets and artists reacting against the horrors of that machine-driven war. The impulse was to oppose the calculated, technological advances of society with art that was supremely irrational. Schamberg's Machine series may be the first rigorous consideration of the machine in an ironic Dadaist context by an American painter. His 1916 untitled work (pl. 28) is one of the most successful of this celebrated group of paintings. Precise yet almost calligraphic in its notation of gears, linear mechanical belts, and two moving, hovering circles that are perhaps separate positions of a single circular element, it is a work that considers the machine from the point of view of the human imagination and not from a point of view dictated by utility. Ironically, Duchamp, Picabia, Schamberg, and others were partially inspired by the elegantly austere technical drawings featured in American magazines on popular mechanics, new inventions, and small household machines.

Many American Dadaists evolved into Surrealists after World War I as the highly influential Surrealist poets André Breton and Paul Eluard were published and as the work of painters such as Giorgio de Chirico, Salvador Dalí, René Magritte, and Joan Miró was exhibited in New York during the late 1920s and early 1930s. Surrealism, a movement that emphasized automatism, or "thought dictated in the absence of all control exerted by reason,"[5] provided artists with a means of creating "pure" art, unencumbered by the reigning aesthetic style. An early Dadaist who himself metamorphosed into a leading proponent of Surrealist transformation and paradox was the Philadelphia-born Emmanuel Radensky who called himself Man Ray (1890–1976). An intimate of the circle of artists around Duchamp and Walter Arensberg, Man Ray took part in the founding of the Society of Independent Artists in New York in 1916 and the Société Anonyme in 1920. Both organizations were

Figure 27
MAN RAY
*Hands and Profile of the Countess
Villombrosa*, 1926
Vintage gelatin silver print
8⅞ x 6⅞ in.

Figure 28
MAN RAY
Hands of the Countess Villombrosa, 1926
Vintage gelatin silver print
8⅞ x 6⅝ in.

radical advocacy groups for Modernist art ranging from Cubism to Dada to early manifestations of Surrealism.

Even as these organizations began to shape the New York art world, Man Ray left the United States to follow Duchamp when he returned to Paris in 1921. This proved a felicitous move, and Man Ray spent many years as a photographer and thinker expanding the fertile interface between avant-garde painting and photography. His are the most brilliant portraits of the age. They have the advantages of intimate acquaintance, cutting-edge aesthetics, dramatic insight, and consummate technique. Man Ray's *Hands and Profile of Countess Villombrosa* (figs. 27–28) is one of a small series of images telling an enigmatic tale of self-contemplation and almost mystical insight. The countess gazes at her outstretched hands as if seeing them for the first time. Image by image, she dissolves, seeming to see through herself. It is an early example of Surrealist metamorphosis achieved by the power of the mind.

Coming from the cradle of Dada in New York, where the image of the machine sparked a new consideration of the twentieth-century technological world, Man Ray took issue with the poet Breton when the Surrealist leader posited that geometric forms were soulless—without emotion, erotic potential, or interest for one living in a biologically determined world. Man Ray created his *Mathematical Object* (1936, pl. 55) in response to Breton's assertion. He invested his image with every tactile, luminous, ambiguous possibility he could incorporate into the three-dimensional model built at the Poincare Institute in Paris to demonstrate that a mechanical form could indeed be the central inspiring image in a work of art.[6] Pursuing this idea in a series of works, Man Ray proved his point over and over until he had virtually retold the central thesis of Dada, which emphasized the lack of sensuousness in the machine, in Surrealist terms.

Man Ray returned to New York in 1940 and immediately traveled onward to the Los Angeles area, where he spent the years from 1940 to 1951. Geometric protagonists again take central roles in a series of paintings he created based upon the plays of William Shakespeare. In *Macbeth* (1948, pl. 56), a spiky black form occupies a central stage defined by swaths of draperies. It is an abstract hieroglyph of the dark, turbulent, violent elements of human nature, a fitting if elliptical interpretation of the betrayals and secrets uncovered in the plot of *Macbeth*. In 1951, Man Ray returned to Paris and to an art world older and perhaps wiser in the language of Modernism.

Throughout the war years, which seemed to many like a dark Surrealist dream,

individual American artists found ways to express transcendent visions of unlimited time, indefinite space, and a belief in the unending repetition and inevitability of human events as evidenced by myth. The first generation of European Modernists struggled to renew tarnished utopian dreams after World War I. Now a new generation of Americans addressed the postwar world of the 1950s with a sober understanding of global politics and a renewed dedication to the power of individual artistic revelation.

With their emphasis on nature as a regenerative force in human life, and their faith in direct personal experience, the Abstract Expressionists would renew and intensify many of the central themes introduced and explored by American Modernists of the early twentieth century. Our entanglements with European art and politics greatly influenced the broad outlines of American cultural life. However, at every turn the remarkable directness and concreteness of the American character put its own stamp on our artistic expression, forging a tradition that is uniquely our own.

NOTES

1. Homer, *Alfred Stieglitz*, appendix 2, 299–303.

2. Homer, appendix 1, 195–198.

3. Davidson, *Early American Modernist Painting*, 16 (photograph).

4. Haskell, *Arthur Dove*, 38.

5. André Breton, quoted in Atkins, *Artspeak*, 156.

6. Erlich, *Pacific Dreams*, 160–61.

Order, Structure, and
the Continuity of Modernism

William C. Agee

Figure 29
OSCAR BLUEMNER
West Pond, South Braintree, 1930
Gouache on paper
5 x 6⅞ in.

As the SBC Collection shows, American Modernist artists were active from 1918 to 1940, which is a period in our history that is not yet fully understood. These years between the wars have been widely viewed as a "retreat" from Modernism, but, in fact, American Modernism continued apace, in both new and old forms. To a large extent, modern artists in this period were seeking a new order based on clarity of structure.

By 1914, American artists such as Alfred Maurer, Marsden Hartley, John Marin, Arthur Dove, Charles Demuth, Arthur B. Carles, Oscar Bluemner (fig. 29), Joseph Stella, John Storrs, and Morton L. Schamberg had become full participants in the first wave of international Modernism that was moving toward a new and more abstract type of art. New possibilities for what a painting could be or could do to achieve an expanded range of expression reverberated simultaneously throughout American and European art. A mood of optimism permeated the art world as a powerful language took shape, embodying the dynamism of a new century.

That mood and that world, however, were changed forever by the unprecedented destruction of World War I. After 1918, the old mood of unbounded international optimism was gone; much of America began to look inward, and the country became increasingly nationalistic and isolationist. But contrary to a still widely held belief, Modernism in America did not cease. The tenor and direction of American art may have been altered, but Modernism continued, albeit often in unexpected ways. After 1918, artists were seeking a new order and structure that might provide a moral and aesthetic model for the creation of a newer and better society.

Nevertheless, as several paintings in the SBC Collection make abundantly clear, after 1918, many artists continued on the same course they had begun prior to the war, with little if any essential change. They were the artists on whose work the foundation of a "new" modern art would be built. Charles Demuth (1883–1935), for example, was a towering figure in American art, and his accomplishments only grew in stature during the 1920s. His watercolor painting *Tuberoses* (1922, pl. 25), which once belonged to Demuth's close friend, the great American poet William Carlos Williams, demonstrates the continuing mastery of the watercolor medium that Demuth had achieved by 1914.

His watercolors belong to a long American tradition that includes Winslow Homer, Marin, and Georgia O'Keeffe, all masters of the medium; indeed, much of the best American art has been in watercolor. However, it was Demuth's exposure to the late watercolors of Paul Cézanne in 1911 at the famous 291 gallery run by Alfred Stieglitz and on trips to Paris in 1907 and 1912–14 that fully released his gifts. After 1916, Demuth developed dual styles: a sharp-edged planar Cubism and the flowing

expressionism of *Tuberoses*. His floral still-life works at first glance can seem pale, fragile, and even unfinished, but with sustained examination, they become ever richer, deeper, and stronger. Their open, lyrical quality anticipated the direct staining of color into canvas initiated in the 1950s by the American color-field painters, among them Helen Frankenthaler (fig. 43, pl. 67, page 138).

Tuberoses is small (the idea that all modern art is outsized is a myth), but this gives the picture a special intimacy, a sense that the artist is sharing a private world with the viewer. The expanse of paper deliberately left unpainted (a device first explored by Cézanne) is by no means empty; the open area we understand to be occupied by the flowers is activated by carefully considered pencil lines and touches of strong yellow washes through which we are made to feel the sensuous, tactile quality of the blooms. Even our sense of smell is involved, for the tuberose is a highly scented flower, and it is as if the artist were willing the scent to permeate the apparent void left by the un-painted surface. The tuberose is a flower of spring, and thus this work speaks to us of regeneration, of the cycle of life, of a world reborn from the ashes of the war. Demuth's watercolors, like much of modern art, are concerned with an art of the surface on which nuances of touch record nuances of feeling.

That Demuth rendered this watercolor with the utmost love is no wonder, for the flowers came from his mother's bountiful garden in Lancaster, Pennsylvania, where Demuth was born and where, weakened by illness, he would retreat from the intense pace of New York to rest and renew himself. The tuberose takes on a double-edged meaning, for in the language of flowers dear to the nineteenth century, the tuberose signified "voluptuousness and dangerous pleasure," an apt characterization of Demuth's life in New York. Thus, Demuth was painting a portrait of his dual worlds of New York and Lancaster, as well as his connection to the very essence of his own life.

Cubism, which could be said to form the semantics, or underlying system, of much of the new language of modern art, took hold at an early date in America. By 1912, it had decisively shaped the art of Max Weber, Marin, and Patrick Henry Bruce, and by 1917 had determined one direction in Demuth's art. It continued to impact American art after 1918, often in unexpected ways and at unlikely times. Alfred Henry Maurer (1868–1932), born a year before Henri Matisse and thirteen years before Pablo Picasso, was one of the oldest of the American Modernists. He was the first to go to Paris, traveling there in 1897 on what was to become an obligatory trip for aspiring American artists. He stayed there until 1914, much longer than most Americans, and in those years he developed an open and airy style of intense Fauve color reminiscent of Cézanne and Matisse. About 1919, he began the series of women's heads that would become the signature style by which he is still most popularly known.

It was not until late in his life that Maurer embarked on what some critics would consider his most important additions to American art, an extensive series of Cubist still lifes that he began in 1928 and continued until his death by suicide in 1932. *Cubist Still Life with Two Pears* (c. 1928–1930, pl. 31) is beautifully painted, with a layered glaz-ing of rich and transparent paint surfaces forming broad planes on and around the rad-ically tilted table planes that structure and define the entire surface and space. The artist painstakingly worked and reworked the surface, thus imbuing the painting with a palpable physical presence. As he worked, Maurer seems to have proceeded from the internal needs and dictates of the painting itself, rather than from the demands of faithful reproduction of the world before him. Thus, the painting creates its own re-ality, defining itself as an autonomous object with its own life. This, too, was a tenet inherent to much of early Modernism, and one that extended into the 1920s.

Maurer has never received the full critical acclaim that his art deserves. He is not,

however, alone in this regard, for Arthur B. Carles (1882–1952) has also suffered a similar fate. Like many American Modernists, Carles was born and trained in Philadelphia, then went to Paris from 1907 through 1910 and again in 1912. There he came to admire deeply the color painting of Matisse, which shaped the course of Carles's art as it did much of Modernism. Color painting was as important as Cubism in shaping modern art, and Carles can be said to have been one of America's greatest colorists.

After 1927, his art grew increasingly abstract, and by the date of the collection's untitled still life (c. 1935, pl. 43), elements of Naturalism are barely evident, having been largely subsumed by interwoven shapes of pure and mixed color whose tones range from light to dark, from resonant to shrill. They flow over and across the canvas, creating a single, tightly woven chromatic surface. That color painting and Cubism were never mutually exclusive is evident in the underlying linear grid that binds the hues to the painting. A singular intensity in these late works, a rhythmic, pulsating improvisation, speaks of Carles's deep passion for the art of painting itself. These late paintings, finished by 1941 when ill health forced him to stop working, are marvels in themselves as well as prophetic of the look and technique of Abstract Expressionism after 1945. Carles's art forces us to see more continuity in American art between the pre- and post-1945 years than we have so far supposed.

Color painting and Cubism also combine in the work of the German-born Oscar Bluemner (1867–1938), who suffered equally undeserved neglect and wound up a suicide. Trained as an architect, he came to this country in 1892 but returned to Europe in 1912, when he inevitably encountered Cubism. From the start, no doubt because of his training, Bluemner's paintings were ordered around the horizontal and vertical planes of Cubism, echoing architectural motifs in a landscape setting. Earlier works show several buildings in multifaceted planes; later, as in the 1932 *Approaching Black* (pl. 32), his work was distilled from a single, broad architectural plane. A brilliant, unrelenting red was his favored color and generally dominated his paintings. Here, Bluemner contrasted it with the deep, resonant blues and blacks of the landscape. Like the great Russian pioneer of abstract art Wassily Kandinsky, Bluemner was a mystic by temperament, striving to produce specific effects through the moods he believed were intrinsic to each color. Like other color painters, he regarded his paintings as musical compositions with their own structure and sounds. The title *Approaching Black* is double-edged. It can refer to the chromatic gradation of the hues as they move to black or, more ominously, to the dark side of Bluemner's soul and a sense of impending doom that eventually led to his death.

John Storrs (1885–1956), Chicago born and trained, had studied in Paris prior to 1914 like other members of the older generation. He was the single abstract sculptor produced by this country until David Smith and Alexander Calder emerged in the early 1930s. Storrs turned seriously to painting only in 1931, so it is not surprising that his paintings have the look and feel of low sculptural relief (fig. 30). They are abstract in form but often, as in *Genesis* (1932, pl. 41), recall the stylized outline of a face, thus evoking the expressive power of a primitive totem or mask. As the title suggests, we are here transported back in time to a primal beginning where life slowly emerges through the sweeping forms of the painting.

Many artists who came to painting late in life found their voice in the twenties, adding significantly to American Modernism. John Graham (1886–1961) was born Ivan Gratianovitch Dombrowski, a member of a noble Polish family living in Russia. In 1917, he escaped the Bolsheviks and moved to Paris, then immigrated to the United States in 1920. Like so

Figure 30
JOHN STORRS
Composition (Abstract), 1931
Oil on masonite
18 x 12½ in.

many immigrants before and after him, he enriched American art immeasurably. A dashing man, Graham was exceptional in many ways. He began to study painting only in 1922 at the age of thirty-six, but within five years he had become an accomplished and important artist. Thereafter, he served as a vital cultural force for advanced art, a bridge between Europe and America at a time when few Americans could afford to go abroad. He was also a mystic, an art dealer, a knowledgeable connoisseur, an art writer and theorist, an organizer of exhibitions, and a crucial mentor in the 1930s for some of America's most gifted young artists.

His biography, however, is so fascinating that it has often overshadowed his very real achievements as a painter. From 1927 to 1931, Graham painted a series of Cubist and Cubist-related still lifes, and it is striking to note just how many radically different Modernist modes Graham succeeded in accommodating within the traditional still-life motif. *Still Life* (c. 1928, pl. 35) is a painting of contrasts; of shifting, eliding objects set into a rigorous Cubist backdrop; of rich, pure tones of white and off-white played in concert with dark grays and browns that fuse with even deeper blues and blacks. It is a painting of strong color, but this is another order of color from the prismatic colors of Carles and other Modernists. Graham used oil paints to work and rework the uniform surface, enriching it by "process and experience lived through,"[1] creating dense, impastoed surfaces that in some areas simulate the look and feel of low relief. There is a certain awkwardness, an almost primitive quality to these shapes and surfaces that Graham valued highly for the directness of expression and primacy of feeling they embodied. We are made to understand that one must struggle with this unwilling and most difficult medium.

The life of Gerald Murphy (1888–1964), like that of Graham, also is a compelling story. Murphy was not a born painter, coming to art only after the age of thirty. The son of a wealthy family, Murphy attended Andover and Harvard but was dissatisfied with American values. He and his wife, Sara, moved to Paris in 1921, searching for a more meaningful direction to their lives. As had so many Americans before him, Murphy found it when he discovered the painting of Picasso, Georges Braque, Fernand Léger, and Matisse. "If that's painting, that's what I want to do," he later recalled.[2] Thereafter, Murphy became one of the most famous American expatriates living in Paris; he was close friends with Picasso and Léger and other well-known artistic and literary figures of the day. He also served as the model for Dick Diver, the character immortalized by F. Scott Fitzgerald in his novel *Tender Is The Night*.

Unfortunately, the romantic lure of his biography has somewhat obscured Murphy's real stature as a painter. It is a tragic story; his career as a painter was brief, lasting only from 1922 until 1929 when his children took ill. Both were to die, and the Murphys' lives were changed forever as Gerald was compelled to abandon painting in order to devote himself to family responsibilities. His known paintings number no more than fifteen, but like *Bibliothèque* of 1927 (pl. 27), they are exceptional. Murphy worked in a Cubist style similar to that of Picasso and Léger as well as the Purists Amédée Ozenfant and Le Corbusier. However, it was a Cubism far different from the brushed textured surfaces of Maurer, Carles, and Graham, proposing rather an art of deliberate preparation, exacting placement, and meticulous drawing. It was as if Murphy's paintings had been conceived and plotted by a mechanical engineer, and we can take this as a reflection of his training as a landscape architect at Harvard. Murphy's painting was part of a shift in the twenties to a broader, more stable and clarifying art, away from the painterly Expressionist simultaneity that characterized much abstract art prior to World War I. After the chaos and destruction of the war, much of the art world sought, in one form or another, an aesthetic order based on classical balance

that would serve as a model for a new world harmony and peace.

If Murphy's *Bibliothèque* seems cool and calculated, it is nevertheless rich in its range of references. Based on memories of his father's study, the classical bust and pilasters refer to the Greco-Roman civilization, the old order, which, in turn, is joined to a new conception of societal harmony by the globe positioned to show the western hemisphere—literally, the New World. It is also Murphy's way of connecting modern America to the traditions of the Western world's great civilizations; it was not for nothing that Picasso called Murphy the most American of artists. The books and reading glass allude to the library as the embodiment of learning and culture, manifesting the values of a new order. We are made to focus on these elements by Murphy's deployment of standard Cubist devices, such as the inversion of scale and spatial position.

America's role in the worldwide drive toward simpler expression, or a "greater perfection," as Guillaume Apollinaire termed it,[3] played out in Precisionism, a primarily figurative style of immaculate surfaces that impacted American art until well after 1945. Precisionism employed both new and old in its depiction of rural and industrial scenes uniquely identified with America. At its core was the sharp-focused clarity that characterized the art of Murphy and Stuart Davis—the precision of line and shape from which it took its name. Precisionism actually began with the exactly drawn machine forms in the untitled 1916 painting by Schamberg (pl. 28; see page 63) and was further defined and expanded in 1917 by Charles Sheeler and Demuth. Schamberg's machine images would later be an important source for the photographs of Clarence Laughlin (1905–1985), especially his 1937 Light on the Cylinders series (fig. 31).

Precisionist art looks as if it is literally machine made. It thus speaks of faith in the promise of a better society through the power of industry and technology, a theme that permeated much American art of the time. By 1922, the pristine Precisionist line and surface were pervasive in the work of a younger generation of American artists, including the rural images of George Ault (1891–1948) in *Provincetown: Boats & Houses* (1922, pl. 29) and Edmund Lewandoski (b. 1914) in *Amish Farmscape, No.4* (fig. 32) and the industrial scenes by artists such as Hilaire Hiler (1898–1966), including Hiler's untitled work of 1931 (fig. 33). In all cases, we are presented with a serene and untroubled world, with no hint of material conflict or human discord. That Precisionism was so long lasting, influencing several decades of American art, points to a common American drive toward clarity, lightness, and openness and away from the weight and density of old European hierarchies.

A s America entered the 1930s, the country sank ever deeper into the Great Depression, which conclusively ended only with the coming of World War II. During this decade—the most difficult and tumultuous in our history—many artists proposed an art that dealt directly with social, political, and economic issues. This Social Realism shared with American Scene painting and Regionalism a concern with a purely American subject matter, often portrayed in *retardaire*, or backward-looking, styles. While it is often thought that these developments precluded the continuation or extension of Modernism, nothing could be further from the truth, as is made clear by a number of paintings in the SBC Collection. A younger generation of artists, in fact, was just as concerned with social and political issues but believed that the best way to address these issues was through a contemporary, abstract art that spoke in a universal language. Indeed, how to fuse a truly modern art with a meaningful content was a primary issue for these artists.

To this younger generation of artists emerging in the early thirties, Picasso and later Cubism continued to be important factors, but new forces in American

Figure 31
CLARENCE LAUGHLIN
Light on the Cylinders #5
(Light on the Cylinders Series), 1937
Gelatin silver print
13½ x 10⅛ in. (image)

Figure 32
EDMUND D. LEWANDOSKI
Amish Farmscape, No. 4, 1985
Oil on canvas
26 x 49¼ in.

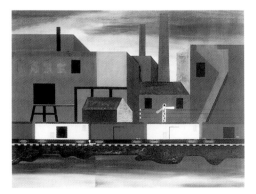

Figure 33
HILAIRE HILER
Untitled [Railroad Station], 1931
Oil on canvas
28¾ x 39½ in.

Modernism were also apparent, most especially Joan Miró and Surrealism, Kandinsky's later painting, and the Dutch de Stijl artist Piet Mondrian. That Cubism continued to yield rich pictorial effects is demonstrated by the multiple and fragmented views employed by Theodore Roszak (1907–1981) to capture the dynamism of the city in his large painting *42nd Street* (1936, pl. 39). Roszak and David Smith are best known as sculptors, but they began as painters in the thirties when, as we are only beginning to realize, they absorbed the tenets of Modernism. Roszak's painting is a bizarre amalgam. At left, the city is conceived of as a Futurist sculptural tower of whirling sights, sounds, and impressions of numbers, names, signs, and faces. At right, we are given, by way of contrast, a deserted and melancholy vista recalling Giorgio de Chirico but framed as if seen through a windshield, a device used at this time by Davis. It is the quintessential modern image—America seen through a windshield. This remarkable painting, with its myriad references to the experience of the modern urban city, depicts the American Scene just as surely as a painting by the Regionalist Thomas Hart Benton. But it uses a Modernist idiom to do so, demonstrating that Modernism and American Scene painting were not necessarily incompatible.

Davis made this point when he declared that he, too, painted the American Scene but used the modern, universal language of Cubism. This became something of a rallying cry for younger American artists who gravitated to a Modernist outlook. This tradition of uniting modern forms with uniquely American subjects includes both Marin and Joseph Stella, who early in the century had united the quintessential symbol of modernity in America—the Brooklyn Bridge—with variants of Cubism. The essential truth of this fusion is equally evident in the painting of George L. K. Morris (1905–1975), whose *Urban Concretion* (1939, pl. 46) also renders the experience of America through a personal variation of European Cubism. *Urban Concretion* is a variant of the *guéridon*, the table still life, with a guitar at center. Derived from a 1917 painting by Juan Gris that Morris owned, the painting is personalized by a uniquely American fusion of strong linear patterns, suggestive of Mondrian, with an atmospheric, painterly field. Morris was a close friend of his teacher A. E. Gallatin (1881–1952), himself an accomplished late Cubist painter (fig. 34) who was also an important collector and who founded the Gallery of Living Art in 1927. In 1936, Morris and Gallatin helped to launch the American Abstract Artists, a pivotal group that began to exhibit and promote the work of many advanced American Modernists in 1937. Morris, who was an intelligent and articulate writer on Modernism, became one of its most effective and tireless spokesmen. Through his painting and writing, Morris made the case that

the only way to achieve a truly American modern art was to combine nativist subjects with the international language of Modernism.

As American artists absorbed the lessons of Miró and Mondrian in the 1930s, they developed an even more abstract type of painting. In his 1941 abstraction (pl. 53), Ilya Bolotowsky (1907–1981), also a young founding member of the American Abstract Artists, moved from a semi-abstract Cubist idiom into an even more rigorous structural art. Derived from the strict verticals and horizontals of Mondrian and Russian Constructivism, the painting appears to dispense with naturalist objects altogether. However, like Davis, Bolotowsky had a point of reference, here probably the superstructure of a ship, a motif common to both artists at this time. Bolotowsky tempered Mondrian's austerity by skewing the grid system, setting planes into a counterpoint of movement, and introducing an astonishing and idiosyncratic range of pastel colors. In their sheer verve, Bolotowsky's colors seem uniquely American, marking him as one of America's most inventive colorists. They are emblematic of the total freedom from the old world order that Bolotowsky had gained when he left his native Russia in 1923. He became one of America's most important modern artists, and his work continued at the same high level of achievement after 1945.

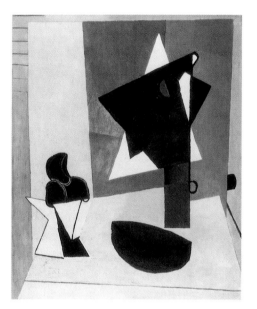

Figure 34
ALBERT E. GALLATIN
Untitled #54, 1935
Oil on canvas
24 x 20 in.

It is in the nature of modern art to question itself and to propose modifications and alternatives to prevailing conventions. Paul Kelpe (1902–1985), who had come to this country from Germany in 1925, insisted on a Purist abstraction even as he rendered geometric forms in a spiraling, illusionistic space. In his 1937 painting *Weightless Balance II* (pl. 52), only the tactile brushwork seems to keep these free-floating shapes attached to the surface. Kelpe posited a tension between illusion and reality that demonstrates just how the language of abstract art poses, in metaphorical but also very real terms, the questions of life that lie at the heart of our existence.

The work of the great Spanish Surrealist painter Miró was seen in abundance in the United States and exerted a profound and continuing influence on American art throughout the thirties and forties. Miró's abstract Surrealism, based on a language of growth and fecundity that used organic and biological shapes (known as biomorphism), posed an alternative to the strict geometry of Mondrian. American artists found the language of Miró a uniquely rich and adaptable vocabulary. Certain artists such as Davis, Bolotowsky, and Burgoyne Diller (1906–1965) at points actually fused the unlikely combination of Mondrian and Miró. Diller's painting *Miró Abstract* (1930, pl. 37) is an early example of American assimilation of Miró. Organic, flowing shapes animate the architecture, as does the heavy impasto, which was a departure from Miró's usually thinly painted surfaces. This fusion is indicative of the daring willingness to experiment that has accounted for much of this country's best art. It was only through this process of assimilation that Diller eventually arrived at his purely geometric art that would evolve into a stunning post-Mondrian statement after 1945.

The free shapes and autonomous line of abstract Surrealism helped other American artists break away from what they increasingly viewed as the confinement of Cubist structure and move toward a looser, more open surface with greater possibilities for freedom of invention. This move is fully evident in the paintings by David Smith (1906–1965) and Alice Trumbull Mason (1904–1971). Smith, best known as our greatest sculptor—and arguably our greatest artist—in the years after 1945, began as a painter, and the aesthetics of modern painting influenced his later work more than traditional sculpture.

Smith's early lessons in Modernism came, to a large extent, from his close relationship with Graham and Jan Matulka, artists whose impact on the younger members

of what later became known as the New York School was already manifest by 1930. Surrealist automatism—working from the unconscious—allowed Smith to open up the Cubist underpinning of his 1933 untitled painting (pl. 38) to achieve a variety of rich, painterly effects. Line and shape traverse separate and ultimately ambiguous paths, enabling the viewer to read the painting simultaneously as a landscape or a still life or both. The painting, one of a series inspired by a trip to the Virgin Islands, has the look and feel of a map and a landscape seen together, with what may be pieces of coral at upper right and lower center. The tracery of the line conveys topographic impressions in what Smith termed a "flash reference and afterimage."[4] It looks forward to his great sculptures, especially *Hudson River Landscape* (1950, Whitney Museum of American Art).

It is also difficult to determine the precise locus of the untitled abstraction of 1938 by Mason (pl. 50), for it also combines elements of still life and landscape, structural rigor, and a looser, more painterly lyricism, all marking her as an artist of exceptional sensitivity and range. We may well compare Mason's work such as *Winter* (fig. 35) to the diffused surfaces and personal kind of biomorphism in the 1935 painting *Reflections* (pl. 47; see page 62) by Arthur Dove, one of America's great early Modernists whose art reached new heights of achievement in the 1930s.

The expressive potential of biomorphism was also explored by artists such as Charles Shaw (1892–1974). Heir to a wealthy family, as were his good friends Morris and Gallatin, Shaw began to paint seriously in 1929, developing a style notable for its clarity of form and organic shapes, as evident in *Abstract Shapes* (1935, pl. 51). Biomorphic shape and line, each working separately but in concert, were taken to another extreme altogether by Ad Reinhardt (1913–1967), a precocious talent who found his direction as an artist early on. His untitled abstraction of 1940 (pl. 54), consisting of flat and unmodulated biomorphic shapes and undiluted color, fuses Cubism and Surrealism in a manner that speaks with the confident voice of youth. Reinhardt later became famous for his single-color, almost invisible geometric abstractions after 1952, but it is important to identify his roots in the thirties.

Another important European source of Modernism was Kandinsky's later, geometric art, which became well known in the United States in the thirties. Kandinsky's own hard-edged variant of Miró's biomorphism was clearly the point of departure for Emil Bisttram (1895–1976) in his painting *Two Cells at Play* (c. 1942, pl. 42), in which the generative forces of life cavort in a jocular dialogue. Kandinsky's influence may also be felt in the lively dispersal of lines, circles, and geometric planes arranged in tiers found in *Composition No. 84* (fig. 36) by the German-born Werner Drewes (1889–1985).

The history of American painting after 1940 has been written primarily in terms of the emergence of the new painterly art of the New York School, widely known as Abstract Expressionism. There can be no doubt that in these years the heroic art of Jackson Pollock, Willem de Kooning, Mark Rothko, and David Smith earned America a position of world leadership in art. Some artists who had pioneered the geometric abstraction of the thirties, Suzy Frelinghuysen (1912–1988) among them, began to absorb some of the New York School's painterly effects in their work. The multiple overlapping planes and lines of Frelinghuysen's untitled collage (1945, pl. 44) demonstrate the continued pictorial viability of Cubism, both in its structure and in its use of collage fragments; references to *savon* (soap) and hair indicate that the picture is a contemporary update of the old Impressionist theme of *femme à sa toilette*, or woman bathing.

But a number of artists including Sheeler, Davis, Ralston Crawford, and Bolotowsky

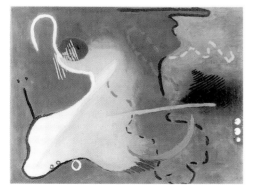

Figure 35
ALICE TRUMBULL MASON
Winter, 1930
Oil on canvas
18½ x 24¼ in.

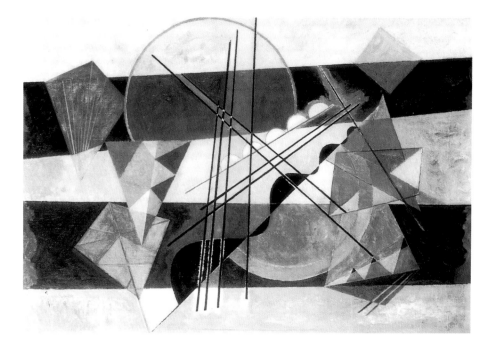

Figure 36
WERNER DREWES
Composition No. 84, 1935
Oil on canvas
17¼ x 25½ in.

continued to explore the structural art they had forged in the 1930s, although to many observers it now seemed outmoded. Nevertheless, these artists, who maintained the same high level in their work, often surpassed their earlier achievements in the years after 1945. In fact, geometric art would continue to exert a strong presence in America after World War II, demonstrating that there was far more continuity in American art before and after 1945 than is widely understood.

Charles Sheeler (1883–1965), for example, whose schematic Cubist style of 1917 was a major component of Precisionism, moved away from his Cubist roots in the period between the wars and developed a Realist style based on his parallel work in photography. His Realist images are some of the most memorable images of that period in American art. By 1940, however, with some notable exceptions, his art seemed to have run dry, drained by what had become an excessive reliance on photographic exactitude. Still, after the war, Sheeler produced some of his finest work. Signs of this rejuvenation actually appeared as early as 1943 in *Powerhouse with Trees* (pl. 57), a small but compelling tempera in which the artist rejected his literalist style and returned to an architectural theme of broad, clear Cubist planes, thus recapturing the clarity and intensity of his 1917–23 work. Here, the building looms above us on a sharp bias from below, no doubt making it appear far larger than it actually was. This is a more dramatic work than anything he had attempted since his 1926 lithograph *Delmonico Building* (The Museum of Modern Art, New York). Sheeler here seems to have once more called on the cinematic framing of views that he had experimented with in his great film *Manhatta*, made with photographer Paul Strand in 1920. In addition, he may well have been inspired by working two years earlier with Edward Weston, who often used dramatic views in his photographs. Thus, Sheeler continued his dialogue between painting and photography but now in fresh ways.

Sheeler had never used much color, but in the forties, the new color film (and perhaps developments in contemporary painting) led him to introduce a wide range of strong and often bold hues into his work. The blue of the sky in *Powerhouse* is intense, worthy of Matisse, whose color masterpiece of 1911, *The Red Studio* (The Museum of Modern Art, New York), Sheeler and his friend Schamberg had long ago admired in the Armory Show. The painting also seems to be a continuation, a kind

of afterthought, of a series on power and energy Sheeler had done for *Fortune* magazine in 1939–40. However, that series was a clear celebration of technology, while this painting is more complex and subtle; the powerhouse could easily be taken for a farmhouse. By linking the two, Sheeler equated the old with the new—a symbol of modern technology, the powerhouse, replacing the old agrarian way of life, symbolized by the farmhouse. The contrast of industry and nature is pointedly made by the solitary tree, realistically depicted, which stands side by side with the pure volumes of the powerhouse building. These themes of old and new recurred throughout Sheeler's art, perhaps most famously in the 1931 *Classic Landscape* (Barney A. Ebsworth Collection, St. Louis) where the machine and the factory were depicted as leading America into a new golden age.

The title of his 1952 painting *Convergence* (pl. 58) is apt, for in it Sheeler continued joining old and new. Here, he took up another architectural theme, the skyscrapers of New York, a subject that he and Strand had brilliantly exploited in *Manhatta*, one of the most powerful documents of the modern city's impact on the arts ever made. As in *Powerhouse*, Sheeler created drama by viewing the buildings from the base up at a spectacular angle, but this time on a far vaster scale. He did this by superimposing negatives of two buildings, a new technique that would form the basis for many of his late works. Sheeler thus linked a new expertise to his past art, for the white structure on the diagonal is the Park Row Building that had appeared in *Manhatta*, although Sheeler used a 1950 photograph for the painting. Similarly, the second view, at right, is a reversed image of Rockefeller Center. Although this shows a newer part of the city, including the International and the RCA buildings, captured in a recent photograph, the view still recalls the angles used in his 1926 lithograph *Delmonico Building*.

Sheeler translated the transparency of the photographic negatives into weightless and dematerialized planes, a novel and effective adaptation of older photographic means to painterly ends. The images create a sensation of ethereal, disembodied space, a pristine world far removed from the gritty here and now of New York. It calls to mind one of Walt Whitman's lines from *Leaves of Grass* used by Sheeler to set the mood in *Manhatta*: "City of the World (for all races are here), City of tall façades of marble and iron, Proud and passionate city." Just as certainly, the painting captures the sense of the city newly transformed in the 1950s into massive canyons of sleek International Style towers. So, too, the reflective planes are like sheets of glass, recalling Sheeler's long-standing admiration of Marcel Duchamp's *The Large Glass* (1915–23, Philadelphia Museum of Art, Louise and Walter Arensberg Collection).

Ralston Crawford (1906–1978), although a generation younger than Sheeler, also began as a Precisionist. Indeed, his images of ships and barns are among the most famous Precisionist paintings of the 1930s, and it is for these that he is best known. However, the destruction of World War II forced him to expand his view of the world beyond the serene and untrammeled world of the Precisionists. By 1944, he had pushed his art to a late Synthetic Cubism, the better to accentuate the emotional impact he associated with his subjects, while holding firm to the clarity of structure and bold, strong color that he derived from his study of Cézanne and Matisse. For Crawford, art might be based on selection, distortion, and abstraction, but it always had a starting point in observable reality as in *Fishing Boats #3* (fig. 37). He often used photographs to start a painting, though never as literally as Sheeler; more often they served as an aid to memory. Using abstraction to reveal the essential planar form of his painting's subject was important only insofar as it could convey Crawford's memories and highly charged feelings. Through its sure line, shape, and color, his painting *On the Sundeck* (1948, pl. 59) embodies a lifelong love of the sea and deep-seated memories

Figure 37
RALSTON CRAWFORD
Fishing Boats #3, 1955
Oil on canvas
18 x 15 in.

that date back to his childhood when he sailed with his father, a ship's captain, on the Great Lakes. What appears at first to be reductive and distilled is, in fact, full of life itself.

In their mutual love for the tempo of modern life, Crawford and Davis, his close friend and colleague, had much in common. Stuart Davis (1892–1964), the greatest American artist to mature in the years between the two wars, was the foremost spokesman for the cause of modern art at a time when it was under constant attack by artists of the American Scene, Regionalist, and Social Realist movements. More than any other artist, through his art as well as his writings, Davis single-handedly made the strongest case for a sustained presence of an advanced, forward-looking art in the 1920s and 1930s. By 1922, he had forged a unique and personal variant of Cubism, and by 1927–28, his great Egg Beater series had ushered in a new era of rigorous abstraction that continued unabated in this country until the death of Mondrian in 1944 in New York. Davis would influence American art for six decades, from his early Ashcan School pictures to the final color abstractions he made just prior to his death in 1964.

After World War II, Davis's work, like Sheeler's, underwent a dramatic resurgence. Long plagued by alcoholism, Davis had produced little in the forties, and by 1948, he was hospitalized in critical condition. In 1949, however, his condition had dramatically improved, and Davis took off in a new stylistic direction, developing an idiosyncratic Cubism marked by larger, broader, and more clarified forms. These late works were suffused with an intensified color prompted by a reengagement with Matisse, an artist long central to Davis's art. Although Cubism had seemed to many increasingly confining, Davis and others, among them David Smith and Niles Spencer (1893–1952) in *In Fairmont, West Virginia* (fig. 38), extended its rich tradition and took it to a glorious conclusion in a chapter still largely undocumented in American art history.

Memo No. 2 of 1956 (pl. 60), like much of Davis's late work, appears abstract or even nonobjective, but, in fact, as Davis insisted, his art always had a source in observed reality. *Memo No. 2* is an abstract version of an early Davis painting (Collection of John F. Lott, Lubbock, Texas), a 1922 landscape of the harbor and surrounding hills at Gloucester, Massachusetts, where Davis spent his summers. Knowing that Davis had painted this calm scene repeatedly since 1915 gives an unexpected dimension to this high-pitched painting that speaks loudly of the dynamics of jazz and the modern city, which Davis loved so much. For all his hipster posturing, Davis had an aesthetic approach rooted in New England frugality. If an idea for a painting was good thirty years ago, it was certainly good today—all it needed was to be updated to reflect current stylistic concerns.

The precedent for *Memo No. 2* was *Memo* (1956, The National Museum of American Art), also an abstracted view of Gloucester harbor. However, the configuration of *Memo No. 2* had been worked out in the 1954 painting *Colonial Cubism* (Walker Art Center, Minneapolis), a larger and more brilliantly colored painting using red, white, and blue, thus slyly referring to the supposed provincialism of Davis and American art. All three paintings are part of a series that Davis had begun in 1932. This reworking of a single theme over many years was all part of what Davis termed "The Amazing Continuity"[5] of American art. *Memo No. 2* and *Colonial Cubism* had seemed out of step with the concurrent painterly art of Abstract Expressionism. However, by 1957, one year after Pollock's death, artists had begun to reassess Abstract Expressionism, which was seeming overworked and excessive in its rhetoric and surface activity. As has happened repeatedly throughout the history of art, after a period of painterly excess, artists began to look for alternatives, for an art of greater clarity

Figure 38
NILES SPENCER
In Fairmont, West Virginia, 1951
Oil on canvas
23½ x 14⅝ in.

and directness. To the younger generation of artists emerging in the late fifties and early sixties—Donald Judd, Frank Stella, and Kenneth Noland among them—Davis offered new and fresh possibilities. His reputation—as well as the standing of geometric art—was thus resurrected. Sadly, Davis did not live long enough to see the full fruits of his final fame. In his laudatory review of Davis's 1962 exhibition, Judd declared, "There should be applause." So there should, for the broad form and intense color of Davis's late work were both a source and a contribution to the new color-field painting and geometric art of the 1960s.

Although the artists active between the two world wars are primarily remembered as pioneers of American Modernism, these artists remained influential throughout their lives and careers. The work of Davis, Bolotowsky, and others greatly affected not only their contemporaries but later generations of artists. In their achievements as colorists, abstractionists, and teachers, early Modernists paved the way for each successive movement in American art, repeatedly proving the continuity and possibilities of Modernism.

NOTES

1. John Graham, *System and Dialectics of Art* (1937, reprint, Baltimore: Johns Hopkins University Press, 1971).

2. Gerald Murphy, quoted in Calvin Tomkins, *Living Well Is the Best Revenge* (New York: Viking Press, 1971), 25.

3. Guillaume Apollinaire, *Sic* (Paris), 8–10 (Aug.–Oct., 1916), n.p.

4. David Smith, "Notes on My Work," *Arts* 34 (Feb. 1960), 44.

5. Stuart Davis, letter to Alfred H. Barr Jr., November 3, 1952, in *Stuart Davis*, Diane Kelder, ed. (New York, Washington, DC, London: Praeger, 1971), 100.

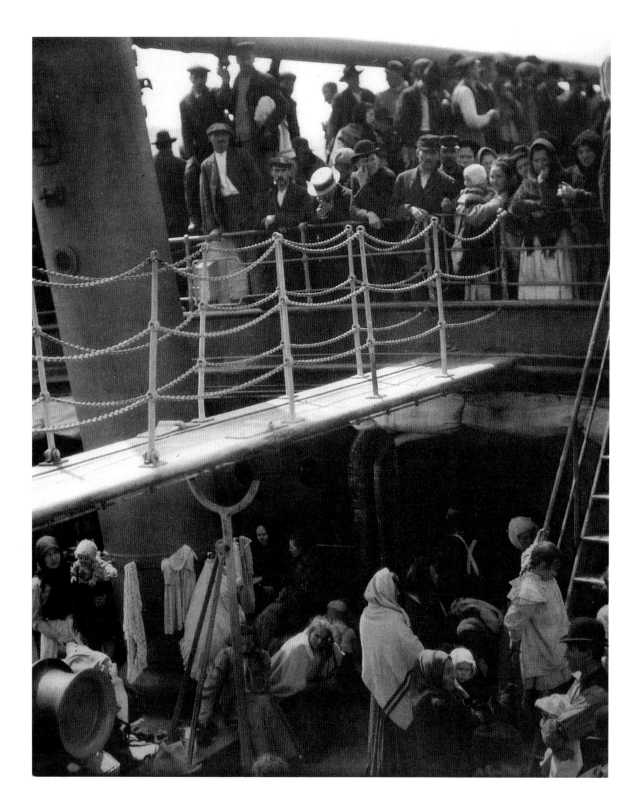

21. ALFRED STIEGLITZ
The Steerage, 1907
Photogravure on Chinese tissue
12¼ x 10 in. (image)

22. MAX WEBER
New York, 1912
Oil on canvas
21¼ x 25¼ in.

23. MARSDEN HARTLEY
Calla Lilies, c. 1920
Pastel on paper
24 3/4 x 17 in.

24. ANDREW DASBURG
Finney Farm, Croton-on-Hudson, c. 1917
Oil on canvas
30⅛ x 24½ in.

25. CHARLES DEMUTH
Tuberoses, 1922
Watercolor and pencil on paper
13 x 10½ in.

26. JOHN MARIN
Off Deer Isle, Maine, 1928
Watercolor on paper
16¼ x 21¾ in.

27. GERALD MURPHY
Bibliothèque, 1927
Oil on canvas
72 1/2 x 52 5/8 in.

28. MORTON LIVINGSTON SCHAMBERG
Untitled, 1916
Oil on fiberboard
15¾ x 12 in.

29. GEORGE AULT
Provincetown: Boats & Houses, 1922
Oil on board
20 x 16 in.

30. JAN MATULKA
New York Elevated, c. 1924–26
Gouache on paper
19¼ x 14¾ in. (image)

31. ALFRED HENRY MAURER
Cubist Still Life with Two Pears, c. 1928–30
Oil on gesso panel mounted on canvas
18 3/8 x 22 1/8 in.

32. Oscar Bluemner
Approaching Black, 1932
Tempera and varnish on panel
22 x 30 in.

33. GEORGIA O'KEEFFE
Black Maple Trunk–Yellow Leaves, 1928
Oil on canvas
40 x 30 in.

34. GEORGIA ENGELHARD
New York Skyscrapers, c. 1928–29
Oil and canvas laid down on board
28⅝ x 22½ in.

35. JOHN D. GRAHAM
Still Life, c. 1928
Oil on canvas
21 x 29 ⅛ in.

36. MARSDEN HARTLEY
Rain Coming – Sea Window – Cape Ann,
c. 1933–36
Oil on board
24 x 18 in.

37. Burgoyne Diller
Miró Abstract, 1930
Mixed media on canvas
32⅛ x 20⅛ in.

38. DAVID SMITH
Untitled [Virgin Island Series], 1933
Oil on canvas
26¼ x 36¼ in.

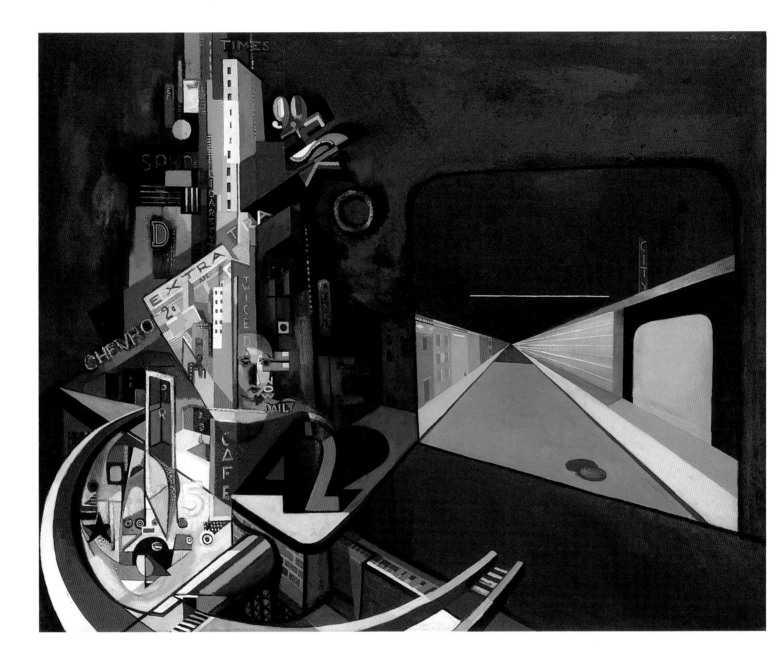

39. Theodore J. Roszak
42nd Street, 1936
Oil on canvas
47 x 59¼ in.

40. BERENICE ABBOTT
Skyscraper, 1935
Contact print
9 1/2 x 7 1/2 in. (image)

41. JOHN STORRS
Genesis, 1932
Oil on board
31 x 25 1/8 in.

42. EMIL BISTTRAM
Two Cells at Play, c. 1942
Oil on canvas
36 x 27 in.

43. ARTHUR B. CARLES
Untitled, c. 1935
Oil on canvas
18 5/8 x 28 1/4 in. (image)

44. Suzy Frelinghuysen
Untitled, 1945
Collage and oil on board
20³/₈ x 13¹/₈ in.

45. HELEN TORR
Composition, 1935
Oil on canvas
22¼ x 25½ in.

46. GEORGE L.K. MORRIS
Urban Concretion, 1939
Oil on canvas
25 x 30⅛ in.

47. ARTHUR G. DOVE
Reflections, 1935
Oil on canvas
15 x 21 in.

48. Arthur G. Dove
White Channel, 1942
Oil on canvas
21 x 15 in.

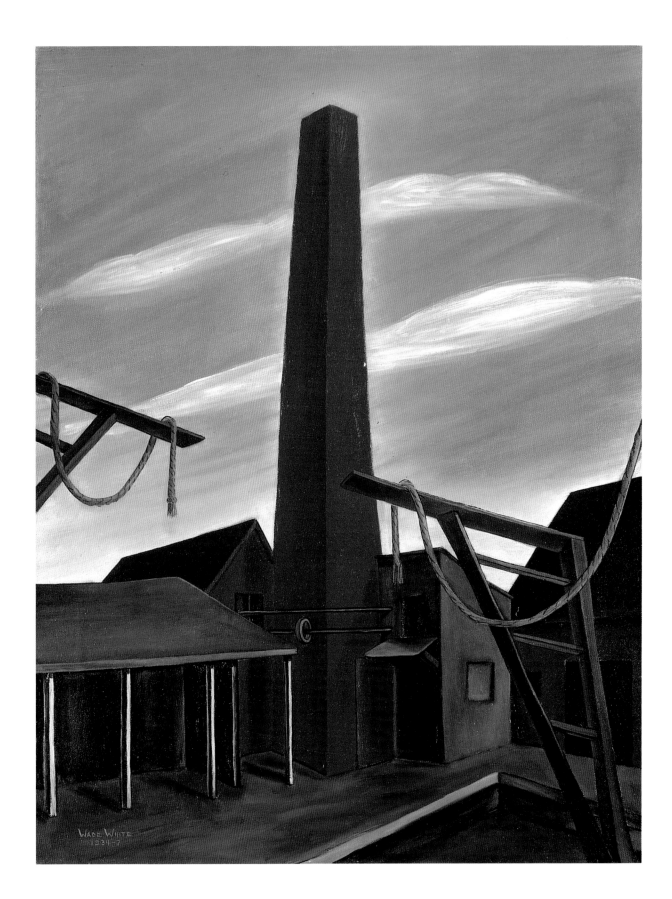

49. WADE WHITE
Captain Drum's Chimney, 1934–37
Oil on canvas
26 x 20 in.

50. ALICE TRUMBULL MASON
Untitled, 1938
Oil on canvas
32 x 48¼ in.

51. CHARLES SHAW
Abstract Shapes, 1935
Oil on canvas
39½ x 32 in.

52. PAUL KELPE
Weightless Balance II, 1937
Oil on canvas
33 1/8 x 23 in.

53. ILYA BOLOTOWSKY
Untitled, 1941
Oil on canvas
13¾ x 20¾ in.

54. AD REINHARDT
Untitled, 1940
Oil on canvas
16 x 20 in.

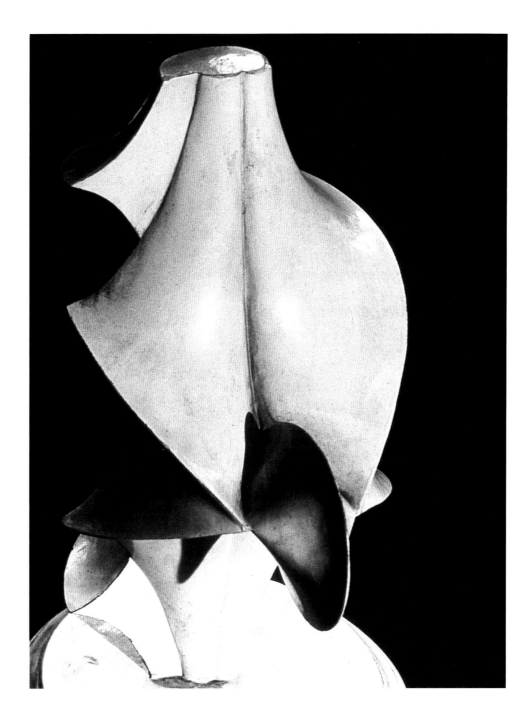

55. MAN RAY
Mathematical Object, 1936
Gelatin silver print
12½ x 9 in.

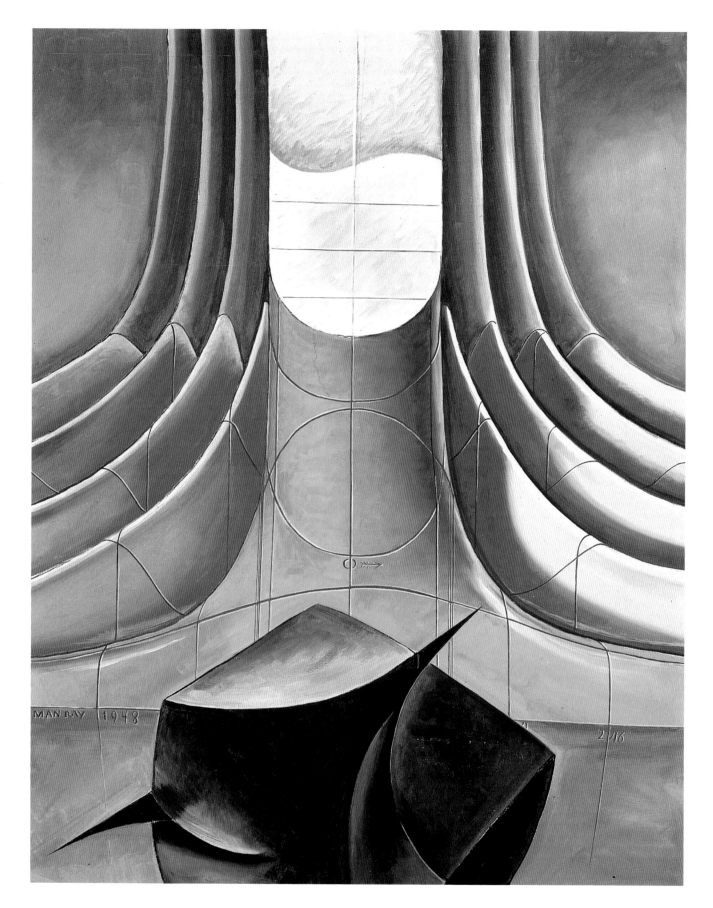

56. MAN RAY
Macbeth (Shakespearian Equations series), 1948
Oil on canvas
30 x 24 in.

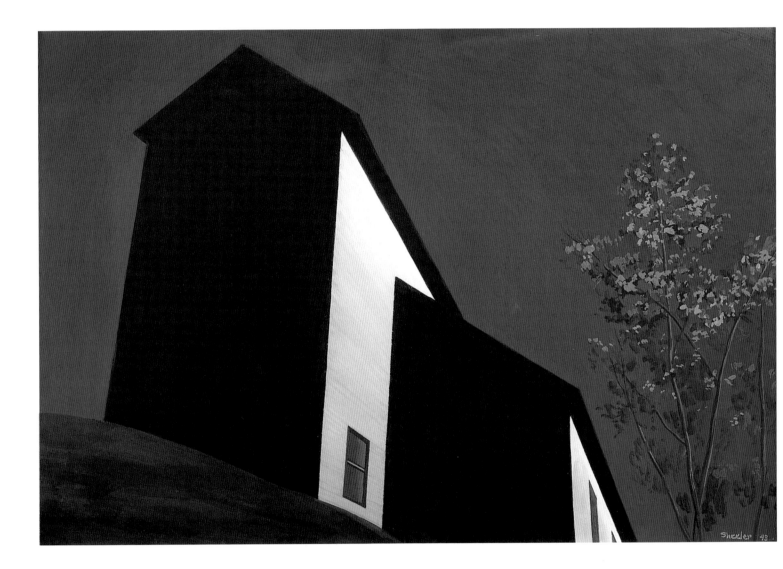

57. CHARLES SHEELER
Powerhouse with Trees, 1943
Gouache on paper
14⅝ x 21¾ in. (image)

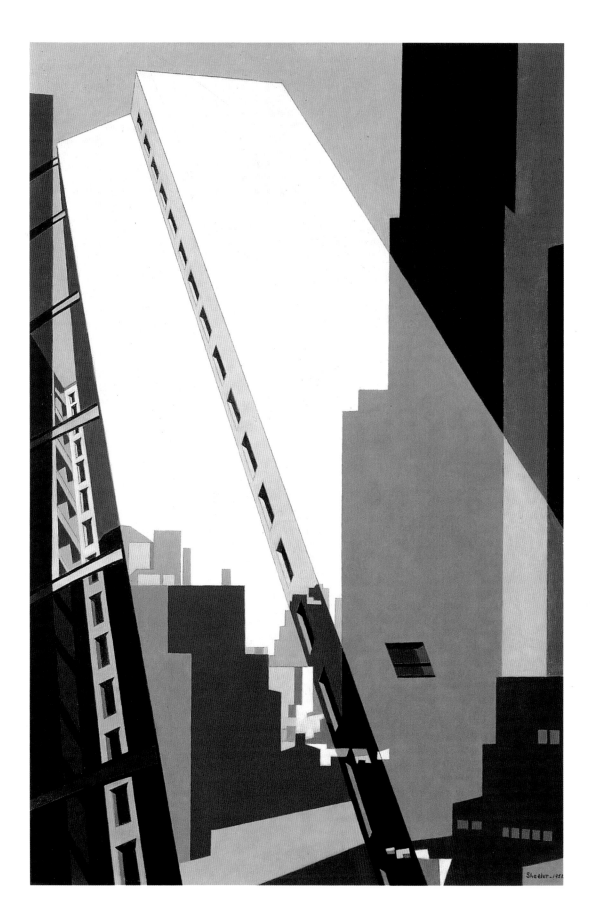

58. CHARLES SHEELER
Convergence, 1952
Oil on canvas
24⅛ x 16⅛ in.

59. RALSTON CRAWFORD
On the Sundeck, 1948
Oil on canvas
30⅛ x 45 in.

60. STUART DAVIS
Memo No. 2, 1956
Oil on canvas
24 x 32 in.

"And I was impressed, aside from everything else, and as never before, by how upsetting and estranging originality in art could be; how the greater its challenge to taste, the more stubbornly and angrily taste would resist it."

—*Clement Greenberg*

Mid-Century Innovation

The Adventures of
the New York School

Dore Ashton

The surging impulse to improvisation that swept through the studios of one painter after another during World War II had been germinating throughout the troubled prewar period. These artists, born within the first two decades of the twentieth century, came to maturity during years when the worldwide Great Depression and great political instability were bringing about radical changes. In New York, where many painters commenced their artistic lives, emergency measures taken by the government to support the unemployed included projects in the arts. For the first time in the United States, society provided artists with sustenance *because* they were artists, thereby acknowledging their importance to American cultural identity. The camaraderie that developed among painters thrust together by circumstance had a great impact on their creative lives. For the first time, artists had a recognizable community—an urban situation in which ideas and inspirations could be exchanged. Painters who considered themselves "progressive"—that is, committed to the great vanguard modern tradition wrought by Pablo Picasso, Henri Matisse, Joan Miró, and others in Paris—came together under conditions that favored the formation of the New York School, a counterpart to the hitherto unique School of Paris.

Many of these painters had been well aware of artistic developments in Europe during the late 1930s—above all, the ideas espoused by the Surrealists. The imperatives of Surrealism were grounded in respect for the early studies in modern psychology, particularly the work of Sigmund Freud and Carl Jung. The basic tool implicit in these studies—the plumbing of the unconscious for unexpected and authentic imagery— was utilized by artists and writers alike as they developed their individual methods of free association. In addition, the imaginations of many painters had been primed by an extraordinary series of exhibitions presented in New York by the new Museum of Modern Art, founded in 1929. Through these exhibitions, director Alfred H. Barr Jr. had systematically explored the complete history of modern art, with all its "isms," in the decade before World War II. Many painters therefore embarked on their adventurous paths armed with a knowledge of widely diverse predecessors and a point of view that favored experimentation. They sparked one another's forays into an unprecedented artistic freedom that would soon be identified in critical responses as Abstract Expressionism: *abstract* because these painters were schooled in early modern painting, and *expressionist* because they declared their fervent belief in the individual gesture and in the freedom to use many means, including the human figure itself, when required.

There can be no all-encompassing definition of the New York School or Abstract

previous page:
CLYFFORD STILL
Untitled (detail), 1945 Plate 63

Expressionism because, like Surrealism, it presented a point of view on the nature of human existence, or a philosophy, rather than serving merely as a stylistic movement. Its basic assumptions, however, were accurately characterized by the painter and art historian William Seitz, who, in a draft for his subsequently published book, wrote that the Abstract Expressionists "value the organism over the static whole, becoming over being, expression over perfection, vitality over finish, fluctuation over repose, feeling over formulation, the unknown over the known, the veiled over the clear, the individual over society and the 'inner' over the outer."[1] Certain artists among those called Abstract Expressionists were also sometimes called "gestural" artists or, as the important critic Harold Rosenberg called them, "action painters." But Rosenberg did not mean that the tendency toward free brushwork and the emphasis on the artist's individual "mark" defined action painting. Rather, he was describing these painters' general conception of the painter's role as one whose actions (in the painter's case, the very act of painting) define his whole being. In short, a philosophy. Rosenberg's view is confirmed by many of the painters' statements. For instance, Arshile Gorky (1904–1948), one of the earliest artists to experiment with free association, wrote in a letter in 1939, "I communicate my innermost perceptions through art, my worldview."[2] And toward the end of his life, he wrote, "It is not new things that are important, but new ways of expressing universals in the tongue of modern times."[3]

Gorky epitomized Seitz's idea of Abstract Expressionism, particularly in his valuing of the organism over the "static" whole and of becoming over being. In his work of the early 1940s, Gorky again and again proposed forms that were in the process of metamorphosis. Untitled (1944, fig. 39; pl. 61), for example, epitomizes Gorky's fusion of suggestive forms that moved with great freedom through uncharted spaces. His forms seem to distill the characteristics of the biological universe, leading the poet and leader of Surrealist thinkers, André Breton, to describe Gorky's work as "biomorphic." The principle of growth, which implies constant movement, underlay Gorky's development of a style that fused his early studies of Paul Cézanne and Cubism with his interest in the ideas of the Surrealists.

Gorky's close friend Willem de Kooning (b. 1904), who, like Gorky, had schooled himself in early modern art, developed his painting philosophy with an emphasis on the painter's right to be inclusive rather than exclusive in his means and motifs. He made these beliefs explicit in a 1951 statement: "Some painters, including myself, do not care what chair they are sitting on. It does not even have to be a comfortable one. They are too nervous to find out where they ought to sit. They do not want to 'sit in style.' Rather, they have found that painting—any kind of painting, any style of painting, to be painting at all, in fact—is a way of living today, a style of living, so to speak."[4] De Kooning's openness to any inspiration that seized him led him to experiment with the broad brush and sweeping gestures with which he is so often associated, but beneath each apparently free movement on the canvas resided the high intelligence of a knowing painter. His frequent use of the emphatic line, which he shared with Gorky, and his subtle suggestions of complicated spaces reading back from the picture plane were consistent throughout his oeuvre until the late phase in which colored lines took on the burden of describing the sensations of movement and growth, as in *Untitled III* of 1983 (pl. 66). Throughout his career, de Kooning has worked with suggestive shapes that encompass his responses to landscape, the human body, light, the sea, and personal impulses.

One of the issues the New York School brought into focus was the importance of "subject" in painting. When Realism, with its recognizable depictions of an outer reality, was challenged by abstraction, the subject in a painting became less clear. It could

Figure 39
ARSHILE GORKY
Untitled (detail), 1944
Colored pencil and crayon on paper
19 x 24 in.

be something as indefinable as a feeling or simply the art itself. The New York School, however, rejected the latter strain in modern painting that regarded the painting as an autonomous object, self-sufficient and seemingly free of any relationship to a particular subject outside of itself. All of the so-called Abstract Expressionists agreed with Mark Rothko (1903–1970) and Adolph Gottlieb when they declared in 1943 that there could be no such thing as a good painting about nothing.[5] For Rothko at that time, the mysteries of ancient myths and of the evolution of organic forms provided him with a subject. Later, as revealed in his atmospheric abstractions with their floating colors, his subjects were more generalized. He felt that human responses to life such as feelings of melancholy or joy and sensations of lightness or darkness could be conveyed by abstract painterly means. Works like *Black over Deep Red* (1957, pl. 64) attempt to do just that, with an emphasis on what Seitz called the "veiled" over the clear.

Clyfford Still (1904–1980), who shared many attitudes with Rothko during the 1940s, also felt that the subject, or the sense of reality that moved the artist, could be transmitted through abstraction and painterly means. Still's passionate belief that, as he once said, "It's not just about painting"[6] led him to experiment with dense masses of paint, troweled onto the canvas in totally new configurations, as in his untitled 1945 work (pl. 63). Using the sudden apparitions of light that erupt through his heavily worked surfaces, Still felt he could communicate the essential drama of human existence. Art, for him, was "a matter of conscience."[7] Still believed that by questioning all traditions, both material and spiritual, and by remaining true to a personal vision, the artist was an individual above all else.

Certainly, of all the Abstract Expressionists, it was Jackson Pollock (1912–1956) who displayed the greatest faith in the reservoir of communicable feelings and images that presumably resides in each human psyche. Like several others, Pollock took a deep interest in the art of tribal peoples, among them Native Americans, with its basis in myth and its tendency toward symbolism. During the early 1940s, he had also been alerted to the Surrealists' use of what they called "automatism" to reach into the unconscious and to the concepts of Jung, who postulated a collective unconscious and found universal symbols in dreams. Pollock's experiments with the free flow of associations in the act of drawing, as in an untitled 1951 work (pl. 62), would inspire him eventually to paint in a state of high tension. He developed his paintings on the floor, allowing the painted surface expansive properties as he moved balletically, trickling paint from unconventional tools such as sticks. Pollock brought his entire body into the act of painting. It was Pollock more than any other artist in the group who most emphatically abandoned previous conventions in painting. His great skeins of paint, flowing freely over large surfaces, shocked his audience. But his fellow artists understood the radical principle at work when he said that he wanted to work on the floor to be "in the painting" and that his painting "has a life of its own."[8] Pollock's faith in the expressive character of the mark—these flowing lines of paint—and in its potential for somehow mirroring forth the whole individual, spiritual and physical, was what aligned him with his various colleagues in the New York School.

Sometimes the strong emphasis placed by certain Abstract Expressionists on the power of the linear flourish led commentators to talk about the "autographic" character of, or the "calligraphic" element in, their works. When Franz Kline (1910–1962) first showed his black-and-white paintings with their magnified, broad, sweeping lines, many saw in them the kind of expressive symbolism common in Asian calligraphy. However, Kline had evolved his works from his own reading of the modern tradition that frequently reversed positive and negative spaces (often reduced to black and white) or made their reading ambiguous. The impression of swiftness was particularly strong

Figure 40
SAM FRANCIS
Dark and Fast, 1982
Five-color lithograph on paper
38 x 30 in.

in Kline's work and suited the basic concerns of the late 1940s and 1950s for a dynamic vision of the nature of existence: everything in flux resisting all static or equilibrated composition of forms. For Kline, the air of improvisation was essential and was until the end of his life, as exemplified in his untitled oil sketch (c. 1958, pl. 65), rendered four years before his death.

Implicit in the stance of the New York School was its reinterpretation of space, addressing one of the painter's chief preoccupations: how to depict space and its all-encompassing character with means that are by definition two-dimensional. The seemingly unending spaces that Pollock created when he worked on the floor; the complex and "slipping" spaces de Kooning created by letting forms expand, overlap, and flow; and the throbbing spaces Rothko produced with his overlay of luminous color and blurred edges—all were experiments in recasting the notion of pictorial space. Sometimes commentators would refer to what they called "allover" space, particularly in reference to the works of Pollock, which to their eyes seemed to spin into infinity. Although Pollock tended to work with a linear arabesque that returned always to itself, as does the infinity sign, the sense of a pictorial vision that spreads far beyond the confines of the canvas stretcher was predominant in Abstract Expressionism. A tendency to work with large canvases and to dispense with conventional perspective and the usual figure-ground depiction of form gave the Abstract Expressionists a range and scale hitherto unknown in American painting.

The next generation was quick to assimilate the ideas proffered by its predecessors in the New York School. In California, Sam Francis (1923–1994) began his artistic life only after World War II. He developed his work in the early 1950s using very large canvas surfaces and a rhythmic allover patterning of biomorphic forms. As

Figure 41
MORRIS LOUIS
D-41, 1949
Pen and ink on paper
18½ x 23⅝ in.

he gradually freed himself from the teeming profusion of smaller elements in these works, Francis began to create gleaming white spaces within which he painted small-ish hints of form, often by means of a splash or spatter of primary color. Visible in his late lithographs of 1982–83 (fig. 40; pl. 68), Francis's concern with light—how to make it a resplendent and vital source of human delectation—has always been pre-eminent. Adopting the freedom of means characteristic of the Abstract Expressionists, Francis used spatters, lines, and thinly painted forms that reel through the vast empty spaces he opened often in the center of his canvas to convey a vision of an ideal universe where sensation is clearly defined.

In a different way, Morris Louis (1912–1962), working in Baltimore and later Washington, D.C., also released the great power of the white of the canvas to generate light. Although born into the generation of the Abstract Expressionists, he emerged as a significant painter only after the mid 1950s, when he began to work with greatly thinned paints that he applied on the floor and often allowed to run freely on his can-vas. Like Francis, Louis often opened a splendid white void central to his vision of ethereal space, marked off by thin veils of shimmering color. *D-41* (fig. 41), an ink drawing from 1949, predates Louis's true Abstract Expressionist technique of color-field painting. However, the biomorphic forms relate to Pollock's early work and demonstrate the Surrealist foundation of Abstract Expressionism.

The lyrical potential in the attitudes of certain Abstract Expressionists, particu-larly Gorky, was developed with a passion by Joan Mitchell (1926–1992). The daughter of a poet, Mitchell thought of poetry with all its emotional allusions as the art form most like her own. For her, the "subject" was most often landscape, which she trans-formed by means of loosely construed brush strokes into abstractions no more specific than those of Gorky or de Kooning. As she said, "I paint from remembered landscapes that I carry with me—and remembered feelings of them, which of course become transformed."[9] Mitchell, who more or less inherited Gorky's elegantly curving lines, de Kooning's accented painterly brushwork, and Pollock's arabesques, was able to turn the freedom inherent in their point of view into a highly personal

idiom. In works like *La Grande Vallee XIX Yves* (1984, pl. 69), she does, as she said, express and transform remembered feelings.

When the adventures in the New York School are considered in the light of art history, it becomes evident that their driving desire was to somehow capture in real, palpable, imaginative terms the abstract notion of freedom. This required the rejection of Social Realism, prevalent in the 1930s and 1940s, that was linked to political movements otherwise capturing their sympathy. During the 1930s, when there were breadlines in Manhattan's bohemia, most of the painters were attracted to radical political visions, including those of socialism. Many belonged to the collective organizations of the time like the Artists' Union. Yet, they were wary of the political demand that they become Social Realists. As artists, their allegiance was to the early modern tradition with its international vision and emphasis on universal aesthetic values. The temptation to adopt an ideology—either political or aesthetic—that demanded adherence to specific rules and ideals was strong during the formative years of the artists of the New York School, but as many commentators have agreed, these artists were instinctively resistant.

When World War II darkened their horizons, they felt that the strongest gesture they could make would be one that emphasized the dignity of the individual, showing how the human imagination could move freely beyond all ideological strictures. To achieve this end, many artists turned to abstraction, or the shaping of matter (paint) by a gesture that was emphatically individual. American life was changing rapidly and immutably; Abstract Expressionism, and the movements that followed, provided a means of expression for the increasing host of attitudes and emotions never before explored in American art.

NOTES

1. Seitz, *Abstract Expressionist Painting* (unpublished manuscript).

2. Arshile Gorky, quoted in Ashton, *Twentieth-Century Artists*, 208.

3. Ibid, 209.

4. Ashton, op. cit., 199.

5. Rothko and Gottlieb, letter to the *New York Times*, reprinted in Chipp, *Theories of Modern Art*, 545.

6. Ashton, op. cit., 34.

7. Ibid.

8. Pollock, "My Painting," in *Possibilities I*, New York, Winter 1947–48, 79.

9. Baur, *Nature in Abstraction*, 75.

No Mere Formality

Peter Plagens

> *Adolph Gottlieb and Mark Rothko:*
> *"There is no such thing as a good painting about nothing."*
>
> *Ad Reinhardt:*
> *"There is no such thing as a good painting about something."*
>
> —Ad Reinhardt, 1991[1]

Abstraction—beginning with the paintings by the Russian Wassily Kandinsky in about 1911—represented an extreme break with the main tradition of Western easel painting, which had always measured itself against the pinnacle of realism achieved in the Italian Renaissance.[2] The question becomes: Why did abstraction occur?

Some argue that abstraction in art was simply an aspect of turn-of-the-century progress parallel to the industrial progress (electrification, mass production, etc.) and social change (democracy, universal suffrage, the beginnings of the welfare state) taking place in the West. This theory partakes of Marxism's sense of historical inevitability—history being the "science" of discovering the laws behind the foregone conclusion that someday we will *all* farm in the morning, hunt in the afternoon, and paint abstract pictures at night.

Then, in retrospective opposition, there is the Freudian answer. As expressed by the critic Donald Kuspit, the onset of the industrial age created an emotional dilemma for artists, who believed romantically in the timelessness of art. Faced with the seemingly insurmountable task of reconciling the timelessness of art with the rapid change generated by modern life, they made of art an even more mystical, irrational (or surrational) entity than it had been before. Art became abstract and enigmatic because this mystification restored its power and eased the artists' insecurity. But this was, according to Kuspit, only a stopgap measure: "The abstract artists, behind their barricade of nonobjectivity, remained stuck in wishful thinking, while the forces of modernity swept around them to ever more realistic thinking."[3]

Whatever its genesis, abstraction is still too often seen as the product of no particular talent or labor, as falsely separating art from real-life experience, and (despite the "no talent") as inherently elitist. If abstraction is conceded anything, it is that it exposed the bare bones of art so that we could better analyze the structure of figurative art: in other words, abstraction gave us the idea of design. As a distinct mode of aesthetic expression, however, abstraction resists easy definition. Since abstraction inherently refuses the test of how well the artist replicates the outside world's physical appearance, and since most proclaimed "laws" governing abstraction sound either ridiculously elastic or intolerably pretentious, how—people ask—is abstract art to be judged? The only tool readily available is that ice on the already slippery slope of relativity: taste.

Abstract Expressionism (the now-consensus term coined by *The New Yorker* magazine art critic Robert M. Coates in 1946)[4] was the first major painting style to originate in America. Its pioneers, according to the critic Clement Greenberg (who preferred the deadpan term "American-type painting"),[5] were six or seven artists—including Jackson Pollock, Mark Rothko, and Clyfford Still—who had shows at Peggy Guggenheim's Art of This Century Gallery in New York between 1943 and 1946. Their work challenged both the precisely delineated illusion of shallow depth that had prevailed in most Modernist painting since the Cubists and the canon of harmonizing the various elements in an abstract painting's composition. In short, these artists were seeking the same moment of revelation that had enabled Kandinsky to achieve the first of his "pure form" paintings three decades earlier. Kandinsky described his rather serendipitous encounter with abstraction as follows:

> I was returning, immersed in thought, from my sketching, when on opening the studio door, I was suddenly confronted by a picture of indescribable and incandescent loveliness. Bewildered, I stopped, staring at it. The painting lacked all subject, depicted no identifiable object and was entirely composed of bright color-patches. Finally, I approached closer and only then saw it for what it really was—my own painting, standing on its side on the easel.... One thing became clear to me: that objectiveness, the depiction of objects, needed no place in my paintings, and was indeed harmful to them.[6]

Much of the Abstract Expressionists' impetus to seek a new relationship with art came from the thickening existentialism in the intellectual climate of World War II and the years immediately following the war. In the wake of the European slaughter and the advent of the atomic bomb, any kind of underlying stability to the world seemed a dubious assumption, and to a growing number of artists, the best response seemed to be the healthy absurdity of the creative act.[7] The critic Harold Rosenberg went so far as to say that, at least for the branch of Abstract Expressionism that he called "action painting," "the canvas began to appear . . . as an arena in which to act—rather than a space in which to reproduce, redesign, analyze or 'express' an object, actual or imagined."[8] In other words, any sort of preliminary cartoon for a painting or even a cool, craftsmanlike execution of the painting itself was held to be inimical to real creativity in painting. In fact, anything that might distance the action painters from their works—training, forethought, conscious knowledge of art history, reverence for the main tradition of Realism in Western painting—was distrusted. The finished painting—a kind of fossil or footprint of *real* creativity—was (allegedly) a secondary concern. Although paint might build up on an action painting's surface, it did so without the artist's conscious concern for the viewer's being able to see how deftly and artfully the paint was applied. In this regard, action paintings were simply extensions of Modernism's original critique of Romanticism, particularly that movement's attempt to make the medium of paint decidedly secondary to the artist's feelings about the subject.

When I went to art school as an undergraduate in the late 1950s and early 1960s, a tremendous animosity prevailed among the faculty and graduate students between proponents of abstraction and champions of figuration. As a fine arts major, my first serious paintings were still figurative because they still derived from class assignments using the still life and the model. But they were getting more and more fragmented because I was looking at art magazine reproductions of Larry Rivers. And they became messily painterly because

I was looking at paintings by Richard Diebenkorn (1922–1993). Yet, of all the Modernist painters I encountered, Diebenkorn seemed to question painting itself the least. He never picked his own work apart to get it in line with any *au courant* aesthetic theory. Instead, he always proceeded like an earnest student: the charcoal skeleton came first, then the washes, then the feathery, viscous paint, and last, a few highlights. The impression carried away from each Diebenkorn work, including the color woodblock *Blue with Red* (fig. 42), is of the artist as a paragon of taste. Every ingredient in Diebenkorn's paintings was added to promote balance and grace. He is the most traditional abstract painter ever.

Nevertheless, Diebenkorn joined the other abstract painters now characterized in my mind as inherently profound and heroically noncommercial. Concurrently, I came to the conclusion that figurative painters were—although often impressively facile—nothing but superficial illustrators, yoking their talents to a sentimental attachment to their subjects. "I serve only one master: the looks of my abstract painting," I used to argue. "You figurative artists futilely try to serve two: the looks of your painting and fidelity to your subjects. Since you can't ever figure out which is more important, your paintings are doomed to equivocation and failure."

However, at about the same time that I was buying big into the aesthetic and ethical (if not moral) superiority of Abstract Expressionism, cracks in the Abstract Expressionist façade appeared, big enough to be noticed by practically everybody. The style (both its action painting and more placid wings) had become academic. Abstract Expressionism's riffs were well known, catalogued, and copied. Instead of looking as if they had arisen directly out of true feeling and creative risk, many second-generation Abstract Expressionist paintings looked like graphic design writ drippy and large. And what Greenberg had called "homeless representation"[9] (conglomerates of brush strokes that looked as if they wanted to represent something, but something blown up, fragmented, or repeated enough to remain conveniently unclear) had worked its way back to the foreground of American abstract painting. Abstract Expressionism's vaunted risk-taking was harder and harder to detect on the canvas.

It also became clear that Rosenberg had rather overrated the effects of Abstract Expressionism's change in emphasis from the finished painting to the working process that produced it. "The new painting," he said, "has broken down every distinction between art and life."[10] But if that had indeed been the case, we would have never seen Allan Kaprow's 1958 Happenings, Claes Oldenburg's 1961 "The Store" exhibition, Chris Burden's 1971 performance in which he had himself plugged in the upper arm with a .22-calibre long, or the inclusion in the 1993 Whitney Biennial exhibition of the videotape of the beating of Rodney King. What Rosenberg did not see was that right there in the midst of his beloved action painting was an undetonated land mine in the tradition of Dada artist Marcel Duchamp. Action painting was also a way of subverting painting as one painted. Destruction was the core of the act itself.

The abstract painter Ad Reinhardt (pl. 54; see page 73) accordingly attacked Abstract Expressionism from within. He ridiculed its mystical pretentiousness and called for a "pure painting" with absolutely "no ideas, no relations, no attributes, no qualities."[11] He said that fifty years of abstraction (from Kandinsky's "Compositions" to his own "black" paintings) had brought about the right conditions for art for art's sake in the extreme. Abstract painting, he said, shouldn't seek any references to anything outside art itself. According to the interior logic of Reinhardt's work, one painting is neither better nor worse than another but instead exists as an indistinguishable part of the artist's oeuvre as a whole. As the critic John Coplans put it, "Reinhardt's work … proved that once the hierarchical links are solved and ironed out it becomes

Figure 42
RICHARD DIEBENKORN
Blue with Red, 1987
Color woodblock on paper
37¼ x 25¼ in.
© 1996 Crown Point Press

Figure 43
HELEN FRANKENTHALER
Tahiti, 1989
Mixografia print on paper
31¾ x 53¼ in.

increasingly difficult to achieve contrast, that is, to give each painting a positive iden-
tity without reasserting rank or becoming overbearingly redundant."[12] Separate paint-
ings thus lost their individual character. In American abstract painting in the 1960s,
where yesterday's risk had become today's craft, "heroic" art looked well on its way to
becoming tomorrow's varnished history.

Was there a way out for abstract painting in America? Was there a way
for it to recover its original meaning and intensity? Greenberg had
opined that paintings derive essentially from previous paintings and
not from surrounding social conditions. Furthermore, Greenberg pro-
claimed, each art medium produces its best art when it pays almost exclusive atten-
tion to what it alone does best.[13] What painting does best is color and flatness.[14]

In 1952, Helen Frankenthaler (b. 1928), a young abstract artist fresh out of
Bennington College and under the sway of Greenberg, painted *Mountains and Sea*
(National Gallery of Art) and, by doing so, broke through the cul-de-sac that Pollock
had constituted for most painters trying to emulate him. In this and subsequent works,
she transformed Pollock's wiry skeins of enamel into pools of translucent oil and meta-
morphosed his quickly running rivulets (more a form of drawing than painting) into
her own wide, meandering, chromatic rivers and lakes (fig. 43). By 1973, in *Moveable
Blue* (pl. 67), Frankenthaler had distilled these flows of paint even further, into crisp,
chromatic incidents on a brightly colored, unified background. What Frankenthaler
started—and what other artists like Morris Louis, Kenneth Noland (both Washington,
D.C., painters), and Jules Olitski continued—came to be called color-field painting.

Color-field painting attended indeed to color and flatness. Because colors were
not only applied to the canvas thinly but often stained right into the fabric, they hit
flatness right on the head. Furthermore, since color-field paintings were composed of
stains on often ungessoed canvas (light beige instead of white), the result was middle-
valued, intensely colored paintings with no startling contrasts of dark and light. Color-
field painting seemed at the time not only to do what painting did best but also to
define the parameters of abstract painting for the foreseeable future. The only thing
more nitty-gritty would have been to staple a piece of precolored fabric to a stretcher
frame and *call* it a painting. But such an *a priori* reduction would link it to a Duchampian
gesture (a slightly altered Readymade), obviating its serious consideration as a painting.[15]

For a while in the 1960s, color-field painting—especially as austerely practiced by artists like Robert Mangold (pl. 101), Brice Marden, and perhaps Agnes Martin—and the sculptural style known as Minimalism had something in common. In both styles, establishing an instant "presence" for the work took precedence over interior aesthetic balances, and the finished product took precedence over whatever *Sturm und Drang* went into its making. Drawing or layout resumed primacy over the painterliness of irregular brushwork; regularity in general triumphed over randomness and improvisation, as in *Blue with Black I* (fig. 44) by Ellsworth Kelly (b. 1923); and the flat application of industrial paint like enamels took precedence over the artsy use of oils. In Kelly's work, the flat application of paint achieved a greater purity than in the work of Frank Stella or even Reinhardt; Kelly's *Violet Panel* (1980, pl. 71) is an elegant case in point.

Al Held (b. 1928), another artist whose career had its genesis in the postwar era, is often associated with color-field painting. His style, however, transcends the limits of color-field painting, as it combines the flowing forms of Jackson Pollock (one of his greatest influences) with the classical lines of Piet Mondrian. Held incorporates abstract, geometric, and symmetrical shapes into his compositions, thus creating the appearance of depth. This style came to be known as "hard-edge" painting, and Held's 1984 work *Vorcex III* (pl. 70) is dominated by such abstract forms in bright hues.

Another major transformation thus had happened to the modern canvas. Where it earlier had gone from being the Fauve painter Maurice Denis's "flat surface covered with colors assembled in a certain order"[16] to Rosenberg's arena in which to act, it was now a kind of map on which artists (and their critic-champions) could stake out either theoretical territory or laboratories for experiments in pure taste.

In the 1960s and '70s, the art community began to get involved in a battle over "issues" in contemporary art. Early on, in the mid 1960s, those issues sprang from Formalist concerns: How complicated could a Minimalist sculpture get before it wandered away from an "unbreakable" *gestalt* and, aesthetically speaking, fell apart? Was the naked idea for a work of art (expressed in a diagram or written statement) more primary than the material processes required to bring it into being (as expressed in the display of stuff in a gallery)? And, finally, did the "space" depicted on the surface of an abstract painting (the merest feeling of over-and-under conveyed through paint) prevent a painting from ever being entirely abstract?

In terms of the cultural cachet of abstract painting, the last twenty years seem to have answered the last question in the affirmative. Except for a few small circles of abstract painters who seem to proceed more out of nostalgia and a siege mentality than genuine enthusiasm, the art world has replaced Formalist concerns with an often critical attention to the impact of mass culture on art, a Postmodern tendency rooted in the explosive Pop Art movement of the early sixties. This Pop aesthetic, more than any other, would push abstraction from the center stage position it once held in contemporary art.

Figure 44
Ellsworth Kelly
Blue with Black I, 1974
Two-color lithograph on paper
42½ x 37¼ in.

NOTES

1. Ad Reinhardt, quoted in Rose, *Art as Art*, 186.

2. It might be argued that the Renaissance's realism carried the seeds of its own destruction. After all, its main tenent of spatial depiction—linear perspective—was based upon a single pinpoint viewpoint, which is not how human beings, with two eyes spaced inches apart horizontally on their heads, actually see things. But that's another story.

3. Donald Kuspit, "Art's Anxious Response to the Modern World," *The Journal of Aesthetics and Art Criticism* (Spring 1989), 47.

4. Robert M. Coates, *The New Yorker*, March 30, 1946.

5. Clement Greenberg, "American-Type Painting," 1955, reprinted in *Clement Greenberg: The Collected Essays and Criticism, Vol. 3: Affirmations and Refusals, 1950–56*, John O'Brien, ed. (Chicago: University of Chicago Press, 1993), 217.

6. Wassily Kandinsky, quoted in Hunter and Jacobus, *Modern Art*, 119.

7. The notion of an "absurd universe" is usually considered to be dark and depressing, as in the belief of such 1950s "Theatre of the Absurd" dramatists such as Samuel Beckett, Eugene Ionesco, and Jean Genet that "in a godless universe human existence has no meaning and therefore all communication breaks down." (*Dictionary of the Arts*, New York: Facts on File, 1994, 3.) The partially compensatory upside for the artist, however, is that this state of affairs also means that he or she can do or use anything in a work of art without fear of violating any universal rules of art.

8. Harold Rosenberg, "The American Action Painters," 1952, reprinted in Gelzhalder, 342.

9. Clement Greenberg, "After Abstract Expressionism," 1962, reprinted in O'Brien, op. cit., *Vol. 4*, 125.

10. Rosenberg, op.cit., 343.

11. Reinhardt, op.cit., 56.

12. John Coplans, *Serial Imagery*, 13.

13. Clement Greenberg, "After Abstract Expressionism," 1962, reprinted in O'Brien, op.cit., *Vol. 4*, 125–133.

14. Greenberg was not the first to proffer this thesis of a medium's inherent nature. Kandinsky, in his treatise *The Art of Spiritual Harmony* (first English edition, Boston: Houghton Mifflin, 1914; retitled *Concerning the Spiritual in Art* in subsequent editions), made the following points about color: 1) Color is an independent means of expression; 2) colors have individual, prerational correlations in the human psyche; 3) the seemingly rational world of ordinary, everyday perception is deceptive; and 4) the task of art is to set aside reasoned seeing and return the viewer to prerational seeing. Ergo—since Kandinsky was a painter—painting would be better off working—*sans* iconography—directly with color.

15. In 1915, Marcel Duchamp attached a bicycle wheel to a stool and called it a "Readymade," positing that found objects, alone or in assemblage, could constitute a work of art. He thus confronted the existing ideas of art, and the issues he raised have had a resounding impact on the art of the twentieth century.

16. Maurice Denis, 1890, quoted in Dorra, *Symbolist Art Theories*, 235.

61. ARSHILE GORKY
Untitled, 1944
Colored pencil and crayon on paper
19 x 24 in.

62. JACKSON POLLOCK
Untitled, 1951
Ink on Howell paper
12¼ x 16 in.

63. CLYFFORD STILL
Untitled, 1945
Oil on paper
26 x 20 in.

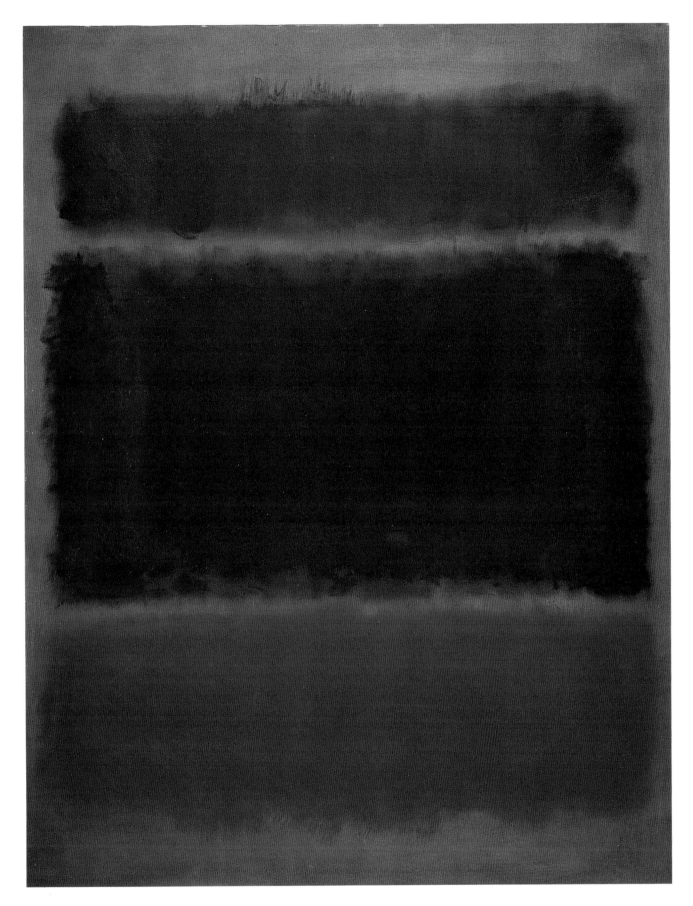

64. MARK ROTHKO
Black over Deep Red, 1957
Oil on canvas
69³/₈ x 53⁷/₈ in.

65. FRANZ KLINE
Untitled, c. 1958
Oil on paper
14¾ x 19⅝ in.

66. WILLEM DE KOONING
Untitled III, 1983
Oil on canvas
88 x 77 in.

67. Helen Frankenthaler
Moveable Blue, 1973
Acrylic on canvas
70 x 243 ¼ in.

68. Sam Francis
Untitled, 1983
Monotype on handmade paper
78 3/8 x 43 in.

69. Joan Mitchell
La Grande Vallee XIX Yves, 1984
Oil on canvas mounted on board
102¼ x 78½ in.

70. Al Held
Vorcex III, 1984
Acrylic on canvas
84³/₈ x 84³/₈ in.

71. ELLSWORTH KELLY
Violet Panel, 1980
Oil on canvas
72 x 88 in.

" 'Non-art,' 'anti-art,' 'non-art art,' and 'anti-art art' are useless.
If someone says his work is art, it's art."

—*Donald Judd*

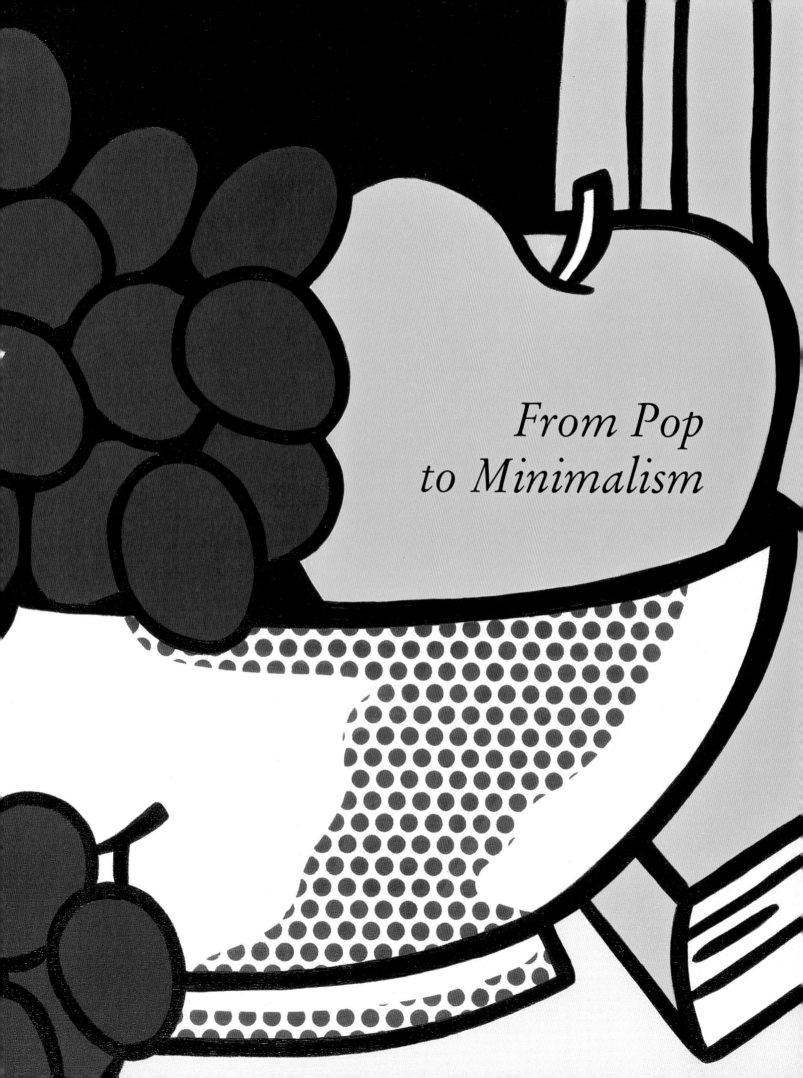

From Pop
to Minimalism

The Deluge of Popular Culture

Irving Sandler

op Art exploded with a *WHAM!* on the New York art scene in 1962 and was quickly featured in both art and mass media. The new movement appalled the Abstract Expressionists, the reigning avant-garde whose leading painters had achieved international recognition for the first time in the history of American art. For them, art existed to reveal the artist's inmost feelings and private visions; consequently, their generally abstract works could be difficult to understand. But, as Andy Warhol said, "the Pop artists did images that anybody walking down Broadway could recognize in a split second—comics, picnic tables, men's trousers, celebrities, shower curtains, refrigerators, Coke bottles—all the great modern things that the Abstract Expressionists tried so hard not to notice at all."[1]

In the opinion of the Abstract Expressionists, the only art more despicable than that which blatantly appropriated its subject matter from popular art or kitsch[2] was that which also borrowed its techniques from commercial art: Roy Lichtenstein's stenciled benday dots, James Rosenquist's billboardlike rendering (fig. 45), and Warhol's photomechanical silkscreening. Pop artists were branded the new vulgarians, while they, in turn, ridiculed the romantic rhetoric of the Abstract Expressionists. Lichtenstein, for example, poked fun at their need for the anxious, improvisational "action" of painting by representing a brush stroke in his meticulous, machinelike Pop style.

Although the fact was not acknowledged at the time, by 1962, Abstract Expressionism had become outworn and was in decline. Lively young artists, both abstract and figurative, were turning to different subjects and different pictorial means. Pop Art was one manifestation of a "new" art that also encompassed the hard-edge abstraction of Ellsworth Kelly and Al Held; the stained color-field abstraction of Morris Louis, Kenneth Noland, and Jules Olitski; the Minimalism of Frank Stella, Carl Andre, Donald Judd, Robert Morris, Dan Flavin, and Sol LeWitt; the New Realism of Philip Pearlstein and Alex Katz; and the Photo-Realism of Malcolm Morley, Richard Estes, and Chuck Close. All of these artists rejected the heated subjectivity implied by ambiguous painterly brushwork and opted for a cool literalism manifest in clearly defined forms. Because of Pop Art's affinities to the new abstraction of painters such as Stella, Held, Kelly, and Noland, claims were made that it was as much "elitist" as it was "populist," and that dualism was the basis of much of Pop Art's appeal in the art world.

previous page:
ROY LICHTENSTEIN
Still Life with Book, Grapes and Apple
(detail), 1972 Plate 73

The suddenness with which Pop Art emerged was deceptive; there had been a buildup of some dozen years. Pop elements had already begun to appear within Abstract Expressionism itself, starting with Willem de Kooning's *Woman I* (1950–52, The Museum of Modern Art), whose smile was based on a cigarette advertisement. Second-generation Abstract Expressionists, notably Larry Rivers and Grace Hartigan, also had introduced popular imagery into their "action" paintings. Other precursors were the collagists and assemblagists who had assimilated urban detritus and ordinary objects into their work: Richard Stankiewicz in "ghoulish buggy creepers, erect starers, careening exerters, floating fliers, squatting blocky ones" made from junk metal;[3] Allan Kaprow in garish collages; Claes Oldenburg in corrugated cardboard reliefs; Jim Dine in collage-paintings and reliefs incorporating tools and pieces of clothing; John Chamberlain (b. 1927) in crumpled automobile assemblies, such as his 1985 sculpture *chACE* (pl. 87); Mark di Suvero in abstract constructions of weathered timbers, heavy chains, rope, and the like; and H. C. Westermann (1922–1981) in bizarre dwellings, such as the one housing *The Dancing Teacher* (1972, pl. 86). There were also the huge, simplified portraits by Alex Katz (b. 1927) that called billboards to mind, including *Blue Umbrella* (1980, pl. 88); Robert Rauschenberg (b. 1925) with his combine paintings, mélanges of throwaway materials and images from the city, and prints, exemplified in his Bellini series (1986–89, pl. 81); and Jasper Johns (b. 1930), whose American flags and targets served as instantly recognizable signs, like *Target with Four Faces* (1968, pl. 72).

Assemblage of this kind led to Environments, in which entire rooms were filled with urban detritus and everyday artifacts, and to Happenings, a sort of collage-theater, that introduced live improvisational drama, music, and dance into Environments. As one of the innovators of Happenings commented: "Not satisfied with the suggestion through paint of our other senses, we shall utilize the specific substances of sight, sound, movements, people, odors, touch."[4] The content of these assemblages, Environments, and Happenings was generally city life in all its poverty, terror, and anxiety, as well as its spectacle.

Assemblages, Environments, and Happenings were the latest manifestation of a time-honored avant-garde practice of muscling nonart, or "low" imagery, into "high" art. They were also the continuation of a long-lived urban Realist tradition in American art. Indeed, what Milton Brown wrote about the Ashcan School artists at the turn of the century fits the later Pop artists just as well. They "stood for 'truth' as against 'beauty,' for 'life' against 'art'.... They accepted Robert Henri's advice: 'Be willing to paint a picture that does not look like a picture.' The realists defended crudity and ugliness because such things were true."[5] In that light, assemblages, Environments,

and Happenings could be thought of as Neo-Regionalist. But, because of their "brutish" look, they were commonly labeled, or rather mislabeled, Neo-Dada—a new antiart. It was not until the early 1960s that the formal quality of much of this work was recognized.

The avant-garde composer John Cage provided a persuasive rationale for the works of Rauschenberg, Johns, and related artists. Influenced by Marcel Duchamp and Zen Buddhism, Cage was indifferent to the artist's inner life and emotions. Instead, he looked out at the world and aspired "to open up one's eyes to just seeing what there was to see" and one's ears to what there was to hear.[6] According to Cage, the purpose of art was to make people alive to their surroundings in order to better their lives. Intent on breaking down every barrier between life and art, Cage announced that any material or sound by itself or in any combination, whether intended or not, is art.

Indicative of the change in the sixties from inward looking to outward looking is this comment by Oldenburg: "I am for an art that takes its form from the lines of life itself, that twists and extends and accumulates and spits and drips, and is heavy and coarse and blunt and sweet and stupid as life itself."[7] By introducing real materials and real images and objects into their art, the creators of assemblages, Environments, and Happenings showed the way to Pop Art. Indeed, Rauschenberg and Johns were often counted among its ranks.

Although the Abstract Expressionists and their supporters saw Pop Art only in negative terms, as nihilistic and unworthy, there were positive reasons for its emergence. American society had changed radically during the dozen years after World War II. Two revolutions had occurred: one in newly computerized and automated production; the second, in mass communications. The upshot was a postindustrial, or consumer, economy, an affluent society defined by an abundance of commodities produced by computer technology and fueled by the newly prevalent mass media.

The revolution in communications was exemplified by a jump in the number of television sets in American households, from ten thousand in 1947 to forty million a decade later. At the touch of a button, viewers were witness to wars, assassinations, and other political happenings; to natural catastrophes; and to the intimate details of life in an underprivileged ghetto or at a go-go party—as they happened, with remarkable vividness and immediacy. This was in addition to soap operas, sitcoms, crime series, game shows, movies, etc. Even if one wanted to, it became difficult to avoid popular culture and the ceaseless flow of commercials—all in one media package. Mass culture, filtered through television, exerted novel pressures on the American consciousness.

Furthermore, because of the new affluence, unprecedented numbers of young people attended college, where they were required by many schools to take at least one course in art history, art appreciation, or a studio discipline. As a consequence, art departments flourished. So did art museums and community art centers, and in the late 1950s, a boom market for contemporary art developed. This growing art consciousness of the American public was reflected in the demand for up-to-date and knowledgeable art reporting in the mass media. Gone were the days when *Time* would label Jackson Pollock "Jack the Dripper," as it did in 1956.[8]

In short, the time was ripe in the early sixties for the introduction of "low" commercial art into "high" culture. It is noteworthy that all the original Pop artists developed their styles independently—each responding to something in the air, as it were. Indeed, only in the sixties was it possible for artists to even imagine borrowing subjects from popular culture with the intention of creating high art. This would have been

Figure 46
ROY LICHTENSTEIN
View from the Window, 1985
Lithograph, woodblock, and serigraph print
on paper
78³⁄₈ x 32³⁄₄ in.

literally unthinkable during the Depression thirties or wartime forties, when consumer goods were not affordable for, or available to, the great mass of Americans. But with the emergence of a consumer society in the fifties, artists came to believe that the evolution in mass media had so drastically and irrevocably changed ways of seeing the world, it had to be dealt with seriously in art.

It was not only Pop artists who sensed that the world had changed and that their art exemplified this change. Responding to the same social stimuli, a new generation of art professionals promoted Pop Art in reviews and articles and in major museum exhibitions at home and abroad. All of this attention led the judges at the 1964 Venice Biennale to award the prestigious International Painting Prize to Rauschenberg. Like Abstract Expressionism earlier, American Pop Art had achieved global recognition.

What did Pop Art signify about society? Some saw it as a critique of consumerism and commercialization. And one of the most notorious Pop paintings, *F–111* (1965, private collection) is a four-panel work by James Rosenquist (b. 1933), a print of which is in the SBC Collection (1974, pl. 76). Named after a warplane, it comments on the interaction of the military-industrial complex and the consumer society. Still, it was an exception. Rosenquist himself, and Pop artists generally, were accepting of consumer society. As Warhol said, Pop Art was about "liking things."[9] Robert Indiana agreed: "Pop is a re-enlistment in the world."[10] What was significant was how these artists appropriated their subjects without interpreting or transforming them—a radical move aesthetically, since artists traditionally had transformed their subjects. To be sure, images gained intensity in Pop Art because they were isolated and enlarged, but the "things" represented were left otherwise unchanged.

Developing independently, the Pop artists created individual styles. Warhol (1928–1987) used a photomechanical silkscreening technique to transfer newspaper and magazine illustrations onto canvas. Among his best known images are commodities—Campbell soup cans, Coke bottles—and photos of celebrities who were, in his opinion, "products"[11]: Marilyn Monroe, Jackie Kennedy, and even dancer and choreographer Martha Graham in *Letter to the World–The Kick* (1986, pl. 80). Warhol's works at once mirrored consumer society and became its consummate icons.

Roy Lichtenstein (b. 1923) tackled big themes—love and war—but for fear of sentimentality, he counteracted their human drama by appropriating images from comic strips. He also culled images from the history of art, particularly those that had been widely circulated as postcards or posters. In the *Bull Profile Series* (1973, pl. 75), he represented with tongue in cheek the famous picture by the Dutch de Stijl artist Theo van Doesburg that transformed the recognizable image of a bull into a geometric abstraction. At the same time, Lichtenstein was occupied with formal issues. For instance, his treatment of traditional subject matter such as a window view (fig. 46) or still life in *Still Life with Book, Grapes and Apple* (1972, pl. 73) proves that despite the resemblance of his pictures to cartoons, the arrangement of every pictorial element was recomposed to create a visually cogent structure—which, in the end, was his primary purpose.

Rosenquist used a billboard painting technique to paint fragments of images drawn from the urban environment. Because the constituent images were often unrelated, as in *F–111*, or shattered like panes of glass, as in *Telephone Explosion* (1983, pl. 78), they evoked a mood of strangeness associated with Surrealism. Talking about his work as a whole, Rosenquist said, "I still think about a space that's put on me by radio commercials, television commercials, because I'm a child of that age. Things, billboard

Figure 47
CLAES OLDENBURG
Baked Potato with Butter, 1972
Lithograph on paper
30½ x 40¼ in.

Figure 48
JIM DINE
Four German Brushes, 1973
One of four etchings on paper
31⅛ x 22¼ in.

signs, everything thrust at me. [In] the numbness that occurred, I thought that something could be done."[12]

Lichtenstein, Rosenquist, and Warhol have been called "hard-core" Pop artists because they all appropriated mass-media images *and* rendered them in the depersonalized techniques of commercial art. However, much of Pop Art is not "cool," certainly not that of Oldenburg (b. 1929) and Jim Dine (b. 1935). Drawing on their background in assemblage, Environments, and Happenings, they created works that depicted or incorporated common objects, but instead of representing them in a deadpan manner, they transformed them imaginatively. In a sense, Oldenburg and Dine are "Pop Expressionists."

Oldenburg was an innovator of "soft" sculpture composed of canvas or vinyl stuffed with kapok and foam rubber. In these works, he introduced a novel range of sensual experiences associated with the human body and its functions, a range that traditional "hard" sculpture did not express. He also enlarged his objects—a hamburger or an ice-cream cone—to gargantuan sizes, often realizing his works in public places. One can imagine *Baked Potato with Butter* (fig. 47) as a giant outdoor monument. All in all, Oldenburg's works in all mediums are extravagant and fantastic.

Oldenburg considered his work "autobiographical."[13] Dine's art is more explicitly so. The common images and objects (fig. 48) that he painted or incorporated into his artworks had personal associations. Dine imagined a bathrobe—which he said "seemed to be my body inside"—to be his self-portrait (1980, pl. 77).[14] Indeed, *The Yellow Robe* is his consummate self-image.

Rather than incorporating utilitarian objects into his work as Dine did, Kenneth Price (b. 1935), a ceramicist who is often labeled a Pop artist, invented new ones with the kind of fantasy associated with Oldenburg. His *Lizard Cup* (1971, pl. 89) depicts a real cup in the shape of a bizarre reptile.

Many artists who were identified with Pop—among them Johns, Dine, Indiana, and Edward Ruscha (b. 1937)—took their cues from advertising and introduced text into their pictures. Juxtaposing words and images, they created visual and verbal

Figure 49
EDWARD RUSCHA
Cities, 1982
Lithograph on paper
25 x 47⅝ in.

poetry. Ruscha's 1982 lithograph *Cities* (fig. 49) is a depiction of the word *city* repeated three times, punctuating a barren landscape like skyscrapers. In another Ruscha work, *Final End* (1992, pl. 85), the words *The End* are placed in Gothic, storybook type behind sections of growing wheat. The implication is clear, as the forces of nature threaten to overtake and obscure the human declaration of a final ending.

What was the legacy of Pop Art? It had no immediate second generation but went underground, emerging again only in the late 1970s. By then, as Kirk Varnedoe and Adam Gopnik wrote, popular culture had become so pervasive and powerful as to "become in every sense, the 'second nature' of modern life."[15] Many artists believed that the mass media had corrupted American society and culture and that it had to be confronted critically and, to use the fashionable word, *deconstructed,* as in the case of Barbara Kruger's photomontages (see page 270). For a greater number, however, among them Richard Prince, David Salle, and Julian Schnabel, vernacular imagery became a compelling realm of fresh experience that stimulated artistic acts of discovery.

NOTES

1. Andy Warhol and Pat Hackett, *POPism*, 3.

2. *Kitsch* is from the German verb, *verkitschen*, which means "to make cheap." The current use of the word is largely derived from an essay by Clement Greenberg entitled "Avant-Garde and Kitsch" (*Partisan Review*, Fall 1939).

3. Richard Stankiewicz, quoted in Philip Pearlstein, "The Private Myth," *Art News* (September 1961): 44, 61.

4. Allan Kaprow, "The Legacy of Jackson Pollock," *Art News* (October 1958): 56–57.

5. Milton Brown, *American Painting from the Armory Show to the Depression* (Princeton, NJ: Princeton University Press, 1955), 12–13.

6. John Cage, interview with the author, New York, May 6, 1966.

7. Claes Oldenburg, *Store Days*, Documents from "The Store" (1961) and "Ray Gun Theater" (1962). Selected by Claes Oldenburg and Emmett Williams (New York: Something Else Press, 1967), 39.

8. "The Wild Ones," *Time* (February 20, 1956), 129.

9. Andy Warhol, quoted by G. R. Swenson, "What Is Pop Art?" part 1, *Art News* (November 1963), 27.

10. Robert Indiana, quoted by G. R. Swenson, op. cit.

11. "Products," *Newsweek* (November 12, 1962), 94.

12. Jeanne Siegel, "An Interview with James Rosenquist," *Artforum* (June 1972), 32.

13. Claes Oldenburg, quoted in "New Talent USA: Sculpture (Chosen by Robert Scull)," *Art in America I* (1962), 33.

14. Jim Dine, quoted in *Art in Process* (New York: Finch College Museum of Art/Contemporary Study Wing, 1965), n.p.

15. Kirk Varnedoe and Adam Gopnik, *High and Low*, 402, 407.

Minimalism and Its Opposition

John R. Clarke

If Pop Art was an expression of American consumer culture and populist politics, the various artistic movements of the sixties associated with Minimalism expressed a different set of ideas. Central to this art was the conviction that "less is more." Artists used commonplace materials, from discarded objects to industrial metal. They reduced forms to simple geometrical shapes; some artists even relegated the actual production of their artworks to machine shops in an effort to emphasize the unimportance of the artist's "touch." An intellectual attitude grounded in reductive aesthetics that stripped the usual associations from art—whether the emotional individualism of Abstract Expressionists or the recognizable imagery of Pop Art—dominated this movement.

Minimalist artists employed these reductive aesthetics to make works of art that challenged both the critics and the viewing public. They seemed to be asking, What is art? According to most Minimalists, the answer depended not on the artist but on the viewer. If a person looking at a painted metal cube saw it as art, then that's what it was. If instead the person saw an uninteresting block (and many critics resented Minimalist art, labeling it overcalculated and boring), the artistic failure was on the part of the person viewing the work. The viewer's imaginative participation was crucial.

The first indication that this Minimalist reduction was where abstract painting was to go in the sixties came from Frank Stella (b. 1936) and the paintings that he regularly exhibited at Leo Castelli's gallery. They abandoned the traditional rectangle, using increasingly bold shapes. In his 1960 Aluminum series, Stella cut uniform holes in the centers of the canvases and notched their edges; by 1966, he was producing big, irregular polygons. Stella also rejected the bravura gesture of Abstract Expressionism by painting the shaped canvases with an allover pattern—first with stripes of identical width, later with simple geometric forms that corresponded to the shape of the canvas. If these plain stripes and shapes both emphasized the flatness of the canvas and underplayed the artist's touch, Stella's use of industrial pigments (metallic paints and Day-Glo) also called attention to the materiality of the paint itself. To reinforce the sculptural presence even further, Stella deepened the stretchers and began to explore ever more daring shapes.

Like most Minimalist painters, Stella worked through problems of shape and color in series. *Damascus Gate III* (1968, pl. 95) belongs to the ambitious Protractor series, a group of large paintings (this one is five by twenty feet) that contrasts the shapes of overlapping protractors with radiating stripes of fluorescent pigment. Other Minimalist painters also explored shape and emphasized the materiality of the paint throughout

their sometimes long careers. Notable are Kenneth Noland, Jules Olitski, Robert Mangold (b. 1937) with his series of untitled woodcuts (1989, pl. 101), and Ellsworth Kelly (b. 1923) with his 1987 lithograph *Dark Gray Curve* (fig. 50). Brice Marden (b. 1938) began by building up layers of beeswax and pigment in monochrome panels that he often juxtaposed and exhibited in series. His dramatic abdication of this signature style in the mid eighties caused a critical furor. The SBC Collection's 1986 Rexroth series (fig. 51) by Marden reflects his new approach: Rather than continuing to separate drawing from painting, as was the tradition, he began in these and other works to create gestural drawings with paint.

In a sense the most "minimal" of the Minimalist painters were the California Space and Light artists who by the end of the sixties had abandoned pigment on canvas for constructions that made pictures out of light itself. James Turrell (b. 1943), one of the premier artists of this genre, used light chimneys to illuminate boxlike enclosures within the art gallery that looked like glowing color-field paintings—until the viewer attempted to touch them. Turrell's First Light series of 1990 (pl. 103) conveys through complex etching techniques the subtle, glowing effects of his constructions in pure light.

Minimalist painters actively engaged Minimalist sculptors in this period to bring about a revolution in thinking. By focusing on the possibilities of modular structures and series and on the relationship of the work to the viewer, they challenged the power of the Formalist criticism espoused by Clement Greenberg and his followers. Michael Fried, for instance, complained that because Minimalist sculpture was considered incomplete without the viewer's response, it became a kind of theater, and "theater tends to the condition of non-art."[1] In fact, the "theatricality" of Minimalist sculpture that so irked Fried and others became the major trait identifying later Minimalist art.

Artists often turned the gallery itself into a "sculptural theater." For instance, Robert Morris exhibited a mass of industrial scraps strewn across the gallery floor as a "de-differentiation" piece, and Carl Andre created a "scatter piece" made up of tiny blocks that filled a corner of the Dwan Gallery in seemingly random fashion. Richard Serra (b. 1939) took the industrial themes even further into the realm of "theater" in a series of exhibitions at Castelli's warehouse. The "process pieces" exhibited there showed the effects of pointedly macho actions: splashing molten lead or cutting rolled lead, marble, timber, and antimony with a heavy-duty saw. By leaning sheets of lead against each other, Serra made sculptures that were held together only by their weight and friction; *One Ton Prop (House of Cards)* (1970, destroyed), a piece consisting of four lead plates, each four by five feet, crushed and killed a worker erecting it for an exhibition.[2] Serra's 1972 lithograph *Double Ring II* (fig. 52) conveys both his Minimalist sense of simple, unitary form and his obsession with process. Its overlapping lines and shaded forms, like layered, half-erased sketches, seem to show different stages in its creation.

Process Art like Serra's emphasized ordinary materials, a trend that found parallels in the *Arte Povera* movement in Europe. This movement's most important exponent was German artist Joseph Beuys, who employed unusual materials such as felt

Figure 52
RICHARD SERRA
Double Ring II, 1972
Lithograph on paper
35¼ x 48¼ in.

Figure 53
CHRISTO
Wrapped Computer (project for Ericsson display monitor unit 3011, wrapped [personal computer] Ericsson type 1050-5ES), 1985
Five-color lithograph with collage on paper
28 x 22½ in.

and animal fat in his influential works, often accompanied by performances.[3] Both American and European artists explored a range of "poor" or "nonartistic" materials in an attempt to narrow the gap between art and everyday life. Central to *Arte Povera* and Process Art alike was getting the viewer involved in the steps that the artist took to assemble these materials. German-American artist Eva Hesse perhaps best exploited the theatrical possibilities of process when she wove skeins of latex to create powerful, room-size installations. Hesse herself recognized the fluid nature of viewer engagement in describing one of these pieces when she said "its order could be chaos."[4]

Given Minimalism's reductions and its concern with the viewer and process, it was only a matter of time before it dissolved the museum walls entirely. Dissatisfied with testing the viewer's perception in the confines of a gallery, Robert Smithson constructed exhibitions using samples taken from sites in the outer world that he identified with maps. He called these exhibited samples the "non-site"; in fact, he defined the art gallery itself as a non-site. By challenging the authority of the gallery as repository and showplace for artworks, Smithson paved the way for a number of artists who wished to expand their activity to make the earth itself their primary material.

Typically located in remote areas and involving mapping, excavating, and moving great quantities of earth and stones, Earth Art questions the relatively small scale and refined materials traditionally associated with sculpture. Smithson's *Spiral Jetty* (1970), for example, is located on a promontory of the Great Salt Lake: 6,650 tons of earth and rocks make an embankment fifteen feet wide and fifteen hundred feet long that spirals out into the water. Smithson's modifications of the land, like Walter DeMaria's drawings on the Nevada Desert or Michael Heizer's *Double Negative* (1970)—two deep cuts on the edge of a mesa that displaced 240,000 tons of rhyolite and sandstone—rely on documentation to communicate their power to their audience.

Christo (b. 1935) and his wife and partner, Jeanne-Claude (b. 1935), whose ambitious projects operate on a similarly monumental scale, began with works that involved simply wrapping common objects in fabric and rope, a process documented in the 1985 lithographs *Wrapped Computer (project for Ericsson display monitor unit 3011, wrapped [personal computer] Ericsson type 1050-5GS* (fig. 53) and *Wrapped Telephone (project for L.M. Ericsson model)* (1985, pl. 84). The couple's action of wrapping here transformed useful objects into art objects, like shrouded and subjugated Duchampian Readymades. When carried out on a grand scale, as in their *Wrapped Coast* (1969)—one mile of coastline near Sydney, Australia, wrapped in one million square feet of fabric—wrapping makes a temporary monument from the landscape itself. For Christo and Jeanne-Claude, the process of realizing the piece, including orchestrating large teams of workers, material, finances, and governmental approval, is itself part of the work of art.

Earth Art challenges notions of scale: Most of these works are so large that they must be documented by aerial photos. Some critics saw advantages in this apparent drawback. Although the average viewer normally cannot experience the work by traveling to the site, its documentation in photos, films, and texts nevertheless interacts with the viewer's imagination. Again, the viewer's role is crucial. For these critics, then, Earth Art is essentially a step toward that most minimal form of all: Conceptual Art, or art as idea or information.

In the late sixties in America, art-as-idea began with the notion of art-as-protest. The target of protest was invariably "the system," or the military-industrial complex that was being fueled by American capitalism, and—by extension—American imperialism in Vietnam. Angry young artists who strove to avoid being co-opted by the system began refusing to make work that could be bought or

sold. This art took many forms, from Earth Art to Body Art, yet central to its genesis and development was the notion that the most advanced art was the idea. Not only did Conceptual Art frustrate the gallery system, since ideas could not easily be bought, carried home, and placed over someone's couch, but it also constituted the logical conclusion to the avant-garde notions first promulgated in the early part of the century by Marcel Duchamp. His Readymades, such as the plumbing-store urinal signed and exhibited in 1917 with the title *Fountain* (like all other Readymades, the original of this artwork was lost), proposed that the advanced artist no longer *made* objects but rather *chose* them, making them art by placing them in the gallery. The Conceptual artists continued this Duchampian logic by doing away with the object entirely.

Sol LeWitt (b. 1928), with his *Sentences on Conceptual Art* (1967), thirty-five in all, issued a vanguard battle cry for Conceptual Art. Sentence 10: "Ideas can be works of art; they are in a chain of development that may eventually find some form. All ideas need not be made physical."[5] By emphasizing the concept of the work of art over its execution, artists were asking the public to judge the success of the idea rather than its physical form. LeWitt's two gouache drawings from 1989, *Untitled (No.1)* (pl. 102) and *Untitled (No.6)*, underscore his emphasis on the unity between idea and execution that is the hallmark of Conceptual Art. An older colleague of LeWitt's who dealt with some of the same issues, John McLaughlin (1898–1976) concentrated on accessing "the truth within" in his fourteen minimal prints, produced during a fellowship residency at the Tamarind Lithographic Workshop in 1963. For McLaughlin, the simple purity of form in Minimalist art reflected his interests in Eastern philosophy and enlightenment. *Untitled 5103* and *Untitled 5108* (1963, pl. 96) exemplify the differing rectangular configurations and muted color of the series.

Conceptual Art could take many seemingly "nonartistic" forms: Joseph Kosuth tested the relationship between language and image in a series that presented an object, a photograph of the object, and a photostat of its thesaurus definition. In this tautological presentation, the artist's activity consisted of stating the existence of the object in several visual and linguistic forms. Lawrence Weiner's own famous conceptual sentences suggested that artworks live in the mind of the perceiver rather than as objects in museums: "An object tossed from one country to another"[6] could be anything from a stone thrown across the border between the United States and Mexico to an intercontinental ballistic missile. As Douglas Huebler said in a statement published in a catalogue, "The world is full of objects, more or less interesting; I do not wish to add any more."[7]

Like any other mode of expression, Conceptual Art was not immune to parody, and California artist John Baldessari (b. 1931) parodied East Coast artists in a variety of ways. These include a video in which he sings LeWitt's *Sentences on Conceptual Art* to the tune of "De Camptown Ladies Sing Dis Song." Many works of the seventies also combined "doctored" or retouched photographs with texts to underscore the fallibility of both photographs and language. Baldessari's *Equestrian (Flesh) In Brackets with Orange Showdown* (1991–92, pl. 83), although at five by eight feet much larger in scale and bolder in both composition and color than earlier works, still maintains the ironic stance arising from his roots in Conceptual Art. Richard Prince (b. 1949), an artist who co-opts advertising images and "rephotographs" them, deals with truth and the media in a more direct way. In 1982 Prince began his Entertainers series, in which he cut out black-and-white publicity shots of entertainers, collaged them onto color backgrounds, and photographed them, slightly out of focus. Often times Prince placed the images in large Plexiglas sheets, which are about human height and lean against the wall. In *Tamara* (fig. 54), for example, Prince questioned the authority

Figure 54
RICHARD PRINCE
Tamara (Entertainers series, detail), 1982
Unique Ektacolor print mounted in
Plexiglas frame
98¼ x 50⅜ in.

and believability of our cultural images, asserting that any image is a version of reality.

Both the politics of protest and the reductive stance of Conceptual Art induced performance artists of the late sixties, some of whom had created the Happenings that sprang up earlier in the decade, to focus their activities on a single socially relevant theme. Chris Burden's performance of being shot called attention to war and violence; Hannah Wilke's self-presentation as a pinup was a feminist statement about how women are reduced to sex objects. Ana Mendieta (1948–1985) staged her performances in the wilderness rather than in the gallery space, using elemental materials, such as mud and fire, in elaborate rituals that recalled primal human emotions and commented on her concerns with environmental, religious, and feminist issues. As a Cuban exile raised in the United States, Mendieta carefully chose the locations for her performances to enhance their personal element: Iowa (her American home), Mexico (geographically and spiritually near Cuba), and finally Cuba itself (her lost homeland). She documented her performances with videos, photographs, and drawings like her *Untitled (Amategram)* of 1981–82 (pl. 99).

Not all artists in this period, however, embraced reductive aesthetics. The Super Realist painters, who emerged in a series of exhibitions in the late sixties, jolted the public with their photographic verisimilitude and slice-of-life subject matter (critics also labeled these artists New Realists and Photo-Realists). Some, like Philip Pearlstein (b. 1924), painted from life. His 1982 lithograph *Nude in Hammock* (pl. 90) reveals his interest in the model not as a personality but as an element of an elegant composition. Although some critics saw in the Super-Realists' canvases themes of urban alienation, the artists often explained their work instead in formal and technical terms.

Richard Estes (b. 1932) projected slides on the canvas to aid him in rendering complex passages, such as the reflections in store windows. *Holland Hotel* (1984, pl. 91) presents his trademark New York cityscape in a serigraph rendered with a typically Precisionist technique. It was through synecdoche—alluding to the whole through its parts—that Yvonne Jacquette (b. 1934) evoked the same city in her *Triboro Triptych at Night* series (1987–88, pls. 92–94). Other Super Realist painters, like Janet Fish (b. 1938), glorified the homely with bravura technique as in her still life *Ball Jars* (fig. 55). Sylvia Plimack Mangold (b. 1938) in *November 19, 1978* (1978, pl. 98), with its combination of Impressionistically painted landscape and trompe l'oeil tape frames, questioned the illusionistic techniques that are the foundation of all Realist painting.

A second major challenge to Minimalism came from the Patterning and Decoration movement. Feminist artists—both male and female—defiantly championed the decorative arts of textiles, mosaic, and other craft traditions in their paintings. Although based on abstract Formalist notions of flatness, shape, and the grid, their work returned painting to recognizable images embedded in repeating and juxtaposed decorative motifs. Joyce Kozloff first used Islamic and Native-American motifs on canvases, but she went on to create public artworks employing ceramic tiles. Cynthia Carlson created contrasting wallpaperlike patterns directly on walls in whole-room installations. Robert Kushner (b.1949) used found fabrics to make "shaped" works that he draped in installations like costumes; in his more recent work, including the Reclining Woman series (fig. 56), he represented the figure in highly patterned fields.

Figure 56
ROBERT KUSHNER
Reclining Woman #31
(Reclining Woman series), 1987
Drypoint printed in black on paper
12½ x 16⅞ in.
© 1996 Crown Point Press

By the end of the 1960s, artists had overturned the Formalist belief that the work of art was self-contained and that it had to be pure both in terms of truth to its medium and in terms of aesthetic reduction. The new art often made the viewer part of the artwork, and sometimes the artwork as a material object even vanished altogether. What had begun as a series of moves to counter the so-called "hot," or emotional, gestures of Abstract Expressionism with cool, calculated, and stripped-down forms ended in questioning the status of the art object itself. Sculpture was no longer a single object created by the artist; it could be a temporary alteration of a landscape or an accumulation of simple, impermanent materials. Painting was no longer a picture made of canvas and pigment; it could be an arrangement of pure light. Performance art, by collapsing the traditional categories of painting, sculpture, and drawing, declared that art could be an action. It could even be an idea that the artist communicated to his or her audience. If all of these moves frustrated Formalist criticism, they had the important function of opening up the visual arts to new critical criteria that were fundamentally social and cultural in nature. Even the verisimilitude of Super Realism called pictorial illusionism into question, and the seemingly innocent, colorful designs of Patterning and Decoration constituted a critique of the dominant Anglo-European culture. The common thread running through the complex tapestry of sixties art was that of testing the time-honored definitions of the visual arts. This intense period of experimentation and probing set the stage for a new generation of artists who proposed fresh answers to the old question: What is art?

NOTES

1. Michael Fried, "Art and Objecthood," *Artforum* 5 (June 1967), 15.

2. The sculpture was later re-created for an exhibition at the Museum of Modern Art in 1990.

3. *Fat Chair* of 1964 consisted of a wooden chair that held layers of fat on the seat. Another Beuys work, *The Chief—Fluxus Chant*, was a performance piece of the same year that featured the artist wrapped in felt in a roomful of objects such as dead hares, external microphones, and animal fat.

4. Quoted in Robert Pincus-Witten, "Eva Hesse: Post-Minimalism into Sublime," *Artforum* 10 (November 1971), 43.

5. Sol LeWitt, quoted in Lippard, *Six Years*, 75.

6. Lawrence Weiner, *Terminal Boundaries*, 1969. Dummy lost and book never published. Documented in Lippard, *Six Years*, 71.

7. Douglas Huebler, statement in unspecified catalogue, c. 1970. Quoted in Lippard, *Six Years*, 74.

72. JASPER JOHNS
Target with Four Faces, 1968
Serigraph and screenprint on paper
40¾ x 29⅜ in.

73. ROY LICHTENSTEIN
Still Life with Book, Grapes and Apple, 1972
Oil and magna on canvas
36 x 40 in.

74. ROY LICHTENSTEIN
Little Glass, 1979
Painted bronze
19¼ x 12⅜ x 5½ in.

75. ROY LICHTENSTEIN
Bull Profile Series, 1973
Six color lithographs on paper
27 x 35 in. (each)

76. JAMES ROSENQUIST
F–111, 1974
Four-panel color lithograph on paper
36½ x 75 in. (two panels, each, approx.)
36½ x 70 in. (two panels, each, approx.)
© 1996 James Rosenquist/Licensed by VAGA, New York, NY

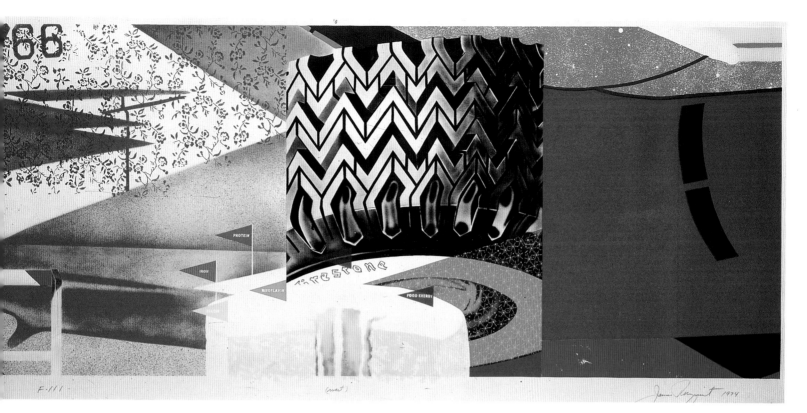

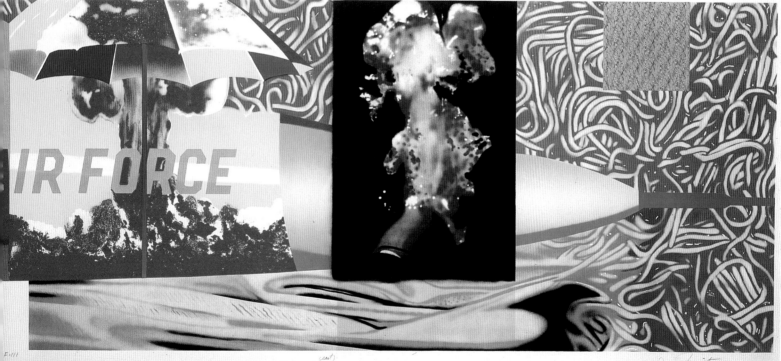

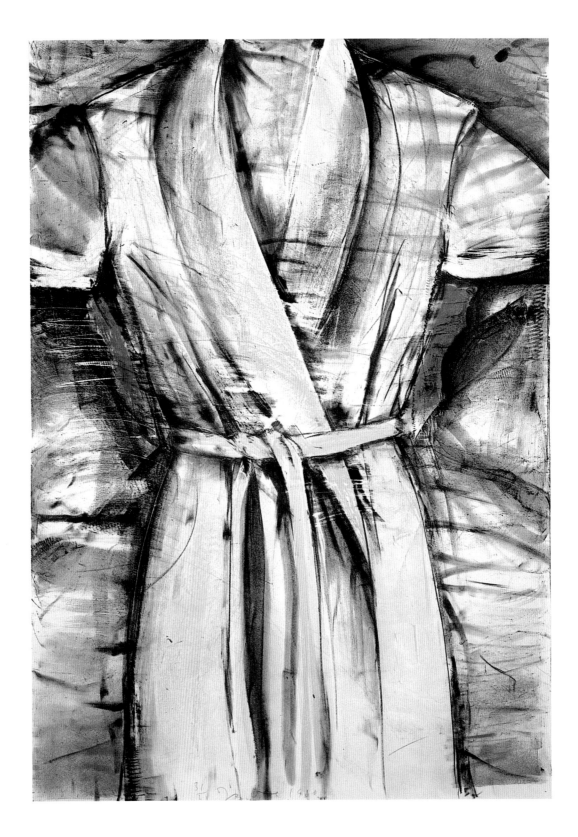

77. JIM DINE
The Yellow Robe, 1980
Lithograph on paper
49⅞ x 35 in.

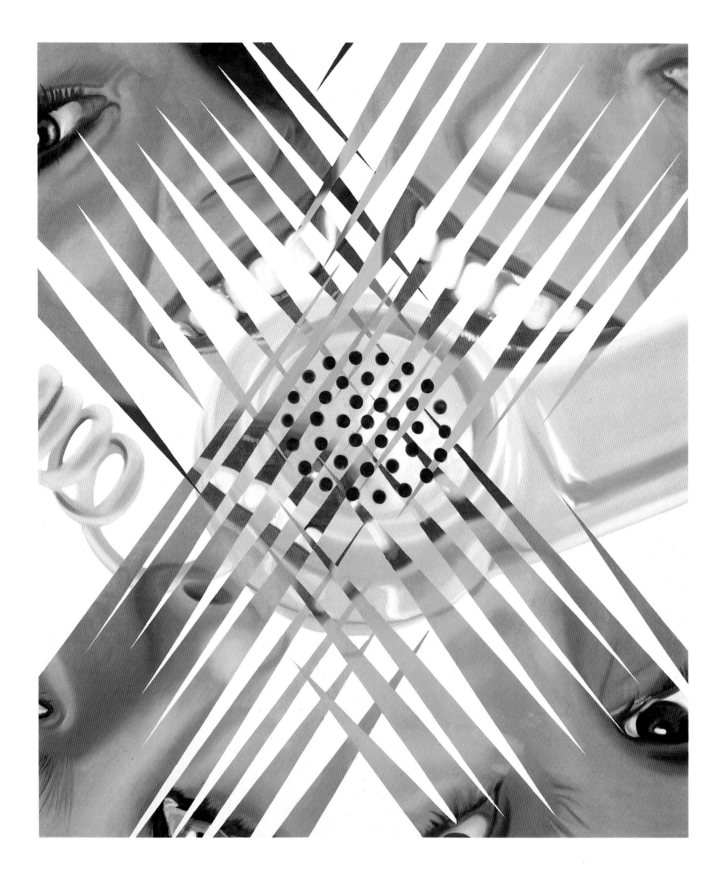

78. JAMES ROSENQUIST
Telephone Explosion, 1983
Oil on canvas mounted on board
78 x 66 in.
© 1996 James Rosenquist/Licensed by VAGA, New York, NY

79. CLAES OLDENBURG
Spring, Summer, Autumn, Winter,
(Apple Core Series), 1989
Four lithographs on paper
40 x 30 in. (each, approx.)

80. ANDY WARHOL
Letter to the World–The Kick, 1986
Serigraph
35½ x 35⅝ in.

81. Robert Rauschenberg
Bellini #1 (Bellini series), 1986
Eleven-color intaglio print on paper
58 1/8 x 37 7/8 in.

82. ROBERT RAUSCHENBERG
III (Samarkand Stitches series), 1989
Unique screenprint and fabric collage
63 x 49¹/₂ x 3¹/₄ in.

83. JOHN BALDESSARI
Equestrian (Flesh) In Brackets with
Orange Showdown, 1991–92
Two color photographs with acrylic paint
68½ x 96⅜ in. (total)

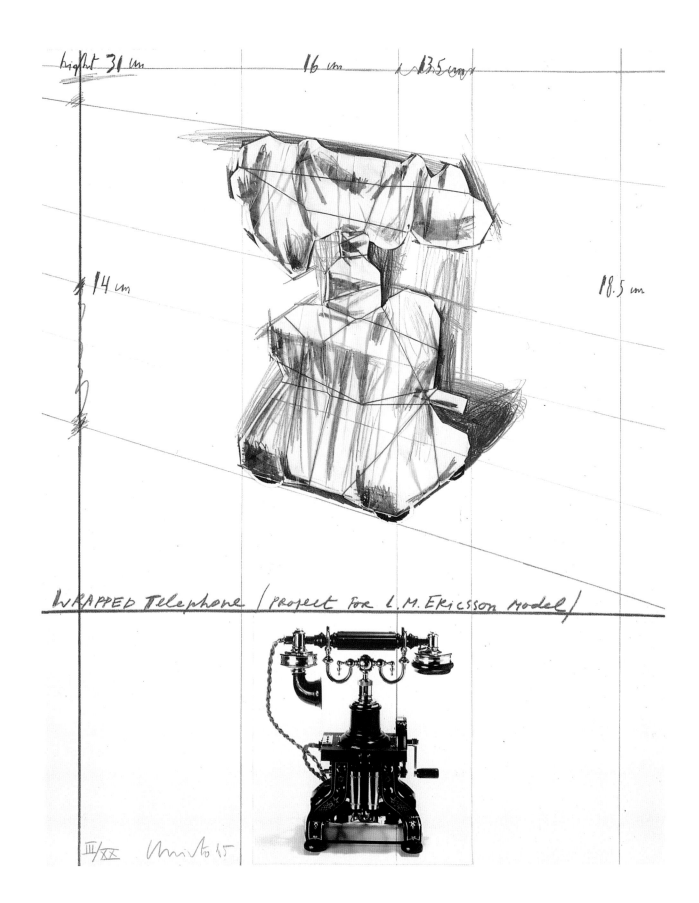

height 31 cm
16 cm
13.5 cm
14 cm
18.5 cm
WRAPPED Telephone (project for L.M. Ericsson Model)
III/XX Christo 85

84. Christo
Wrapped Telephone (project for L.M. Ericsson model), 1985
Three-color lithograph with collage on paper
27³/₄ x 21³/₄ in.
© 1985 Christo

85. EDWARD RUSCHA
Final End, 1992
Acrylic on canvas
70 x 138 in.

173

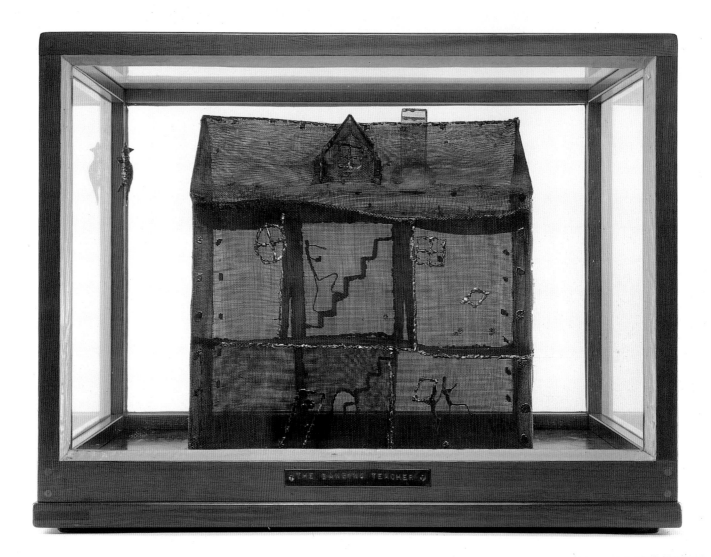

86. H.C. WESTERMANN JR.
The Dancing Teacher, 1972
Mixed media sculpture
20¾ x 28⅛ x 18 in.

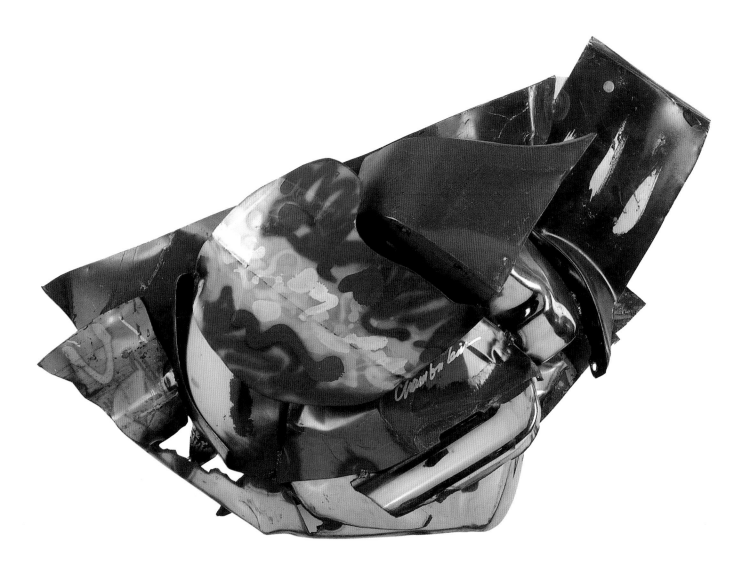

87. JOHN CHAMBERLAIN
chACE, 1985
Painted and chromium-plated steel relief
34 x 47 x 13 in.

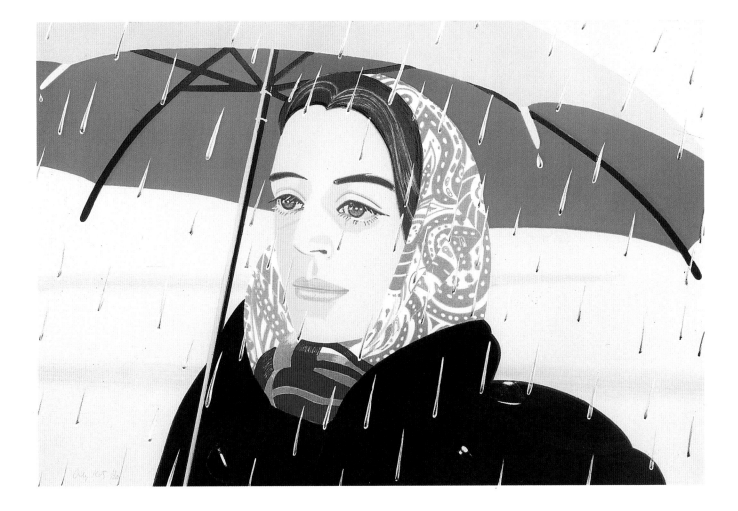

88. ALEX KATZ
Blue Umbrella, 1980
Lithograph on paper
20 x 30 in.

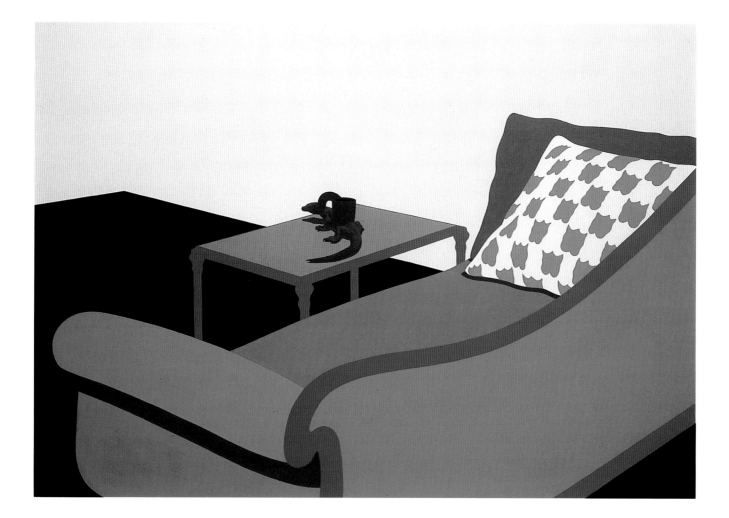

89. KENNETH PRICE
Lizard Cup, 1971
Poster paint on illustration board
25 x 35⅝ in. (image)

90. PHILIP PEARLSTEIN
Nude in Hammock, 1982
Lithograph on paper
30 1/8 x 40 3/8 in.

91. RICHARD ESTES
Holland Hotel, 1984
Serigraph and screenprint on paper
46 x 76 in.
© 1996 Richard Estes/Licensed by VAGA, New York, NY

92. Yvonne Jacquette
Queens, Night, Clouds
(Triboro Triptych at Night II series), 1987–88
Oil on canvas
79¼ x 63⅜ in.

93. YVONNE JACQUETTE
Manhattan, Night, Clouds
(Triboro Triptych at Night II series), 1987–88
Oil on canvas
79¼ x 63⅜ in.

94. YVONNE JACQUETTE
Staten Island, Night, Clouds
(Triboro Triptych at Night II series), 1987–88
Oil on canvas
79¼ x 63½ in.

95. Frank Stella
Damascus Gate III, 1968
Polymer and fluorescent polymer on canvas
60 x 240 x 3 in.

96. JOHN MCLAUGHLIN
Untitled 5103, 1963
Lithograph on paper
18 x 21½ in.

97. ED MOSES
Untitled, 1972
Lithograph on paper
23 1/2 x 31 1/4 in.

98. Sylvia Plimack Mangold
November 19, 1978, 1978
Oil on canvas
30 x 40 in.

99. ANA MENDIETA
Untitled (Amategram), 1981–82
Acrylic on amate paper
16 x 11⅝ in.

100. JOE GOODE
Untitled #17, 1987
Oil on board
84¼ x 36⅛ in.

101. ROBERT MANGOLD
Untitled, 1989
One of four color woodcuts on paper
14⅝ x 26½ in.

102. SOL LeWITT
Untitled (No. 1), 1989
Gouache on paper
22¹/₈ x 29⁵/₈ in.

190

103. JAMES TURRELL
First Light, C1 (Carn); First Light, C2 (Acro);
First Light, C3 (Ondoe); First Light, C4 (Phantom);
First Light series; 1990 *(each)*
Four of twenty etchings and aquatint on paper
42 1/8 x 29 3/4 in. (each)

"It takes a certain ability to perceive the fictiveness of history, and to proceed from there. To just decide one day, History is Fiction . . . and begin to see the degree to which things have to do with representation."

—*Richard Prince*

Contemporary Diversity

The Personal as Political

Leslie King-Hammond

> *"It is a peculiar sensation, this double-consciousness, this sense of always look-ing at one's self through the eyes of others, of measuring one's soul by the tape of a world that looks on in amused contempt and pity. One ever feels his twoness—an American, a Negro; two souls, two thoughts, two unreconciled strivings; two warring ideals in one dark body, whose dogged strength alone keeps it from being torn asunder."*

> W. E. B. Du Bois, 1903[1]

Nearly one hundred years ago, W. E. B. Du Bois wrote *The Souls of Black Folk*, a seminal work that, if Du Bois had never written again, would stand as a brilliant achievement securing his legacy as one of the great-est intellectual minds in American history. Du Bois outlined in this rather brief treatise fundamental issues crucial to the state of descendent Africans in America. The "peculiar sensation" of "double-consciousness" described in *The Souls of Black Folk* discussed for the first time in depth the principles of *duality* that still govern the lives of African Americans within the socially and politically fragmented structure of the United States. The conditions that surround living a double life cre-ate situations of enormous complexity. People caught between the polemics of the black-white ethos in the sociopolitical struggle for equal opportunity find themselves trapped in a society resistant to their presence and participation and opposed to the recognition even of their humanity.

Between this *veil* of the dark skin and the imposition of a double-conscious iden-tity, African-American artists have found themselves continually challenged by a para-doxical, if not schizoid, existence. Creating an imagery to mediate the ambiguity of their position in American society while simultaneously attempting to foster an au-thentic personal voice became a "warring" task for many artists of color in this na-tion. The question became how to visualize the multiple worldview experiences that many artists experience in some form simultaneously throughout their lives.

However, for artists of African descent in America, aesthetic issues would consume their creative and technical energies as they sought a means to transcend the stereotypical expectations prevalent in their respective eras. The confrontation be-tween the personal and the political often inspired these artists to invent an imagery that reflected, both overtly and subliminally, the conflicts inherent in Du Bois's white-black, double-identity crisis. Artists were further challenged by the complexity of the passive-aggressive interplay that occurs with *veiling*, or when a black person assumes a deliberate invisibility while in a dominant white situation. *Veiling* became a clever strategy employed by blacks to resist, agitate against, protect themselves from, and survive arduous conditions created by oppressive, Eurocentric, mainstream demands.

Prior to the twentieth century, black artists—enslaved, free, or freed—endured a range of staggering obstacles as they sought to find a means to express their earliest visions within the Western traditions of the fine arts and the remembered traditions of the lost homeland—Africa. The early black artist in America tried to reconcile the two traditions as a means not just to survive but to record and interpret that experience.

previous page:
WILLIAM A. CHRISTENBERRY
Alabama Wall II (detail), 1990

But it was not until the middle 1920s that the first significant community of black intellectuals, writers, political figures, scholars, leaders, musicians, and artists burst like a meteor onto the American scene in a movement commonly known as the Harlem Renaissance.

Langston Hughes was one of the most outspoken, respected, and prolific writers of the period. In 1926, he wrote an article that became the ideological manifesto for artists and writers of African descent to force open the doors of literary and visual experimentation with new forms of black imagery. Hughes, who was aware of the inherent risks that confronted these artists, declared:

> We younger Negro artists who create now intend to express our individual dark-skinned selves without fear or shame. If white people are pleased we are glad. If they are not, it doesn't matter. We know we are beautiful. And ugly too. The tom-tom cries and the tom-tom laughs. If colored people are pleased we are glad. If they are not, their displeasure doesn't matter either. We build our temples for tomorrow, strong as we know how, and we stand on top of the mountain, free within ourselves.[2]

Thus, the first renaissance of black intellectual thought and creativity in American culture was launched.

An heir apparent to this first major wave of critical thought was the young genius Jacob Lawrence (b. 1917), who was just a child during the years of the New Negro movement. Migrating to and settling in Harlem from Atlantic City, New Jersey, Lawrence soon became involved in the myriad cultural arts programs that flourished in the Harlem community from the 1920s to the 1940s. Charles Alston, himself a young painter studying at Columbia Teacher's College, was Lawrence's first teacher at the Utopia Children's Center after-school program. Lawrence drew strength from being in the midst of intellectuals, like Alston, who recognized his genius and "taught" him through nurturing and mentoring. They allowed Lawrence to find his own visual language through trial, error, and direct observation.[3]

By the time Lawrence was twenty-four years old, he had completed four of the most significant series of his career: Toussaint L. Ouverture (1937), Frederick Douglass (1938–39), Harriet Tubman (1939–40), and the critically acclaimed Migration of the Negro (1940–41). It was in the Migration series that Lawrence crystallized one of the essential concerns confronting African-American displacement: The politics of being denied ownership of land or a viable place to live free of harassment was a constant obstacle in the pursuit of a better quality of life. As a result, a sense of community was a critical component of Lawrence's urban experience, grounding him throughout a lifetime of visual explorations of the relationships crucial to understanding the unique dynamics of African-American culture. Lawrence firmly asserted, "I am a product of the Harlem community—it was that community which made me what I am today."[4]

Lawrence is a storyteller who draws his themes from historical events and contemporary genre scenes. His early narrative paintings with their African-American subject matter are a response to the "double-consciousness" experience of living in a racially segregated society. In a sense, by depicting scenes of black history and communal life, Lawrence's compositions "lift the veil," revealing the vitality of an otherwise invisible complex community alive with energy. As his work matured, Lawrence's more contemporary themes centered on humanistic issues of mutual concern to all people. *Builders in the City* (1993, pl. 116), one of a series begun in 1969, typifies his mature style with its placement of flat, opaque, bright colors. The painting fuses

figurative elements with the concerns of expressive abstraction. The movement of the workers, shown engaged in the creative energy of construction, acts as a symbolic comment on the role that Africans and, in the larger sense, all people played in building the New World. Reflecting the essentiality of these skills, tools are portrayed as three-dimensional abstract objects (tools held a special fascination for Lawrence and were often used as props in his paintings). Lawrence's work, which was rooted in the era of Social Realism when artists such as Philip Evergood, Ben Shahn, and Mexican artists José Clemente Orozco and Diego Rivera sought to address the problems in society by using figurative rather than abstract forms, has spanned more than seven decades. He was one of the first American Modernist artists of critical significance to emerge out of the creative fire of the Harlem Renaissance.

Artists of African descent were equally inspired by the Civil Rights movement of the 1960s, and saw in their community the opportunity to further pursue a visual identity of self-determined origins. Again, writers, musicians, historians, and scholars played a significant role in helping to articulate the voice and vision of a people still denied opportunity and access in American society. However, in 1965, it was a more angry and assertive voice that gave shape to the future agenda for all black artists. Defiantly, poet Amiri Baraka stated:

> The Black artist, in this context, is desperately needed to change the images his people identify with, by asserting Black feeling, Black mind, Black judgment. The Black intellectual, in this same context, is needed to change the interpretation of facts toward the Black Man's best interests, instead of merely tagging along reciting white judgments of the world.[5]

This was a pivotal moment for the black artist. The call to become a political advocate for the community, using art as a vehicle, meant that those artists who did not follow that path risked being rejected by their peers as well as by the art world at large.

A growing number of black artists were concerned that not only were they alienated from the mainstream art world but also that their own communities had little recognition and understanding of the role and relationship of the artist to the black community. These artists believed that it was essential for the artist to become the visual conscience of the community. They created positive, uplifting, self-determining models of cultural pride that focused on historical, heroic, symbolic, and iconographic imagery. Street murals and activist groups began to emerge all over the United States as artists reinvented the concept of Du Bois's "double-consciousness," striving to create their own distinctive imagery. Romare Bearden (1914–1988), a particularly active artist during the sixties, grew up between the dense urban culture of Harlem and the rural south of Mecklenburg County, North Carolina. In 1963, he founded an artists' group of fourteen members called Spiral. The purpose was to "examine the plight of Black American artists in America."[6] Meeting regularly, members of the group discussed the possibilities of working collaboratively on a single project in a collage medium. While the group eventually rejected the concept, Bearden found the collage technique to have great potential for expressing his ideas, and he set about experimenting with the form. Bearden's strong ties to his family and the community and his special love and respect for African-American culture became the inspiration for his canvases. Throughout his career, the painted mixed-media collage would remain his primary medium.

Lithographs became an extension of Bearden's experimentation with painting techniques and symbolic images. *In the Garden* (fig. 57) and *The Lantern* (1979, pl. 115) date from his late period when he excelled in the interplay of intense colors and the

Figure 57
ROMARE BEARDEN
In the Garden, 1979
Lithograph on paper
28¾ x 21⅛ in.

creation of a subtle narrative context. The central female figure in *In the Garden* stands with arm raised, evoking an acknowledgment or a blessing. The image of a rooster—often used by the artist as a sign of resurrection, transcendence, or liberation—is a powerful motif that recurs in Bearden's work, possibly inspired by the memory of Bearden's grandmother, herself a powerful woman. *The Lantern* was constructed with a similar intent. The male figure, who dominates the composition, holds a lantern, while flat planes of color reflect Bearden's primary collage techniques. Metaphorically, the lantern lights the way to freedom much as the "conductors" or "ticket masters" sent signals of safe passage for runaway slaves on the Underground Railroad. Bearden's work is profoundly spiritual with a deep reverence for nature. His images sought to discover and document the inherent retention of African traditions in the urban and rural black communities of America.

Photographer, artist, and storyteller Carrie Mae Weems (b. 1953) posed yet another worldview in the photographs that comprise her 1992 Sea Island Series. In that series, Weems investigated the Gullah culture of the Sea Islands located off the coasts of Georgia, South Carolina, and Florida. The Gullah are descendants of the Gola people who were brought to America in the late eighteenth century as part of the Atlantic slave trade. Geographic isolation allowed for the continuance of their African cultural traditions. Weems's work explores the relationship between their Gola heritage, the coastal environment, and the earlier slave experience.

The background of the untitled image in the SBC Collection (1992, pl. 153) is dominated by large expansive trees that fill the skyline. Nearly dwarfed by the trees are small shacks at the peripheral edge of a dense forest. Two cannonballs sit in the foreground and middle distance. This particular series was shot at the site of the Boone Plantation, which was used to reenact a battle from the Civil War. The cannonballs were deliberately placed as props for the reenactment.

Discussing the elements of diminutive shacks and looming cannonballs, Weems explained, "It became a question of how to circle all this material, how to tell the story and find the poetry in this ongoing historical fight over humanity. I tried to layer the entire series around perspectives of meaning."[7]

For that reason, the textual panel accompanying the photo is a device critical to Weems's work. It recounts an old Gullah tale about Africans who could fly back to Africa and away from slavery. Occasionally, the Africans would fly back to see their children and then return to the homeland. Metaphors of flight, like the presence of birds or lights in Bearden's compositions or the ladders in Lawrence's *Builders in the City*, are signifiers of freedom or deliverance in the pursuit of a better life. In contrast, the cannonballs, separate and immovable, evoke the memory of lost loved ones and a sense of physical disconnection from the homeland. These are photographs designed not only to preserve personal memory but also to document, recall, and give tribute to the legacy of Gullah African traditions in America and to question the issue of human bondage.

The work of Beverly Buchanan (b. 1940) is firmly rooted in her family ties to Georgia and the Carolinas. Born in North Carolina and raised in South Carolina, Buchanan moved to Georgia to practice her art. Encouraged in the 1970s by painters Norman Lewis and Bearden, she showed in her first works a keen interest in the tentative, asymmetrical architecture of poor Southern communities. *Miss Hester's Place* (1994, pl. 147) is a mixed-media reconstruction of an actual house built and occupied by Hester McCoy, a woman who had worked on a nearby air base for twenty years without a vacation. Buchanan's pieced re-creation of the McCoy house explores the unique personal application of materials that create a home. Buchanan juxtaposes the conditions of deprivation

from which Miss Hester cannot escape while celebrating the inventiveness of the form's originality.

The architectonics of shacks like this have intrigued Buchanan her entire life. She observed people living in despair and enforced poverty; however, their shacks resonated with an innate sense of spirituality and resistance. By including in *Miss Hester's Place* the presence of a rooster, a symbol of defiance and strength also used in Bearden's work, the artist cleverly honored the pride and nobility of a hardworking woman while simultaneously condemning the oppressive realities behind such impoverishment. Buchanan's structures are about the totality of the human experience, black and white. She states that "one important thing to clarify is that these shacks are not just about black people…that I knew growing up. Once I became an adult, I saw other people living in similar conditions.… These are not necessarily black or white structures."[8]

The politics of artists such as Lawrence, Bearden, Weems, and Buchanan confront the larger issues of identity and environment and locate African-American culture by expanding the definition of the American experience. A great number of black artists, however, worked in more subtle, conceptualized, or abstract personal modes, seeking to define this issue without using a literal or figurative approach. They realized that they risked rejection, as earlier suggested by Hughes, being well aware that nonfigurative and nonobjective art does not easily support sociopolitical concerns.

Carroll Sockwell (1943–1992) used the geometry of the square as a point of departure in *A Wise Tale* (1979, pl. 114), a small mixed-media composition. The central focus of the composition is a minute rectilinear construction of brightly colored abstract forms placed within a gray square mounted on a lighter gray panel set into a gray squared box frame. The framing or squaring device evokes a dissonant tension by isolating the bright energy-filled center in a succession of gray neutral grounds. Sockwell was an enigmatic "character" within the Washington, D.C. art world and community. He had strong feelings about being labeled or stereotyped by race and avoided exhibitions showcasing only African-American artists.

By contrast, the paintings of Lois Mailou Jones (b. 1905) highlight and celebrate the artist's African-American heritage. Her career, like that of Lawrence, spans seven decades. Jones's exceptional technical facilities allow her to explore many genres. She is equally adept in traditional or classical figurative motifs as well as in abstract compositional studies, and she has a strong command of wet media including oil, watercolor, gouache, ink, and acrylic. *Symbols d'Afrique II* (1983, pl. 118) is one of a series of paintings that reflect the culmination of her experience as a figurative painter, stage and costume designer, world traveler, and astute observer of cultural traditions. Drawing on the concept of strip-woven African cloth, Jones created a grid composition with a strong vertical axis, using the heads of working African women as the central theme. It is a symbolic statement of great power and beauty.

The brightly colored grids on each side of the central panel incorporate symbols critical to the worldview beliefs of Africans and Americans of African descent in the New World. Lightning bolts, trees, spirals, a rooster, the iron shoes of the *hogun*— a West African Dogon priest—are some of the symbols that form a part of the patterning and design of this painting. Jones found inspiration for this work in the weavings and appliqués of quilts stitched and pieced by African-American women, especially in the South. Many of the sources for these quilts, as well as Jones's conceptualized interpretation, can be found in the ceremonial cloths of the Fon, Ashanti, Benin, and Dahomey kingdoms of West Africa. Jones created *Symbols d'Afrique II* at a time

Figure 58
Bert Long Jr.
The Promise, 1986
Acrylic, canvas, and mixed media on
hydrostone frame
35¼ x 23½ x 6½ in.

when many African-American artists began to visit the continent of Africa for the first time. Jones's works reflect her synthesis of this West African heritage.

The remarkable diversity of African-American artists and their influences is further evident in the work of Bert Long Jr. (b. 1940). *The Promise* (fig. 58) is a mixed-media painting intended to elicit a response by integrating objects that agitate the viewer. To the right of the canvas is a dark tree trunk form set against a light ground punctuated by intense hues of red and blue. Into the tree a heart is carved, flanked by flowers of fire and ice, making symbolic reference to the emotional extremes of human relationships. Under the tree is a pair of boxing gloves, lending an element of confrontation to the scene depicted. Throughout the painting, a graffiti-style text *("darling, bastard, friend, brother, sister, trust, forever, lover, me+you, sex, agreement, peace, maybe, I need you, hate . . .")* fills the space with tension and energy. The surface thus is loaded with terms of endearment, conflict, and irresolution, while the gestural execution of the brushwork on the surface creates a mood of agitation and discomfort. The dichotomies of emotion and commitment challenge the artist, who must invent an imagery that will raise the consciousness of the audience while also signaling hope for positive social change and moral accountability between human beings. Long transcends the issue of the "double consciousness" by confronting the commonality of these human dynamics.

Sam Gilliam (b. 1933) is another painter of remarkable invention, vision, and originality. Driven by an insatiable desire to work at the edge of chaos, he found excitement in manipulating pigment and form. Late in the 1960s, he began his Carousel series of paintings that were so large they had to be worked on the floor of his studio. Employing canvases up to three hundred feet in length, Gilliam poured, dripped, and swirled acrylic pigments across the flat surface with large brooms used like paint brushes, playing with elements of chance and serendipity. As Gilliam stated, "I pour to experience the effects of gravity."[9] Bursts of energy seemed to surge across the canvas as the artist explored his fascination with the process of painting. Gilliam has constantly challenged traditional notions regarding the composition of a painting; smaller creations are just as important as the early works, which commanded a grander scale. *Renaissance I* (1986, pl. 112) is part of a series of rectangular abstractions assembled from edged strips of painted canvas aligned on an asymmetrical axis. A counterbalance rhythm is established between the play of intense, splashing color, sweeping textures, and shifting angularities of the reconfigured shapes of the canvas.

Much as it has been for Gilliam, the act of painting has been an activity of great inquiry for William T. Williams (b. 1942). Williams has long been preoccupied with the nature of painting and personal history, both of which are critical to the power of his aesthetic. *Red Admiral* (1990, pl. 113) is an investigation into a memory inspired by a Harlem building where his aunt lived when Williams was a child. Walking through the hallway, Williams was intrigued with the play of light as it altered the colors on the textured surfaces of the walls. In *Red Admiral*, he sought to recapture that memory and recount that experience in an acrylic medium using a wet-on-wet technique. The thickly applied layers of wet impasto acrylic have dried on the canvas to produce a deep crackle texture within the rectilinear red, green, and black grids of the painting. The abstracted space reflects a transmuted sense of color, texture, and light recalled from that hallway in Williams's past.

While Gilliam and Williams have developed distinctive styles and ideologies, the imagery of Jack Whitten (b. 1939) continues to expand the discourse on the nature of the painted surface. Whitten considers himself to be more of a "builder" than a traditional painter. His inspiration comes from a direct observation of the oppositional

forces in nature, which he dissects and reassembles on the canvas. It is a process he defines as "construction, de-construction, and re-construction."[10]

Fancy Triangle (fig. 59) is a "built" work made from sheets of clear acrylic one-eighth to one-fourth inches thick. Whitten "constructed" the texture of the sheets by adding dyes, eggshells, soot, and other materials to the acrylic while it was still wet. After the sheets were dry, he "deconstructed" them by cutting them into small tiles, which he calls *tesserae* to emphasize their connection to Greco-Roman mosaics. He then "reconstructed" the sheets by attaching the tiles to a canvas. This process links the mosaics of antiquity with Modernist and Postmodernist thinking about reality as a composition of particles and motion, evoking visual analogs as various as quiltmaking and DNA, computer chips and digital imaging.

The placement of painted chips in *Fancy Triangle*, like the daubs of paint in Impressionist paintings, produces a sensation of particalized light filtered through the atmosphere. Whitten uses imagery and the acrylic medium to create temporal connections between the past and the future and literally to reconstruct an aesthetic reality for the experience of African Americans in both a personal and political context. The choice to become an artist was not just about image-object making, but, according to Whitten, it was also about "an amazing kind of freedom":

> You can actually build this thing the way you want to build it The fact is that you have to re-create it. After all these years of work I realize I'm really setting the state and re-creating it so I can say that I have a place. If we were to take what we are saying politically, in terms of blacks in this country—blacks have to do this mentally, consciously. They have to establish a sense of place. And it's founded upon an aesthetic base.[11]

It has been stated often enough by politicians, critics, scholars, and just ordinary folk that there is nothing new in the making of art. More important, however, there is always a new way to see or interpret the process of image-making. Willie Cole (b. 1955) reshapes the thinking and attitudes about ordinary domestic objects with works that excite the eye and intellect. In 1989, Cole began a body of work that addressed what he called "Household Cosmology," referring to the blow dryers, irons,

Figure 59
JACK WHITTEN
Fancy Triangle, 1993
Acrylic and mixed media on canvas
32 x 32 in.

Figure 60
WILLIE COLE
Untitled (detail), 1994
One of six etched glass panels
13⅝ x 10⅝ in.

and ironing boards out of which he created huge sculptured figurations. Cole's aesthetic has been shaped by a structure of intersecting horizontal and vertical axes derived from the philosophical and spiritual belief systems of the Kongo people of the Congo-Angola region of Africa. Cole, who uses many found objects in the creation of his art, says, "The salvage pieces are political in the sense that ecology has become a political issue. But my making them deals with my aesthetic concerns and my interest in spirituality."[12] It is at this juncture that the "double-consciousness," or the pressure of black artists living and creating in a Euro-dominant culture, leads Cole to the following observation: "I think this is true with a lot of African-American artists, a need to find the African in themselves, whether they're conscious of it or not, it comes out in their work."[13]

Untitled (fig. 60) is a suite of six etched glass plates, in alternating states of gray tones, depicting the sole plate (underside) of a steam iron. It is startling both to recognize the image and to accept that its standing here as an art form in fact allows it to become an icon of hierarchical status. The commonness of the iron gives the viewers' sensibilities a moment of pause, thus forcing them to consider the deeper implications of this object's role in society and their own relationship to its functions.

Issues of the personal and the political continue to raise complex, difficult questions for the artist of African descent in America to address. In spite of the contradictions and conflicts imposed by a society largely in denial regarding the prevalence of racism in the United States, these artists will continue to find the means and mechanisms to create an imagery that addresses the duality or "double consciousness" of their specific conditions and the larger questions of humanity, while continually redefining the nature of contemporary American aesthetics.

As early as the 1930s, artists expressed very strong opinions regarding their role in society. In an essay for an exhibition of artists at Alston's studio in Harlem, Bearden stated:

> I believe that art is an expression of what people feel and want. In order for a painting to be 'good,' two things are necessary: that there be a communion of belief and desire between artist and spectator; that the artist be able to see and say something that enriches the fund of communicable feeling, and medium for expressing it.[14]

Until the issues of inclusion and representation are addressed within the larger discourse on the nature of American art, however, the position of the African-American artist will remain ambivalent even as we forge into the new millennium.

NOTES

1. W.E.B. Du Bois, *The Souls of Black Folk*, 3.

2. Langston Hughes, *The Nation*, 694.

3. Ellen Wheat Harkins, *Jacob Lawrence*, 25–58. Harkins provides an insightful discussion on the early activities and influences of Lawrence's first encounters in art.

4. Jacob Lawrence, conversation with the author, January 19, 1995.

5. Amiri Bakara, quoted in Harris, *Jones/Baraka Reader*, 167.

6. The Studio Museum in Harlem, *Memory and Metaphor*, 32. Original members of Spiral included Norman Lewis, Richard Mayhew, Hale Woodruff, Charles Alston, Felrath Hines, Alvin Hollingsworth, Perry Ferguson, Reginald Gammon, Emma Amos, Earle Miller, William Majors, Merton Simpson, and Calvin Douglas.

7. Carrie Mae Weems, conversation with the author, June 23, 1995.

8. Beverly Buchanan, quoted in Clark, *Parameters*, n.p.

9. Donald Miller, "Hanging loose: an interview with Sam Gilliam," *Art News* 72 (January 1973), 43.

10. Jack Whitten, artist's statement.

11. Jack Whitten, quoted in Wright, *Jack Whitten*.

12. Willie Cole, quoted in Brown, 21.

13. Ibid.

14. Romare Bearden, quoted in Studio Museum, Harlem, *Memory and Metaphor*, 24.

Ethnicity, Outsiderness, New Regionalism

Jacinto Quirarte

I n the past, artists represented in this collection with cultural, artistic, and historical ties to Mexico and other parts of Latin America have found themselves identified not by a particular art movement but by their "ethnicity." Artists have been labeled as Spanish American, Latin American, or Mexican American and in recent years as Chicano, Nuyo Rican, Cuban American, Latino, or Latino Hispanic;[1] however, *Hispanic* is now the most widely used and generally recognized term for Americans whose antecedents are found in Latin America. As this essay explores, while the label is sometimes useful—most of these artists are acutely conscious of their cultural roots—"ethnicity" does not necessarily explain the work of all Hispanic artists in the United States. Their art ranges over diverse territory, from overtly social, political, and cultural statements of life in the barrio, to multiple interpretations of Southwestern and Mexican heritage and imagery, and finally to the figurative and formal concerns that have long interested American and European artists.

The most visible and vocal group of Hispanic artists in the United States has its roots in the social and political upheavals of the 1960s, exemplified by the Civil Rights movement, the antiwar movement, and the women's movement, which politicized many ethnic minorities. Starting in the 1960s, American artists of Mexican ancestry began to identify themselves as Chicanos, an act of self-naming that erased the marginal status implied by a qualified "hyphenated" identity (i.e. Mexican-American) and the colonialist oppression underlying "Hispanic" labels. They also began to organize art groups in an effort to strengthen Chicano culture, to instill pride and a sense of identity within the community of Mexican Americans, and to create a new Chicano art.

The Chicano movement spawned an extraordinary outpouring of artistic activity in the barrios, where the vast majority of Mexican Americans and Chicanos lived. The new ethnic consciousness of Chicanos was particularly evident in the early manifestos drawn up by artists outlining their aims at the very beginning of the movement.[2] Since the goal of many Chicano artists was to create images for the community, their primary focus was on public art, such as outdoor murals. Chicano artists freely appropriated the forms and content of Mexican art and culture, fusing them with their own experience in the United States. Turning to the Mexican muralists for inspiration, they rediscovered their own roots, which they then linked to the barrio and to the surrounding Southwest. Like other artists of the time, they adopted formats that ignored the traditional demarcation of painting and sculpture as discrete entities, creating Environments and installations in addition to more established varieties of public art. What distinguishes the Chicano works from those of other contemporary Hispanic artists, however, is their distinct imagery and culturally coded meaning.

A number of artists paraphrased murals painted by Diego Rivera, José Clemente Orozco, and David Alfaro Siqueiros. Like them, they went through a "neo-Indigenist" phase similar to the Neo-Regionalist movement in other parts of American art, with its emphasis on nativist imagery and subjects.[3] But most of the work created by the early Chicano artists can be characterized as an art of protest. While this early movement drew most directly on the Mexican muralist tradition for its style, it also developed recurrent motifs linked to political protest, street life, and the ubiquitous car culture that grew from the freeway-dominated sprawl of large cities like Los Angeles. Many of these artists at first organized or belonged to art groups formed for the specifically political purposes of instilling ethnic pride and identity; only later did they work independently. Some of the most influential are Mel Casas (b. 1929), a painter and a founding member of Con Safos; the painters Carlos Almaraz (1941–1989), Roberto de la Rocha (b. 1937), and Frank Romero (b. 1941), all members of Los Four; Gronk (Glugio Gronk Nicandro, b. 1954), a Conceptual and performance artist as well as a muralist and co-founding member of Asco; and Daniel J. Martinez (b. 1957), a multimedia artist who joined Asco in 1984. All except Casas and Martinez painted murals at the height of the Chicano movement in the 1970s.[4]

Casas, a key figure in the development of Chicano art in San Antonio in the 1960s and 1970s, calls his works *humanscapes*. Their format is modeled on an outdoor movie screen that includes texts in the manner of subtitles along the bottom of the painting. The figures and images are defined in a hard-edged cartoon style with bright, flat colors. They contain visual and verbal puns that are critical of American society, particularly the discriminatory treatment of Chicanos in the United States that ensured their exclusion from access to political and economic power, as well as the use of sex to sell products on television and in other media. The latter concern links Casas's work to the concurrent Pop Art movement; however, whereas Pop generally accepted the commercialization of American society, Casas's work, like that of other Chicano artists, is explicitly critical.

In the 1980s, Casas began to focus on motifs that dealt less with homogeneous mass culture and more directly with the barrio and Texas. For instance, *Slyboots* (1993, pl. 145) is a late example of the artist's Pop aesthetic focused on stereotypical attributes of Texan culture. While Casas continued to use a modified humanscape format—his paintings still contain borders and distinct foreground and background images—he began to build up the glossy surface with tendril-like ribbons of color applied directly from tubes of paint. In the early 1990s he lived in Italy for a few years, where he found subjects for some of his later paintings, such as *On the Way to Paestum* (fig. 61), a landscape that employs the humanscape format.

Almaraz, a muralist and painter, was a prominent figure in the Chicano art movement of East Los Angeles in the early 1970s, when he focused his murals on political issues and the struggles of California farmworkers. An exhibition of his work along with the work of other members of Los Four at the Los Angeles County Museum of Art in 1974 brought Chicano artists and their concerns to a wider audience for the first time. Toward the end of the decade, however, Almaraz distanced himself from the Chicano movement and concentrated on broader concerns relating to the Southwestern landscape, Mexican and Chicano culture, and the culture of Southern California. Incorporating the cartoon style often used in his murals into his paintings, Almaraz developed an expressive style that reflects the brushwork of the Abstract Expressionists. He invariably divided the urban or landscape setting of his paintings with horizontal bands of bright colors and then added violent actions—a car crash on a freeway or the confrontation between coyotes depicted in his 1989 serigraph *Greed*

Figure 61
MEL CASAS
On the Way to Paestum, 1991
Acrylic on canvas
24 x 24 in.

(pl. 130). In contemporary Chicano culture, "coyotes" are those individuals who prey on Mexican farm workers as those workers illegally cross the border in order to find employment. The "coyotes" exploit these often destitute people by charging exorbitant prices to smuggle them into the United States. In contrast, the hummingbirds hovering overhead are common motifs in pre-Columbian art. As the two coyotes fight over a bare bone in the parched desert landscape, Almaraz suggests the spiritual depravation that can occur as a result of exploitative capitalism, or "greed." Thus, Almaraz uses ancient and contemporary symbolism to critique American culture.

De la Rocha, also a member of Los Four, has also consistently emphasized social issues and the car culture of Los Angeles in his work. His delicate drawing style, with its swirls, graffiti-like scrolls, and curvilinear shapes, encompasses texts in Spanish and English that elaborate upon the themes of his work. A good example of this is the untitled work in the SBC Collection (1994, pl. 121). The profusion of automobiles and hearts underscores the Angeleno's love affair with the car. The pictorial surface is framed by texts in the upper part that read *un carro a todo dar* ("a truly beautiful car") and along the right margin, which includes both the Spanish phrase *Ponle Colores* and its English translation, "Color it in."

The use of bright color to evoke the Latino people and popular culture of East Los Angeles also characterizes the highly textured paintings of Romero, another member of Los Four. His affinity with a Pop aesthetic, directed particularly toward American icons like the automobile, was shared by all members of Los Four, who were intent on giving expression to the "low" culture making up the vibrant core of Chicano life. In his large, multipaneled work, Romero arranged the elements of his still lifes and urban scenes as if they were being viewed head-on or from a slight elevation. In *Phone*, *High Heel Shoe*, and *Cherry Pie* (1995, pls.122–23, 125) he favored boxlike settings and broadly defined objects and figures, applying bright colors in a Fauve-like manner with heavy outlines. Only in street scenes like *L.A. at Night* (1995, pls.126) does a more complex spatial arrangement emerge.

Other groups, organized like Los Four to provide a forum for Chicano expression, were even more provocative. In 1971, Gronk helped cofound the East Los Angeles performance art group that became Asco. The group, which also included founders Harry Gamboa, Willie Herron, and Patssi Valdez, was named Asco (Spanish for *nausea*) in 1973 to encapsulate the reactions to the four performance artists' work by the people of the barrio as well as by the established art community. Their best-known work, *Walking Mural*, was performed on Whittier Boulevard in East Los Angeles around Christmas in 1972. In this work, the artists made fun of the early Chicano murals by dressing in costume: Valdez was Our Lady of Guadalupe, dressed in black; Herron was disguised as a portable mural with screaming faces; and Gronk became a walking Christmas tree. Gronk's primary focus in his controversial early works was barrio life. He later began to communicate his views of society beyond the barrio in large-scale paintings that provide humorous as well as satirical views of the world. His more Expressionistic paintings like *Electricity and Water* (1990, pl. 127) are characterized by the use of heavy black lines and broad areas of color to define the painting's figures. This work is part of the Hotel Senator series in which Gronk explored the seamy side of a once opulent hotel. Life, Gronk explained, is like hotels: "We check in, and we check out, and we never seem to get the hang of it."[5] The faceless figure in the painting is an outsider, a symbol of isolation, perhaps indicating the separation of Chicano artists and their beliefs from society as a whole.

Daniel J. Martinez, a Los Angeles installation artist and photographer, is also known for controversial works that challenge all forms of established authority. In

1984, he began to participate with Asco artists in a number of photo, video, and theater projects. As a photographer, he has used three-dimensional and holographic images in some of his installations, including the reproduction of enlarged photographic images on metal, as in his 1988 untitled work (pl. 150). The single human eye in this work points to multiple meanings about seeing and being seen. This photograph, part of a 1988 Martinez installation at the Santa Monica Museum of Art entitled *Big Fish Eat Little Fish,* was one of several identical images arranged around the perimeter of the room, which housed a grouping of figurative sculptures. The large eyes, relentlessly staring, created an unsettling and inescapable effect of being watched. This insistent attention to who is controlling whose identity, a dominant concern in Martinez's work, was also apparent in 1993 when the artist distinguished himself at the Whitney Biennial exhibition by wearing several identification buttons arranged to form the statement I CAN'T-IMAGINE-EVER WANTING TO BE-WHITE—a deliberately defiant statement and gesture. While members of Asco and other installation and performance artists eventually moved beyond overt protest, their emphasis on undermining authority—even the "authority" of their own art establishment—remains a constant in much of their work.

By the mid 1970s, many artists were drifting from the "public art" aesthetic. Their work shows fewer formal ties to the bright color and style of muralist-grounded protest art, ranging instead from Fiberglas sculptures to paper cutouts to manipulated, hand-colored photographs. Even earlier, many easel painters, sculptors, printmakers, and poster artists had been inspired by the Chicano movement and its celebration of Chicano identity without embracing the muralist form, while a number of muralists also painted easel pictures or produced altars and other nonmural work. A number of Chicano artists already had started in the late 1960s to exhibit their paintings, drawings, and prints in cultural centers and small galleries. Most of these exhibitions were strictly local and regional events, but with this mobility the impact of Chicano art was diffused, affecting artists across the United States. By the late 1970s, major exhibitions that included all Hispanic groups were being organized and presented in the United States and abroad.[6] However, by the end of that decade, as disagreements sprang up within the Chicano art community over its loss of purpose and direction, the formal cohesion of the muralist movement increasingly dissolved. The socially and politically driven art that had defined the Chicano movement began to give way to art influenced more by images associated with the Hispanic heritage of many artists working in the American Southwest.

Those Chicano artists who did not start out painting murals but nonetheless emphasized the people and culture of the barrio, the Southwest, and Mexico in their works include the sculptor and graphic artist Luis Jimenez (b. 1940), the painters and graphic artists Cesar Martinez (b. 1944) and Carmen Lomas Garza (b. 1948), the painter and muralist John Valadez (b. 1951), and the photographer Kathy Vargas (b. 1950).[7]

Jimenez's early works, produced in New York in the late 1960s and early 1970s, reflect American popular culture and the political upheavals of the time. He used polychromed cast Fiberglas for these sculptures, which he first depicted with colored pencils in preparatory drawings and prints (fig. 62). The automobiles, gas masks, large-breasted women, and motorcycles of his early work are highly stylized, cartoonlike configurations. In the early 1970s, however, Jimenez returned to his native El Paso and began to focus on the history and cultures of Mexico and the Southwest, specifically the Mexico-United States border, both as popular culture and as place. *Mustang* (1992, pl. 129) links the native mustang (from the Spanish *mesteno* for wild horse) to both the Mexican *vaquero* and the American cowboy. Jimenez began to add

Figure 62
LUIS JIMENEZ JR.
Mustang, 1994
Lithograph on paper
40⅝ x 29½ in.

colored lights to his figures in the early 1970s, and over the last ten years has devoted most of his time to producing large public works in different parts of the country.

Like Jimenez, Cesar Martinez began with images of the barrio (though his were not cartoonlike) only to expand to the landscapes of the Southwest borderlands. A painter and printmaker, Martinez began depicting barrio life in the late 1970s and early 1980s by creating a series of portraits of individuals from that community. He invariably presented a single figure in full frontal view, usually from the waist up, against a bright background. The social character and/or reputations of the sitters are clearly signaled by their attire and hair, as well as by the titles that themselves have multiple meanings. More recently, Martinez has broadened his aesthetic range to emphasize the landscape between San Antonio and Laredo and the confluence of cultures there, including ancient Mexico, the Southwest, and Spain. Highly textured paintings like *El Tiempo Borra Todo (Time Erases Everything)* (1994, pl. 138) have color schemes made up of tans, ochres, and browns that evoke the arid landscape of southern Texas. The subject of this painting, though obscured, is a man-made pyramid-shaped mound that is being eradicated by a *remolino*, or dust devil. The action, as well as the title of the painting, suggests the gradual elimination of human presence in a world dominated by the forces of nature.

The Texas border is also important to Garza. Although she is often identified as a San Francisco artist, Garza is originally from South Texas and she repeatedly draws on her experiences growing up to create her paintings, prints, paper cutouts, and installations (altars). Invariably focusing on Mexican and Mexican-American culture, she uses a folk style in defining a shallow space for the meticulously rendered figures and surroundings of her pictures. *A Medio Dia Como Los Camaleones* (fig. 63) is in part an homage to Mexican folk artists who use *papel picado*, or cut paper, in their art and in part a feminist gesture lending authority to this traditionally female form of expression. The zigzag markings of the two chameleons echo the details of the rocks and plants that surround them.

Valadez, a figurative artist who uses oils and pastels for his works, also focuses on events in daily life, though his subjects are the people of East Los Angeles and their surroundings, both in crowds and in single portraits. While Valadez is primarily interested in affirming his own identity and the identity of Chicanos as a group, his subject matter is radically different from the images more typical of Chicano protest art. Among his most noteworthy achievements is his portrayal of one of the busiest downtown streets in Los Angeles in *The Broadway Mural* (eight by sixty feet), completed in 1981 for the Victor Clothing Company. This masterful work is characterized by superreal renderings in very bright colors. The pastel drawing *MPICA* (1987, pl. 146) shows the same classic technique; its focus on the clothing, bric-a-brac, and Mexican "calendar" art typical of a barrio store contrasts with Valadez's technical mastery of a difficult medium.

Vargas, a directorial photographer who composes her works in the studio, departs even more radically from the formal approaches of other Hispanic artists. She uses multiple exposures of arranged objects or collages and then hand colors or otherwise alters them through drawing or painting. These images reflect her interest both in the concept of duality that is fundamental to the cultures of ancient Mexico and in the layering of time used by Latin American writers like Gabriel García Márquez. The photograph *FOR A #1* (fig. 64) reflects this concern for duality and layering in its overlapping elements. The central image is the shape of a heart, a recurring image in contemporary Mexican iconography that often appears in *milagros*, or metal offerings to a saint in exchange or thanks for healing. The heart is also significant in the history of Hispanic art where it has traditionally referred to love and piety, sacrifice, and suffering.

Figure 63
CARMEN LOMAS GARZA
A Medio Dia Como Los Camaleones, 1988
Gray paper cutout
25½ x 19⅝ in.

Figure 64
KATHY VARGAS
FOR A #1, 1992
Hand-colored gelatin silver print
22¼ x 17¼ in. (image)

FOR A #1 is part of a series in which the artist explored the emotions connected with death. For example, the inclusion of feathers, structured around the heart, indicates the joy of spiritual flight after being released from this world.

Whereas artists working at the height of the Chicano movement based their works on political issues, and other artists, such as Vargas, relied on imagery central to Hispanic culture, another group of Latin American artists created works that were based on formal and aesthetic concerns rather than ethnic or social ones. This tradition reaches back to the emerging abstract and nonfigurative styles of the postwar period.[8] As the art world continued to evolve in succeeding decades, artists who were Mexican American, Nuyo Rican, and Cuban American, and other Latino Hispanics came under the influence of the many "isms" that at different times dominated the art scene in the United States, Europe, and Latin America, including Pop Art, Funk Art, Conceptual Art, performance art, and installations.

Among those Hispanic artists deeply rooted in the postwar movements of Abstract Expressionism is Alberto Mijangos (b. 1925). Mijangos, now based in San Antonio, belonged in the mid 1950s to a generation of abstract painters in Mexico City known as *informalistas*, whose work was inspired by European, American, and Latin American Abstract Expressionists.[9] Although Mijangos left Mexico for the United States, he continued for a number of years to be identified with contemporary Mexican art. His work was included in the exhibition "Pintura Contemporanea de Mexico," which traveled to a number of Latin American cities in 1962.[10] Since then, however, he has exhibited as an American artist. Mijangos considers the painting of his intricately ordered abstract images, based on a Cubist grid, to be the result of a magical process between himself and the canvas. *T-Shirt III* (fig. 65) is one in a recent series of works based on the crosslike shape of an outstretched T-shirt. The T-shirt image (which is evocative of the crucified Christ), in its accessibility as a supremely ordinary article of clothing, points to the universality of Christ's passion in the Christian tradition.

Figure 65
ALBERTO MIJANGOS
T-Shirt III, 1988
Mixed media on canvas
80 x 80 in.

A younger generation of artists following Mijangos reflected in their work the assorted formal and philosophical issues raised by the pluralistic movements of the 1960s and 1970s. Jesus Bautista Moroles (b. 1950), a sculptor whose largely geometric stone pieces are monumental in scale, is one of many artists who continued to explore abstraction, while Jesse Amado (b. 1951), also a sculptor, turned to creating sixties-style installations. Roberto Juarez (b. 1952) joined other figurative painters in their rejection of the growing emphasis on flatness and a Minimalist approach, drawing imagery from European, Latin American, and "primitive" sources for his paintings.[11]

Moroles uses traditional materials such as granite to create abstract sculptures that evoke ancient monuments. This significance is enhanced by the sculptures' placement on the floor or on a pedestal, their geometric configurations, and their surface treatment. *Las Mesas Vase* (1993, pl. 136), a column that has been divided in horizontal bands, gives the impression of a vessel "boxed in" by the repetitive horizontal extensions. While its profound abstraction, only obliquely hinting at the vaselike shape within, would seem to remove Moroles's work from a particular ethnic identity, the native stone and its evocation of Meso-American monuments imbue the work with a sense of indigenous roots. In fact, the development of this and other of Moroles's industrial-scale sculptures owes as much to his technical/graphic training at several Texas schools as it does to his apprenticeship at Luis Jimenez's studio in 1979 (though he considers the exposure to Jimenez's work to have been pivotal to his development as an artist).

Juarez, who spent his formative years in Chicago, San Francisco, and Los Angeles, now works in New York. Primarily a figurative painter, he uses nuanced colors in a saturated form or bright colors layered to produce a highly textured surface. Reflecting the new pluralism that blends an international universality with more specific regional imagery, Juarez seeks out both modern and "primitive" sources for his carefully structured paintings: A still life with plants on a windowsill that recalls the work of Henri Matisse or a "primitivist" narrative picture that is reminiscent of Wifredo Lam's work. Works such as *Second Liquid* (1993, pl. 155), with the abstracted floral and "eye" elements in its cartouche design, exemplify Juarez's interest in the modern technique and sources such as pre-Columbian art.

Amado, a San Antonio artist, reflects the attitudes of earlier Conceptual artists in his two- and three-dimensional works of art. He considers his sculptures and installations, which bring together meticulously crafted objects made of diverse materials, to be the concrete realizations of his thought processes rather than art objects to be appreciated for their formal qualities. *One (MCMXCIII)* (1993, pl. 161) represents the beginning of an idea. The completion of the cones is a complex process that Amado documents in his mixed media works *Two (MCMXCIV)* (fig. 66) and *Three (MCMXCIV)*, which are also part of the SBC Collection.

Over the past several decades, the definition of American art has been greatly expanded to include the work of artists who had previously achieved, at best, only a marginalized status. As we are learning, the recognition, acceptance, and celebration of the art of ethnic minorities is a significant step in the realization of an art that is uniquely American. Accordingly, the Hispanic art represented in the SBC Collection comprises a significant part of the move toward pluralism that is rapidly changing the face of art in the United States. The works of Hispanic artists demonstrate both the innovations of successive postwar movements and traditional cultural practices. The sources, from historical to political, are varied, but the artistic language in all cases serves to give unique expression to the experience of artists negotiating within the two worlds of their various roots and their place in the United States.

Figure 66
JESSE AMADO
Two (MCMXCIV), 1994
Charcoal, graphite, chalk, tire black on paper
with metal frame
30 x 30 in.

NOTES

1. The terms *Hispanic* and *Latino* include Americans whose antecedents may be from the Caribbean, Central America, or South America. Americans of Mexican descent living in the Southwest, Pacific Coast, and Great Lakes regions have traditionally referred to themselves as Mexican Americans. Those living in New Mexico and Colorado whose beginnings can also be traced to Mexico, and New Spain before that, have preferred to call themselves Spanish Americans. Beginning in the mid sixties, Mexican Americans and Spanish Americans in all these regions started to identify themselves as Chicanos for political as well as ethnic reasons. The term *Chicano* is provisional and fluid. For instance, it does not encompass those artists who no longer identify with the movement that gave rise to their art or those artists who may never have been part of that movement. Nonetheless, all Chicano artists belong to a much broader culture whose beginnings can be traced to New Spain, Mexico, or the Southwest region of the United States. For more information, see Jacinto Quirarte, *Chicano Art History*.

2. For information on the manifestos of the Chicano movement, see Quirarte, *A History and Appreciation of Chicano Art*, 9–12.

3. Jacinto Quirarte, "A Search for Identity: Mexican and Chicano Art," 781–88.

4. For information on Casas, see Quirarte, *Mexican American Artists*, and Hickey, *Border Lord*. For information on Almaraz, Romero, and Gronk, see Beardsley and Livingston, *Hispanic Art in the United States*. For information on Martinez, see Burnham, "Art with a Chicano Accent." For information on Asco, see Gamboa, "In the City of Angels."

5. Gronk, quoted in Tarshis, "Lofty Daydreams, Harsh Reality."

6. For more information on exhibitions of Chicano art, see Quirarte, "Exhibitions of Chicano Art."

7. For information on Jimenez, Martinez, Garza, and Valadez, see Beardsley and Livingston, *Hispanic Art in the United States*. For information on Vargas, see Hulick, "Immortalizing Death."

8. For information on the figurative and abstract styles of Spanish American, Mexican American, and other Latino Hispanic artists and their work (paintings and murals) from the 1920s through the 1940s, see Quirarte, "Art," in Kanellos, *The Hispanic American Almanac*, 463–504.

9. *Informalismo* (Abstract Expressionism in the United States and Informalism in Europe) is identified with a number of Mexican painters who were influenced in the mid 1950s by the works of Willem de Kooning, Jasper Johns, Antonio Tapies, and Lucio Fontana. For further discussion, see Goldman, *Contemporary Mexican Painting*, xxii, xxiv, xxv.

10. The exhibition was organized by the Organismo de Promocion Internacional de Cultura (OPIC) and included works by the muralists, *abstractos* (abstractionists), and *Interioristas* (Insiders). The show traveled to such venues as the Museo de Arte Moderno de Chile (Santiago, Chile; May 1962), the Museo Nacional de Bellas Artes de Buenos Aires (Buenos Aires, Argentina; August 1962), and the Museo de Bellas Artes de Montevideo (Montevideo, Uruguay; October 1962).

11. For information on Moroles and Juarez, see Beardsley and Livingston, *Hispanic Art in the United States*.

Art After Modernism: The Pluralist Era

John Beardsley

At its deepest level, collecting is an effort to make sense of a culture. Despite the efforts of many sixties movements to eliminate art as an object to buy and sell, the acquisition of artworks remains a part of American cultural life. The sifting, selection, and display that define the collection of art are a way of establishing both personal and social identity. For individuals, collecting can be a way of affirming connoisseurship, superior intellect, and means. Among public and semipublic institutions—museums, universities, and corporations—collecting assumes educational and social functions as well. All collections have monetary value, but they also represent a wealth of knowledge, experience, and memory. They are a means of examining and understanding contemporary life, a way of coming to terms with history, and a forum for expressing cultural values and for constructing a collective identity. Assembled objects take on multiple associations, expressing something about the time and the place in which they were made, but also assuming new relationships and meanings in the context of the particular collection.[1]

Collecting is a deeply subjective activity in any field, but in art it is even more so, involving qualitative judgments in addition to assessments of historical value. In the present cultural context, collecting is still more problematic, which makes it more compelling than ever. American culture has probably never been as cohesive as it sometimes appears in hindsight, and in recent years, as disparate voices demand a hearing, it has become more avowedly pluralist, even fractious. The difficulty today of putting together a collection of contemporary art that is coherent and yet expressive of diversity is in some ways analogous to a much larger and still unfinished social project—the quest to create a common culture that is tolerant, even respectful, of its various parts. We have yet to make real sense of contemporary American culture. Collecting is one of several ways we might begin to talk about, if not resolve, some of our larger social dilemmas.

Our era is often described as Postmodern. This is a term with various meanings, depending on the user; it can refer simply to a renewed interest in historical precedent, or it can signify a thoroughgoing critique of the hierarchies and ideological assumptions implicit in Modernist culture.[2] Understood in the latter sense, Postmodernism clearly has given expression to the profound demographic and social changes that in recent years have injected new points of view about a range of matters including class, race, gender, ethnicity, and sexual preference into the conversation about contemporary culture. The rhetoric of Modernism is in retreat—not only the Modernist faith in innovation, progress, and benevolent technology, but also the conviction that the cultivation of individual intellectual and artistic freedom is compatible with or even

coincident with a more communitarian conception of social development. A number of dominant cultural theories have also been challenged, especially the notion that deep-seated racial and class divisions can be healed by eliminating legally sanctioned discrimination, and the conviction that all racial and ethnic groups in the end will merge seamlessly into the prevailing culture. The reassuring certainty that a single "master narrative" underlies all American history and culture has been shattered. Increasingly, we have to contend with the fact that American culture is composed of multiple voices that tell mutually contradictory stories about a shared history and a common social space; we must also reckon with the backlash that resists this heterodoxy.

In a world of social and cultural fragmentation, we speak haltingly across frontiers of class, race, and gender—frontiers we have only recently begun to acknowledge. Some other framework for understanding culture is needed, and pluralism offers a possible alternative. Originally a philosophical notion, pluralism gained its initial currency in this country through the efforts of psychologist and philosopher William James, first in *The Will to Believe* (1897) and then more extensively in *A Pluralistic Universe* (1909). It was a student of James's, Horace Kallen, who applied the concept to American society and coined the term *cultural pluralism*.[3] In the turbulent years of the late sixties, the pluralist idea drew many converts, and by the middle of the 1970s and into the 1980s, its popularity had started to provoke dissent. Most pointedly, dissenters argued that pluralism failed to describe the common values that could hold together a disparate society; they also observed that the cultural differences embraced by pluralism not only could flow from but also could reinforce social inequalities.[4] Yet some version of pluralism seems destined to prevail as a general model for American culture—perhaps the pluralism of historian John Higham, who has found his unifying faith in a concept he terms *pluralistic integration*.[5] By suggesting that a middle ground exists between full assimilation into a dominant culture and a dangerous Balkanization, Higham's pluralistic integration embraces ambiguity, creolization, and inclusiveness while calling for a reexamination of the values that might cement an avowedly disparate culture.

The art critic Donald Kuspit has acknowledged that a case can easily be made for pluralism as a model for artistic democracy. But he has critiqued pluralism as possessing "an inner uncertainty of direction inseparable from the rise of Postmodernism" and as promoting a hollow celebration of variety that obscures the loss of conflict between tradition and invention, once the animating force of Modernism. "Pluralism is worse than a way of suspending critical judgment," he wrote. "It is not knowing how to make any."[6] But to my mind, pluralism is not synonymous with the dissolution of the critical faculties. Rather, it supposes that they operate in a broader field in which different systems of value are in competition, even conflict, with each other. Pluralism is not, in other words, to be conflated with the simple celebration of variety. Although it assumes we can address difference without prejudice, it also proposes that the uneasy coexistence of diverse approaches to art is analogous to the competition among different groups for political and cultural authority.

Like any collection that seeks to represent the range of recent American art, the SBC Collection expresses the contested pluralism of Postmodern culture. Yet several general frameworks enable us to look at the collection and, through the collection, to glimpse the complexion of contemporary culture. For instance, the collection reveals the continued vitality of various forms of Modernist abstraction, from the combined gestural and geometric compositions of Sam Gilliam (fig. 67) and Charles Arnoldi (b. 1946) to the biomorphic abstraction of Stephen

Figure 67
SAM GILLIAM
Golden Neck, 1993
Offset lithograph and silkscreen with hand painting
43 1/4 x 29 7/8 in.

Mueller (b. 1947) and the shaped canvases of Joe Mancuso (b. 1954). Gilliam's work *Renaissance I* (1986, pl. 112) is an exuberant collage of acrylic on canvas combined with enamel on metal relief, while Arnoldi's *Billion* (1985, pl. 111) incorporates vividly colored sculptural elements with painted wood relief. Mueller's Chi Stories series, including an untitled work of 1993 (pl. 143), recalls Surrealist works derived from organic forms, and Mancuso's *Inside Straight* (1993, pl. 135) would seem to be a Minimalist-inspired composition of concentric rings on an oval surface, although it, too, has its organic sources—tree rings, in this case.

While confirming the continued strength of abstract painting, the SBC Collection also reveals that abstraction's hegemony has been challenged by a reengagement with some of the more traditional subjects and themes of art: Landscape and the figure, narrative and allegory. The baffling complexity of styles, in which the traditional is often blended with the contemporary, the abstract with the representational, reveals a willingness on the part of contemporary artists to confront political and social themes ranging from a celebration of ethnic and regional distinctions in American culture to commentary on sexual and racial discrimination. It acknowledges the proliferation of mediums as well. Photography, for example, is now generally perceived to be on a par with painting and sculpture, and video and performance have emerged as distinctive forms of contemporary visual expression.

As a way into the range of the collection, consider two paintings: *Waterfall of Ancient Ghosts* (1990, pl. 110) by Pat Steir (b. 1940) and *Sky in Cora's Marsh* (1986, pl. 105) by Neil Welliver (b. 1929). The former is a composition of white oil paint splashed and poured on a black ground, very much in the tradition of Abstract Expressionism; The latter is a more avowedly Realist image of a landscape near the artist's home in Maine. While they would thus seem to be diametrically different works, there are points of comparison between them. The Welliver painting has abstract elements: the linear pattern of trunks and branches that creates the dense web of the forest and the strong diagonal counterpoint in the fallen tree. The painting also has its visual anomalies, which reinforce the sense of nature abstracted; the dappled light seems to dissolve the solid surfaces, and the sky is inverted, barely visible through the trees but clearly reflected in the water.

Steir's painting, while apparently abstract, is highly evocative of a natural phenomenon, providing a visual analog for the relentless pouring and spraying of a waterfall. The effect is in part a function of the artist's technique: On a black ground, Steir released rivulets of white paint that spread across the canvas, then showered specks on top by flicking her brush, carefully avoiding a too-literal rendering of a waterfall. Part of the effect also comes from scale: the large canvas evokes the awesome power, even sublimity, of her subject in the manner of some of the grander nineteenth-century landscape painters. For all their differences, in other words, Welliver and Steir used landscape in these works as points of departure to explore both the expressive possibilities of paint and the emotional resonances of nature.

One could make other comparisons illustrating both the variety and the subtle correspondences among works in the SBC Collection. Take *Aloha Kakahiaka* (1984, pl. 108) by Billy Al Bengston (b. 1934), for example, and *Tides* (1990, pl. 109) by Richard Bosman (b. 1944). Bengston's painting is an optical puzzle, a seemingly abstract field defined by bands of color, while Bosman's is a far more literal rendering of a coastal scene. Yet Bengston's painting, on closer inspection, begins to resolve itself into a view through venetian blinds to a luminous sky streaked with the shadow of a passing plane, while Bosman's dissolves into patterns formed by the simultaneous repetition and transformation of the image in time. Like the Steir and Welliver

Figure 68
Vija Celmins
Ocean Surface–Second State, 1985
Drypoint etching on paper
23⅞ x 18⅞ in.

paintings, both suggest a reengagement with representational subject matter but from widely divergent points of view. They represent not a simple return to tradition but a reconsideration of the past in light of more recent abstract forms.

These four paintings might bracket a whole host of approaches to landscape that are evident in the SBC Collection, in which the competing claims of Realism and abstraction are answered differently by different artists. Vija Celmins (b. 1939), for example, might be seen as an extreme Realist in the meticulous rendering of her drypoint etching *Ocean Surface–Second State* (fig. 68) but for the lack of a horizon line. By making the representation virtually placeless, she has focused attention on the abstract play of lines that compose the image. John Alexander (b. 1945) combines in his work the turbulent surfaces and energetic brushwork of Abstract Expressionism with an inventory of images derived from the flora and fauna of his native East Texas. *Feathering the Cultural Nest* (1986, pl. 119) pictures the swamp of this region as a tangled and claustrophobic world populated with real and fantastical creatures in implausible combinations—birds and fish occupy the same space. The title of the painting is typical of the artist's humorous, even satirical streak, suggesting an analogy between the frenzied activity of nature and the rank acquisitiveness that often seems to animate the art market. Some landscape artists, such as David Bates (b. 1952), show even more pronounced regional distinctions. Inspired by the landscape and vernacular culture of the Gulf coast of Texas, Bates's *Evening Storm* (1993, pl. 120) features the fishing trawlers, palm trees, and stilt houses of port towns like Galveston, rendered in the broad brush strokes and blunt colors that often characterize the work of self-taught artists.

Still others use landscape to more narrative or allegorical ends. Through a combination of image and text, Vernon Fisher (b. 1943) explores parallel worlds of visual and verbal communication. His *Blue Landscape* (1984, pl. 154) features handwritten numbers and a typed narrative superimposed on a blue-tinted mountain landscape. There is a decidedly contemporary sense of dislocation or unease to the painting. Smoke erupts from the hills in the ominous shape of a mushroom cloud, while the text documents both optical and psychological failures in human perception. As is usual in Fisher's painting, no direct correspondence exists between word and image. While both contribute to the air of anxiety, the viewer is left to unravel any relationship they might have.

Although figurative works are less numerous in the SBC Collection, they reveal the same range in contemporary approaches to the human image. The work of Jim Martin (b. 1953) is at first glance quite abstract, with images rendered in an angular, blocklike fashion. But upon closer inspection, the figurative allusions are unmistakable as limbs and torsos drawn in black chalk tumble energetically across the paper. *Brabble* (1993, pl. 140) suggests the figure twinned, as if two bodies were locked in struggle or perhaps a figure and its shadow. The title is a slang term that means to squabble; as with many of Martin's works, the image is inspired by the word, the artist trying to capture in a visual medium the emotional directness of the linguistic form.

By comparison, Manuel Neri (b. 1930) creates work that is more Realist; it is also more closely identified with a regional movement. Neri is associated with the Bay Area Figurative School, an Expressionistic style that emerged in Northern California in the late 1950s and early 1960s among artists such as David Park, Elmer Bischoff, and Richard Diebenkorn. Somewhat younger than these painters, Neri translated the style into three dimensions. He often built his sculptures in plaster, hacking and abrading it to form a richly textured surface; at other times, he cast the plaster into bronze, as with *Rosa Negra #1* (1983, pl. 104). The bronzes, like the plasters from which they come, are typically painted with the loose brushwork and vivid colors associated with the Bay Area Figurative style.

As evident in Neri's work, as well as that of Alexander and Bates, much contemporary art takes on deliberately regional aspects, both to distance itself from the self-conscious internationalism of modern art and to challenge the primacy of New York as the center of the art world. Though regional tendencies are typically expressed in representational art, they can assume more abstract forms as well, thus conveying considerable ambiguity as local and more universal impulses meet. The work of the Texan Michael Tracy (b. 1943), for example, is often quite abstract, even as it evokes the forms and images of Mexican-American Catholicism, especially the icons, crosses, and altar pieces that furnish church interiors. *Septima Estacion: Que Sepamos Levantarnos de Nuestra Caidas* (1986, pl. 139), for example, is part of a series of works inspired by the Stations of the Cross, the images that illustrate the story of Christ's route to Calvary. Their sacred source is suggested not only by the title but also by the dramatic colors and the use of gold leaf, a common element in church decoration. *Santo de Noche* (1989, pl. 134), a painting by Tracy's fellow Texan Virgil Grotfeldt (b. 1948), shows some of the same interest in ritualistic imagery. In a dreamlike space floats a group of golden images made of bronze powder, including a rough cross and a ring that suggests a halo or crown of thorns. Still another Texan, James Surls (b. 1943), has expressed some of the same ambiguity by blending the local and the universal in sculpture. His pieces, hewn from the pines of rural East Texas, where Surls lives, often exploit the shape of the wood itself in the spirit of root sculptures by self-taught Southern artists. But they have an emblematic quality that reaches beyond the local. The spiraling form of *Around the Sun* (1985, pl. 133), for example, suggests a cosmographic rendering of the universe.

Since the late 1960s waning of Minimalism, with its geometric rigor and machine-tooled precision, sculpture has returned to a more handcrafted and allusive character. Some artists, such as Lynda Benglis (b. 1941), have opted for a kind of organic abstraction. Her *Eridanus* (1984, pl. 106) is an elegant, almost floral, composition that is made paradoxically from corrugated metal, which she bent and folded almost as if it were fabric. Other artists, like Howard Ben Tre (b. 1949), allude to functional forms such as the column or vessel in their work. Ben Tre, utilizing the technically difficult medium of cast glass, takes a material we expect to be light and flawless and renders it thick, opaque, textured, and sometimes fractured. *Second Beaker* (1990, pl. 132), with its bronze base and interior lining, has a reflective, luminous quality that suggests a pillar of ice. Still others explore figurative and regional motifs. Timothy Woodman (b. 1952) creates aluminum relief sculpture, cutting and riveting sheet metal, then painting it with oils. Although his material is flat, Woodman achieves the illusion of three-dimensionality through the painted image. *Woodcutters* (1987, pl. 117) depicts a scene of north woods lumberjacks in their characteristic caps and plaid flannel shirts.

Along with painting and sculpture, the SBC Collection features work in a number of newer modes. In particular, it documents the establishment of photography as an expressive medium virtually on a par with painting and sculpture. Photography is similarly open to a wide range of approaches, from the meticulous technical and compositional concerns of fine-art photographers to more Regionalist or narrative impulses. The works of Robert Mapplethorpe (1946–1989) and Jan Groover (b. 1943)—in vastly different ways—convey a strong Formalist emphasis in their carefully composed images that draw on the traditional figure and still life. Mapplethorpe achieved considerable notoriety near the end of his life for explicitly homoerotic photographs, the exhibition of which incited battles over censorship and pornography, especially in Washington and Cincinnati. But obscured in

Figure 69
JAN GROOVER
Untitled, 1988
C-Print
33¾ x 26⅞ in. (image)

the fuss was a sense of Mapplethorpe's considerable technical skills and his feeling for serene, balanced, almost classical form, all of which are evident in his enigmatic silver gelatin portrait *Alistair Butler, 1980 (Hands Over Face, NYC)* (1980, pl. 149). Groover's work, represented in the collection by two untitled type "C" prints (fig. 69), often centers on the mundane, sometimes mass-produced objects of domestic existence, which the artist endows with an almost preternatural perfection through odd juxtapositions, complex spatial illusion, and theatrical effects of light and shadow.

The photographs of William Christenberry (b. 1936) reveal an equal emphasis on composition, but they convey a more regional flavor as well. Christenberry has spent much of his artistic life creating loving depictions of the landscape, road signs, and vernacular architecture of Hale County, Alabama, where he grew up on a farm. *Red Building in Forest, Hale County, Alabama* (1989, pl. 148) is part of a continuing series documenting the roadside structures of his home county—stores, gas stations, and farm buildings—to which he returns again and again, showing these common landmarks as they succumb to age and to the cultural transformations of modern life. These images serve as works of art in their own right, as well as inspiration for small architectural sculptures that he makes in his studio in Washington, D.C. Christenberry's photographs convey a generally elegiac feeling, but they express more particular narratives as well. The red building is deeply enigmatic, evidently windowless, and swallowed up by the forest; the small sign that reads BEAT 13 alludes to its use as a rural polling station.

Photography's narrative impulse also finds expression in the works of William Wegman (b. 1943) and Sandy Skoglund (b. 1946). Wegman's work is wildly humorous, featuring his Weimaraner dogs—first Man Ray, then after Man Ray's death, Fay Ray—in a variety of utterly implausible circumstances. In *Rapunzel* (1991, pl. 152), the dog sits upon a table with long golden hair cascading down over not one, not two, but *three* oversized Polaroid prints. Skoglund's narratives are equally unlikely, but more Surreal in character. She creates actual environments with figures and props, which

she then photographs to fantastic effect, as in *The Sound of Food* (1986, pl. 151). A dye-transfer photograph, it includes an oversized cat seemingly ready to pounce on a bowl of food held by a woman in a leopard vest and tie. The inconsistent scale of the figures, the impossible spatial relationships, and the almost lurid hues of pink, orange, and blue render the image at once comic and disturbing.

Among other new mediums represented in the SBC Collection are video and performance art. A pair of lead and Fiberglas *Stalin Chairs* (fig. 70) are by the producer and director Robert Wilson (b. 1941). Best known for his opera *Einstein on the Beach*, with music and lyrics by Philip Glass, and for his long, nonnarrative performance pieces such as *the CIVIL warS*, Wilson also makes sculptures based on the sets of his theater pieces. The *Stalin Chairs* are enigmatic, draped armchairs inspired by the multimedia performance work *The Life and Times of Joseph Stalin*, which was first produced in 1973.

The collection also includes a provocative video installation, *Untitled (Virtual Memory)* (1987, pl. 162), by Gretchen Bender (b. 1951). The blocky construction of burnished stainless steel houses sixteen monitors—four on a side—that project laser-disc images. The visual material is assembled from existing video clips, computer graphics, magazine illustrations, and reproductions of the works of other contemporary artists. At times, all four monitors on a side display the same image, then, one by one, the images change until all are different. As the images flicker, so does the reflective steel surface, which is burnished with vigorous gestural patterns in a way that recalls the *Cubi* sculptures of David Smith. Bender's installation addresses the proliferation of images in American culture, where television and the computer, rather than the written word, have become the primary sources of information. It also reflects the confusion that results from seeing news, dramatic reenactments, fiction, and advertising in quick succession. All imagery becomes equal and, in some senses, equally meaningless. The parenthetical title, *Virtual Memory*, suggests that this phantasmagoric inventory of shifting images is replacing more substantial and meaningful versions of public history.

As Bender's construction confirms, some artists have begun addressing the fragmented, contested character of contemporary culture directly. Barbara Kruger (b. 1945), for example, is explicitly concerned with power, investigating the ways that hierarchical political, economic, and gender relationships are expressed in the mass

Figure 70
Robert Wilson
Stalin Chairs, 1992
Lead over Fiberglas
7¾ x 19¾ x 20½ in. (each)

Figure 71
RACHEL HECKER
Shut, 1994
Acrylic on canvas
24 x 24 in.

media. Utilizing the conventions of advertising—and with a nod in the direction of post-revolutionary Russian and Weimar German photomontage—she typically juxtaposes image and text to undermine repressive representations, especially of women. The SBC Collection includes four lenticular photographs by the artist (all 1985, pls. 157–60), which are composed of two layers of images. From some vantage points, the upper only is visible, while from others, the lower predominates. The upper is a tinted lenticular surface that bears a written text; beneath is a grainy, black-and-white photograph, often with its own text.

Despite being graphically plain, these compositions are conceptually ambiguous. One features the face of a woman peering through some kind of mesh, coupled with the text "We are astonishingly lifelike." On the lenticular surface is the urgent plea, "Help! I'm locked inside this picture," suggesting, perhaps, that women are trapped by stereotypical images remote from their real experience. Another bears the message "We decorate your life," pointing to women as projections of male desire and possession as a form of control. Economic power is the subject of another, which features an image of a half dollar beneath the words "God is on your side."

The power of the mass media, not only in the production and distribution of images but also in the representation of cultural values, is also explored by artists such as Rachel Hecker (b. 1958) in *Shut* (fig. 71). The photographs of Richard Prince (b. 1949) (fig. 54; see page 155) are copied almost exactly ("appropriated") from advertisements, constituting both a challenge to the Modernist orthodoxy of originality and a commentary on commercialism. An untitled print of 1993 (pl. 163) evokes familiar cigarette ads, inviting us to consider the stereotypes of American masculinity and the way that an icon of manliness and health is paradoxically used to lure people into an unhealthy pursuit. The painter David Salle (b. 1952), like Bender, shows us the jarring and often apparently meaningless juxtapositions that are increasingly common in an image-saturated society; like Kruger, he often invokes gender conflicts. *Sugar Bowl with Carved Bird* (1988, pl. 156) foregrounds the two named objects, the former floating over a representation of a big-busted woman. While there is no explicit narrative here, the work carries allusions to the objectification of women—who are regarded as either useful or decorative in the manner of the sugar bowl or the carved bird—and a subtext about pornography: "Sugar bowl" alludes to the perception of

women as little more than the sum of their sexual parts, and the bird becomes a predatory phallic stand-in. Gender identity and conflict are likewise a theme in the work of Robert Longo (b. 1953). His lithograph *Eric* (1984, pl. 165), from the Men in the Cities series, shows a male in corporate dress caught in a severely contorted pose, suggesting the emotional pressures exerted by conventionalized notions of masculinity. The bronze relief *Strong in Love* (1986, pl. 166), by comparison, alludes to erotic conflict between men and women. Eyes closed, the pair kisses, seemingly conjoined, but the hair sweeps back to form snarling canine heads, revealing the contention beneath the surface.

Competing ideas about racial and ethnic identity are also apparent in the collection, which includes a good representation of African-American and Latino artists who have come to prominence in recent years (see pages 194–209). Although their works are examined in detail in other chapters in this volume, it is crucial in the context of this essay to acknowledge that ethnic and racial groups are themselves pluralist. Among the African Americans featured in the collection are the abstract painter Gilliam; the Realist Jacob Lawrence, who celebrated the black working class in his gouache *Builders in the City* (1993, pl. 116); and the photographer Carrie Mae Weems, who combined image and text to evoke slave narratives about freedom in her Sea Island series (1992, pl. 153). Latino artists are equally diverse, ranging from those who are deeply embedded in the popular culture of their communities to those who look to more international and formal sources of inspiration. The Los Angeles artists Frank Romero (1995, pls. 122–26) and Roberto de la Rocha (1994, pl. 121) explore images drawn specifically from an urban car culture, while the Texan Luis Jimenez (1992, pl. 129) depicts icons of the West—the cowboy and the mustang—in the shiny enamel and Fiberglas of commercial art. By contrast, the New York painter Roberto Juarez is represented in the collection by an elegantly patterned, almost calligraphic abstraction (1993, pl. 155), as well as an earlier print (fig. 72), and the work of the Texas sculptor Jesus Moroles (1993, pl. 136) is exemplified by a rigorously geometric column sliced in bands to reveal the form of a vase within.

In addition to winning their place in the larger art world, these artists have all weathered debates over how much their art ought to express the values of their respective communities and how clearly it ought to reveal the particular visual traditions of Africa or Latin America. Each of these African-American or Latino artists has answered the competing claims of individualism and community in a distinct way, just as the many other contemporary artists in the collection have had to grapple with the bewildering cultural circumstances that confront us all. Some address social conflicts directly; others embody them in the wide range of competing affinities to which they owe their allegiance.

Taken as a whole, the SBC Collection suggests some of the ways that individual identity is forged from the convergence of personal and social experience. It offers some larger lessons as well, revealing disparities in individual perspectives and exemplifying some of the ways that we might begin to speak across the barriers of race, class, gender, and ethnic heritage. These artists are affirming the importance of articulating various points of view on how we define ourselves in the effort to construct a more democratic civic life. What is at issue in this collection, as in the culture it examines, is whether or not American society will ever be able to reconcile pluralism with the values of a common culture—that is, whether diversity will be our distinct endowment or our ultimate undoing.

Figure 72
ROBERTO JUAREZ
Pine-Palm, 1987
Color woodcut print on paper
74 x 37½ in.

NOTES

1. For more on collecting, see Clifford, "On Collecting Art and Culture," in *The Predicament of Culture*.

2. By now, writings on Postmodernism are legion. Two good anthologies that provide an introduction to the subject are Foster, *The Anti-Aesthetic*, and Wallis, *Art After Modernism*. Harvey, Huyssen, Jameson, and McEvilley, among others, have since authored books on the subject.

3. Horace Kallen's ideas were articulated in *Culture and Democracy in the United States* (New York: Boni and Liveright, 1924), in which he first used the term "cultural pluralism," and later in *Cultural Pluralism and the American Idea* (Philadelphia: University of Pennsylvania Press, 1956).

4. For a general critique of the pluralist model, see Mann, *The One and the Many*; on the notion that cultural differences can perpetuate social inequity, see Nicholas Lemann, "The Origins of the Underclass," *The Atlantic* 257 (June 1986), 31–55, and 258 (July 1986), 54–68.

5. John Higham, *Send These to Me*.

6. Donald Kuspit, "The Emptiness of Pluralism, the End of the New," in *The New Subjectivism*, 521–30; quotation is from p. 529.

104. MANUEL NERI
Rosa Negra #1, 1983
Bronze with enamel paint
67 1/2 x 36 x 17 3/4 in.

105. NEIL WELLIVER
Sky in Cora's Marsh, 1986
Oil on canvas
96 1/8 x 120 in.

106. LYNDA BENGLIS
Eridanus, 1984
Bronze, zinc, copper, aluminum,
and wire relief sculpture
58 x 48 x 27 in.

107. TONY BERLANT
Music of the Spheres #7, 1989
Found metal collage on plywood with
steel brads
127 x 121¼ in.

108. BILLY AL BENGSTON
Aloha Kakahiaka, 1984
Acrylic on canvas (two panels)
48 x 60 in. (each)

109. RICHARD BOSMAN
Tides, 1990
Oil on canvas (two panels)
36 1/8 x 96 in. (each)

110. PAT STEIR
Waterfall of Ancient Ghosts, 1990
Oil on canvas
78 x 150½ in.

111. Charles Arnoldi
Billion, 1985
Acrylic on wood relief
60 x 168 x 12 in.

112. SAM GILLIAM
Renaissance I, 1986
Acrylic on canvas and enameled metal relief
73 3/4 x 88 5/8 x 8 in.

113. WILLIAM T. WILLIAMS
Red Admiral (111½ Series), 1990
Acrylic on canvas
52¼ x 34¼ in.

114. CARROLL SOCKWELL
A Wise Tale, 1979
Mixed media relief
30⅛ x 30⅛ x 5½ in.

115. ROMARE BEARDEN
The Lantern, 1979
Lithograph on paper
28½ x 20 in.

232

116. JACOB ARMSTEAD LAWRENCE
Builders in the City, 1993
Gouache on paper
19 x 28 5/8 in.

117. TIMOTHY WOODMAN
Woodcutters, 1987
Oil paint on prepared aluminum
71 x 36 x 11¾ in.

118. Lois Mailou Jones
Symbols d'Afrique II, 1983
Acrylic on canvas
35³/₈ x 25¹/₂ in.

119. JOHN ALEXANDER
Feathering the Cultural Nest, 1986
Oil on canvas
77 x 83 in.

120. DAVID BATES
Evening Storm, 1993
Oil on canvas
36 x 48 in.

121. ROBERTO ISAAC DE LA ROCHA
Untitled, 1994
Mixed media on paper
8 1/2 x 11 in.

122–126. FRANK ROMERO
High Heel Shoe, 1995
Phone, 1995
Car, 1995 (2 panels)

Cherry Pie, 1995
L.A. at Night, 1995
Acrylic and oil on wood
23½ x 23½ in. (each)

127. GRONK
Electricity and Water, 1990
Acrylic on wood
24 x 24 in.

128. Elizabeth Murray
Down Dog, 1988
Nine color lithographs and twelve col-
laged papers on paper
41 x 50¾ in.

129. LUIS JIMENEZ JR.
Mustang, 1992
Cast Fiberglas sculpture
29½ x 8 x 8 in.

130. Carlos Almaraz
Greed, 1989
Serigraph and screenprint on paper
40¹/₈ x 47 in.

131. Lucas Johnson
Untitled (Hope, Idaho Series), 1994
Ink and ink wash on paper
10½ x 9 in.

132. HOWARD BEN TRE
Second Beaker, 1990
Cast glass, bronze, lead, and bronze powder
54 x 19 in. (diameter)

133. JAMES SURLS
Around the Sun, 1985
Pine and steel sculpture
53 x 63 x 19 in. (approx.)

134. VIRGIL GROTFELDT
Santo de Noche, 1989
Acrylic and metallic powder on paper
52½ x 51⅛ in.

135. JOE MANCUSO
Inside Straight, 1993
Acrylic on canvas
82 1/8 x 59 3/4 in.

136. JESUS BAUTISTA MOROLES
Las Mesas Vase, 1993
Morning Rose granite sculpture
30³⁄₈ x 15¹⁄₂ x 3¹⁄₈ in.

137. TERENCE LA NOUE
Ringmaster I, 1993–94
Mixed media on canvas
51³/₈ x 48¹/₄ in.

138. Cesar Augusto Martinez
El Tiempo Borra Todo
[Time Erases Everything], 1994
Mixed media on wood
65³/₈ x 65¹/₄ in.

139. Michael Tracy
Septima Estacion: Que Sepamos
Levantarnos de Nuestra Caidas, 1986
Acrylic, paper, and foil on Mexican board
39½ x 27½ in.

140. Jim Martin
Brabble, 1993
Colored chalk on paper
71³⁄₄ x 50³⁄₈ in.

141. KATHERINE BOWLING
Omen, 1993
Oil on panel
23⁷⁄₈ x 23⁵⁄₈ in.

142. JOSEPH HAVEL
One Week Collar, 1995
Bronze sculpture with cream patina
32½ x 7 in. (diameter)

143. STEPHEN MUELLER
Untitled 1993 (Chi Stories series), 1993
Acrylic on canvas
28 x 28 in.

144. JULIE BOZZI
Untitled, 1990
Oil on paper
10 x 14 in.

145. MEL CASAS
Slyboots, 1993
Acrylic on canvas
24 x 24 in.

258

146. JOHN VALADEZ
MPICA, 1987
Pastel on paper
50 x 38³/₈ in.

147. BEVERLY BUCHANAN
Miss Hester's Place, 1994
Mixed media wood sculpture
27 x 18¼ x 19½ in.

148. WILLIAM A. CHRISTENBERRY
Red Building in Forest, Hale County, Alabama, 1989
Ektacolor print
20 x 24 in.

149. ROBERT MAPPLETHORPE
Alistair Butler, 1980
(Hands Over Face, NYC), 1980
Unique gelatin silver print
30 x 30 in.

150. DANIEL J. MARTINEZ
Untitled (Big Fish Eat Little Fish,
site-specific installation), 1988
Photograph on metal
48 x 48 in.

151. Sandy Skoglund
The Sound of Food, 1986
Dye transfer photograph
20 x 24 in.

152. WILLIAM WEGMAN
Rapunzel, 1991
Three Polaroid prints
86 1/2 x 22 in. (total)

Lots of slaves brought over from Africa could fly. There folks can fly even now. They tell me them people could do all kinda curious things. They could even make farm tools work for em just by talkin to em. And some of em could disappear at will. Wist! And they'd be gone!!

Ole man Waldburg own slaves, and worked them hard and one day they was hoein' in the field and the driver come over and two of em was up under the shade tree and the hoe was working by itself. The driver say "What's this?" and they say,

Kum Buba Yali
Jum Bumba Tambe,
Kum Kunka Yali, Kum Kuma Tambe

Quick like. Then they rize off the ground and flew back to Africa. Nobody ever see em no more. My grandmother see that with her own eyes. Anytime they wanted they would fly back to Africa, then come back again to the plantation. They'd come back cause they have chillun who didn't have the power to fly and had to stay on the plantation.

153. CARRIE MAE WEEMS
Untitled (Sea Island series), 1992
Gelatin silver print with text panel
31 x 31 in. (image)
19 1/8 x 19 1/8 in. (text)

154. VERNON FISHER
Blue Landscape, 1984
Acrylic on paper
70¾ x 84¾ in.

155. ROBERTO JUAREZ
Second Liquid, 1993
Acrylic, peat moss, Japanese paper,
pastel, charcoal on linen
46 x 58⅛ in.

156. DAVID SALLE
Sugar Bowl with Carved Bird, 1988
Oil and acrylic on canvas (two panels)
41 x 28 in. (each)

157–160. Barbara Kruger
Untitled, 1985 (each)
Lenticular photograph
20 x 20 in. (each)

161. Jesse Amado
One (MCMXCIII), 1993
Charcoal, graphite, chalk, tire black
on paper with metal frame
24 x 24 in.

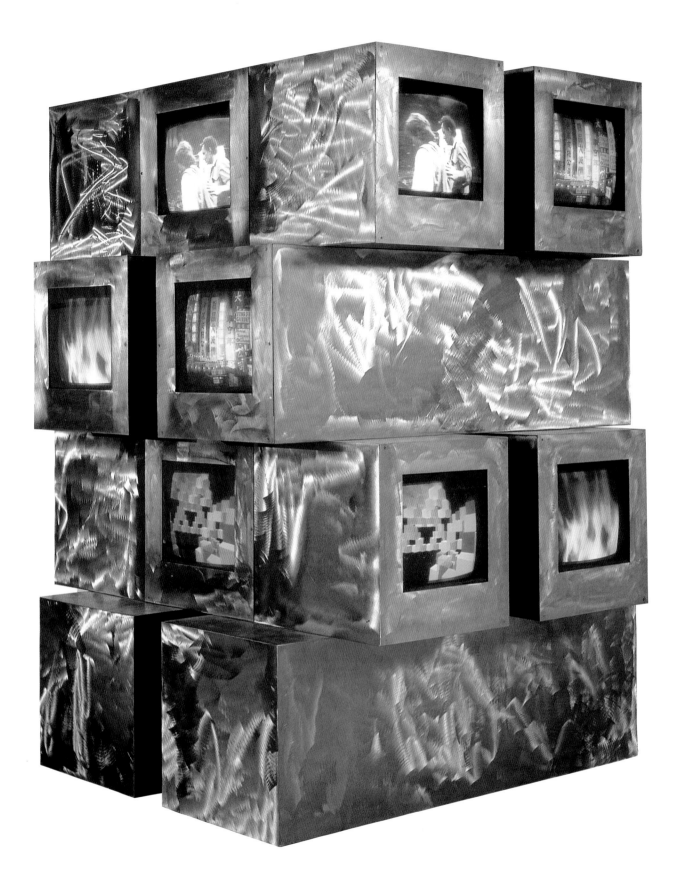

162. GRETCHEN BENDER
Untitled (Virtual Memory), 1987
Video laser disc players housed in steel
98 x 72⅛ x 72¼ in.

163. RICHARD PRINCE
Untitled, 1993
Ektacolor print
47 x 71 in.

164. PETER NAGY
Industrial Culture, 1987
Eight panels: photo-etched magnesium relief
20 x 20 in. (each)

165. ROBERT LONGO
Eric (Men in the Cities series), 1984
Color lithograph on paper
67³⁄₄ x 39 in.

276

166. ROBERT LONGO
Strong in Love, 1986
Bronze relief
54 x 53¾ x 8 in.

Afterword

Peter Marzio

SBC Communications has assembled a world-class collection of American art that reflects the observations, values, talents, and hopes of generations. The educational importance of the collection cannot be overestimated. These artworks communicate timeless messages that speak to each of us, encouraging us to contemplate and ultimately reach our own conclusions about art, beauty, and society.

To me, the integrity of the SBC Collection is that its rich assemblage of artworks affords the opportunity to perceive the full richness of American life in the twentieth century. Vividly portrayed in the urban Realism of Robert Henri and his counterparts, for example, is the rise of the city as a powerful force that would change this nation forever. At the same time, we see pictures of an America that was clinging tenaciously to its local roots and trying to nourish a regional outlook as captured and, to some extent, defined by an artist like Thomas Hart Benton. No matter how often history is rewritten, those two important, somewhat contradictory, facts are embodied in the art.

The collection is distinguished by its range of mediums: prints, drawings, watercolors, photographs, paintings, sculptures, and mixed media. Within each art historical category, there is also a full range. In short, a survey of the SBC Collection contains all the principal means of expression used by painters, sculptors, and photographers from the beginning of this century.

The collection also dramatizes an accelerating momentum for change in America—a momentum that may be unique to American life in the past century. For example, due to the centralizing force of urbanism and the decentralizing impact of regionalism, one notices European influences rising after 1913; these influences encouraged a vast range of styles and ideas, from pure abstraction to Marxism. Despite numerous attempts by politicians in the 1920s to isolate America, to slow down the rate of change, and to return its citizens to a nineteenth-century style, artists and intellectuals openly sought the world of ideas where a new reality just emerging in psychology, science, and math would soon shatter the older notion of objectivity. Artists found themselves defining their own reality, creating a myriad of "isms" to disseminate the meaning of their works; among these prominent artistic movements were Constructivism, Cubism, and Surrealism. This medley of intellectual currents is evident in the early modern art of pre–World War II America, and it is reflected clearly in the SBC Collection.

The willingness of SBC Communications to assume the task of assembling an important collection is admirable, but most praiseworthy is the company's desire

to build a challenging collection. The diversity of the collection mirrors the diversity of the company's employees and customers. Two points remain clear: 1) this collection does not compromise, and 2) this collection represents the best work that could be collected. This is perhaps seen most clearly in the art that emerged after World War II.

The atrocities of that war drove thousands of artists to the United States. They brought with them an even greater variety of styles and ideas and, together with the artists already here, established America as the center of the contemporary art world. As the most powerful nation in the world after the war, America seemed unsure of what it should do or how it should act. But modern artists forged ahead to become new types of American heroes, proclaiming the arrival of the American century. First came Abstract Expressionism, then color-field painting, followed by Pop Art, Neo-Dada, Minimalism, and so forth—one movement in rapid-fire succession replacing or countering another. This aggressive activity reflected the fiercely competitive nature of America itself. The art of the new was a constant challenge.

The SBC Collection appropriately communicates this intensity and even demands that viewers think on a higher level. It teaches us to see in ways that are new and exhilarating.

Catalogue of Works

References to those works illustrated as figures or plates are included at the end of the corresponding catalogue entry. Illustrations of other selected works are adjacent to catalogue entries. Dimensions are given in inches. Height precedes width precedes depth.

P. Alexander, *Cayucos*, 1984

Allen, *China Night*, 1985

Amado, *Three (MCMXCIV)*, 1994

Amenhoff, *Chamber*, 1985

Andoe, *Untitled (Goldilocks Buttercup)*, 1989

BERENICE ABBOTT (1898–1991)
Skyscraper, 1935
Contact print
9½ x 7½ in. (image) — Plate 40

JOHN ALEXANDER (b. 1945)
Feathering the Cultural Nest, 1986
Oil on canvas
77 x 83 in. — Plate 119

PETER ALEXANDER (b. 1939)
Cayucos, 1984
Lithograph on paper
29½ x 35½ in.

TERRY ALLEN (b. 1943)
China Night, 1985
Mixed media on paper
21¾ x 29¾ in.

CARLOS ALMARAZ (1941–1989)
Greed, 1989
Serigraph and screenprint on paper
40⅛ x 47 in. — Plate 130

JESSE AMADO (b. 1951)
One (MCMXCIII), 1993
Charcoal, graphite, chalk, tire black
on paper with metal frame
24 x 24 in. — Plate 161

JESSE AMADO
Two (MCMXCIV), 1994
Charcoal, graphite, chalk, tire black
on paper with metal frame
30 x 30 in. — Figure 66

JESSE AMADO
Three (MCMXCIV), 1994
Charcoal, graphite, chalk, tire black
on paper with metal frame
30 x 30 in.

GREGORY AMENHOFF (b. 1948)
Chamber, 1985
Woodcut on paper
33⅜ x 39½ in. (image)

JOE ANDOE (b. 1955)
Untitled (Goldilocks Buttercup), 1989
Oil on linen
50 x 60 in.

Arnoldi , Untitled, 1976

Arnoldi, Untitled, 1987

Arnoldi , Untitled, 1988

Arnoldi , Untitled, 1989

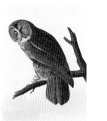

Audubon, *Great Cinerous Owl*, 1837

CHARLES ARNOLDI (b. 1946)
Untitled, 1976
Acrylic on wood
43 x 37 x 4 in.

CHARLES ARNOLDI
For Decisions and Revisions, 1983
Lithograph on paper
30 x 24 in. — not illus.

CHARLES ARNOLDI
Untitled, 1983
Lithograph on paper
42⅛ x 26⅞ in. — not illus.

CHARLES ARNOLDI
Billion, 1985
Acrylic on wood relief
60 x 168 x 12 in. — Plate 111

CHARLES ARNOLDI
Untitled, 1987
Gouache on paper
12⅝ x 9⅜ in.

CHARLES ARNOLDI
Untitled, 1988
Cast and assembled bronze with dry
pigment
18 x 20 x 7 in.

CHARLES ARNOLDI
Untitled, 1989
Monotype on paper
44⅞ x 41⅞ in.

JOHN JAMES AUDUBON (1785–1851)
Scarlet Ibis, 1837
Hand-colored engraving and
aquatint on paper
24½ x 32½ in. (image) — Figure 1

JOHN JAMES AUDUBON
Great Cinerous Owl, 1837
Hand-colored etching with engraving and aquatint on paper
38 x 25⅜ in. (image)

JOHN JAMES AUDUBON
White Winged Crossbill, 1837
Engraving on paper
38½ x 25¾ in. (image) — not illus.

Ault, *Boats on the Beach*, 1921

Bartlett, *In the Garden #118*, 1982

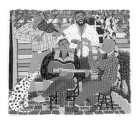

Bates, *The Musicians*, 1983

Bates, *Crab*, 1984

Bates, *Man in a Chair*, 1984

Bates, *Study for Crow*, 1988

Bates, *Cyclamen and Lemon*, 1992

GEORGE AULT (1891–1948)
Boats on the Beach, 1921
Watercolor on paper
11 x 15½ in.

GEORGE AULT
Provincetown: Boats & Houses, 1922
Oil on board
20 x 16 in. Plate 29

MILTON AVERY (1893–1965)
Sketcher by Seaside Cliff, 1939
Watercolor on paper
21⅝ x 29½ in. Figure 21

JOHN BALDESSARI (b. 1931)
Equestrian (Flesh) In Brackets with Orange Showdown, 1991–92
Two color photographs with acrylic paint
68½ x 96⅜ in. (total) Plate 83

JENNIFER LOSCH BARTLETT (b. 1941)
In the Garden #118, 1982
Forty-two-color silkscreen on hand-made Japanese Kurotani Kozo paper
29 x 38½ in.

DAVID BATES (b. 1952)
The Musicians, 1983
Serigraph and screenprint on paper
30¼ x 36 in.

DAVID BATES
Crab, 1984
Charcoal on paper
15⅛ x 11⅝ in.

DAVID BATES
Sheephead, 1984
Charcoal on paper
8 x 15 in. not illus.

DAVID BATES
Man in a Chair, 1984
Charcoal on paper
11¼ x 9¾ in.

DAVID BATES
Study for Crow, 1988
Charcoal on paper
22 x 29¾ in.

DAVID BATES
Cyclamen and Lemon, 1992
Oil on canvas
20 x 24 in.

DAVID BATES
Evening Storm, 1993
Oil on canvas
36 x 48 in. Plate 120

Bates, *Ashton Villa*, 1993

Beal, *Circus Wagons* (no date)

Beal, *Gorman Brothers Circus*, 1936

Beard, *On the Watch*, 1870

Beerman, Untitled, 1989

Beerman, Untitled, 1990

DAVID BATES
Ashton Villa, 1993
Oil on canvas
24 x 30 in.

REYNOLDS BEAL (1867–1951)
Circus Wagons (no date)
Pastel on paper
8¾ x 11¼ in. (image)

REYNOLDS BEAL
Gorman Brothers Circus, 1936
Watercolor on paper
10½ x 13⅝ in.

WILLIAM HOLBROOK BEARD
(1825–1900)
On the Watch, 1870
Charcoal on paper
45¼ x 34¾ in. (image)

ROMARE BEARDEN (1914–1988)
In the Garden, 1979
Lithograph on paper
28¾ x 21⅛ in. Figure 57

ROMARE BEARDEN
The Lantern, 1979
Lithograph on paper
28½ x 20 in. Plate 115

JOHN BEERMAN (b. 1958)
Untitled, 1989
Etching with gold leaf on paper
20⅞ x 26⅜ in. not illus.

JOHN BEERMAN
Untitled, 1989
Monoprint with gold-leaf on paper
19¾ x 20½ in.

JOHN BEERMAN
Untitled, 1990
Etching with gold leaf on paper
22 x 30¾ in.

GEORGE BELLOWS (1882–1925)
Artists Evening, 1916
Lithograph on paper
9½ x 12⅞ in. Figure 11

GEORGE BELLOWS
Harbor at Monhegan, 1913–15
Oil on canvas
25¾ x 38 in. Plate 1

GEORGE BELLOWS
Three Children, 1919
Oil on canvas
30⅜ x 44⅛ in. Plate 2

Bengston, *Venice*, 1975

Bengston, *Lanai Draculas*, 1982

Bengston, *Ho Opuka Mua*, 1983

Benson, *November Moon* (no date)

Benson, *Old Tom*, 1926

HOWARD BEN TRE (b. 1949)
Second Beaker, 1990
Cast glass, bronze, lead, and bronze
powder
54 x 19 in. (diameter) Plate 132

GRETCHEN BENDER (b. 1951)
Untitled (Virtual Memory), 1987
Video laser disc players housed in
steel
98 x 72⅛ x 72¼ in. Plate 162

LYNDA BENGLIS (b. 1941)
Eridanus, 1984
Bronze, zinc, copper, aluminum, and
wire relief sculpture
58 x 48 x 27 in. Plate 106

BILLY AL BENGSTON (b. 1934)
Venice, 1975
Watercolor on paper
29½ x 40⅛ in.

BILLY AL BENGSTON
Lanai Draculas, 1982
Lithograph on paper
32⅜ x 20⅜ in.

BILLY AL BENGSTON
Ho Opuka Mua, 1983
Serigraph and screenprint on paper
44⅝ x 23⅛ in. (image)

BILLY AL BENGSTON
Aloha Kakahiaka, 1984
Acrylic on canvas (two panels)
48 x 60 in. (each) Plate 108

FRANK WESTON BENSON
(1862–1951)
November Moon (no date)
Etching and aquatint on paper
10⅜ x 8⅜ in. (image)

FRANK WESTON BENSON
Old Tom, 1926
Etching on paper
15½ x 10⅜ in. (image)

THOMAS HART BENTON
(1889–1975)
Huck Finn, 1936
Lithograph on paper
17½ x 22½ in. (image) Figure 13

THOMAS HART BENTON
Jesse James, 1936
Lithograph on paper
17½ x 22½ in. (image) Figure 14

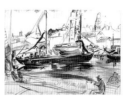

Bernstein, *Docks at Gloucester*
(no date)

Berresford, *Untitled*, 1926

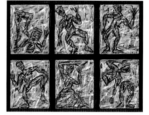

Bettison, *The Storm*, 1985

Bingham, *County Election*, 1854

Bisttram, *Interior*, 1942

THOMAS HART BENTON
Frankie and Johnnie, 1936
Lithograph on paper
17¾ x 22¾ in. (image) Figure 15

TONY BERLANT (b. 1941)
Music of the Spheres #7, 1989
Found metal collage on plywood
with steel brads
127 x 121¼ in. Plate 107

THERESA BERNSTEIN (b. 1890)
Docks at Gloucester (no date)
Watercolor on paper
15½ x 22½ in.

VIRGINIA BERRESFORD (b. 1902–199
Untitled, 1926
Oil on canvas
25⅝ x 21½ in.

JAMES BETTISON (b. 1957)
The Storm, 1985
Mixed media on canvas (six panels)
21 x 27 in. (total)

ALBERT BIERSTADT (1830–1902)
Mountainous Landscape (no date)
Oil on paper mounted on canvas
21¼ x 15¼ in. Figure 6

JOHN BIGGERS (b. 1924)
Four Seasons, 1990
Color lithograph on paper
23½ x 32 in. (image)

GEORGE CALEB BINGHAM
(1811–1879)
County Election, 1854
Engraving on paper
24 x 30⅞ in. (image)

ROBERT A. BIRMELIN (b. 1933)
Seeing Past and Through, 1985
Conte crayon on paper
36⅞ x 49 in. not illus.

EMIL BISTTRAM (1895–1976)
Still Life with Red Apples, 1935–36
Gouache on paper
17⅛ x 23⅛ in. not illus.

EMIL BISTTRAM
Interior, 1942
Gouache on paper
8⅜ x 7½ in.

EMIL BISTTRAM
Two Cells at Play, c. 1942
Oil on canvas
36 x 27 in. Plate 42

Bleckner, *Wish*, 1993

Bluemner, *Red House with Trees*, 1918

Bluemner, Untitled, 1932

Bolotowsky, *Open Space Blue Tondo*, 1981

© 1996 Estate of Ilya Bolotowsky/Licensed by VAGA, New York, NY

Borein, *The Twister*, 1915

Bosman, *Full Moon*, 1986

ROSS BLECKNER (b. 1949)
Wish, 1993
Watercolor on paper
29½ x 22¼ in.

OSCAR BLUEMNER (1867–1938)
Red House with Trees, 1918
Gouache on paper
3½ x 5½ in.

OSCAR BLUEMNER
Sketch for "Lowlands," 1924
Charcoal on paper
5¼ x 6¾ in. not illus.

OSCAR BLUEMNER
West Pond, South Braintree, 1930
Gouache on paper
5 x 6⅞ in. Figure 29

OSCAR BLUEMNER
Untitled, 1932
Charcoal on paper
4 x 5 in.

OSCAR BLUEMNER
Approaching Black, 1932
Tempera and varnish on panel
22 x 30 in. Plate 32

ILYA BOLOTOWSKY (1907–1981)
Untitled, 1941
Oil on canvas
13¾ x 20¾ in. Plate 53

ILYA BOLOTOWSKY
Open Space Blue Tondo, 1981
Acrylic on canvas
58⅝ in. (diameter)

EDWARD BOREIN (1872–1945)
The Twister, 1915
Etching on paper
10⅞ x 7⅝ in. (image)

RICHARD BOSMAN (b. 1944)
The Fall, 1984
Woodcut on paper
60⅞ x 41⅞ in. not illus.

RICHARD BOSMAN
Full Moon, 1986
Color woodcut on paper
35 x 46 in.

RICHARD BOSMAN
Volcano, 1989
Color woodcut on paper
43⅜ x 30⅛ in. not illus.

Bourgeois, *Homely Girl, A Life*,
1992, (7 of 10)
© 1996 Louise Bourgeois/Licensed by VAGA, New York, NY

Bowling, *Hedge*, 1993

Bozzi, Untitled, 1990

Brevoort, *Autumn Landscape*, 1865

Brown, *July Porch*, 1985

J. Brown, *Black and White Woodcuts*,
1986, (1 of 4)

R. Brown, *Fog*, 1985

RICHARD BOSMAN
Tides, 1990
Oil on canvas (two panels)
36⅛ x 96 in. (each) Plate 109

LOUISE BOURGEOIS (b. 1911)
Homely Girl, A Life, 1992
Suite of ten drypoint etchings on
Somerset soft white paper
20½ x 15 in. (each)

KATHERINE BOWLING (b. 1955)
Hedge, 1993
Oil and spackle on wood
23¾ x 23¾ in.

KATHERINE BOWLING
Omen, 1993
Oil on panel
23⅞ x 23⅝ in. Plate 141

JULIE BOZZI (b. 1943)
Untitled, 1989
Oil on paper
10 x 14 in. not illus.

JULIE BOZZI
Untitled, 1990
Oil on paper
10 x 14 in. Plate 144

JULIE BOZZI
Untitled, 1990
Oil on paper
10 x 14 in.

JAMES R. BREVOORT (1832–1918)
Autumn Landscape, 1865
Oil on canvas
7½ x 13½ in.

ALICE DALTON BROWN (b. 1939)
July Porch, 1985
Oil on canvas
56 x 84 in.

ALICE DALTON BROWN
A Glimpse Within II, 1985
Pastel on paper
49¾ x 28¾ in. not illus.

JAMES BROWN (b. 1951)
Black and White Woodcuts, 1986
Suite of four woodcuts on paper
24½ x 19¼ in. (each)

ROGER BROWN (b. 1941)
Fog, 1985
Oil on canvas
47⅞ x 72⅛ in.

Burchfield, *Dusk*, 1916

Burchfield, *High Noon*, 1916

Burckhardt, *Little Rock, Arkansas*, 1948

Burckhardt, *Mississippi*, 1948

Carter, *Snow in the Forest*, 1945

Celmins, *Constellation-Ucello*, 1982

BEVERLY BUCHANAN (b. 1940)
Miss Hester's Place, 1994
Mixed media wood sculpture
27 x 18¼ x 19½ in. Plate 147

CHARLES BURCHFIELD (1893–1967)
Dusk, 1916
Watercolor on paper
20 x 14 in.

CHARLES BURCHFIELD
High Noon, 1916
Watercolor on paper
20 x 13⅞ in.

CHARLES BURCHFIELD
November Sun Emerging, 1956–59
Watercolor on paper
37¾ x 31⅞ in. (image) Plate 14

RUDY BURCKHARDT (b. 1914)
34th Street, New York, 1946
Gelatin silver print
6⅞ x 10⅜ in. (image) not illus.

RUDY BURCKHARDT
Little Rock, Arkansas, 1948
Gelatin silver print
6⅞ x 10⅜ in. (image)

RUDY BURCKHARDT
Mississippi, 1948
Gelatin silver print
8½ x 8¾ in. (image)

ARTHUR B. CARLES (1882–1952)
Untitled, c. 1935
Oil on canvas
18⅝ x 28¼ in. (image) Plate 43

CLARENCE CARTER (b. 1904)
Snow in the Forest, 1945
Watercolor on paper
18⅜ x 23½ in.

MEL CASAS (b. 1929)
On the Way to Paestum, 1991
Acrylic on canvas
24 x 24 in. Figure 61

MEL CASAS
Slyboots, 1993
Acrylic on canvas
24 x 24 in. Plate 145

VIJA CELMINS (b. 1939)
Constellation-Ucello, 1982
Four-color aquatint/etching on paper
27¼ x 23⅛ in.

Chase, Untitled, 1988

Chihuly, *Black and Gold Ikebana with Two Leaves*, 1992

Christenberry, *Alabama Wall II*, 1990

Christenberry, *Red Building in Forest, Hale County*, 1991

VIJA CELMINS
Ocean Surface–Second State, 1985
Drypoint etching on paper
23⅞ x 18⅞ in. Figure 68

JOHN CHAMBERLAIN (b. 1927)
chACE, 1985
Painted and chromium-plated steel relief
34 x 47 x 13 in. Plate 87

LOUISA CHASE (b. 1951)
Untitled, 1988
Color lithograph on paper
38⅝ x 24½ in.

CLARENCE K. CHATTERTON
(1880–1973)
Rock Pasture, 1931
Oil on canvas
30 x 44 in. Plate 11

DALE CHIHULY (b. 1941)
Black and Gold Ikebana with Two Leaves, 1992
Glass sculpture
64½ x 35 x 16 in.

WILLIAM A. CHRISTENBERRY
(b. 1936)
Red Building in Forest, Hale County, Alabama, 1989
Ektacolor print
20 x 24 in. Plate 148

WILLIAM A. CHRISTENBERRY
Alabama Wall II, 1990
Wood, metal, paper, and tempera on plywood
45⅛ x 50¼ x 3⅞ in.

WILLIAM A. CHRISTENBERRY
Red Building in Forest, Hale County, Alabama, 1991
Ektacolor print
20 x 24 in.

CHRISTO (b. 1935)
Wrapped Telephone (project for L.M. Ericsson model), 1985
Three-color lithograph with collage on paper
27¾ x 21¾ in. Plate 84

CHRISTO
Wrapped Computer (project forEricsson display monitor unit 3011, wrapped [personal computer] Ericsson type 1050-5ES), 1985
Five-color lithograph with collage on paper
28 x 22½ in. Figure 53

Clutz, *Bus Stop*, 1985

Cook, *Mexican Interior*, 1933

Cortinas, *No Puede Hablar*, 1991

Cowie, *Small Sculpture II*, 1995

Crawford, *Boiler*, 1940

Culwell, *Astro*, 1976

MINNA CITRON (1896–1992)
Construction II, 1945
Two-color etching on paper
16½ x 8 in. Figure 18

WILLIAM CLUTZ (b. 1935)
Bus Stop, 1985
Pastel on paper
40⅜ x 30⅛ in.

WILLIE COLE (b. 1955)
Untitled, 1994
Six etched glass panels
13⅝ x 10⅝ in. (each) Figure 60

HOWARD COOK (1901–1980)
Mexican Interior, 1933
Etching on paper
16 x 10⅝ in.

MIGUEL CORTINAS (b. 1955)
No Puede Hablar, 1991
Pencil on paper
17¾ x 23⅝ in. (image)

JEFFREY COWIE (b. 1958)
Puzzle, 1995
Collage with drawing on paper
22 x 19 in. not illus.

JEFFREY COWIE
Small Sculpture II, 1995
Collage with drawing on paper
22 x 19 in.

RALSTON CRAWFORD (1906–1978)
Boiler, 1940
Gelatin silver print
7½ x 9 in.

RALSTON CRAWFORD
On the Sundeck, 1948
Oil on canvas
30⅛ x 45 in. Plate 59

RALSTON CRAWFORD
Fishing Boats #3, 1955
Oil on canvas
18 x 15 in. Figure 37

BEN CULWELL (b. 1918)
Astro, 1976
Oil, lacquer, and mixed media on
masonite
48⅛ x 35½ in.

JOHN STEUART CURRY (1897–1946)
The Sun Rises Over Kansas (no date)
Oil on canvas
30 x 38 in. Plate 10

Dasburg, *Trees and Houses*, 1919

Davis, *Black Vent Beam*, 1975

Dawson, Untitled, 1914

de Lisio, *Georgia O'Keeffe*, 1981

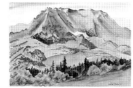
Dehn, *Mountain Landscape*, 1937

ANDREW DASBURG (1887–1979)
Finney Farm, Croton-on-Hudson,
c. 1917
Oil on canvas
30⅛ x 24½ in. Plate 24

ANDREW DASBURG
Trees and Houses, 1919
Graphite on paper
17 x 12½ in.

RON DAVIS (b. 1937)
Black Vent Beam, 1975
Lithograph on paper
25 x 36 in.

STUART DAVIS (1894–1964)
Detail Study #1 for Cliche, 1955
Gouache on paper
12¾ x 15 in. Figure 2

STUART DAVIS
Memo No. 2, 1956
Oil on canvas
24 x 32 in. Plate 60

MANIERRE DAWSON (1887–1969)
Untitled, 1914
Oil on canvas
18 x 24 in.

WILLEM DE KOONING (b. 1904)
Untitled III, 1983
Oil on canvas
88 x 77 in. Plate 66

ROBERTO ISAAC DE LA ROCHA
(b. 1937)
Untitled, 1994
Mixed media on paper
8½ x 11 in. Plate 121

MICHAEL DE LISIO (b. 1911)
Georgia O'Keeffe, 1981
Bronze sculpture
13¾ x 6¾ x 5¼ in.

MICHAEL DE LISIO
Arthur Dove, 1982
Bronze sculpture
11¼ x 5½ x 5⅜ in. not illus.

ADOLF DEHN (1895–1968)
Mountain Landscape, 1937
Watercolor on paper
14¼ x 21⅜ in. (image)

ADOLF DEHN
Winter Scene, 1948, 1948
Watercolor on paper
18 x 25¾ in. not illus.

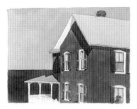

Dewey, *Red House at York Harbor*, 1984

Dewey, *Bell Tower & Light House*, 1984

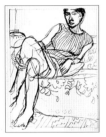

Diebenkorn, *Seated Woman in Striped Dress*, 1965

Diebenkorn, *Blue Club*, 1981
© 1996 Crown Point Press

Dill, Untitled, 1985

CHARLES DEMUTH (1883–1935)
Tuberoses, 1922
Watercolor and pencil on paper
13 x 10½ in. Plate 25

DAVID DEWEY (b. 1946)
Red House at York Harbor, 1984
Watercolor on paper
8⅞ x 11⅞ in.

DAVID DEWEY
Bell Tower & Light House, 1984
Watercolor on paper
8⅞ x 12 in.

DAVID DEWEY
Marshall's Point Light, Afternoon, 1985
Watercolor on paper
14 x 21 in. not illus.

DAVID DEWEY
Peniaquid Point (Day), 1993
Watercolor on paper
17⅜ x 27¼ in. not illus.

RICHARD DIEBENKORN (1922–1993)
Seated Woman in Striped Dress, 1965
Lithograph on paper
28 x 22 in.

RICHARD DIEBENKORN
Blue Club, 1981
Color aquatint with soft ground
etching on paper
37½ x 30½ in.

RICHARD DIEBENKORN
White Club, 1981
Aquatint reversal print on paper
37½ x 30½ in. not illus.

RICHARD DIEBENKORN
Blue with Red, 1987
Color woodcut on paper
37½ x 25½ in. Figure 42

LADDIE JOHN DILL (b. 1943)
Untitled, 1985
Oil on rag board
14⅞ x 12⅛ in. not illus.

LADDIE JOHN DILL
Untitled, 1985
Oil on rag board
15 x 12 in. not illus.

LADDIE JOHN DILL
Untitled, 1985
Oil on rag board
14¾ x 12⅛ in.

Dine, *Rise Up Solitude*, 1985

Dixon, *Near Los Olivos*, 1985

Doran, *Ball and Chain*, 1986

Duff, *Homoousian Column*, 1985

Dunham, *Places & Things*, 1992, (1 of 5)

BURGOYNE DILLER (1906–1965)
Miró Abstract, 1930
Mixed media on canvas
32⅛ x 20⅛ in. Plate 37

JIM DINE (b. 1935)
Four German Brushes, 1973
Four etchings on paper
31⅛ x 22¼ in. (each) Figure 48

JIM DINE
The Yellow Robe, 1980
Lithograph on paper
49⅞ x 35 in. Plate 77

JIM DINE
Rise Up Solitude, 1985
Hand-colored etching on paper
51⅜ x 57¼ in.

WILLARD DIXON (b. 1942)
Near Los Olivos, 1985
Oil on canvas
50 x 78 in.

ANNE DORAN (b. 1957)
Ball and Chain, 1986
Photographs mounted on aluminum bars
38 x 41 x 10 in.

ARTHUR G. DOVE (1880–1946)
Reflections, 1935
Oil on canvas
15 x 21 in. Plate 47

ARTHUR G. DOVE
White Channel, 1942
Oil on canvas
21 x 15 in. Plate 48

WERNER DREWES (1889–1985)
Composition No. 84, 1935
Oil on canvas
17¼ x 25½ in. Figure 36

GUY PENE DU BOIS (1884–1958)
Addressing the Jury, 1947
Oil on masonite
19⅝ x 25½ in. Plate 20

JOHN DUFF (b. 1943)
Homoousian Column, 1985
Fiberglas, enamel paint, and shellac
sculpture
67 x 21 x 21 in.

CARROLL DUNHAM (b. 1949)
Places & Things, 1992
Suite of five color linoleum prints on
Kozo misumi paper
13 x 17 in. (each)

Espada, *Untitled*, 1985

Farber, *Across Tracks*, 1982

Feininger, *Street Scene*, 1952

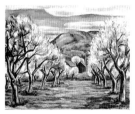

Fiene, *Apple Orchard*, 1924

Fiene, *New York Harbor*, 1937

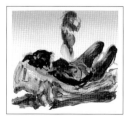

Fischl, *Untitled*, 1988
© 1996 Crown Point Press

GEORGIA ENGELHARD (1906–1986)
New York Skyscrapers, c. 1928-29
Oil and canvas laid down on board
28⅝ x 22½ in. Plate 34

IBSEN ESPADA (b. 1952)
Untitled, 1985
Mixed media on paper
24¼ x 33¾ in.

RICHARD ESTES (b. 1932)
Holland Hotel, 1984
Serigraph and screenprint on paper
46 x 76 in. Plate 91

MANNY FARBER (b. 1917)
Across Tracks, 1982
Oil on board
46½ in. (diameter)

LYONEL FEININGER (1871–1956)
Street Scene, 1952
Ink and watercolor on paper
11¾ x 17¾ in.

ERNEST FIENE (1894–1966)
Apple Orchard, 1924
Oil on canvas
18 x 22⅛ in.

ERNEST FIENE
Razing Buildings, West 49th Street,
1932
Lithograph on paper
11 x 14⅜ in. Figure 19

ERNEST FIENE
New York Harbor, 1937
Watercolor on paper
22 x 17 in.

ERNEST FIENE
Entrance to Woodstock, c. 1958
Oil on canvas
20⅛ x 28¼ in. not illus.

ERIC FISCHL (b. 1948)
Puppet Tears, 1985
Aquatint, sugarlift, and drypoint on
paper
15 x 12¼ in. not illus.

ERIC FISCHL
Untitled, 1988
Color woodcut on paper
17 x 16½ in.

JANET FISH (b. 1938)
Ball Jars, 1975
Lithograph on paper
29¾ x 21¾ in. Figure 55

Fisher, *Hanging Man*, 1985

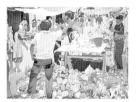

Flato, *Oaxaca*, 1985

Fonseca, *Pietrasantra Drawing #9*,
1993

Frailey, *Untitled*, 1986, (5 of 5)

Frailey, *Untitled*, 1988

Francis, *Paradise of Ash*, 1982

VERNON FISHER (b. 1943)
Blue Landscape, 1984
Acrylic on paper
70¾ x 84¾ in. Plate 154

VERNON FISHER
Hanging Man, 1985
Lithograph and serigraph on paper
25⅞ x 36 in.

MALOU FLATO (b. 1953)
Oaxaca, 1985
Watercolor on paper
22⅛ x 29¾ in.

MALOU FLATO
Greve, 1985
Watercolor on paper
44 x 66 in. not illus.

MALOU FLATO
San Marcos, 1985
Watercolor on paper
14¼ x 19⅝ in. not illus.

CAIO FONSECA (b. 1959)
Pietrasantra Drawing #9, 1993
Gouache and ink on paper
11¾ x 8⅞ in.

CAIO FONSECA
Pietrasantra Drawing #26, 1993
Gouache and ink on paper
10 x 7 in. not illus.

CAIO FONSECA
Pietrasantra Drawing #43, 1993
Gouache and ink on paper
10 x 7 in. not illus.

CAIO FONSECA
Pietrasantra Drawing #44, 1993
Gouache and ink on paper
12 x 8⅞ in. not illus.

STEPHEN FRAILEY (b. 1957)
Untitled, 1986
Suite of five Polaroid prints
20 x 20 in. (each)

STEPHEN FRAILEY
Untitled, 1988
Ektacolor print
28⅝ x 29 in.

SAM FRANCIS (1923–1994)
Paradise of Ash (two panels), 1982
Lithograph on paper
L: 46⅛ x 32½ in.
R: 45⅞ x 32½ in.

SAM FRANCIS
Dark and Fast, 1982
Five-color lithograph on paper
38 x 30 in. Figure 40

SAM FRANCIS
Untitled, 1983
Monotype on handmade paper
78⅜ x 43 in. Plate 68

HELEN FRANKENTHALER (b. 1928)
Moveable Blue, 1973
Acrylic on canvas
70 x 243¼ in. Plate 67

HELEN FRANKENTHALER
Tahiti, 1989
Mixografia print on paper
31¾ x 53¼ in. Figure 43

SUZY FRELINGHUYSEN (1911–1988)
Untitled, 1945
Collage and oil on board
20⅜ x 13⅛ in. Plate 44

Fuss, *Lovers*, 1985

ADAM FUSS (b. 1961)
Lovers, 1985
Gelatin silver print
24 x 20 in.

ADAM FUSS
The Way We Live, 1985
Gelatin silver print
24 x 20 in. not illus.

ADAM FUSS
Untitled, 1985
Gelatin silver print
24 x 20 in.

Fuss, Untitled, 1985

ADAM FUSS
Untitled [Blue Amazon], 1986
Cibachrome print
24 x 20 in. not illus.

ADAM FUSS
You Know My Name, 1986
Cibachrome print
24 x 20 in. not illus.

ALBERT E. GALLATIN (1881–1952)
Untitled #54, 1935
Oil on canvas
24 x 20 in. Figure 34

Gallatin, *Composition #26*, 1938

ALBERT E. GALLATIN
Composition #26, 1938
Oil on canvas
30⅛ x 20 in.

Gerlach, *Shadow Play: Balboa Park*, 1985

Gilliam, *Lattice III*, 1983

Godfrey, Untitled, 1988

Goode, Untitled, 1971

Goode, Untitled, 1987

CARMEN LOMAS GARZA (b. 1948)
A Medio Dia Como Los Camaleones, 1988
Gray paper cutout
25½ x 19⅝ in. Figure 63

CHRISTOPHER GERLACH (b. 1952)
Shadow Play: Balboa Park, 1985
Oil on canvas
23¼ x 29¼ in.

SAM GILLIAM (b. 1933)
Lattice III, 1983
Intaglio and lithograph on paper
32 x 44½ in.

SAM GILLIAM
Renaissance I, 1986
Acrylic on canvas and enameled
metal relief
73¾ x 88⅝ x 8 in. Plate 112

SAM GILLIAM
Golden Neck, 1993
Offset lithograph and silkscreen with
hand painting
43¼ x 29⅞ in. Figure 67

WILLIAM J. GLACKENS (1870–1938)
Washington Square (no date)
Pastel on paper
10⅝ x 18⅝ in. (image) Plate 6

DEWITT GODFREY (b. 1960)
Untitled, 1988
Oil stick, charcoal, and gesso on paper
31¼ x 31¼ in. (diagonal) not illus.

DEWITT GODFREY
Untitled, 1988
Oil stick and gesso on paper
25½ x 25½ in. (image)

JOE GOODE (b. 1937)
Untitled, 1971
Color lithograph on paper
14 x 23 in. not illus.

JOE GOODE
Untitled, 1971
Color lithograph on paper
14 x 23 in.

JOE GOODE
Untitled #17, 1987
Oil on board
84¼ x 36⅛ in. Plate 100

JOE GOODE
Untitled, 1987
Oil on paper
14⅛ x 9⅝ in.

Gornik, *Untitled*, 1985

R. Graham, *Untitled*, 1975

Green, *Untitled*, 1937

Greene, *The Light of Memory #4*, 1993

Greenwood, *Black Girl* (no date)

Groll, *Arizona Desert* (no date)

ARSHILE GORKY (1904–1948)
Untitled, 1944
Colored pencil and crayon on paper
19 x 24 in. Figure 39 (detail); Plate 61

APRIL GORNIK (b. 1953)
Untitled, 1985
Monotype on paper
42¼ x 31 in.

AARON HARRY GORSON
(1872–1933)
Industrial Site at the River, c. 1916
Oil on canvas mounted on board
16 x 20 in. Figure 12

JOHN D. GRAHAM (1881–1961)
Still Life, c. 1928
Oil on canvas
21 x 29⅛ in. Plate 35

JOHN D. GRAHAM
An American Girl, 1931
Oil on canvas
36 x 28¼ in. Figure 3

ROBERT GRAHAM (b. 1938)
Untitled, 1975
Five-color screenprint on paper
39¾ x 51⅛ in.

GERTRUDE GREEN (1911–1956)
Untitled, 1937
Collage—paper on paper
7⅞ x 11⅞ in.

STEPHEN GREENE (b. 1917)
The Light of Memory #4, 1993
Oil on linen
32 x 22¼ in.

MARION GREENWOOD
(1909–1970)
Black Girl (no date)
Lithograph on paper
11½ x 9¼ in. (image)

CASIMIR C. GRISWOLD (1834–1918)
Angler in River, 1872
Oil on canvas
18⅜ x 25⅛ in. not illus.

ALBERT GROLL (1866–1952)
Arizona Desert (no date)
Oil on canvas
20 x 24 in.

GRONK (b. 1954)
Electricity and Water, 1990
Acrylic on wood
24 x 24 in. Plate 127

Grooms, *Truck*, 1979

Grotfeldt, *Twin Bill*, 1994

Guérin, *Chateau Chaumont,
France*, 1906

Guérin, *France*, 1906

Gutmann, *Texas Women*, 1937

Gutmann, *Texas License*, 1937

Hart, *New Orleans Market*, 1913

RED GROOMS (b. 1937)
Truck, 1979
Lithograph on paper
24⅞ x 62½ in.

JAN GROOVER (b. 1943)
Untitled, 1987
C-Print
33⅞ x 26¾ in. (image) not illus.

JAN GROOVER
Untitled, 1988
C-Print
33¾ x 26⅞ in. (image) Figure 69

WILLIAM GROPPER (1897–1977)
Field Workers (Tobacco Pickers), 1942
Oil on canvas
27 x 34 in. Plate 15

VIRGIL GROTFELDT (b. 1948)
Stag Hunt, 1988
Mixed media on paper
43½ x 35⅜ in. not illus.

VIRGIL GROTFELDT
Santo de Noche, 1989
Acrylic and metallic powder on paper
52½ x 51⅛ in. Plate 134

VIRGIL GROTFELDT
Twin Bill, 1994
Enamel, acrylic, and bronze powder
on canvas
29¾ x 29¾ x 2⅛ in.

JULES GUÉRIN (1866–1946)
Chateau Chaumont, France, 1906
Watercolor and gouache on board
29½ x 19½ in.

JULES GUÉRIN
France, 1906
Gouache and pastel on cardboard
29¼ x 19¾ in. (image)

JOHN GUTMANN (b. 1905)
Texas Women, 1937
Gelatin silver print
9½ x 6 in.

JOHN GUTMANN
Texas License, 1937
Gelatin silver print
8½ x 7¼ in.

GEORGE OVERBURY (POP) HART
(1868–1933)
New Orleans Market, 1913
Watercolor and pencil on board
17½ x 21½ in.

Hartley, *Drawing #9*, c. 1930

MARSDEN HARTLEY (1877–1943)
Calla Lilies, c. 1920
Pastel on paper
24¾ x 17 in. Plate 23

MARSDEN HARTLEY
Drawing #9, c. 1930
Conte crayon on paper
15⅞ x 12½ in. (image)

MARSDEN HARTLEY
*Rain Coming–Sea Window–Cape
Ann*, c. 1933–36
Oil on board
24 x 18 in. Plate 36

BERTRAM HARTMAN (1882–1960)
Washington Square Park in Spring,
1939
Watercolor on paper
14⅞ x 22 in. (image)

Hartman, *Washington Square Park
in Spring*, 1939

BERTRAM HARTMAN
Washington Square Park in Autumn,
1940
Watercolor on paper
15 x 22 in. (image) not illus.

DU BOIS FENELON HASBROUCK
(1860–1917)
Winter Pond, 1888
Oil on canvas
14 x 20 in.

Hasbrouck, *Winter Pond*, 1888

CHILDE HASSAM (1859–1935)
Independence Hall, Philadelphia, 1926
Etching on paper
7½ x 9½ in.

CHILDE HASSAM
The Chase House, Annapolis, 1929
Etching on paper
7¾ x 9 in. Figure 7

Hassam, *Independence Hall,
Philadelphia*, 1926

JOSEPH HAVEL (b. 1954)
One Week Collar, 1995
Bronze sculpture with cream patina
32½ x 7 in. (diameter) Plate 142

MARTIN JOHNSON HEADE
(1819–1904)
Pink Apple Trees, c. 1873
Oil on canvas
10⅛ x 14⅛ in.

Heade, *Pink Apple Trees*, c. 1873

RACHEL HECKER (b. 1958)
Shut, 1994
Acrylic on canvas
24 x 24 in. Figure 71

Held, *Auriga I*, 1989

Herzog, *A Country Road* (no date)

Hill, *Pont Marie on the Seine*
(no date)

Hirsch, *Factories, Portsmouth, New
Hampshire*, 1930

Holland, Untitled, 1982

AL HELD (b. 1928)
Vorcex III, 1984
Acrylic on canvas
84⅜ x 84⅜ in. Plate 70

AL HELD
Auriga I, 1989
Acrylic on canvas
47⅞ x 83⅞ in.

ROBERT HENRI (1865–1929)
In the Deep Woods, 1918
Pastel on paper
12⅜ x 19⅞ in. Plate 7

ROBERT HENRI
Sunlight in the Woods, 1918
Pastel on paper
15¼ x 19 in. Plate 8

HERMANN HERZOG (1832–1932)
A Country Road (no date)
Oil on canvas
16⅛ x 13¼ in.

VICTOR HIGGINS (1884–1949)
Taos Foothills, c. 1925
Oil on canvas board
14 x 17⅞ in. Plate 13

HILAIRE HILER (1898–1966)
Untitled [Railroad Station], 1931
Oil on canvas
28¾ x 39½ in. Figure 33

GEORGE HILL (1898–1969)
Pont Marie on the Seine (no date)
Oil on wood
8⅝ x 10⅝ in.

LEWIS HINE (1874–1940)
Untitled [Construction of the
Empire State Building], 1931
Vintage gelatin silver print
19¼ x 15¼ in. (image) Plate 17

STEFAN HIRSCH (1899–1964)
*Factories, Portsmouth, New
Hampshire*, 1930
Oil on canvas
17½ x 27½ in.

TOM HOLLAND (b. 1936)
Untitled, 1982
Epoxy on paper
27¼ x 21⅝ in.

MIKE HOLLIS (b. 1953)
Strawberries Mean Luv, 1984
Mixed media on mahogany
32 x 64¼ in. not illus.

Hollis, *Utility Core for Versatility*, 1988

Hornby, *Rue Tiquetonne, Paris* (no date)

Hornby, *At Verneuil–Peasant Woman Returning from the, Fields*, c. 1913

Hornby, *Eastern Point*, 1922

Huerta, *Divas, Destruction, and Depravity*, 1990–93

Hunt, *Quarry at Tuy*, 1988

MIKE HOLLIS
Utility Core for Versatility, 1988
Latex, Day Glo, aniline dyes, and lacquer on mahogany and birch panels
70⅝ x 97⅝ x 5⅝ in.

EDWARD HOPPER (1882–1967)
Night Shadows, 1921
Etching on paper
7½ x 8⅞ in. (image) Figure 20

EDWARD HOPPER
Gloucester Harbor, 1926
Watercolor on paper
14½ x 20 in. Plate 12

LESTER GEORGE HORNBY
(1882–1956)
Rue Tiquetonne, Paris (no date)
Pencil on paper
11¾ x 9 1/4 in. (image)

LESTER GEORGE HORNBY
Overlooking the Ocean, near Trejaster, France, c. 1913
Pencil on paper
8¾ x 11 in. (image) not illus.

LESTER GEORGE HORNBY
At Verneuil–Peasant Woman Returning from the Fields, c. 1913
Pencil on paper
8⅝ x 11⅜ in.

LESTER GEORGE HORNBY
Eastern Point, 1922
Pencil on paper
7½ x 9⅞ in. (image)

BENITO HUERTA (b. 1952)
Divas, Destruction, and Depravity, 1990–93
Gouache, ink, pastel, lead, and gunpowder on paper
34 x 54½ in.

BRYAN HUNT (b. 1947)
Quarry at Tuy, 1988
Etching on paper
22½ x 29⅞ in.

YVONNE JACQUETTE (b. 1934)
Queens, Night, Clouds (Triboro Triptych at Night II series), 1987–88
Oil on canvas
79¼ x 63⅜ in. Plate 92

James, *Land, Water, Rocks III*, 1994

James, *Land, Water, Rocks IV*, 1994

Larry Johnson, Untitled, 1987

Jonson, *Arabesque No. 2*, 1933

YVONNE JACQUETTE
Manhattan, Night, Clouds (Triboro Triptych at Night II series), 1987–88
Oil on canvas
79¼ x 63⅜ in. Plate 93

YVONNE JACQUETTE
Staten Island, Night, Clouds (Triboro Triptych at Night II series), 1987–88
Oil on canvas
79¼ x 63½ in. Plate 94

TERRELL JAMES (b. 1955)
Land, Water, Rocks III, 1994
Oil on gessoed paper
49⅝ x 38¼ in.

TERRELL JAMES
Land, Water, Rocks IV, 1994
Oil on gessoed paper
49⅝ x 38¼ in.

LUIS JIMENEZ JR. (b. 1940)
Mustang, 1992
Cast Fiberglas sculpture
29½ x 8 x 8 in. Plate 129

LUIS JIMENEZ JR.
Mustang, 1994
Lithograph on paper
40⅝ x 29½ in. Figure 62

JASPER JOHNS (b. 1930)
Target with Four Faces, 1968
Serigraph and screenprint on paper
40¾ x 29⅜ in. Plate 72

LARRY JOHNSON (b. 1959)
Untitled, 1987
Three Ektacolor prints
18⅜ x 18½ in.

LUCAS JOHNSON (b. 1940)
Untitled (Hope, Idaho Series), 1994
Ink and ink wash on paper
10½ x 9 in. Plate 131

LOIS MAILOU JONES (b. 1905)
Symbols d'Afrique II, 1983
Acrylic on canvas
35⅜ x 25½ in. Plate 118

RAYMOND JONSON (1891–1982)
Arabesque No. 2, 1933
Watercolor on paper
18¾ x 12⅞ in.

ROBERTO JUAREZ (b. 1952)
Pine-Palm, 1987
Color woodcut print on paper
74 x 37½ in. Figure 72

ROBERTO JUAREZ
Second Liquid, 1993
Acrylic, peat moss, Japanese paper,
pastel, charcoal on linen
46 x 58⅛ in. Plate 155

ALEX KATZ (b. 1927)
Blue Umbrella, 1980
Lithograph on paper
20 x 30 in. Plate 88

ELLSWORTH KELLY (b. 1923)
Rouge sur Jaune, 1964
Lithograph on paper
35 x 23¼ in.

Kelly, *Rouge sur Jaune*, 1964

ELLSWORTH KELLY
Blue with Black I, 1974
Two-color lithograph on paper
42½ x 37¼ in. Figure 44

ELLSWORTH KELLY
Black Variation I, 1975
One-color lithograph, intaglio, and
debossing on paper
42 x 34 in.

Kelly, *Black Variation I*, 1975

ELLSWORTH KELLY
Violet Panel, 1980
Oil on canvas
72 x 88 in. Plate 71

ELLSWORTH KELLY
Philodendron 1, 1984
One-color lithograph on paper
25 x 36 in.

Kelly, *Philodendron 1*, 1983

ELLSWORTH KELLY
Calla Lily 2, 1984
One-color lithograph on paper
36 x 25 in.

ELLSWORTH KELLY
Calla Lily 3, 1984
One-color lithograph on paper
36 x 25 in. not illus.

Kelly, *Calla Lily 2*, 1983

ELLSWORTH KELLY
Dark Gray Curve, 1988
Color lithograph
25¼ x 83¾ in. Figure 50

Kelly, *EK/Spectrum I*, 1989

ELLSWORTH KELLY
EK/Spectrum I, 1990
Twelve-color lithograph on paper
25⅝ x 94 in.

PAUL KELPE (1902–1985)
Weightless Balance II, 1937
Oil on canvas
33⅛ x 23 in. Plate 52

Kushner, *Seraphina I*, 1983

Kushner, *Spring IX*, 1987
© 1996 Crown Point Press

Kushner, *Reclining Woman #26*,
1987
© 1996 Crown Point Press

La Noue, *Patagonia Suite XVI*,
1993

ROCKWELL KENT (1882–1971)
Asgaard Cornfield, California, 1950
Oil on canvas
28 x 44 in. Plate 16

FRANZ KLINE (1910–1962)
Untitled, c. 1958
Oil on paper
14¾ x 19⅝ in. Plate 65

BARBARA KRUGER (b. 1945)
Untitled, 1985
Lenticular photograph
20 x 20 in. Plate 157

BARBARA KRUGER
Untitled, 1985
Lenticular photograph
20 x 20 in. Plate 158

BARBARA KRUGER
Untitled, 1985
Lenticular photograph
20 x 20 in. Plate 159

BARBARA KRUGER
Untitled, 1985
Lenticular photograph
20 x 20 in. Plate 160

ROBERT KUSHNER (b. 1949)
Seraphina I, 1983
Lithograph on paper
25 x 38 in.

ROBERT KUSHNER
Spring IX, 1987
Aquatint with sugar lift aquatint and
flat bite etching on handmade paper
24¾ x 18¾ in.

ROBERT KUSHNER
Reclining Woman #6 (Reclining
Woman series), 1987
Drypoint etching on unique paper
12 x 16 in. (approx.) not illus.

ROBERT KUSHNER
Reclining Woman #26 (Reclining
Woman series), 1987
Drypoint etching on unique paper
12 x 16 in. (approx.)

ROBERT KUSHNER
Reclining Woman #31 (Reclining
Woman series), 1987
Drypoint etching on unique paper
12 x 16 in. (approx.) Figure 56

TERENCE LA NOUE (b. 1941)
Patagonia Suite XVI, 1993
Mixed media on paper
29¼ x 21⅞ in.

Laughlin, *The Staggered Treads*, 1948

Laughlin, *The Autonomous Spiral*, 1949

Laughlin, Untitled, 1951

Lawler, Untitled, 1985

Lee, *Dancing, Green*, 1989

Lever, *Staten Island Looking Toward Brooklyn*, 1938

TERENCE LA NOUE
Ringmaster I, 1993–94
Mixed media on canvas
51³⁄₈ x 48¹⁄₄ in. Plate 137

CLARENCE LAUGHLIN (1905–1985)
Light on the Cylinders #4, 1937
Gelatin silver print
13¹⁄₂ x 10 ¹⁄₈ in. (image) not illus.

CLARENCE LAUGHLIN
Light on the Cylinders #5, 1937
Gelatin silver print
13¹⁄₂ x 10 in. (image) Figure 31

CLARENCE LAUGHLIN
The Staggered Treads, 1948
Gelatin silver print
13¹⁄₄ x 10¹⁄₂ in. (image)

CLARENCE LAUGHLIN
The Autonomous Spiral, 1949
Gelatin silver print
13³⁄₄ x 10⁷⁄₈ in. (image)

CLARENCE LAUGHLIN
Untitled, 1951
Gelatin silver print
13¹⁄₄ x 10⁵⁄₈ in. (image)

LOUISE LAWLER (b. 1947)
Untitled, 1985
Cibachrome photograph
29¹⁄₄ x 39¹⁄₂ in.

JACOB ARMSTEAD LAWRENCE (b. 1917)
Builders in the City, 1993
Gouache on paper
19 x 28⁵⁄₈ in. Plate 116

ERNEST LAWSON (1873–1939)
The Pond and Gapstow Bridge, New York City, 1914
Oil on canvas
21⁷⁄₈ x 25 in. Plate 5

CATHERINE LEE (b. 1950)
Dancing, Green, 1989
Cast bronze sculpture
84¹⁄₂ x 49⁵⁄₈ x 3⁷⁄₈ in.

RICHARD HAYLEY LEVER (1876–1958)
Staten Island Looking Toward Brooklyn, 1938
Pen and ink on paper
14 x 18 in.

EDMUND D. LEWANDOSKI (b. 1914)
Amish Farmscape, No. 4, 1985
Oil on canvas
26 x 49¹⁄₄ in. Figure 32

Lewis, *Derricks*, 1927

LeWitt, *Untitled, (No. 6)*, 1989

Lichtenstein, *Vertical Apple*, 1983

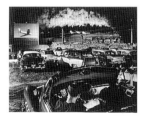

Link, *Hot Shot East Bound, Iaeger, West Virginia*, 1956

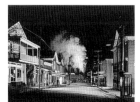

Link, *Ghost Town*, 1957

MARTIN LEWIS (1881–1962)
Derricks, 1927
Drypoint on paper
8¹⁄₄ x 12¹⁄₄ in.

SOL LEWITT (b. 1928)
Untitled (No. 1), 1989
Gouache on paper
22¹⁄₈ x 29⁵⁄₈ in. Plate 102

SOL LEWITT
Untitled (No. 6), 1989
Gouache on paper
22¹⁄₈ x 29⁵⁄₈ in.

ROY LICHTENSTEIN (b. 1923)
Still Life with Book, Grapes and Apple, 1972
Oil and magna on canvas
36 x 40 in. Plate 73

ROY LICHTENSTEIN
Bull Profile Series, 1973
Six color lithographs on paper
27 x 35 in. (each) Plate 75

ROY LICHTENSTEIN
Little Glass, 1979
Painted bronze
19¹⁄₄ x 12³⁄₈ x 5¹⁄₂ in. Plate 74

ROY LICHTENSTEIN
Vertical Apple, 1983
Woodcut on paper
37¹⁄₄ x 32¹⁄₄ in.

ROY LICHTENSTEIN
View from the Window, 1985
Lithograph, woodblock, and serigraph print on paper
78³⁄₈ x 32³⁄₄ in. Figure 46

O. WINSTON LINK (b. 1914)
Hot Shot East Bound, Iaeger, West Virginia, 1956
Gelatin silver print
16 x 20 in.

O. WINSTON LINK
Maud Bows to the Virginia Creeper, Greencove, Virginia, 1956
Gelatin silver print
16 x 20 in. not illus.

O. WINSTON LINK
Ghost Town, 1957
Gelatin silver print
16 x 20 in.

Link, *Birmingham Special, Rural Retreat, Virginia*, 1957

Longo, *Gretchen* (Men in the Cities series), 1984

Longo, *Edmund* (Men in the Cities series), 1985

Longo, *Ann* (Men in the Cities series), 1985

O. WINSTON LINK
Birmingham Special, Rural Retreat, Virginia, 1957
Gelatin silver print
16 x 20 in.

BERT LONG JR. (b. 1940)
The Promise, 1986
Acrylic, canvas, and mixed media on hydrostone frame
35¼ x 23½ x 6½ in. Figure 58

ROBERT LONGO (b. 1953)
Eric (Men in the Cities series), 1984
Color lithograph on paper
67¾ x 39 in. Plate 165

ROBERT LONGO
Gretchen (Men in the Cities series), 1984
Color lithograph on paper
67¾ x 38⅞ in.

ROBERT LONGO
Cindy (Men in the Cities series), 1984
Color lithograph on paper
67¾ x 39 in. not illus.

ROBERT LONGO
Edmund (Men in the Cities series), 1985
Color lithograph on paper
68 x 39⅛ in.

ROBERT LONGO
Ann (Men in the Cities series), 1985
Color lithograph on paper
67¾ x 39 in.

ROBERT LONGO
Arena Brains, 1986
Lithograph on paper
44 x 28⅞ in. Figure 5

ROBERT LONGO
Strong in Love, 1986
Bronze relief
54 x 53¾ x 8 in. Plate 166

MORRIS LOUIS (1912–1962)
D-41, 1949
Pen and ink on paper
18½ x 23⅝ in. Figure 41

JOE MANCUSO (b. 1954)
Inside Straight, 1993
Acrylic on canvas
82⅛ x 59¾ in. Plate 135

Mangold, Untitled, 1989, (3 of 4)

Man Ray, *Mathematical Object*, 1936

Man Ray, *Mathematical Object*, 1936

Man Ray, *Mathematical Object*, 1936

ROBERT MANGOLD (b. 1937)
Untitled, 1989
Four color woodcuts on paper
14⅝ x 26½ in. (each) Plate 101

SYLVIA PLIMACK MANGOLD (b. 1938)
November 19, 1978, 1978
Oil on canvas
30 x 40 in. Plate 98

MAN RAY (1890–1976)
Hands of the Countess Villombrosa, 1926
Vintage gelatin silver print
8⅞ x 6⅝ in. Figure 28

MAN RAY
Hands and Profile of the Countess Villombrosa, 1926
Vintage gelatin silver print
8⅞ x 6⅞ in. Figure 27

MAN RAY
Hands and Profile of Countess Villombrosa, 1926
Vintage gelatin silver print
6⅞ x 4⅝ in. not illus.

MAN RAY
Mathematical Object, 1936
Gelatin silver print
12½ x 9 in. Plate 55

MAN RAY
Mathematical Object, 1936
Gelatin silver print
12 x 9 in. (top)

MAN RAY
Mathematical Object, 1936
Gelatin silver print
12 x 9 in. (middle)

MAN RAY
Mathematical Object, 1936
Gelatin silver print
11½ x 9 in. (bottom)

MAN RAY
Mathematical Object, 1936
Gelatin silver print
11½ x 9 in. not illus.

MAN RAY
Macbeth (Shakespearian Equations series), 1948
Oil on canvas
30 x 24 in. Plate 56

Man Ray, *Poire d'Erik Satie*, 1969

Mapplethorpe, *Andre*, 1984
Copyright © 1984 The Estate of Robert Mapplethorpe

Mapplethorpe, *Flower*, 1984
Copyright © 1984 The Estate of Robert Mapplethorpe

Mapplethorpe, *Pheasant*, 1984
Copyright © 1984 The Estate of Robert Mapplethorpe

Marden, *Etchings to Rexroth #16*,
1986

Marsh, *Rue Bonaparte–Priests–Lovers*,
1928

MAN RAY
Poire d'Erik Satie, 1969
Color lithograph on paper
19³⁄₈ x 13¹⁄₈ in. (image)

MAN RAY
Pechage, 1970
Color lithograph on paper
19³⁄₈ x 13¹⁄₈ in. (image) not illus.

ROBERT MAPPLETHORPE (1946–1989)
*Alistair Butler, 1980 (Hands Over
Face, NYC)*, 1980
Unique gelatin silver print
30 x 30 in. Plate 149

ROBERT MAPPLETHORPE
Andre, 1984
Gelatin silver print
20 x 16 in.

ROBERT MAPPLETHORPE
Flower, 1984
Gelatin silver print
20 x 16 in.

ROBERT MAPPLETHORPE
Flower, 1984
Gelatin silver print
20 x 16 in. not illus.

ROBERT MAPPLETHORPE
Pheasant, 1984
Platinum print
25³⁄₄ x 22 in.

BRICE MARDEN (b. 1938)
*Etchings to Rexroth #1, 11, 15, 16, 17,
19, 20, 21*, 1986 (all)
Eight etchings: sugarlift, aquatint, dry-
point, and open bite print on paper
19³⁄₈ x 15⁷⁄₈ in. (each, approx.)
 (#1) Figure 51

JOHN MARIN (1870–1953)
Off Deer Isle, Maine, 1928
Watercolor on paper
16¹⁄₄ x 21³⁄₄ in. Plate 26

REGINALD MARSH (1898–1954)
Rue Bonaparte–Priests–Lovers, 1928
Lithograph on paper
9¹⁄₄ x 13³⁄₄ in.

REGINALD MARSH
Girls in the Street, 1946
Tempera on paper
22¹⁄₂ x 31 in. Plate 18

Doug Martin, *Star Stuff*, 1994

Jim Martin, *Pell mell*, 1992

Jim Martin, *Belvedere*, 1992

Jim Martin, *Quail*, 1993

Robert Martin, *Agosto #8*, 1992

DOUG MARTIN (b. 1947)
Star Stuff, 1994
Oil and maps on canvas
86 x 77 in.

JIM MARTIN (b. 1953)
Pell mell, 1992
Acrylic on paper
35³⁄₄ x 50 in.

JIM MARTIN
Swill, 1992
Acrylic on paper
35³⁄₄ x 50 in. not illus.

JIM MARTIN
Belvedere, 1992
Acrylic on paper
35³⁄₄ x 49³⁄₄ in.

JIM MARTIN
Quail, 1993
Acrylic on canvas
83⁷⁄₈ x 60¹⁄₈ in.

JIM MARTIN
Brabble, 1993
Colored chalk on paper
71³⁄₄ x 50³⁄₈ in. Plate 140

ROBERT MARTIN (b. 1947)
Agosto #8, 1992
Oil on canvas
30¹⁄₈ x 40¹⁄₈ in.

CESAR AUGUSTO MARTINEZ
(b. 1944)
*El Tiempo Borra Todo (Time Erases
Everything)*, 1994
Mixed media on wood
65³⁄₈ x 65¹⁄₄ in. Plate 138

DANIEL J. MARTINEZ (b. 1957)
Untitled (Big Fish Eat Little Fish,
site-specific installation), 1988
Photograph on metal
48 x 48 in. Plate 150

ALICE TRUMBULL MASON
(1904–1971)
Winter, 1930
Oil on canvas
18¹⁄₂ x 24¹⁄₄ in. Figure 35

ALICE TRUMBULL MASON
Untitled, 1938
Oil on canvas
32 x 48¹⁄₄ in. Plate 50

Mason, *Drawing for Black Division*, 1944

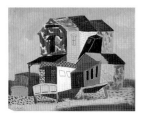

Matulka, *Beach House* (no date)

McClelland, *more, more, more*, 1994

McClelland, *anymore*, 1994

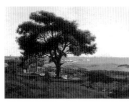

McEntee, *Near Kennebunkport*, 1871

McLaughlin, *Untitled 5108*, 1963

ALICE TRUMBULL MASON
Drawing for Black Division, 1944
Chalk and pencil on paper
11⅞ x 17 in.

JAN MATULKA (1890–1972)
Beach House (no date)
Oil on canvas
16¼ x 20¼ in.

JAN MATULKA
New York Elevated, c. 1924-26
Gouache on paper
19¼ x 14¾ in. (image) Plate 30

ALFRED HENRY MAURER
(1868–1932)
Cubist Still Life with Two Pears, c. 1928–30
Oil on gessoed panel mounted on canvas
18⅜ x 22⅛ in. Plate 31

SUZANNE MCCLELLAND (b. 1957)
more, more, more, 1994
Charcoal, Acrylex, and enamel on
sandpaper
19½ x 17 in.

SUZANNE MCCLELLAND
anymore, 1994
Charcoal, Acrylex, and enamel on
sandpaper
16¼ x 15½ in.

JERVIS MCENTEE (1828–1891)
Near Kennebunkport, 1871
Oil on canvas
11½ x 16 in.

JOHN MCLAUGHLIN (1898–1976)
Untitled 5103, 1963
Lithograph on paper
18 x 21½ in. Plate 96

JOHN MCLAUGHLIN
Untitled 5108, 1963
Lithograph on paper
16 x 21½ in.

ARTHUR MELTZER (b. 1893)
Pennsylvania Plowing (no date)
Oil on canvas
22 x 36⅛ in. Figure 17

ANA MENDIETA (1948–1985)
Untitled (Amategram), 1981–82
Acrylic on amate paper
16 x 11⅝ in. Plate 99

Mendieta, *Untitled, (Amategram)*,
1981–82

Michals, *The Man Who Ran Ahead
of His Time*, 1989

Michals, *Many Moons*, 1989

Moroles, *Lapstrake*, 1992

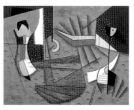

Morris, *Raft on the Lake*, 1946

ANA MENDIETA
Untitled (Amategram), 1981–82
Acrylic on amate paper
16 x 11¾ in.

WILLARD LEROY METCALF
(1858–1925)
Cherry Blossom, 1912
Oil on canvas
26 x 29 in. Plate 3

DUANE MICHALS (b. 1932)
*The Man Who Ran Ahead of His
Time*, 1989
Gelatin silver print
16 x 20 in.

DUANE MICHALS
Miss Kitty Thought She Was Pretty, 1989
Gelatin silver print
16 x 20 in. not illus.

DUANE MICHALS
Many Moons, 1989
Gelatin silver print
16 x 20 in.

ALBERTO MIJANGOS (b. 1925)
T-Shirt III, 1988
Mixed media on canvas
80 x 80 in. Figure 65

JOAN MITCHELL (1926–1992)
La Grande Vallee XIX Yves, 1984
Oil on canvas mounted on board
102¼ x 78½ in. Plate 69

JESUS BAUTISTA MOROLES (b. 1950)
Lapstrake, 1992
Cast paper
35¼ x 22¾ in.

JESUS BAUTISTA MOROLES
Las Mesas Vase, 1993
Morning Rose granite sculpture
30⅜ x 15½ x 3⅛ in. Plate 136

GEORGE L.K. MORRIS (1905–1975)
Urban Concretion, 1939
Oil on canvas
25 x 30⅛ in. Plate 46

GEORGE L.K. MORRIS
Raft on the Lake, 1946
Oil on canvas
28¾ x 36 in.

ED MOSES (b. 1926)
Untitled, 1972
Lithograph on paper
23½ x 31¼ in. Plate 97

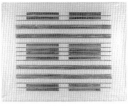

Moses, *Untitled*, 1972

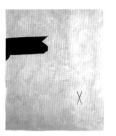

Moskowitz, *Cadillac Chopsticks*, 1985-86

Mueller, *Untitled 1992* (Chi Stories series), 1992

Murch, *Nails and Onion*, c. 1947

Murphy, *After the Storm*, 1876

Murray, *Untitled*, 1982

ED MOSES
Untitled, 1972
Lithograph on paper
23¾ x 31½ in.

ROBERT MOSKOWITZ (b. 1935)
Cadillac Chopsticks, 1985-86
Lithograph, linocut, and screenprint
on paper
35¾ x 29⅞ in.

STEPHEN MUELLER (b. 1947)
Untitled 1992 (Chi Stories series),
1992
Acrylic on canvas
28 x 28 in.

STEPHEN MUELLER
Untitled 1993 (Chi Stories series),
1993
Acrylic on canvas
28 x 28 in. Plate 143

WALTER TANDY MURCH (1907–1967)
Nails and Onion, c. 1947
Oil on panel
16 x 20 in.

GERALD MURPHY (1888–1964)
Bibliothèque, 1927
Oil on canvas
72½ x 52⅝ in. Plate 27

JOHN FRANCIS MURPHY (1853–1921)
After the Storm, 1876
Oil on canvas
16⅛ x 21⅛ in.

ELIZABETH MURRAY (b. 1940)
Untitled, 1982
Fifteen-color silkscreen on three
sheets of Japanese Kurotani Kozo
handmade paper
48¾ x 32¼ in.

ELIZABETH MURRAY
Down Dog, 1988
Nine color lithographs and twelve
collaged papers on paper
41 x 50¾ in. Plate 128

ELIE NADELMAN (1882–1946)
Female Nude (no date)
India ink wash on paper
16⅜ x 5 in. not illus.

ELIE NADELMAN
Female Nude, 1906
Ink on paper
15⅜ x 7¼ in. Figure 24

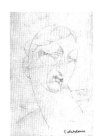

Nadelman, *Head of a Woman*, 1907

Nauman, *4 Fingers, 1 Hole*, 1994

Neely, *Oliveto Cambello*, 1983

Nelson, Untitled, 1994

Neri, *Vicola III*, 1988

Newman, Untitled, 1985

O'Connor, *Negative Cross*, 1991

ELIE NADELMAN
Head of a Woman, 1907
Ink on paper
13 x 8⅞ in.

PETER NAGY (b. 1959)
Industrial Culture, 1987
Eight panels: photo-etched
magnesium relief
20 x 20 in. (each) Plate 164

BRUCE NAUMAN (b. 1941)
4 Fingers, 1 Hole, 1994
Etching on paper
19⅝ x 22 in.

ANNE NEELY (b. 1946)
Oliveto Cambello, 1983
Oil and pastel on paper
22¼ x 29¾ in.

JOAN NELSON (b. 1958)
Untitled, 1994
Vinyl, oil, powdered pigment, and
tumeric on wood
29¾ x 29¾ in.

MANUEL NERI (b. 1930)
Rosa Negra #1, 1983
Enamel painted bronze sculpture
67½ x 36 x 17¾ in. Plate 104

MANUEL NERI
Vicola III, 1988
Charcoal, pastel, and oil paint stick
on paper
39 x 28 in.

JOHN NEWMAN (b. 1952)
Untitled, 1985
Oilstick, graphite, and acrylic on
paper
58¼ x 58⅞ in.

MADELINE O'CONNOR (b. 1931)
Negative Cross, 1991
Acrylic, gesso, and metallic powder
on canvas (two panels)
40 x 20 x 2½ in. (each)

GEORGIA O'KEEFFE (1887–1986)
Black Maple Trunk–Yellow Leaves,
1928
Oil on canvas
40 x 30 in. Plate 33

GEORGIA O'KEEFFE
Not from My Garden, 1967
Oil on canvas
15⅛ x 12 in. Figure 26

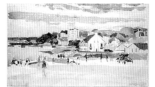

Oberteuffer, *Orchard Beach Scene*
(no date)

Eric Orr, *Sumar #9*, 1986

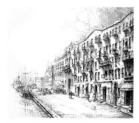

Louis Orr, *Savannah*, 1928

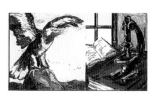

Ott, *Nature Morte*, 1985

Pfaff, *Untitled*, 1993

GEORGE OBERTEUFFER (1878–1940)
Orchard Beach Scene (no date)
Watercolor on paper
11¼ x 19¼ in. (image)

CLAES OLDENBURG (b. 1929)
Baked Potato with Butter, 1972
Lithograph on paper
30½ x 40¼ in. Figure 47

CLAES OLDENBURG
Spring, Summer, Autumn, Winter
(Apple Core Series), 1989
Four lithographs on paper
40 x 30 in. (each, approx.) Plate 79

JULIAN ONDERDONK (1882–1922)
Texas Bluebonnets, 1910
Oil on canvas
14 x 20⅛ in. Plate 4

ERIC ORR (b. 1939)
Sumar #9, 1986
Gold leaf, pigment, blood, and lead
on board
25½ x 22¾ in.

LOUIS ORR (1879–1961)
Savannah, 1928
Etching on paper
8⅝ x 9⅝ in.

SABINA OTT (b. 1955)
Nature Morte, 1985
Oil on canvas (two panels)
L: 36 x 36 in.
R: 36 x 30⅛ in.

PHILIP PEARLSTEIN (b. 1924)
Nude in Hammock, 1982
Lithograph on paper
30⅛ x 40⅜ in. Plate 90

JOSEPH PENNELL (1857–1926)
The Banqueting Hall, Whitehall,
(no date)
Watercolor with Chinese white on
paper
9 x 13½ in. Figure 8

JUDY PFAFF (b. 1946)
Untitled, 1993
Burn marks, flocking, iridescent pig-
ment, oilstick, watercolor, and pho-
tocopy transfers on Gampi paper
29⅞ x 20⅛ in.

Plagens, *131-94*, 1994

Pleissner, *The Cliffs at Big Salmon*
(no date)

Potthast, *Stargazer* (no date)

Price, *Untitled*, (no date)

Prince, *Fayy*, (Entertainers series),
1982

Raffael, *Rachel II*, 1984

PETER PLAGENS (b. 1941)
131-94, 1994
Mixed media on paper
43¾ x 35 in.

ODGEN MINTON PLEISSNER
(1905–1983)
The Cliffs at Big Salmon (no date)
Watercolor on paper
17¼ x 24 in. (image)

JACKSON POLLOCK (1912–1956)
Untitled, 1951
Ink on Howell paper
12¼ x 16 in. Plate 62

EDWARD HENRY POTTHAST
(1857–1927)
Stargazer (no date)
Gouache, pen, and ink wash on paper
16¾ x 10¾ in. (image)

KENNETH PRICE (b. 1935)
Untitled (no date)
Ceramic vase
8 in. (height) x 5 in. (diameter)

KENNETH PRICE
Lizard Cup, 1971
Poster paint on illustration board
25 x 35⅝ in. (image) Plate 89

RICHARD PRINCE (b. 1949)
Tamara (Entertainers series), 1982
Unique Ektacolor print mounted in
Plexiglas frame
98¼ x 50⅜ in. Figure 54

RICHARD PRINCE
Fayy (Entertainers series), 1982
Unique Ektacolor print mounted in
Plexiglas frame
98¾ x 50¼ in.

RICHARD PRINCE
Panic, Psycho, Gone, 1986
Ektacolor print
85½ x 46½ in. not illus.

RICHARD PRINCE
Untitled, 1993
Ektacolor print
47 x 71 in. Plate 163

JOSEPH RAFFAEL (b. 1933)
Rachel II, 1984
Acrylic and pastel on paper
79¾ x 74¼ in.

Rauschenberg, *Bellini #2*, 1987

Rauschenberg, *Bellini #5*, 1989

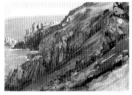

Richards, *Cornwall Cliffs* (no date)

Ripley, *Construction at the Dock*, 1928

Rittenberg, *French Waterfront Scene, Brittany* (no date)

Rivers, *Camel Quartet*, 1978

ROBERT RAUSCHENBERG (b. 1925)
Bellini #1 (Bellini series), 1986
Eleven-color intaglio print on paper
58⅛ x 37⅞ in. Plate 81

ROBERT RAUSCHENBERG
Bellini #2 (Bellini series), 1987
Eleven-color intaglio print on paper
58¾ x 37⅞ in.

ROBERT RAUSCHENBERG
Bellini #3 (Bellini series), 1988
Eight-color intaglio print on paper
59 x 37⅝ in. not illus.

ROBERT RAUSCHENBERG
Bellini #4 (Bellini series), 1988
Seven-color intaglio print on paper
59⅞ x 38⅜ in. not illus.

ROBERT RAUSCHENBERG
Bellini #5 (Bellini series), 1989
Fourteen-color intaglio print on paper
58⅞ x 38¼ in.

ROBERT RAUSCHENBERG
III (Samarkand Stitches series), 1989
Unique screenprint and fabric collage
63 x 49½ x 3¼ in. Plate 82

AD REINHARDT (1913–1967)
Untitled, 1940
Oil on canvas
16 x 20 in. Plate 54

WILLIAM RICHARDS (1833–1905)
Cornwall Cliffs (no date)
Watercolor on paper
8½ x 12 in.

AIDEN RIPLEY (1896–1969)
Park Scene (no date)
Watercolor on paper
14¾ x 18¾ in. (image) not illus.

AIDEN RIPLEY
Construction at the Dock, 1928
Watercolor on paper
15¼ x 18⅞ in. (image)

HENRY R. RITTENBERG (1879–1969)
French Waterfront Scene, Brittany
(no date)
Oil on canvas
25 x 30 in.

LARRY RIVERS (b. 1923)
Camel Quartet, 1978
Silkscreen and lithograph on paper
22¼ x 20½ in.

Robus, *Seated Nude* (no date)

Rosenberg, Untitled, 1992

Rosenberg, Untitled, 1992

Rosenquist, *Moon Box*, 1971

Rosenquist, *Moon Beam Mistaken for the News*, 1971

HUGO ROBUS (1885–1964)
Seated Nude (no date)
Ink and crayon on paper
7 x 8¼ in. (image)

FRANK ROMERO (b. 1941)
High Heel Shoe, 1995
Acrylic and oil on wood
23½ x 23½ in. Plate 122

FRANK ROMERO
Phone, 1995
Acrylic and oil on wood
23½ x 23½ in. Plate 123

FRANK ROMERO
Car, 1995
Acrylic and oil on wood (two panels)
23½ x 23½ in. (each) Plate 124

FRANK ROMERO
Cherry Pie, 1995
Acrylic and oil on wood
23½ x 23½ in. Plate 125

FRANK ROMERO
L.A. at Night, 1995
Acrylic and oil on wood
23½ x 23½ in. Plate 126

ANDREA ROSENBERG (b. 1948)
Untitled, 1992
Hand-colored monotype on paper
29⅝ x 22¾ in.

ANDREA ROSENBERG
Untitled, 1992
Hand-colored monotype on paper
29⅝ x 22¾ in.

JAMES ROSENQUIST (b. 1933)
Area Code, 1969
Color lithograph (two panels)
28⅝ x 25¾ in. (each, approx.)
 Figure 45

JAMES ROSENQUIST
Moon Box, 1971
Lithograph on paper
16½ x 19⅛ in.

JAMES ROSENQUIST
Moon Beam Mistaken for the News,
1971
Lithograph on paper
22¼ x 30⅛ in.

JAMES ROSENQUIST
F–111, 1974
Four-panel color lithograph on paper
36½ x 75 in. (two panels, each, approx.)
36½ x 70 in. (two panels, each, approx.)
Plate 76

JAMES ROSENQUIST
Telephone Explosion, 1983
Oil on canvas mounted on board
78 x 66 in. Plate 78

THEODORE J. ROSZAK (1907–1981)
42nd Street, 1936
Oil on canvas
47 x 59¼ in. Plate 39

MARK ROTHKO (1903–1970)
Black over Deep Red, 1957
Oil on canvas
69⅜ x 53⅞ in. Plate 64

EDWARD RUSCHA (b. 1937)
World Without Countries, 1980
Oil on canvas
22 x 80 in.

Ruscha, *World Without Countries*,
1980

EDWARD RUSCHA
Big Dipper over Desert, 1982
Aquatint printed in blue on paper
33½ x 45 in. not illus.

EDWARD RUSCHA
Cities, 1982
Lithograph on paper
25 x 47⅝ in. Figure 49

Ruscha, *Exhibition of Crooners*,
1985

EDWARD RUSCHA
Exhibition of Crooners, 1985
Acrylic and dry pigment on paper
40¼ x 60 in.

EDWARD RUSCHA
Jockey, 1988
Aquatint on paper
39¾ x 26¾ in.

Ruscha, *Jockey*, 1988

EDWARD RUSCHA
Final End, 1992
Acrylic on canvas
70 x 138 in. Plate 85

DAVID SALLE (b. 1952)
Sugar Bowl with Carved Bird, 1988
Oil and acrylic on canvas (two panels)
41 x 28 in. (each) Plate 156

ITALO SCANGA (b. 1932)
Visiting with John Muir, 1981
Color hard ground etching with
aquatint on paper
42 x 30 in.

Scanga, *Sacrificial Lamb*, 1981
© 1996 Crown Point Press

Scanga, Untitled, 1987

Schnabel, *Dream*, 1983

Shapiro, *Seers, Actors, Knowers,
Doers*, 1986

Sheeler, *Tree and Landscape*, 1947

ITALO SCANGA
Sacrificial Lamb, 1981
Color hard ground etching with
aquatint on paper
42 x 30 in.

ITALO SCANGA
Untitled, 1987
Monotype on handmade paper
29¼ x 22⅝ in.

MORTON LIVINGSTON
SCHAMBERG (1881–1918)
Untitled, 1916
Oil on fiberboard
15¾ x 12 in. Plate 28

JULIAN SCHNABEL (b. 1951)
Dream, 1983
Etching on paper
46½ x 70¾ in.

RICHARD SERRA (b. 1939)
Double Ring II, 1972
Lithograph on paper
35¼ x 48¼ in. Figure 52

DAVID SHAPIRO (b. 1944)
Seers, Actors, Knowers, Doers, 1986
Etching, drypoint, and collage
on hand-painted paper
70⅞ x 37⅛ in.

CHARLES SHAW (1892–1974)
Abstract Shapes, 1935
Oil on canvas
39½ x 32 in. Plate 51

CHARLES SHEELER (1883–1965)
Powerhouse with Trees, 1943
Gouache on paper
14⅝ x 21¾ in. (image) Plate 57

CHARLES SHEELER
Tree and Landscape, 1947
Tempera on board
15⅝ x 13½ in.

CHARLES SHEELER
Convergence, 1952
Oil on canvas
24⅛ x 16⅛ in. Plate 58

EVERETT SHINN (1876–1953)
Paris Square (Winter), 1940
Pastel on paper
14 x 20 in. Plate 19

Skoglund, *The Possibilities of Trash*, 1986

Francis Smith, *Cargo Boats on the Seine* (no date)

Sockwell, *July*, 1979

Sockwell, *White Space*, 1979

Sonneman, *Torn, Paris*, 1983

Sonneman, *Butterflies in Plastic*, 1983

SANDY SKOGLUND (b. 1946)
The Sound of Food, 1986
Dye transfer photograph
20 x 24 in. Plate 151

SANDY SKOGLUND
The Possibilities of Trash, 1986
Dye transfer photograph
20 x 24 in.

JOHN SLOAN (1871–1951)
Romany Marye's in Christopher St., 1922
Etching on paper
8½ x 8¾ in. (image) Figure 9

JOHN SLOAN
Landscape, Santa Fe, c. 1925
Oil on board
16 x 20¼ in. Plate 9

JOHN SLOAN
Sunbathers on the Roof, 1941
Etching on paper
7 x 7¾ in. (image) Figure 10

DAVID SMITH (1906–1965)
Untitled (Virgin Island series), 1933
Oil on canvas
26¼ x 36¼ in. Plate 38

FRANCIS SMITH (1838–1915)
Cargo Boats on the Seine (no date)
Gouache and watercolor on paper
12 x 19¼ in.

CARROLL SOCKWELL (1943–1992)
July, 1979
Pastel on paper
10¾ x 13½ in. (image)

CARROLL SOCKWELL
A Wise Tale, 1979
Mixed media relief
30⅛ x 30⅛ x 5½ in. Plate 114

CARROLL SOCKWELL
White Space, 1979
Charcoal, pastel, and pencil on ragboard
40⅛ x 59 in.

EVE SONNEMAN (b. 1946)
Torn, Paris, 1983
Cibachrome photograph
20 x 24 in.

EVE SONNEMAN
Butterflies in Plastic, 1983
Cibachrome photograph
19½ x 23⅝ in.

Souza, *Dead Volks*, 1981

Speed, *Who What When Where How & Why*, 1993

Steir, *Waterfall #35*, 1988
© 1996 Crown Point Press

Frank Stella, *Imola Five II*, 1983

Joseph Stella, *Hyacinth and Sparrow*, c. 1919

Stephan, Untitled, 1988

AL SOUZA (b. 1944)
Dead Volks, 1981
Mixed media on paper
28¼ x 38 in.

JULIE SPEED (b. 1951)
Who What When Where How & Why, 1993
Mixed media construction
16 x 25½ x 3 in.

NILES SPENCER (1893–1952)
In Fairmont, West Virginia, 1951
Oil on canvas
23½ x 14⅝ in. Figure 38

PAT STEIR (b. 1940)
Waterfall, 1988
Etching on paper
53 x 41 in. not illus.

PAT STEIR
Waterfall #35, 1988
One of a series of 37 color monoprints on paper
50½ x 39 in.

PAT STEIR
Waterfall of Ancient Ghosts, 1990
Oil on canvas
78 x 150½ in. Plate 110

FRANK STELLA (b. 1936)
Damascus Gate III, 1968
Polymer and fluorescent polymer on canvas
60 x 240 x 3 in. Plate 95

FRANK STELLA
Imola Five II, 1983
Woodcut and relief print on paper
66½ x 48¼ in.

FRANK STELLA
The Great Heidelburgh Tun, 1988
Silkscreen, lithograph, and linoleum block print on paper
74¼ x 54¼ in. Figure 4

JOSEPH STELLA (1880–1946)
Hyacinth and Sparrow, c. 1919
Silver point and color pencil on paper
27 x 10¼ in. (image)

GARY STEPHAN (b. 1942)
Untitled, 1988
Etching on paper
15⅜ x 11 in.

Stephan, *Untitled, 1988*

Stephan, *Untitled, 1989*

Struss, *Manhattan Bridge, 1911*

Stuart, *Voyage to the South Seas: Flora Iris,* 1989

Stuart, *Voyage to the South Seas: Flora Otaheite,* 1989

GARY STEPHAN
Untitled, 1988
Etching on paper
25 x 18¾ in.

GARY STEPHAN
Untitled, 1989
Etching on paper
20⅛ x 14¾ in.

ALFRED STIEGLITZ (1864–1946)
The Steerage, 1907
Photogravure on Chinese tissue
12¼ x 10 in. (image) Plate 21

ALFRED STIEGLITZ
Portrait of Georgia O'Keeffe, c. 1932
Vintage gelatin silver print
9¼ x 6⅝ in. (image) Figure 25

CLYFFORD STILL (1904–1980)
Untitled, 1945
Oil on paper
26 x 20 in. Plate 63

JOHN STORRS (1885–1956)
Composition (Abstract), 1931
Oil on masonite
18 x 12½ in. Figure 30

JOHN STORRS
Genesis, 1932
Oil on board
31 x 25⅛ in. Plate 41

KARL STRUSS (1886–1981)
Manhattan Bridge, 1911
Platinum print
3⅞ x 3½ in.

MICHELLE STUART (b. 1940)
Voyage to the South Seas: Flora Australis, 1989
Etching and aquatint on paper
26⅛ x 32⅝ in. not illus.

MICHELLE STUART
Voyage to the South Seas: Flora Iris, 1989
Etching and aquatint on paper
26⅜ x 32¾ in.

MICHELLE STUART
Voyage to the South Seas: Flora Otaheite, 1989
Etching and aquatint on paper
26½ x 33 in.

Sultan, *Sailor Hats, March 21, 1979* (Water Under the Bridge series), 1979

Sultan, *Cigarette/Stack, March 28, 1979* (Water Under the Bridge series), 1979

Sultan, *Still Life with Pears and Lemons,* 1986

Sultan, *1987, Black Lemons, April 16, 1987* (Black Lemons series), 1987

Surls, *Flower,* 1988
© 1996 James Surls/Licensed by VAGA, New York, NY, Marlborough Gallery, NY

Symons, *Landscape, Berkshires* (no date)

DONALD SULTAN (b. 1951)
Boat/Table, March 20, 1979 *
Sailor Hats, March 21, 1979
Half Hats, March 22, 1979 *
*Half Hats and Whole, March 22, 1979**
*Whole Hats and Halves, March 22, 1979**
Iceberg/Boat Prow, March 25, 1979 *
Lake and Moon, March 26, 1979 *
Cigarette/Stack, March 28, 1979
(Water Under the Bridge series), 1979
Eight aquatints on paper
18 x 18 in. (each) *not illus.

DONALD SULTAN
Still Life with Pears and Lemons, 1986
Offset color lithograph on paper
24¼ x 20⅞ in.

DONALD SULTAN
Still Life with Pears and Lemons, 1986
Etching on paper
24¼ x 20⅞ in. not illus.

DONALD SULTAN
Still Life with Pears and Lemons, 1986
Offset color lithograph and aquatint on paper
24¼ x 20¾ in. not illus.

DONALD SULTAN
Black Lemon, April 20, 1987 *
Black Lemons, April 16, 1987
Black Lemons, April 16, 1987 *
*Black Lemon and Egg, April 14, 1987**
(Black Lemons series), 1987
Four aquatints on paper
62⅞ x 48⅞ in. *not illus.

JAMES SURLS (b. 1943)
Around the Sun, 1985
Pine and steel sculpture
53 x 63 x 19 in. (approx.) Plate 133

JAMES SURLS
Flower, 1988
Linocut on paper
26½ x 37⅜ in.

JAMES SURLS
We See, 1988
Linocut on paper
26 x 37¼ in. not illus.

GEORGE GARDNER SYMONS
(1861–1930)
Landscape, Berkshires (no date)
Oil on canvas
25⅛ x 30 in.

Taylor, *Cubist Still Life*, 1914

Tetherow, *Compost Series #1*, 1990

Therrien, *No Title*, 1987

Thiebaud, *Hill Street*, 1987
Courtesy Allan Stone Gallery

Thomas, *Brooklyn Dock*, 1930

Tracy, *Agony in the Garden, I*, 1984

HENRY FITCH TAYLOR (1853–1925)
Cubist Still Life, 1914
Oil on canvas
28 x 22 in.

MICHAEL TETHEROW (b. 1942)
Compost Series #1, 1990
Ink and acrylic on paper
35 ⅞ x 36 ⅜ in.

ROBERT THERRIEN (b. 1947)
No Title, 1987
Oil and pencil on canvas mounted on wood
64 x 96 in.

WAYNE THIEBAUD (b. 1920)
Hill Street, 1987
Color woodblock print on paper
36 ¾ x 24 in.

WAYNE THIEBAUD
Country City, 1988
Color soft ground etching with dry-point and aquatint on paper
30 ½ x 40 ¾ in. not illus.

BYRON THOMAS (1902–1978)
Brooklyn Dock, 1930
Oil on board
12 ⅜ x 20 in.

HELEN TORR (1886–1967)
Composition, 1935
Oil on canvas
22 ¼ x 25 ½ in. Plate 45

MICHAEL TRACY (b. 1943)
Agony in the Garden, I, 1984
Ink, watercolor, and crayon on paper
44 ⅞ x 47 ⅝ in.

MICHAEL TRACY
Agony in the Garden, VIII, 1984
Watercolor, oilstick, cray-pas, gouache, and ink on paper
44 ¾ x 44 ⅜ in. not illus.

MICHAEL TRACY
Agony in the Garden, IX, 1984
Watercolor, oilstick, cray-pas, gouache, and ink on paper
44 ¾ x 46 ¾ in. not illus.

MICHAEL TRACY
Septima Estacion: Que Sepamos Levantarnos de Nuestra Caidas, 1986
Acrylic, paper, and foil on Mexican board
39 ½ x 27 ½ in. Plate 139

Tracy, *Decimasegunda Estacion: Padre en Tus Manos Encomiendo Mi Espiritu*, 1986

True, *Open Channel*, 1987
© 1996 Crown Point Press

Trunk, *Trees*, c. 1935

Turnbull, *Black Girl*, 1943

Turrell, *First Light, Meeting*, 1990

Turrell, *First Light, A1, (Shanta)*, 1990

MICHAEL TRACY
Novena Estacion: En Profunda Adoracion, 1986
Acrylic, paper, and foil on Mexican board
39 x 27 ¼ in. not illus.

MICHAEL TRACY
Decimasegunda Estacion: Padre en Tus Manos Encomiendo Mi Espiritu, 1986
Acrylic, paper, and foil on Mexican board
39 x 27 ¼ in.

MICHAEL TRACY
Dicimatercera Estacion: Jesus en los Brazos de su Santisma Madre, 1986
Acrylic, paper, and foil on Mexican board
39 x 27 ¼ in. not illus.

DAVID TRUE (b. 1942)
Roaming Swiftly, Knowing Quickly, 1985
Aquatint on paper
65 ½ x 48 ¼ in. not illus.

DAVID TRUE
Open Channel, 1987
Color aquatint on paper
30 x 52 in.

HERMAN TRUNK (1894–1963)
Trees, c. 1935
Watercolor and pencil on paper
17 x 12 ¼ in.

JAMES TURNBULL (1909–1976)
Black Girl, 1943
Watercolor on paper
21 ¼ x 14 ½ in.

JAMES TURRELL (b. 1943)
First Light, Meeting (First Light series), 1990
One of twenty etchings and aquatint on paper
42 ⅛ x 29 ¾ in.

JAMES TURRELL
First Light, A1 (Shanta)
First Light, A2 (Catso) *
First Light, A3 (Afrum) *
First Light, A4 (Munson) *
First Light, A5 (Squat) *
(First Light series), 1990 (all)
Five of twenty etchings and aquatint on paper
42 ⅛ x 29 ¾ in. (all) *not illus.

Turrell, *First Light, B1, (Raethro),*
1990

Turrell, *First Light, D1, (Juke),* 1990

Turrell, *First Light, E1, (Joecar),* 1990

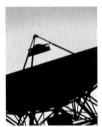

Twaddle, *Antenna,* 1989

Utterback, *Untitled #729,* 1994

JAMES TURRELL
First Light, B1 (Raethro)
First Light, B2 (Alta) *
First Light, B3 (Gard) *
(First Light series), 1990 (all)
Three of twenty etchings and
aquatint on paper
42⅛ x 29¾ in. (all) *not illus.

JAMES TURRELL
First Light, C1 (Carn)
First Light, C2 (Acro)
First Light, C3 (Ondoe)
First Light, C4 (Phantom)
(First Light series), 1990 (all)
Four of twenty etchings and
aquatint on paper
42⅛ x 29¾ in. (all) Plate 103

JAMES TURRELL
First Light, D1 (Juke)
First Light, D2 (Sloan) *
First Light, D3 (Fargo) *
First Light, D4 (Decker) *
(First Light series), 1990 (all)
Four of twenty etchings and
aquatint on paper
42⅛ x 29¾ in. (all) *not illus.

JAMES TURRELL
First Light, E1 (Joecar)
First Light, E2 (Enzu) *
First Light, E3 (Tollyn) *
(First Light series), 1990 (all)
Three of twenty etchings and
aquatint on paper
42⅛ x 29¾ in. (all) *not illus.

RANDY TWADDLE (b. 1957)
Arecibo, 1989
Oilstick on paper
64 x 53 in. not illus.

RANDY TWADDLE
Antenna, 1989
Oilstick on paper
64 x 53 in.

ROBIN UTTERBACK (b. 1949)
Untitled #729, 1994
Acrylic and collage on canvas
41¾ x 48¾ in.

JOHN VALADEZ (b. 1951)
MPICA, 1987
Pastel on paper
50 x 38⅜ in. Plate 146

Van Everen, *Abstract,* 1925

Vargas, *FOR A #10,* 1994

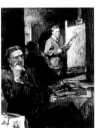

Voulkos, *Untitled,* 1992

Ward, *Artist at Work,* 1918

Warhol, *Star Ferry,* 1976–86

Waterston, *Archaic Fall,* 1994

JAY VAN EVEREN (1875–1947)
Abstract, 1925
Gouache and watercolor on paper
5¼ x 5⅛ in.

KATHY VARGAS (b. 1950)
FOR A #1, 1992
Hand-colored gelatin silver print
22¼ x 17¼ in. (image) Figure 64

KATHY VARGAS
FOR A #10, 1994
Hand-colored gelatin silver print
22⅝ x 17¾ in. (image)

PETER VOULKOS (b. 1924)
Untitled, 1992
Ceramic and porcelain plate
22½ in. (diameter)

ABRAHAM WALKOWITZ (1878–1965)
Cityscape, 1912
Charcoal on paper
18¾ x 14¼ in. (image) Figure 22

EDMUND F. WARD (1892–1990)
Artist at Work, 1918
Oil on board
38 x 29⅞ in. (image)

ANDY WARHOL (1928–1987)
Star Ferry, 1976–86
Four gelatin silver prints with
stitching
27⅜ x 21⅜ in.

ANDY WARHOL
Letter to the World–The Kick, 1986
Serigraph on paper
35½ x 35⅝ in. Plate 80

DARREN WATERSTON (b. 1965)
Archaic Fall, 1994
Oil and encaustic on wood panel
30½ x 20 in.

DARREN WATERSTON
Synthesis No. 9, 1994
Oil on canvas
48½ x 24 in. not illus.

MAX WEBER (1881–1961)
New York, 1912
Oil on canvas
21¼ x 25¼ in. Plate 22

CARRIE MAE WEEMS (b. 1953)
Untitled (Sea Island Series), 1992
Gelatin silver print with text panel
31 x 31 in. (image)
19⅛ x 19⅛ in. (text) Plate 153

Wegman, *Land Bird*, 1990

Welliver, *Maine Landscape*, 1976
© 1996 Neil Welliver/Licensed by VAGA, New York, NY

Wetta, *Jason & Kristen in Vicky's Kitchen*, 1987

Whorf, *Playing the Fish* (no date)

Wiles, *Down the Little Missouri* (no date)

Wiley, *Eerie Grotto? Okini*, 1982
© 1996 Crown Point Press

WILLIAM WEGMAN (b. 1943)
Land Bird, 1990
Unique Polaroid polacolor ER
photograph
24 x 20 in.

WILLIAM WEGMAN
Rapunzel, 1991
Three Polaroid prints
86½ x 22 in. (total) Plate 152

NEIL WELLIVER (b. 1929)
Maine Landscape, 1976
Lithograph on paper
22 x 29⅞ in.

NEIL WELLIVER
Sky in Cora's Marsh, 1986
Oil on canvas
96⅛ x 120 in. Plate 105

H.C. WESTERMANN, JR. (1922–1981)
The Dancing Teacher, 1972
Mixed media sculpture
20¾ x 28⅛ x 18 in. Plate 86

JEAN WETTA (b. 1944)
X-Begonia, 1985
Oil on paper
5⅜ x 5⅜ in. (image) not illus.

JEAN WETTA
Jason & Kristen in Vicky's Kitchen, 1987
Oil on paper
5½ x 7½ in. (image)

WADE WHITE (1909–1995)
Captain Drum's Chimney, 1934–37
Oil on canvas
26 x 20 in. Plate 49

JACK WHITTEN (b. 1939)
Fancy Triangle, 1993
Acrylic and ink on canvas
32 x 32 in. Figure 59

JOHN WHORF (1903–1959)
Playing the Fish (no date)
Watercolor on paper
18½ x 18 in.

IRVING RAMSEY WILES (1861–1948)
Down the Little Missouri (no date)
Ink on paper
14 x 20¼ in. (image)

WILLIAM T. WILEY (b. 1937)
Eerie Grotto? Okini, 1982
Color woodcut on paper
22½ x 29½ in.

Wiley, *Rhoom for Error #7*, 1983
© 1996 Crown Point Press

Wilke, *Hername*, 1978–91

Williams, *Western Art for 8' x 8'*, 1984

Williams, *Hawkins Ranch, Matagorda County (for mural 4' x 10')*, 1985

Williams, *Santa Fe (for mural 4' x 10')*, 1985

Williams, *Untitled*, 1985

WILLIAM T. WILEY
Rhoom for Error #7, 1983
One of forty-six monoprints with
soft ground etching on paper
26¼ x 37 in. (approx.)

WILLIAM T. WILEY
Rhoom for Error #35, 1983
Etching with monoprint on paper
26⅛ x 36¾ in. (approx.) not illus.

WILLIAM T. WILEY
Rhoom for Error #12, 1983
Etching with monoprint on paper
26¼ x 35 in. (approx.) not illus.

HANNAH WILKE (1940–1993)
Hername, 1978-91
Etching on paper
36⅜ x 26¼ in.

CASEY WILLIAMS (b. 1947)
Western Art for 4' x 4', 1984
Hand-colored black-and-white print
10⅝ x 10½ in. (image) not illus.

CASEY WILLIAMS
Western Art for 8' x 8', 1984
Hand-colored black-and-white print
10⅝ x 10½ in. (image) not illus.

CASEY WILLIAMS
Western Art for 8' x 8', 1984
Hand-colored black-and-white print
10¾ x 10½ in. (image)

CASEY WILLIAMS
*Hawkins Ranch, Matagorda County
(for mural 4' x 10')*, 1985
Hand-colored black-and-white print
7 x 17¾ in.

CASEY WILLIAMS
*Hawkins Ranch, Matagorda County
(for mural 4' x 10')*, 1985
Hand-colored black-and-white print
7 x 17¾ in. not illus.

CASEY WILLIAMS
Santa Fe (for mural 4' x 10'), 1985
Hand-colored black-and-white print
7 x 17¾ in.

CASEY WILLIAMS
Untitled, 1985
Hand-colored black-and-white print
47⅜ x 62¾ in.

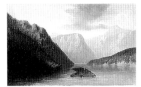

Williamson, *Raft on Lake George*
(no date)

Wilson, *When We Dead Awaken,
Act I, Amsterdam*, 1991

Charles Winter, *Liberty vs.
Violence*, 1918

Roger Winter, *Landscape with
Houses*, 1984–85

WILLIAM T. WILLIAMS (b. 1942)
Red Admiral (111½ Series), 1990
Acrylic on canvas
52¼ x 34¼ in. Plate 113

JOHN WILLIAMSON (1826–1885)
Raft on Lake George (no date)
Oil on board
8⅛ x 13¼ in.

ROBERT WILSON (b. 1941)
*When We Dead Awaken, Act I,
Amsterdam*, 1991
Charcoal and color crayon on
Fabriano paper
27⅝ x 39¼ in.

ROBERT WILSON
Stalin Chairs, 1992
Lead over Fiberglas sculptures
7¾ x 19¾ x 20½ in. (each) Figure 70

CHARLES WINTER (1868–1942)
Liberty vs. Violence, 1918
Oil on canvas
18 x 17⅛ in.

ROGER WINTER (b. 1934)
Landscape with Houses, 1984–85
Oil on canvas
60 x 80 in.

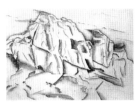

Yarrow, *Mountain Landscape*, 1920

Zakanitch (b. 1935), *Manet Slept
Here*, (*Tag Sale* series), 1993

Zorach, *Half Dome Yosemite
Valley*, 1923

Zorach, *Puma*, 1950, (2 of 2)

GRANT WOOD (1892–1942)
In the Spring, 1939
Lithograph on paper
9½ x 12½ in. Figure 16

TIMOTHY WOODMAN (b. 1952)
Woodcutters, 1987
Oil paint on prepared aluminum
71 x 36 x 11¾ in. Plate 117

WILLIAM YARROW (1891–1941)
Mountain Landscape, 1920
Watercolor on paper
9⅞ x 13¾ in.

ROBERT RAHWAY ZAKANITCH
(b. 1935)
Manet Slept Here (Tag Sale series),
1993
Acrylic on canvas
48 x 42 x 3 in.

WILLIAM ZORACH (1887–1966)
Maine Houses, 1918
Watercolor on paper
15¼ x 11⅞ in. Figure 23

WILLIAM ZORACH
Half Dome Yosemite Valley, 1923
Pencil on paper
18 x 15½ in.

WILLIAM ZORACH
Pair of Pumas, 1950
Two bronze sculptures
18½ x 13¼ in. (each)

Bibliography

Realism: Tradition and Innovation
Betsy Fahlman

A Circle of Friends: Art Colonies of Cornish and Dublin. Durham: University Art Gallery, University of New Hampshire, and Keene, NH: Thorne-Sagendorph Art Gallery, Keene State College, 1985.

An American Master: Prints by Martin Lewis. Detroit: Detroit Institute of Arts, 1991.

Anderson, Nancy K., and Linda S. Ferber. *Albert Bierstadt: Art and Enterprise.* New York: Hudson Hills Press, in association with the Brooklyn Art Museum, 1991.

Baekeland, Frederick. *Images of America: The Painter's Eye, 1833–1925.* Birmingham, AL: Birmingham Museum of Art, 1991.

Beard, Rick, and Leslie Cohen Berlowitz, eds. *Greenwich Village: Culture and Counterculture.* New Brunswick, NJ: Rutgers University Press (for the Museum of the City of New York), 1993.

Bermingham, Peter. *American Art in the Barbizon Mood.* Washington, DC: National Collection of Fine Arts, 1975.

Blackwell, Barbara. *Emerging from the Shadows: The Art of Martin Lewis, 1881–1962.* Ithaca, NY: Herbert F. Johnson Museum of Art, Cornell University, 1983.

Blaugrund, Annette, and Theodore E. Stebbins, Jr., eds. *John James Audubon: The Watercolors for The Birds of America.* New York: Villard Books, Random House, for the NewYork Historical Society, 1993.

Bloch, E. Maurice. *George Caleb Bingham.* Vol. I: *The Evolution of an Artist,* Vol. II: *A Catalogue Raisonné.* Berkeley: University of California Press, 1967.

———. *The Paintings of George Caleb Bingham: A Catalogue Raisonné.* Columbia: University of Missouri Press, 1986.

Bressler, Sidney. *Reynolds Beal: Impressionist Landscapes and Seascapes.* Rutherford, NJ: Fairleigh Dickinson University Press, 1989.

Brooks, Van Wyck. *John Sloan, A Painter's Life.* New York: E. P. Dutton, 1955.

Burke, Doreen Bolger. *American Paintings in the Metropolitan Museum of Art, Volume III, A Catalogue of Works by Artists Born between 1846 and 1864.* New York: Metropolitan Museum of Art, 1980.

Cortissoz, Royal, and the Leonard Clayton Gallery. *Catalogue of the Etchings and Dry-Points of Childe Hassam, N.A.* San Francisco: Alan Wofsey Fine Arts, 1989 [revision of catalogues of 1925, 1933].

Craven, Wayne. *American Art: History and Culture.* Madison: Brown and Benchmark, 1994.

Curtis, Jane, Will Curtis, and Frank Lieberman. *Monhegan: The Artist's Island.* Camden, ME: Down East Books, 1995

DeShazo, Edith. *Everett Shinn, 1876–1953: A Figure in His Time.* New York: Clarkson N. Potter, 1974.

de Veer, Elizabeth, and Richard J. Boyle. *Sunlight and Shadow: The Life and Art of Willard L. Metcalf.* New York: Abbeville Press, 1987.

Doezema, Marianne. *George Bellows and Urban America.* New Haven: Yale University Press, 1992.

Eldredge, Charles C., Julie Schimmel, and William H. Truettner. *Art in New Mexico, 1900–1945, Paths to Taos and Santa Fe.* Washington, DC: National Museum of American Art, 1986.

Elzea, Rowland. *John Sloan's Oil Paintings: A Catalogue Raisonné.* 2 vols. Newark: University of Delaware Press, 1991.

Fahlman, Betsy. *Guy Pène du Bois: Artist About Town.* Washington, DC: Corcoran Gallery of Art, 1980.

———. *Guy Pène du Bois: The Twenties at Home and Abroad.* Wilkes-Barre, PA.: Sordoni Art Gallery, Wilkes University, 1995.

Falk, Peter Hastings. *Who Was Who in American Art.* Madison, CT: Sound View Press, 1985.

Freundlich, August L. *William Gropper: Retrospective.* Coral Gables: Joe and Emily Lowe Art Gallery, University of Miami, 1968.

Gerdts, William H. *American Impressionism.* Seattle: The Henry Art Gallery, University of Washington, 1980.

———. *Revealed Masters: 19th Century American Art.* New York: American Federation of Arts, 1974.

———. *William Holbrook Beard: Animals in Fantasy.* New York: Alexander Gallery, 1981.

———. *Impressionist New York.* New York: Abbeville Press, 1994.

Gerdts, William H. and David B. Dearinger. *Masterworks of American Impressionism from the Pfeil Collection.* Alexandria, VA: Art Services International, 1992.

Glackens, Ira. *William Glackens and the Ashcan Group.* New York: Crown, 1957.

Groce, George C., and David H. Wallace. *The New York-Historical Society's Dictionary of Artists in America, 1564–1860.* New Haven: Yale University Press, 1957.

Henning, Robert, Jr. *New York, New York! The Prints and Drawings of Martin Lewis and Armin Landeck.* Santa Barbara: Santa Barbara Museum of Art, 1984.

Herman Herzog, 1831–1932. New York: Chapellier Galleries, n.d.

Hewitt, Mark A. *Jules Guérin: Master Delineator.* Houston: Farish Gallery, Rice University, 1983.

Hills, Patricia, and Roberta K. Tarbell. *The Figurative Tradition and the Whitney Museum of American Art.* New York: Whitney Museum of American Art, 1980.

Homer, William Innes. *Robert Henri and His Circle.* Ithaca: Cornell University Press, 1969.

The Impressionist as Printmaker, Childe Hassam, 1859–1935, from the Collection of the San Diego Museum of Art. San Diego: Founders' Gallery, University of San Diego, 1982.

Jacobowitz, Arlene. *Edward Henry Potthast, 1857 to 1927.* New York: Chapellier Galleries, 1969.

Karpiscak, Adeline Lee. *Ernest Lawson, 1873–1939.* Tucson: University of Arizona Museum of Art, 1979.

Loughery, John. *John Sloan: Painter and Rebel.* New York: Henry Holt, 1995.

Maine and its Role in American Art, 1740–1963. New York: Viking Press, 1963.

Mason, Lauris, and Joan Ludman. *The Lithographs of George Bellows: A Catalogue Raisonné.* Millwood, NY: KTO Press, 1977.

McCarron, Paul. *Martin Lewis: the Graphic Work.* New York: Kennedy Galleries, 1973.

McColley, Sutherland. *The Works of James Renwick Brevoort, 1832–1918, American Landscape Painter.* Yonkers, NY: Hudson River Museum, 1972.

Mead, Katherine Harper, ed. *The Preston Morton Collection of American Art.* Santa Barbara: Santa Barbara Museum of Art, 1981.

Milroy, Elizabeth. *Painters of a New Century: The Eight and American Art.* Milwaukee: Milwaukee Art Museum, 1991.

Morgan, Charles H. *George Bellows, Painter of America*. New York: Reynal and Co., 1965.

Morse, Peter. *John Sloan's Prints, A Catalogue Raisonné of the Etchings, Lithographs, and Posters*. New Haven: Yale University Press, 1969.

Murphy, Francis. *J. Francis Murphy, The Landscape Within, 1853–1921*. Yonkers, NY: Hudson River Museum, 1982.

Myers, Jane, and Linda Ayres. *George Bellows: The Artist and His Lithographs, 1916–1924*. Fort Worth: Amon Carter Museum, 1988.

Myers, Kenneth. *The Catskills, Painters, Writers, and Tourists in the Mountains, 1820–1895*. Yonkers: Hudson River Museum of Westchester, 1987.

Nicoll, Jessica F. *The Allure of the Maine Coast: Robert Henri and His Circle, 1903–1918*. Portland, ME: Portland Museum of Art, 1995.

Novak, Barbara, and Annette Blaugrund. *Next to Nature: Landscape Paintings from the National Academy of Design*. New York: Harper & Row, 1980.

Palumbo, Anne Cannon. "Joseph Pennell and the Landscape of Change." Ph.D. dissertation, University of Maryland, 1982.

Pennell, Elizabeth Robins. *The Life and Letters of Joseph Pennell*. 2 vols. Boston: Little, Brown, 1929.

Pennell, Joseph. *Adventures of An Illustrator*. Boston: Little, Brown, 1925.

Perlman, Bennard B. *The Immortal Eight*. New York: Exposition Press, 1962.

———. *Robert Henri, Painter*. Wilmington: Delaware Art Museum, 1984.

———. *Robert Henri: His Life and Art*. New York: Dover, 1991.

Quick, Michael, Jane Myers, Marianne Doezema, and Franklin Kelly. *The Paintings of George Bellows*. New York: Harry N. Abrams, Inc., for the Los Angeles County Museum of Art and the Amon Carter Museum, 1992.

Rand, Barbara C. "The Art of Everett Shinn." Ph.D. dissertation, University of California, Santa Barbara, 1992.

Rash, Nancy. *The Paintings and Politics of George Caleb Bingham*. New Haven: Yale University Press, 1991.

Reynolds, Gary A. *Irving R. Wiles*. New York: National Academy of Design, 1988.

Robertson, Bruce. *Reckoning with Winslow Homer: His Late Paintings and Their Influence*. Cleveland: Cleveland Museum of Art, 1990.

Scott, David W., and E. John Bullard. *John Sloan, 1871–1951*. Washington, DC: National Gallery of Art, 1971.

Shapiro, Michael Edward. *George Caleb Bingham*. New York: Harry N. Abrams, in association with the National Museum of American Art, 1993.

Shapiro, Michael Edward, and Barbara Groseclose, Elizabeth Johns, Paul C. Nagel, and John Wilmerding. *George Caleb Bingham*. New York: Harry N. Abrams, Inc., for the St. Louis Art Museum, 1990.

Skolnick, Arnold, ed. *Paintings of Maine*. New York: Clarkson N. Potter, 1991.

Sloan, Helen Farr, ed. *John Sloan, New York Etchings (1905–1949)*. New York: Dover, 1978.

Sloan, John. *Gist of Art*. New York: American Artists Group, 1939.

Soria, Regina. *Dictionary of Nineteenth-Century American Artists in Italy, 1760–1914*. Rutherford, NJ: Fairleigh Dickinson University Press, 1982.

Spassky, Natalie, et al. *American Paintings in the Metropolitan Museum of Art, Volume II, A Catalogue of Works by Artists Born between 1816 and 1845*. New York: Metropolitan Museum of Art, 1985.

Stebbins, Theodore E., Jr. *The Life and Works of Martin Johnson Heade*. New Haven: Yale University Press, 1975.

Swales, Francis S. "Master Draftsmen, Part II: Jules Guérin." *Pencil Points* 5 (May 1924): 63–66, 70.

Swift, Samuel. "The Pictorial Representation of Architecture—The Work of Jules Guérin." *The Brickbuilder* 18 (September 1909): 177–184.

Weinberg, H. Barbara, Doreen Bolger, and David Park Curry. *American Impressionism and Realism: The Painting of Modern Life, 1885–1915*. New York: Metropolitan Museum of Art, 1994.

Workman, Robert G. *The Eden of America, Rhode Island Landscapes, 1820–1920*. Providence: Museum of Art, Rhode Island School of Design, 1986.

Youngner, Rina. *The Power and the Glory: Pittsburgh Industrial Landscapes by Aaron Harry Gorson (1872–1933)*. New York: Spanierman Gallery, 1989.

Yount, Sylvia L. "Consuming Drama: Everett Shinn and the Spectacular City." *American Art* 6 (Fall 1992): 86–109.

Zurier, Rebecca. "Picturing the City: New York in the Press and the Art of the Ashcan School, 1890–1917." Ph.D. dissertation, Yale University, 1988.

The Vigor of Americanism
Matthew Baigell

Adams, Henry. *Thomas Hart Benton: An American Original*. New York: Knopf, 1989.

Baur, John I. H. *The Inlander: Life and Work of Charles Burchfield*. Newark: University of Delaware Press, 1984.

Bernstein, Theresa. *Theresa Bernstein*. Stamford, CT: Smith-Gerard, 1985.

C. K. Chatterton, 1880–1973. New York: ACA Galleries, 1980.

Davidson, Harold. *Edward Borein: Cowboy Artist*. Garden City, NY: Doubleday, 1974.

Dennis, James. *Grant Wood: A Study in American Art and Culture*. Columbia: University of Missouri Press, 1986.

Gilbert, Gregory. *George Overbury "Pop" Hart: His Life and Art*. New Brunswick, NJ: Rutgers University Press, 1986.

Goodrich, Lloyd. *Reginald Marsh*. New York: Harry N. Abrams, Inc., 1972.

Green, Eleanor. *John Graham: Artist and Avatar*. Washington, DC: Phillips Gallery, 1987.

Hobbs, Robert. *Milton Avery*. New York: Hudson Hills, 1990.

Hyman, Lynda. *Ernest Fiene: Art of the City, 1925–1955*. New York: ACA Galleries, 1981.

Kendall, M. Sue. *Rethinking Regionalism: John Steuart Curry and the Kansas Mural Controversy*. Washington, DC: Smithsonian Institution Press, 1986.

Korner, Anthony. "The Night Owl," *Artforum*, 27 (May 1989), 141–142.

Levin, Gail. *Edward Hopper: The Art and the Artist*. New York: Whitney Museum of American Art, 1980.

Minna Citron: A Survey of Paintings and Works on Paper, 1931–1989. New York: Susan Teller Gallery, 1990.

Porter, Dean A. *Victor Higgins: An American Master*. Salt Lake City: Peregrine Smith Books, 1991.

Rosenblum, Walter, et al. *America and Lewis Hine*. Millerton, NY: Aperture Books, 1977.

Steinfeldt, Cecilia. *Julian Onderdonk: A Texas Tradition*. Amarillo: Amarillo Art Center, 1985.

West, Richard O. *"An Enkindled Eye": The Paintings of Rockwell Kent*. Santa Barbara: Santa Barbara Museum of Art, 1985.

Wilmerding, John, et al. *Frank W. Benson: The Impressionist Years*. New York: Ira Spanierman Gallery, 1988.

The Lure of the Modern
Susan C. Larsen

Atkins, Robert. *Artspeak: A Guide to Contemporary Ideas, Movements, and Buzzwords.* New York: Abbeville Press, 1990.

Berman, Avis. *Rebels on Eighth Street: Juliana Force and the Whitney Museum of American Art.* New York: Atheneum, 1990.

Brown, Milton. *American Art from the Armory Show to the Depression.* Princeton, NJ: Princeton University Press, 1955.

———. *The Story of the Armory Show.* New York: Abbeville Press, 1988.

Davidson, Abraham. *Early American Modernist Painting 1910–1935.* New York: Harper & Row, 1981.

Erlich, Susan, ed. *Pacific Dreams: Currents of Surrealism and Fantasy in California Art 1934–1957.* Los Angeles: University of California, 1995.

Haskell, Barbara. *Arthur Dove.* San Francisco: San Francisco Museum of Modern Art, 1974.

———. *Marsden Hartley.* New York: Whitney Museum of American Art, 1980.

Homer, William Innes. *Alfred Stieglitz and the American Avant-Garde.* Boston: New York Graphic Society, 1977.

Kirstein, Lincoln. *Elie Nadelman.* New York: Eakins, 1973.

Kuhn, Walt. *The Story of the Armory Show.* New York: Walt Kuhn, 1938.

Lisle, Laurie. *Portrait of an Artist: A Biography of Georgia O'Keeffe.* New York: Seaview, 1980.

Lowe, Sue Davidson. *Stieglitz: A Memoir/Biography.* New York: Farrar, Straus and Giroux, 1983.

Lynes, Barbara Buhler. *O'Keeffe, Stieglitz and the Critics 1916–29.* Ann Arbor and London: UMI Research Press, 1989.

Morgan, Ann Lee, ed. *Dear Stieglitz, Dear Dove.* Newark, DE.: Associated University Presses, 1988.

Scott, Gail. *Marsden Hartley.* New York: Abbeville Press, 1988.

Tashjian, Dickran. *Skyscraper Primitives.* Middletown, CT: Wesleyan University Press, 1972.

Watson, Steven. *Strange Bedfellows: The First American Avant Garde.* New York: Abbeville Press, 1991.

Order, Structure, and the Continuity of Modernism
William C. Agee

Agee, William C. "Stuart Davis in the 1960s: 'The Amazing Continuity.'" In *Stuart Davis, American Painter* (exhibition catalogue). New York: The Metropolitan Museum of Art, 1991, 82–96.

Agee, William C., et al. *Patterns of Abstraction: Selections from the CIBA Art Collection* (exhibition catalogue). New York: Hunter College, 1994.

Barr, Alfred H. Jr. "Tendencies in Modern American Painting" (summary of lecture). *Bowdoin Orient.* (May 11, 1927), 3–4.

———. "American Art Has Numerous Styles" (summary of lecture). *Wellesley College News* (May 9, 1929), 2.

Baur, John I.H., and Lloyd Goodrich. *American Art of Our Century.* New York: Frederick A. Praeger for the Whitney Museum of American Art, 1961.

———. *Revolution and Tradition in Modern American Art.* Cambridge, MA: Harvard University Press, 1951.

Brown, Milton W. *American Painting from the Armory Show to the Depression.* Princeton: Princeton University Press, 1955.

———. *The Modern Spirit: American Painting, 1908–1935* (exhibition catalogue). London: Arts Council of Great Britain, 1977.

Cahill, Holger, and Alfred H. Barr Jr. *Art in America: A Complete Survey.* New York: Reynal and Hitchcock, 1935.

Davidson, Abraham A. *Early American Modern Painting 1910–1935.* New York: Harper & Row, 1981.

Homer, William, ed. *Avant Garde Painting and Sculpture in America, 1910–1925* (exhibition catalogue). Wilmington: Delaware Art Museum, 1975.

Kootz, Samuel M. *Modern American Painters.* Norwood, MA: Brewer and Warren, Inc., 1930.

Lane, John R., and Susan C. Larkin, eds. *Abstract Painting and Sculpture in America,1927–1944* (exhibition catalogue). Pittsburgh and New York: Carnegie Institute and Harry N. Abrams, Inc., 1983.

Soby, James Thrall. *Contemporary Painters.* New York: The Museum of Modern Art, 1948.

Stavitsky, Gail, et al. *Precisionism in America, 1915–1941: Reordering Reality* (exhibition catalogue). New York: Harry N. Abrams, Inc. for the Montclair Art Museum, 1994, 52–59.

The Adventures of the New York School
Dore Ashton

Anfam, David. *Abstract Expressionism.* London: Thames & Hudson, 1990.

Ashton, Dore. *Twentieth-Century Artists on Art.* New York: Pantheon, 1985.

———. *The New York School.* New York: Viking Press, 1973.

Baur, John I. H. *Nature in Abstraction.* New York: Whitney Museum of American Art, 1958.

Chipp, Herschel B. *Theories of Modern Art.* Berkeley: University of California Press, 1968.

Sandler, Irving. *Abstract Expressionism: The Triumph of American Painting.* New York: Praeger, 1970.

Seitz, William. *Abstract Expressionist Painting in America.* Cambridge, MA and London: Harvard University Press, 1983.

No Mere Formality
Peter Plagens

Artstudio, No. 24: Spécial Ellsworth Kelly. Paris: Centre national des lettres, 1992.

Agee, William C. *Kenneth Noland: The Circle Paintings, 1956–63.* Houston: The Museum of Fine Arts, 1993.

Armstrong, Richard. *Al Held.* New York: Rizzoli, 1991.

Breslin, James E. B. *Mark Rothko: A Biography.* Chicago: University of Chicago Press, 1993.

Carmean, E. A. *Helen Frankenthaler: A Paintings Retrospective.* New York: Harry N. Abrams, Inc., 1989.

Chave, Anna C. *Mark Rothko: Subjects in Abstraction.* New Haven: Yale University Press, 1989.

Chipp, Herschel. *Theories of Modern Art: A Source Book by Artists and Critics.* Berkeley: University of California Press, 1968.

Cole, Alison. *Virtue and Magnificence: Art of the Italian Renaissance Courts.* New York: Harry N. Abrams, Inc., 1995.

Colpitt, Frances. *Minimal Art: The Critical Perspective.* Ann Arbor: UMI Research Press, 1990.

Coplans, John. *Serial Imagery.* Pasadena: Pasadena Museum of Art, 1969.

d'Harnoncourt, Anne, and Walter Hopps. *Etant Donnés: 1. la chute*

d'eau, 2. le gas d'éclairage: Reflections on a New Work by Marcel Duchamp. Philadelphia: Philadelphia Museum of Art, 1987.

Dictionary of the Arts. New York: Facts on File, 1994.

Dorra, Henri. *Symbolist Art Theories: A Critical Anthology.* Berkeley: University of California Press, 1994.

Elderfield, John, ed. *Studies in Modern Art, No. 1: American Art of the 1960s.* New York: The Museum of Modern Art, 1991.

Geldzahler, Henry. *New York Painting and Sculpture.* New York: E. P. Dutton, 1970.

Hapgood, Susan. *Neo-Dada: Redefining Art, 1958–62.* New York: The American Federation of Arts, 1994.

Haskell, Barbara. *Agnes Martin.* NewYork: Harry N. Abrams, Inc., 1992

Hirschfeld, Susan B. *Watercolors by Kandinsky.* New York: The Solomon R. Guggenheim Foundation, 1991.

Hoberg, Annegret. *Wassily Kandinsky and Gabriele Münter.* Munich: Prestel-Verlag, 1994.

Hunter, Sam, and John Jacobus. *Modern Art.* New York: Harry N. Abrams, Inc., 1992.

Kandinsky, Wassily. *The Art of Spiritual Harmony.* Boston: Houghton Mifflin, 1914.

Kellein, Thomas, ed. *Clyfford Still.* Munich: Prestel-Verlag, 1992.

Kertess, Klaus. *Brice Marden: Paintings and Drawings.* New York: Harry N. Abrams, Inc., 1992.

Lampert, Catherine. *Richard Diebenkorn.* London: The Whitechapel Gallery, 1991.

Leja, Michael. *Reframing Abstract Expressionism: Subjectivity and Painting in the 1940s.* New Haven: Yale University Press, 1993.

Naifeh, Steven, and Gregory White Smith. *Jackson Pollock: An American Saga.* New York: Clarkson N. Potter, 1989.

O'Brien, John. *Clement Greenberg: The Collected Essays and Criticism,* Vols 1–4. Chicago: University of Chicago Press.

Paz, Octavio. *Marcel Duchamp.* New York: Seaver Books, 1981.

Rose, Barbara, ed. *Ad Reinhardt. Art as Art: The Selected Writings of Ad Reinhardt.* Berkeley: University of California Press, 1991.

Rubin, William. *Frank Stella: 1970–1987.* New York: The Museum of Modern Art, 1987.

Sandler, Irving. *American Art of the 1960s.* New York: Harper & Row, 1988.

Solomon, Deborah. *Jackson Pollock: A Biography.* New York: Simon and Schuster, 1987.

Tashjian, Dickran. *A Boatload of Madmen: Surrealism and the American Avant-Garde, 1920–1950.* New York: Thames & Hudson, 1995.

Upright, Diane. *Morris Louis: The Complete Paintings, a Catalogue Raisonné.* New York: Harry N. Abrams, Inc., 1985.

Wilkin, Karen. *Kenneth Noland.* New York: Rizzoli, 1989.

The Deluge of Popular Culture
Irving Sandler

Alloway, Lawrence. *American Pop Art.* New York: Macmillan/Collier, 1974.

Amayo, Mario. *Pop Art . . . and After.* New York: Viking, 1966.

Ashberry, John, Sidney Janis, and Pierre Restany. *New Realists.* New York: Sidney Janis Gallery, 1962.

Compton, Michael. *Pop Art.* London: Hamlyn, 1970.

Coplans, John. *Pop Art USA.* Oakland, CA: Oakland Art Museum, 1963.

Finch, Christopher. *Pop Art: Object and Image.* New York: E. P. Dutton, 1968.

Gablik, Suzi. "Protagonists of Pop: Five Interviews." *Studio International* (July–August 1969), 9–12.

Geldzahler, Henry. *Pop Art 1955–70.* Sydney, Australia: International Cultural Corporation of Australia Limited, 1985.

Glazer, Bruce. "Lichtenstein, Oldenburg, Warhol: A Discussion." *Artforum* (February 1966), 20–24.

Haskell, Barbara. *Blam! The Explosion of Pop, Minimalism, and Performance 1958–1964.* New York: Whitney Museum of American Art, 1984.

Kaprow, Allan. *Assemblage, Environments & Happenings.* New York: Harry N. Abrams, Inc., 1966.

Lippard, Lucy, ed. *Pop Art .* New York: Praeger, 1966, revised in 1970. Texts by Lawrence Alloway, Nicolas Calas, and Nancy Marmer.

Livingston, Marco. *Pop Art: A Continuing History.* London: Thames and Hudson, 1990.

Mahsun, Carol Anne, ed. *Pop Art: The Critical Dialogue.* Ann Arbor: UMI Research Press, 1989.

———. *Pop Art and the Critics.* Ann Arbor: UMI Research Press, 1987.

Pierre, José. *Pop Art: An Illustrated Dictionary.* London: Eyre Methuen, 1977.

Rosenblum, Robert. "Pop Art and Non-Pop Art." *Art and Literature* 5 (Summer 1965), 80–93.

Rublowsky, John. *Pop Art: Images of the American Dream.* New York: Basic Books, 1965).

Russell, John, and Suzi Gablik. *Pop Art Redefined.* New York: Praeger, 1969.

Sandler, Irving. *American Art of the 1960s.* New York: Harper & Collins, 1988.

———. *The New York School: The Painters and Sculptors of the Fifties.* New York: Harper & Collins, 1978.

Stich, Sidra. *Made in USA: An Americanization in Modern Art, the '50s and '60s.* Berkeley, CA: University Art Museum, 1987.

Swenson, G. R. "The New American 'Sign Painters.'" *Art News* (September 1962), 44–47, 60–62.

———, ed. "What Is Pop Art?" Part 1. *Art News* (November 1963), 24–27, 60–64 (Interviews with Jim Dine, Robert Indiana, Roy Lichtenstein, and Andy Warhol).

———, ed. "What Is Pop Art?" Part 2. *Art News* (February 1964), 40–43, 62–66 (Interviews with Stephen Durkee, James Rosenquist, Jasper Johns, and Tom Wesselmann).

"A Symposium on Pop Art." *Arts Magazine* (April 1963), 36–44.

Varnedoe, Kirk, and Adam Gopnik. *High and Low: Modern Art and Popular Culture.* New York: The Museum of Modern Art and Harry N. Abrams, Inc., 1990.

Warhol, Andy, and Pat Hackett. *POPism: The Warhol '60s.* New York: Harcourt Brace Jovanovich, 1980.

Wells, Jennifer. "The Sixties: Pop Goes the Market." *Definitive Statements: American Art: 1964–66.* Providence, RI: List Art Center, Brown University, 1986.

Wilson, Simon. *Pop.* London: Thames and Hudson, 1974.

Minimalism and Its Opposition
John R. Clarke

Alloway, Lawrence. "Robert Smithson's Development." *Artforum* 11 (November 1972), 52–61.

Baker, Kenneth. *Minimalism.* New York: Abbeville Press, 1988.

Battcock, Gregory, ed. *Minimal Art.* New York: E.P. Dutton, 1968.

———. *Super Realism.* New York: E.P. Dutton, 1975.

Bourdon, David. "The Razed Sites of Carl Andre." *Artforum* (October 1966). Reprinted in Battock, *Minimal Art*, 1968.

Fried, Michael. "Shape as Form: Frank Stella's New Paintings." *Artforum* 5 (November 1966), 18–27.

———. "Art and Objecthood," *Artforum* (Summer 1967), 12–23. Reprinted in Battcock, *Minimal Art*, 1968.

Goldin, Amy. "Patterns, Grids, and Painting." *Artforum* 14 (September 1975), 50–54.

Krauss, Rosalind E. *Passages in Modern Sculpture*. New York: Viking Press, 1977.

Lippard, Lucy R., ed. *Six Years: The Dematerialization of the Art Object from 1966 to 1972; A Cross-Reference Book of Information on Some Esthetic Boundaries*. New York: Praeger, 1973.

Morris, Robert. "Notes on Sculpture, Part 3: Notes and Nonsequiturs." *Artforum* (Summer, 1967), 24–29.

Nodelman, Sheldon. "Sixties Art: Some Philosophical Perspectives," *Perspecta* (1968), 73–89.

Perreault, John. "Issues in Pattern Painting." *Artforum* 16 (November 1977), 32–36.

Rose, Barbara. "ABC Art." *Art in America* 53 (October–November, 1965), 57–69.

Thirty-six Poems by Tu Fu. Translated by Kenneth Rexroth with twenty-five etchings by Brice Marden. New York: P. Blum Editing, 1987.

The Personal as Political
Leslie King-Hammond

Brown, Elizabeth A. *Social Studies: 4+4 Young Americans*. Oberlin, OH: Allen Memorial Art Museum, 1990.

Clark, Trinkett. *Parameters*. Norfolk, VA: The Chrysler Museum, 1992.

Du Bois, W. E. B. *The Souls of Black Folk*. (1903, reprint, New York: Bantam, 1989).

Harkins, Ellen Wheat. *Jacob Lawrence—American Painter*. Seattle: University of Washington Press, 1986.

Harris, William J., ed. *The LeRoi Jones/Amiri Baraka Reader*. New York: Thunder's Mouth Press, 1991.

Hughes, Langston. "The Negro Artist and the Racial Mountain." *The Nation* (June 23, 1926).

Mercer, Valerie. *Fourteen Paintings: William T. Williams*. Montclair, NJ: The Montclair Art Museum, 1991.

Miller, Donald. "Hanging Loose: an Interview with Sam Gilliam." *Art News* 72 (January 1973).

The Studio Museum in Harlem. *Memory and Metaphor—The Art of Romare Bearden 1940–1987*. New York: Oxford University Press, 1991.

Wright, Beryl J. *Jack Whitten* (exhibition catalogue). Newark, NJ: The Newark Museum, 1990.

Ethnicity, Outsiderness, New Regionalism
Jacinto Quirarte

Beardsley, John, and Jane Livingston. *Hispanic Art in the United States: Thirty Contemporary Painters and Sculptors*. New York: Abbeville Press, 1987.

Burnham, Linda. "Art with a Chicano Accent." *High Performance* 9, no. 3 (1986), 55.

Gamboa, Harry, Jr. "In the City of Angels, Chameleons, and Phantoms: Asco, a Case Study of Chicano Art in Urban Tone (or *Asco* Was a Four-Member Word)." *Chicano Art: Resistance and Affirmation*. (Los Angeles: Wight Gallery, University of California, 1991), 121–130.

Goldman, Shifra. *Contemporary Mexican Painting in a Time of Change*. Austin: University of Texas Press, 1977.

Hickey, Dave. *Border Lord*. Austin: Laguna Gloria Art Museum, 1988.

Hulick, Diana Emery. "Immortalizing Death: The Photography of Kathy Vargas." *Latin American Art* 6, no.1 (1994), 62–65.

Kanellos, Nicolas, ed. *The Hispanic American Almanac: A Reference Work on Hispanics in the United States*. Detroit: Gale Research Inc., 1993.

Quirarte, Jacinto. *Mexican American Artists*. Austin: University of Texas Press, 1973.

———. "A Search for Identity: Mexican and Chicano Art." *World Art: Themes of Unity in Diversity, Acts of the XXVIth International Congress of the History of Art*, vol. 3. (University Park: Pennsylvania State University Press, 1989), 781–88.

———. "Exhibitions of Chicano Art: 1965 to the Present." *Chicano Art: Resistance and Affirmation, 1965–1985*. (Los Angeles: Wight Gallery, University of California, 1991), 163–79.

———, ed. *Chicano Art History: A Book of Selected Readings*. San Antonio: Research Center for the Arts and Humanities, 1984.

———, ed. *A History and Appreciation of Chicano Art*. San Antonio: Research Center for the Arts and Humanities, 1984.

Tarshis, Jerome. "Lofty Daydreams, Harsh Reality." *The Christian Science Monitor* (October 18, 1993), 16.

Art After Modernism: The Pluralist Era
John Beardsley

Clifford, James. *The Predicament of Culture*. Cambridge: Harvard University Press, 1988.

Foster, Hal, ed. *The Anti-aesthetic: Essays on Postmodern Culture*. Port Townsend, WA: Bay Press, 1983.

Harvey, David. *The Condition of Postmodernity: An Enquiry into the Origins of Cultural Change*. Oxford and Cambridge, MA: Blackwell, 1989.

Higham, John. *Send These to Me*. 1975. Reprint. Baltimore: Johns Hopkins, 1984.

Huyssen, Andreas. *After the Great Divide: Modernism, Mass Culture, Postmodernism*. Bloomington: Indiana University Press, 1991,

Jameson, Frederic. *Postmodernism, or The Cultural Logic of Late Capitalism*. Durham, NC: Duke University Press, 1991.

Kuspit, Donald. *The New Subjectivism*. Ann Arbor, MI: UMI Research Press, 1979.

Mann, Arthur. *The One and the Many*. Chicago: University of Chicago Press, 1979.

McEvilley, Thomas. *The Exile's Return: Toward a Redefinition of Painting for the Postmodern Era*. Cambridge, England, and New York: Cambridge University Press, 1993.

Wallis, Brian, ed. *Art After Modernism: Rethinking Representation*. New York: New Museum of Contemporary Art, and Boston: David R. Godine, 1984.

Index

Note: Page numbers in *Italics* refer to illustrations.

Biographies of the Authors

William Agee is currently Professor of Art History at Hunter College in New York. Formerly Director of the Museum of Fine Arts, Houston, he has written extensively on modern American art.

Dore Ashton is an art critic, historian, and author of more than twenty books on the arts. Her interests range from the United States to Europe and from Latin America to Japan. She is presently Professor of Art History at the Cooper Union in New York as well as a broadcaster and television commentator.

Matthew Baigell holds a Ph. D. from the University of Pennsylvania and presently holds the special rank of Professor II at Rutgers University. He has written nine books on American art, specializing in the art and artists of the American Regionalist movement. In addition, he has edited two books and has written more than fifty articles as well as essays for exhibition catalogues. Current projects include a study of the presence of Ralph Waldo Emerson in twentieth-century American art.

John Beardsley is recognized as an author, curator, and lecturer with a wide range of expertise on contemporary art and the public space. His most recent book, *Gardens of Revelation*, is a look at the part-architectural, part-sculptural creations of visionary artists. His other titles include *Earthworks and Beyond: Contemporary Art in the Landscape* and *Art in Public Places*, a survey of public art projects supported by the Art in Public Places program of the National Endowment for the Arts. As a museum curator, Beardsley has organized a number of exhibitions including "Hispanic Art in the United States: Thirty Contemporary Painters and Sculptors," for the Museum of Fine Arts, Houston (1987); and "Black Folk Art in America: 1930–1980," for the Corcoran Gallery of Art, Washington, D.C. (1982). Beardsley has taught in the landscape architecture programs at the University of Virginia, Harvard, and the University of Pennsylvania.

John R. Clarke, Annie Laurie Howard Regents Professor of Fine Arts at the University of Texas at Austin, teaches the history of Roman art, contemporary American art, and art-historical methodology. He received his Ph.D. in Art History at Yale University, where he taught until coming to Austin in 1980. In addition to numerous articles and essays on contemporary art, Clarke is the author of *Roman Black-and-White Figural Mosaics* (1979) and *The Houses of Roman Italy, 100 B.C.–A.D. 250* (1991). He was recently a resident at the American Academy in Rome where he completed a new book called *Looking at Lovemaking in Roman Art: Constructions of Sexuality 100 B.C.–A.D. 250*; it will be published by the University of California Press in 1997.

Betsy Fahlman has taught art history at Arizona State University since 1988. She received her B. A. from Mount Holyoke College and her M. A. and Ph. D. degrees from the University of Delaware. She has authored major publications in the field of American art, including articles and catalogues on Guy Pène du Bois, Charles Demuth, Alexander Galt, and Wilson Eyre. Her book, *John Ferguson Weir: The Labor of Art*, will soon be published by the University of Delaware Press.

Leslie King-Hammond is a leading expert on African-American art. Currently a lecturer in the Art History Department as well as Dean of Graduate Studies at the Maryland Institute, College of Art, she also holds a position as Project Director for the Philip Morris Fellowships for Artists of Color and is President-Elect for the College Art Association. In addition to her numerous responsibilities, she has also written several articles on the history of African-American art.

Walter Hopps has had a distinguished career in the art field, serving as Curator and Director of the Pasadena Art Museum, Director of the Corcoran Gallery of Art, Curator of 20th Century American Art at the Smithsonian Institution, and Founding Director of the Menil Collection in Houston. In addition to his curatorial and directorial positions, he has taught art history at the University of California–Irvine and has acted as United States Commissioner at the 1972 Venice Biennale. He currently holds the position of Consulting Curator at the Menil Collection.

Susan Larsen is a writer, art historian, and curator of exhibitions. Formerly Curator of the Permanent Collection at the Whitney Museum of American Art in New York, she was also Professor of Art History at the University of Southern California for twenty years. Her areas of special interest include American twentieth-century painting and sculpture and American folk and outsider art.

Peter Marzio is presently Director of The Museum of Fine Arts, Houston; past positions include Director and Chief Executive Officer of the Corcoran Gallery of Art, Curator of Prints (Smithsonian Institution, National Museum of American History), and Chairman of the Smithsonian's Department of Cultural History. He taught at the University of Maryland for several years and has also written a number of books and articles; he presently serves on many professional boards and advisory committees.

Peter Plagens currently holds the position of art critic at *Newsweek* magazine. He has held a number of teaching positions at schools such as the University of North Carolina, Chapel Hill, the University of Southern California, and the University of Texas and has also written several books, reviews, and essays for publication. Plagens is an artist as well as a scholar whose work has been exhibited widely and is included in a number of public and private collections.

Jacinto Quirarte is Professor of Art and Architecture and Director of the Research Center for the Visual Arts in the College of Fine Arts and Humanities at The University of Texas at San Antonio. His specialty is the history and criticism of Latin American and Hispanic American art. He is the author of several books and monographs as well as numerous papers and reviews on the art of Mexico (pre-Columbian, Colonial, and modern) and Hispanic America (Chicano art).

Irving Sandler is currently Professor of Art History at the State University of New York at Purchase. His special interests include American art since the 1950s and he has written a number of books on the subject. He also serves as a contributing editor at *Art in America* and has held a number of positions throughout his career, including President of the American Section of the International Art Critics Association, Director of the College Art Association, and Chairman of the Overview Committee of the Visual Arts (National Endowment for the Arts).